MAJOLICA

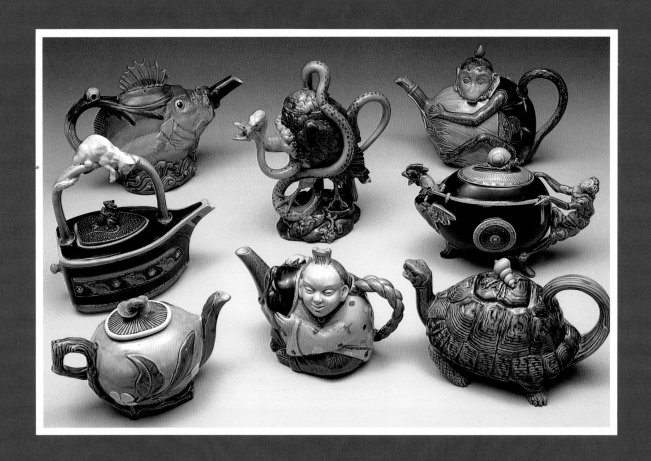

MAJOLICA

A Complete History and Illustrated Survey

by
Marilyn G. Karmason
with Joan B. Stacke

HARRY N. ABRAMS, INC. PUBLISHERS

To our families . . . and to Herbert, Josiah, and George.

Editor: *Robert Morton*
Designers: *Carol Ann Robson, Gilda Hannah*

Page 2:
A collection of Minton & Co. teapots
Page 6:
A collection of American and English majolica
Page 10:
Minton & Co. Pigeon-pie tureen, 1864.
Height 11". (No. 777)

Editorial note: most of the majolica illustrated in this book
is in private collections and, by agreement, is not identified by owner.
Credit for other illustrations appears with the captions.

Library of Congress Control Number: 2002105463
ISBN 0–8109–3595–3

Harry N. Abrams, Inc.
100 Fifth Avenue
New York, N.Y. 10011
www.abramsbooks.com

Abrams is a subsidiary of

CONTENTS

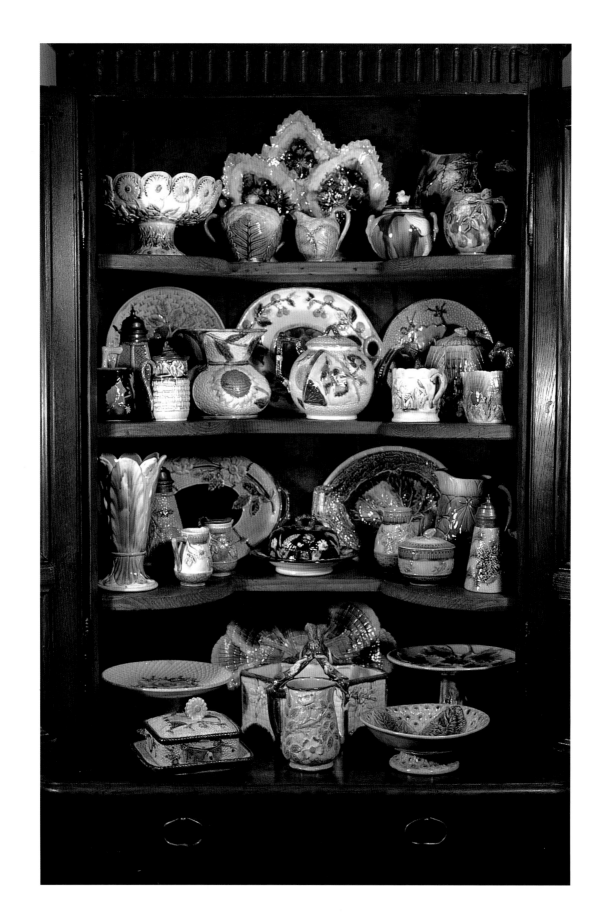

ACKNOWLEDGMENTS

Before embarking on this history of Victorian majolica, we would like to thank our colleagues and friends who, like the story of majolica itself, are represented on both sides of the Atlantic.

Four learned art historians have been most gracious and generous with invaluable information and unfailing encouragement throughout our years of research and writing. These are Joan Jones, Curator of the Minton Museum, and Lynn Miller, Museum Information Officer of the Wedgwood Museum, both in Stoke-on-Trent, England, whose patient guidance was unparalleled and whose magnificent photographs are so essential to the illustration of this text; Ruth I. Weidner, Associate Professor, Department of Art, West Chester University, West Chester, Pennsylvania, whose research of American majolica was so important to our work, and who generously shared her ideas with us; and David R. McFadden, Curator of Decorative Arts at the Cooper-Hewitt Museum, New York City, whose scholarly intuition and great sense of style were responsible for the first museum exhibition of English majolica in the United States, in 1982. These advisors were also kind enough to introduce us to their experienced colleagues. We value their help and their friendship.

In addition to curatorial assistance during our visits to the Stoke-on-Trent museums, we are grateful for illuminating conversations with Susan H. Myers, Curator of Ceramics and Glass at the Smithsonian Institution, Washington, D.C.; Jennifer Faulds Goldsborough, Chief Curator, Museum of Maryland History, Baltimore; Dr. Barbara Perry, Curator of Ceramics, Everson Museum of Art, Syracuse, New York; Susan Finkel, Assistant Curator, Cultural History Bureau, New Jersey State Museum, Trenton; Jack Lindsey, Assistant Curator of American Art, Philadelphia Museum of Art; David M. Frees, Jr., former member of the Board of Directors, Phoenixville Historical Society, Phoenixville, Pennsylvania; Charles B. Barlow, former president of the New Milford Historical Society, New Milford, Connecticut; Alan F. Rumrill, Director, Historical Society of Cheshire County, Keene, New Hampshire; Susan R. Strong, Acting Dean, New York State College of Ceramics at Alfred University, Alfred, New York. We very much enjoyed informative discussions about the production of ceramics with Wayne D. Higby, Professor of Ceramics, and Chairperson of the Ceramics Division; John Gill, Associate Professor of Ceramics; and

Andrea Gill, Assistant Professor of Ceramics—all three at Alfred University; David V. Becker, M.D.; John Morton, manager of the Minton Museum; and John H. Baker, instructor in art, West Chester University, West Chester, Pennsylvania.

We are also indebted to Arnold Mountford, retired director of the City Museum and Art Gallery, Hanley, for a very special tour of the museum; to Patricia Halfpenny, Keeper of Ceramics, and to Debbie Skinner, Assistant Keeper of Ceramics at the same museum; to Dr. Francis Celoria, retired director of the Gladstone Pottery Museum, Longton; to Aileen Dawson, a curator of medieval and later antiquities, British Museum, London; to Robert Copeland, history consultant, Copeland-Spode Museum, Stoke-on-Trent; and to Sandra Weston, head of public relations at Thomas Goode and Company, London. Our research in England was assisted by Amanda Fielding, Ceramics Department, Victoria and Albert Museum, London; Margaret Hodson and Rose Wheat of Stoke-on-Trent; and Mandy Banton, Search Department, Public Record Office in Kew. We are grateful for help with our research in New York to Paula Frosch, Assistant Museum Librarian, Metropolitan Museum of Art, and to Adrienne M. Baxter. We wish to thank, as well, the many directors and curators who helped us compile the list of museums that readers can visit to view majolica.

Photography permits the reader to partake of the extravagant imagery of majolica. The majority of the photographs were taken by Jacob J. Graham, M.D., and Jill Graham Klein. We appreciate their skill behind the camera and are grateful for their unending involvement with this project. Our designers at Abrams have enhanced the effectiveness of the photographs with their superb visualization of the partnership between the images and the words.

Photographs were generously provided by many museums, auction houses, dealers, and collectors on both sides of the Atlantic. We very much appreciate the special assistance of Mark Newstead, Sotheby's, London; Debe Cuevas, Sotheby's, New York; Dan Klein, Christie's, London; Susan Rolfe, Christie's, New York; and John Sandon, Phillips, London. Antiques dealers who have brought majolica to the attention of the public and who have shared their excitement and expertise with us include Jeremy Cooper, Richard Dennis, Rita and Ian Smythe, and P. T. Arenski in England; Bonnie Heller, Charles Washburne, Garvin Mecking and

Dwight Crockett, Hubert Des Forges, Barney's New York Chelsea Passage, Paul and Kay Sarver, Mariann Katz-Marks, Rufus Foshee, Joan Pappas, Linda and Kenneth Ketterling, Richard Saunders, all in the United States. J. Garrison and Diana Stradling were most helpful with their scholarly advice on American ceramics.

Collectors have been most enthusiastic and supportive. Many of them have allowed us to photograph their collections and, in several instances, have contributed their own photographs as well. They include William Aberbach, Dr. and Mrs. Harold Ayers, Sr. and Mrs. John Boraten, Mrs. Helen Cornog, Mr. and Mrs. Russell Custer, Julie and Jim Dale, Joan Esch, Mrs. Grace Yarnall Hadfield, Flora and Adam Hanft, Drs. Lawrence and Myra Hatterer, Gilbert and Toby Heller, Jerry and Aviva Leberfeld, Leo Lerman and Gray Foy, Robert and Judy Natkin, Floyd and Shelley Orn, Michael and Doris Simon, Mrs. Ellis Stern, Robert and Patricia Weiner, and Marc and Susan Weitzen. We thank the Wedgwood Society of New York for inviting us to speak at their meeting on English and American majolica, which, in addition to the exhibition of English majolica at the Cooper-Hewitt Museum, was important to the early development of this book.

Leo Lerman, Editorial Advisor to the Condé Nast Publications, is an astute collector of Victoriana, and especially of majolica. We can truly say that without him this book would not have been written. He is an inspiring, knowledgeable, and insightful mentor, and we thank him for his wisdom and guidance. Other friends who were specifically involved with our project from the start include Leslie Glucksman, Martin Bresler, and Floria V. Lasky. Special thanks are happily given to Nina Spritz and Norton Spritz, M.D., J.D., whose careful review of the manuscript was exceeded only by their patience, forbearance, and ever-present understanding; to Carrie and Alvin Lake, family members and perceptive dealers and collectors, whose extensive knowledge contributed greatly to the final polishing of the manuscript; to Ellen Kean for her cheerful assistance with typing and correspondence; and to Eula Singh and Emma Gunther for their constant moral support. It is with the greatest delight that we thank Sarah B. Sherrill for her meticulous editorial work reflecting her academic background in art history, for the elegance of her style, and for the tenacity of her spirit. Our collaborators Sophie and Robert Lehr contributed in Chapter Ten of this book their vast knowledge of French majolica and other European majolica. Their excellent photographs accompany their text. Both Sophie and Robert Lehr are collectors, dealers, and scholars. To Robert Morton, Director of Special Projects at Harry N. Abrams, Inc., goes our deepest gratitude for his professional acumen, for his steadfast encouragement, and for his own enjoyment of majolica, an enjoyment that made our work with him such a great and rare pleasure.

MARILYN G. KARMASON, M.D.
JOAN B. STACKE

ACKNOWLEDGMENTS FOR THE REVISED EDITION

With great appreciation to: Jill Graham Klein (photography); Rita and Ian Smythe and Charles Washburne (photographs); Adrienne Baxter (editorial consultant); collectors who researched in museums, Ann Dylis, Margaret Howland, Mimi Kersun, Nancy Kramer, Ida Pfeffer, Mary (Polly) Wilbert; Philip and Deborah English, Jerry and Aviva Leberfeld, David and Donna Reis for permitting photography of their collections; Marshall P. Katz for his knowledge of Palissy ware; Duane Matthes for his Internet instruction; Matthew Winterbottom, The Royal Collection Trust, St. James Palace, London; Sally Salvesen and Ruth Applin, Yale University Press, London; Sian Cooksey, Picture Library Assistant, Windsor Castle, Windsor; Paula Frosch, Associate Librarian, and Deeana Cross, Photography Librarian, the Metropolitan Museum of Art; Elizabeth Broman, Librarian, the Cooper-Hewitt Museum, Smithsonian Institution; The Lightner Museum, St. Augustine, Florida; Sotheby's (New York); Melissa Bennie, Christie's East; George Costa and Dodie Lake, Ophelia Fine Arts, Woollahra, Australia; Christopher Menz, curator, National Gallery of Victoria, Melbourne, Australia; Georgia Hale, Rights and Reproductions Officer, Art Gallery of South Australia, Adelaide, Australia; Paul Atterbury, and Robert Morton.

FOREWORD

To protect and preserve what is unpopular is a challenge and a responsibility that brings collectors and museums together. This goal is based on a belief that time will eventually prove that what is deemed unimportant—and is thus overlooked—by one generation is often of great significance and interest to those who follow. The family of nineteenth-century ceramics referred to as majolica is a striking example of this phenomenon. Admired and avidly acquired in its own day, majolica fell into disfavor in the twentieth century as the extraordinarily creative and complex society that flourished under Queen Victoria came to be regarded as the epitome of vulgarity and pretension. Like electroplated silver, pressed and blown glass ornaments, flocked wallpapers, and revival-style furniture, majolica was evicted from the dining room and tea table, banished to basements or attics, or discarded. The return to popularity of nineteenth-century majolica, as documented by museum exhibitions, saleroom prices, and publications such as this, offers confirmation of belief in the inherent cultural value of objects.

In its early years of production, majolica was often inspired directly by the ceramics of the Renaissance, particularly those works made by the great artist-potter Bernard Palissy, and his contemporaries. The forms and ornaments of ewers, basins, dishes, and chargers were based on a vocabulary of design derived from classical sources, and enriched by an exceptional palette of lead-glaze colors that included jewel-like tones of emerald green and sapphire blue. The color range made possible through glaze technology soon grew to encompass pinks, turquoises, and yellows that were as refreshing as they were striking when used together.

England, Europe, and America contributed their distinctive wares to the majolica tradition; classically-inspired designs were joined by an ever-expanding repertoire of shapes derived from natural forms. It is these delicately modelled and painted designs—based on flowers and foliage, sea creatures, birds, and other small animals—that seduced the popular imagination of the nineteenth century, and continue to do so today. Even when majolica wares in natural forms followed the dictates of "fitness for purpose" in strawberry dishes formed of woven baskets and strawberry leaves, or in seafood servers that depicted fish and crustaceans in vivid and sometimes gelatinous colors, the unpretentious charm and humor of the designs enchanted the eye. Adding exotic interest to the design vocabulary in this period were objects inspired by the arts of the east—China and Japan—contributing a glamorous and worldly note to the tabletop.

The revival of interest in nineteenth-century majolica during the last two decades has progressed far beyond the handful of pioneer collectors who first recognized the aesthetic value of these wares. Fortuitous circumstances helped, I believe, to focus attention on these extraordinary pieces: the "studio craft" movement of the 1960s brought with it a new appreciation of clay as a material of artistic expression, while a revitalized interest in industrial art production in the nineteenth century made itself felt in the academic community. A parallel can even be posited that links interests in the decorative arts to the world of fine arts of the '60s and '70s when hyper-realism was a mainstream movement, with which majolica wares were often surprisingly sympathetic. A final element that contributed to the reevaluation of majolica during this period was the growing awareness of nineteenth-century decorative arts in general on the part of art historians, collectors, and museums. This upsurge of interest in decorative arts in recent years has changed

both public attitudes and museum policies about both collections and exhibitions. Nineteenth-century majolica has been one of the beneficiaries of this awareness and appreciation.

Majolica continues to intrigue and to delight both specialists and non-specialists. In subjects, techniques, and functions in display and use, majolica encapsulates a special moment in nineteenth-century history. Its appeal, however, is no longer limited to antiquarians and specialized collectors. This publication, which comprises a lively and comprehensive survey of majolica, provides important information for those who have already succumbed to majolica's charms, and offers to potential converts a memorable invitation to join in the celebration.

DAVID R. MCFADDEN
CURATOR OF DECORATIVE ARTS
COOPER-HEWITT MUSEUM,
SMITHSONIAN INSTITUTION

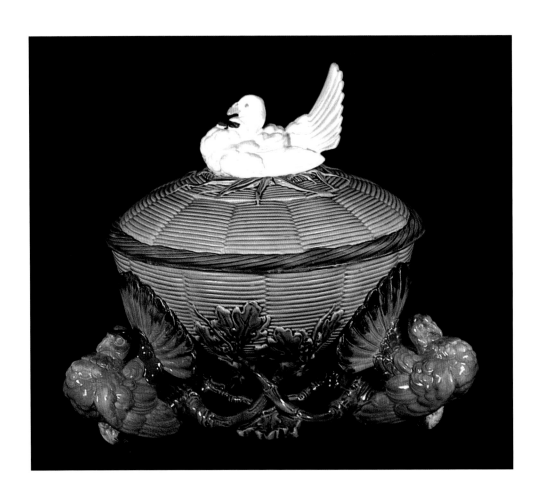

INTRODUCTION

During the reign of Queen Victoria (1837–1901) Britain reached the height of its commercial and political power. By the middle of the nineteenth century Britain controlled the world's banking, shipbuilding, and transportation industries. Agriculture and commerce enjoyed the protection of appropriate importation laws and benefited from railway expansion. There was a feeling of national invincibility, supported by the power of the British Navy. A mood of internal stability and trust prevailed in English institutions. Schools and intellectuals, trade unions and workers, all believed in the value of work, morality, and religion. Above all, the family and the home were sacrosanct and embodied these traditions, exemplified by Queen Victoria and Prince Albert themselves.

In this atmosphere of prosperity, in 1849 Prince Albert and Henry Cole, a colleague in the Royal Society of Arts, initiated plans for an international exhibition in England "to bring into comparison the works of human skill" of "all civilized nations" (C. H. Gibbs-Smith, *The Great Exhibition of 1851,* p. 7). London's Great Exhibition of the Works of Industry of All Nations (known as the Crystal Palace Exhibition) opened in 1851. With its entwined gospels of work and peace, it became the symbol of Victorian England.

The Crystal Palace, the building that housed the exhibition in Hyde Park, was one of the major successes of the event. Ground was broken for Joseph Paxton's brilliant iron and glass edifice on July 30, 1850. Licensed architects and engineers (Paxton was neither) prophesied that the building would not stand—they were proven wrong. The building, after eight months in fierce progress, was completed on Paxton's exact schedule, and exhibits began to arrive on February 12, 1851. The queen visited on many occasions and made frequent, positive reference to it in her private journal. The exhibition, open to the public from May 1 to October 11, attracted a total of 6,039,195 people; 13,937 firms were represented. Half the space was occupied by Great Britain and the colonies; the other half, by foreign countries, most notably France and Germany. The more than one hundred thousand individual exhibits were divided among six categories: Raw Materials; Machinery; Manufactures: Textile Fabrics; Manufactures: Metallic, Vitreous, and Ceramic; Miscellaneous; and Fine Arts.

It was in this memorable setting that Victorian majolica was introduced to the public. Herbert Minton—who, with his gifted art director and chief chemist, Léon Arnoux, had originated majolica—displayed several pieces of the new wares in the subgroup called Ceramic Manufactures: China, Porcelain, Earthenware, etc. The catalogue of the Crystal Palace Exhibition states, with an accompanying picture: "Messrs. MINTON, & Co., of Stoke-upon-Trent, Staffordshire, exhibit some excellent FLOWER-VASES, coloured after the style of the old Majolica" (p. 282).

Within a matter of years the dramatically sculpted and brilliantly glazed majolica produced under Minton's creative leadership had become immensely popular. The world of ceramics was suddenly enriched by images that evoked Italian Renaissance masters. There were magnificent majolica urns, elaborate garden fountains, ewers, and candelabra, all glistening in cobalt blue, turquoise, lavender, gold, and every shade of green in nature. The next thirty years saw placid cows grazing on tops of majolica cheese bells, fish swimming over platters and pitchers, furred and feathered quarry on the lids and sides of game-pie dishes. Oyster plates added their brilliant kaleidoscopic hues. Shells and seaweed were

11

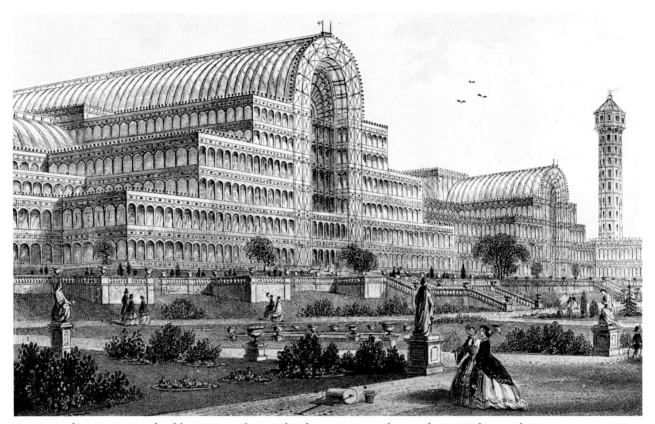

Engraving from a souvenir booklet "Views of Crystal Palace exterior and grounds." T. Nelson and Sons, 1851

scooped from the sea and heaped onto platters in variety and profusion. Leaves of trees, realistically rendered, decorated plates and compotes. Victorian banquets, with lavish twelve-course menus, were creatively served on the most appropriate and colorful of ceramic ware—Victorian majolica. Elizabeth Aslin and Paul Atterbury, writing of majolica in the catalogue of the exhibition *Minton 1798–1910* held in 1976 at the Victoria and Albert Museum, declared that "the boldly modelled wares with their rich colouring rapidly became the most characteristic earthenware of the Victorian period" (p. 43).

Majolica was the third part of a triad in the history of ceramics. The first, Spain's Hispano–Moresque pottery, was exported to Italy in the fifteenth century by way of the island of Majorca. In Italy the pottery was at first imitated; soon it was splendidly developed further and known as *maiolica,* the most outstanding ceramic art of the Italian Renaissance. The third phase occurred in Stoke-on-Trent, in England in 1849. Applying vibrant and gleaming polychrome glazes to boldly sculpted earthenware, Minton and Arnoux created "majolica," the

ceramic art form that complemented the ornate, opulent Victorian era. Léon Arnoux, in his 1855 treatise on "Ceramic Manufactures, Porcelain and Pottery," simply defined majolica: "We understand by majolica a pottery formed of a calcareous clay gently fired, and covered with an opaque enamel composed of sand, lead, and tin. This enamel, although melted at rather low temperatures, is much hardened by the oxide of tin it contains, and adheres perfectly to the biscuit. This biscuit has generally a light yellow colour, disappearing under the opacity of the enamel" (p. 20). That simple, scientific definition of majolica does not describe the great range of emotional tone of the pieces, responsible for the equally wide personal response of many viewers. The most engaging aspects of Victorian majolica are its humor, whimsy, charm, elegance, and great natural beauty.

There are several prerequisites for a piece to be considered Victorian majolica. It must be soft porous earthenware fired to the biscuit stage, and then covered with an opaque background glaze of tin or lead enamel

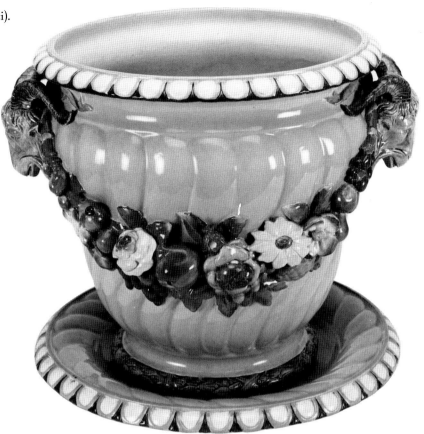

Minton & Co. (Baron Carlo Marochetti).
Ram's Head and Festoon garden pot.
1851. Height 14¾". (No. 727)

(or a combination of both). The decoration in brightly colored metallic-oxide glazes is then painted on the dried, unfired background glaze, often on design elements modeled in high or low relief. When the piece is next fired, the translucent and richly colored glazes impart a lustrous, silky brilliance that is characteristic of Victorian majolica. The application of metallic-oxide glazes to other types of ceramic ware does not result in majolica. For example, Parian, stoneware, or creamware—however colorfully glazed—are not thereby transformed into majolica.

With its rich colors and eclectic mix of revival styles, majolica was in harmony with the Victorian era. Victorians reveled in many materials such as elaborately designed silver, gold, and brass; ornate glass; enormous porcelain pieces; and highly carved wooden furniture. Majolica artists celebrated Victorian scientific developments in botany and horticulture, zoology and ornithology, marine biology and conchology—and also reflected the culinary and gastronomic enthusiasms that inspired the Victorian cook.

The philosophy of Victorian decorative art was to design a piece first to attract the eye and only then to be acknowledged as useful. It was the antithesis of the twentieth-century concept "form follows function," which would never permit the whimsical figurative shapes and decoration of much of Victorian majolica. The design of these ceramics often elaborated a message, as an ebullient narration of what a piece was to be used for, and thus indicated its function by decoration, rather than by form alone.

Majolica—alternately termed *"maiolica,"* "Della Robbia ware," "faience," or "Palissy ware" because of its various antecedents—was a welcome and colorful change from the familiar blue-and-white wares, creamwares, and white ironstone on the tables of middle-class families. Fine porcelain was reserved for the wealthy, but with the advent of mass-produced, beautifully glazed majolica pottery, the growing middle class in England could satisfy a desire for elegant and creative dining. The cost of majolica was considerably less than the cost of English bone china and imported French or German porcelain.

13

Although Minton had exhibited a few pieces of majolica at the 1853 New York Crystal Palace Exhibition, the American public at large can be said to have discovered both English and American majolica at the 1876 Philadelphia Centennial Exhibition. American dining rooms and parlors were soon decorated with the colorful new wares.

Throughout the last quarter of the nineteenth century, English and American ceramists vied with each other, designing and refining majolica. At each succeeding international exhibition—in London, Paris, and the United States—the public viewed new fantasies in these colorful ceramics. The New Orleans World's Industrial and Cotton Centennial Exposition in 1884 and 1885 presented the most outstanding American majolica, which was from the firm of Griffen, Smith and Hill, with its now famous Shell and Seaweed pattern. As the years went on, despite copyright restrictions, potters imitated each other's most successful designs.

Majolica kept pace with successive movements in the decorative arts. Japanese wares displayed at the 1862 international exhibition in London heightened interest in oriental art and influenced new majolica designs. Majolica artists in the 1870s and 1880s acknowledged the Aesthetic Movement, which had its origins in England before 1851 and in America reached its height after the 1876 Philadelphia Centennial. On both sides of the Atlantic majolica artists adopted the sunflower and lily motifs associated with the Aesthetic Movement and applied its principles of more simplified naturalism to new wares. In the last decade of the century, especially in France and Germany, majolica incorporated the sinuous Art Nouveau patterns, in both shape and decoration.

At the end of the reign of Queen Victoria majolica production all but ceased. Not only had majolica become too familiar, but overproduction in its last decade resulted in poorly manufactured pieces that could not compete with bone china and porcelain. Although the use of lead in glazes had been decreased, workers still suffered the fatal effects of plumbism (lead poisoning). Labor and management were not able to resolve strikers' demands and factory doors were shut as manufacturers faced falling profits. Public affection turned to Art Nouveau and to the art pottery movement.

One may consider why there has been a current resurgence of interest in Victorian majolica. Astute post–World War II collectors had the foresight to recognize its potential aesthetic and financial value. By the 1960s and 1970s, English majolica—more than a century old and therefore antique—was admitted to the United States duty-free. It is no longer the target of "grandmother's attic" scorn. Interior designers have discovered it; magazine covers and articles feature it; antiques dealers roam the United States, Great Britain, and the Continent, finding private sources for eager clients' new collections. The clients themselves have developed their own trade routes, both in the States and in Europe. A segment of the public has tired of the "less is more" principle. Perhaps because of world-threatening national and international problems, people now choose to surround themselves with charming mementos of a bygone era. It would be naive not to recognize that the problems of the Victorian era were as great as ours—poverty, political tensions, and the wars that would soon shatter Victorian peace—but the creative joys of 1851 continue to delight us today.

Chapter 1
THE CERAMIC CARAVAN

Majolica, with all its hallmarks of the Victorian era, drew its inspiration from precursors throughout ceramic history. Glazes from ancient Eastern lands, as well as shapes and motifs from the earliest cultures, led to the development of Italian Renaissance *maiolica*. (The Italian spelling *"maiolica"* will be used when referring to the Renaissance ware, and the nineteenth-century English spelling "majolica," for the Victorian ware.) In the next four centuries, the ceramic caravan traveled from Italy up through northern Europe and crossed the Channel to England and Staffordshire. Knowledge of these past artistic and technical developments can enhance the appreciation of majolica, both for the ceramic scholar and the enthusiastic collector.

The study of pottery reveals much information of earlier cultures and the degree of sophistication of the times. Ceramics may be recovered after thousands of years beneath the surface of the earth or sea, albeit often in fragments, but in no way chemically changed. The earliest piece of pottery, excavated by James Mellaart in the early 1960s, was found on the Anatolian Plateau of Turkey; this crude, handmade, soft earthenware was judged to be approximately nine thousand years old. It was either in China or Egypt, in the third millennium B.C., or in ancient Mesopotamia, in the second half of the fourth millennium B.C., that the potter's wheel was invented. The earliest wheel-made pottery, discovered by archaeologists immediately above the "Flood deposit" (c. 3000 B.C.), were vases, bowls, and goblets.

Near Eastern potters of Assyria and Egypt in the second millennium B.C. have been credited with the development of glazing techniques. With the discovery of the techniques of tin enameling and lead glazing, the semiporous, low-fired pottery became more effective. Glazing made the vessels impervious to liquids and also served as decoration. Evidence of the first use of tin enamel, as early as 1100 B.C., was found in the ruins of Khorsabad, Nimrud, Susa, and Babylon. Roman and Near Eastern potters during the early days of the Roman Empire (third to first century B.C.) produced green glazes using metallic oxides of copper, and yellow or brown glazes using iron oxides. Chinese ceramists developed glazes in the Shang and Chou dynasties (c. 1766–256 B.C.).

By the first century A.D., glazed pottery had reached the Rhineland from Italy and France. By the third century A.D., Denbighshire, in Great Britain, was involved in the manufacture of glazed and slip-decorated pottery. Pottery, however, was for the peasant population and for kitchen use. The gentry and the nobility dined from metal wares until the eighth or ninth century. It is from this point that the caravan of pottery history began its artistic and commercial adventures.

The Byzantine Empire

The Byzantine era (330 B.C.–A.D. 1453) contributed two major categories of pottery. The first is a red-bodied pottery decorated with stamped relief under a clear glaze. The second type, in *sgraffito* style, has decorations of human and animal figures, birds, leaves, monograms, and the Greek cross. Designs were engraved through a white slip, and glazed in yellows and greens.

The Islamic World

Between the ninth and thirteenth centuries new contributions were made to the ceramic arts in the Islamic world, particularly in Syria, Egypt, Persia, Afghanistan, and Spain. Rivaled only by the wares of Chinese potters, Islamic ceramics and other arts influenced the development of European pottery for centuries. In the ninth

century A.D. the rediscovery and refinement in Damascus and Baghdad of the technique of tin enamel was considered to be the most important contribution of the Islamic world to ceramic history. The Hispano–Moresque potters learned from Near Eastern artisans to add stannous, or tin, oxide to transparent glazes, thus producing the opaque white glaze that would lead to the development of the Italian *maiolica* and the northern European faience industry.

Islamic potters are credited with, in addition to tin-glaze techniques, innovations such as colored slip decoration. When slip—a watered-down clay—is applied to a pottery body, designs can be executed by cutting through the slip to the body underneath—a technique known as *sgraffito*, from the Italian word meaning "scratched." The resulting designs featured large floral forms or inscriptions. *Sgraffito* was widely used in the Middle East in the thirteenth century and is still used today.

Colored glazes were developed in Mesopotamia and Persia in the eleventh to thirteenth centuries. Matte finishes of turquoise, purple, red, green, and white were produced. In later centuries the Persians created lustreware, using finely powdered metallic oxides of silver, copper, and gold. The technique most relevant to maiolica that twelfth-century Persians developed was the application of enamel colors on a glazed and fired pot, followed by the refiring of the piece at a lower temperature to fix the additional colors. With this process, colors would not dissolve and "bleed" as they would at the higher temperature.

First under the Seljuk Turks (1077–1307) and then under the Ottoman Turks, there was an outpouring of ceramic tiles produced in Anatolia. Tiles and bricks covered with colored glazes were used on walls of mosques. In the sixteenth century, the great era of Turkish pottery, during the height of the Ottoman Empire, Iznik was the center of ceramic activity. Decoration was created with high-temperature glazes under a transparent siliceous glaze. From 1525 to 1550 many Chinese blue-and-white Ming patterns were copied directly. Gradually Turkish artists replaced Chinese motifs with their own designs. Tulips, poppies, carnations, and roses—none Chinese in origin—were seen on flat dishes, jugs, footed serving pieces, and cylindrical vessels. Flowers were quite stylized. Ground patterns of geometric designs, such as the imbricated patterns of the scales of fish, were frequently used. Paintings of animals and birds, together with an occasional human figure, appeared as decoration.

Hispano–Moresque influences

Moorish potters were noted for two techniques—lustre pottery and tin-enameled wares. The lustre technique had spread from the Middle East to the southern regions of Spain as early as the ninth century but its use increased during the Muslim occupation, particularly in the thirteenth century. The body of lustre pottery was of coarse clay, fired to a pinkish buff, covered with a stanniferous glaze. The lustre overglaze, containing copper or silver oxide, fired in a reduction kiln, varied from golden to pale straw. Alhambra vases, *albarelli,* and dishes were decorated with plant forms, arabesques, and heraldic animals. Blue and manganese purple designs were frequently added. Shapes included large conical bowls, spouted vessels imitating metal designs, two-handled jugs, cups, and plates. Malaga and Valencia were the principal sites of production, which continued through the seventeenth century. Hispano–Moresque lustrewares were exported at that time to England, in large numbers; fragments retrieved there from docksides in the nineteenth century caused the incorrect attribution of these lustrewares to English potters.

Hispano–Moresque tin-enameled ware was produced in the fourteenth century in Paterna, near Valencia, in copper green and manganese purple, with Moorish-inspired designs. Most important, it was the tin-enameled Hispano–Moresque pottery exported from the island of Majorca, off the east coast of Spain, to Italy in the fifteenth century that was to herald the beginning of Italian *maiolica* and to give the Italian ware its name.

The Italian Renaissance and the birth of *maiolica*

The pottery of the Italian Renaissance greatly influenced both the development of new technical aspects of ceramic art and the production of pottery in France, Germany, Holland, and England. Although the technique of painting metallic oxides on a tin-glazed surface had been used in the eleventh and twelfth centuries in Sicily and other parts of Italy, it was in the fifteenth century that it reached its height.

The classical Italian *maiolica* technique was described by Cipriano Michele di Piccolpasso (1524–1579) of Castel Durante, in the province of Pesaro e Urbino. Piccolpasso, a potter, was most renowned as the author of the earliest known manuscript on pottery to be written in Europe. It was first published in Rome in 1857, six years after the introduction of Minton majolica at the 1851 Crystal Palace Exhibition in London. Translated into French in 1860, it was influential in the development of French majolica. The original manuscript, with illustrations, is in the Victoria and Albert Museum.

In his manuscript, entitled *Li tre libri dell'arte del vasaio* (1556–1559), Piccolpasso described the methods of preparing the clay and the use of the opaque white tin-enamel glaze. The glaze served both to hide the buff body of the clay and to prepare a ground for the painting. Paint was applied on the dry but unfired tin glaze, and great care was taken to avoid errors in the design. The dry chalky surface absorbed the colors and therefore erasures were not possible. It was this interplay among paint, chalk, and the porous ceramic body that resulted in the attractive soft colors of the pigments when the piece was fired. After this first high-temperature firing, to preserve the surface, a second clear lead glaze, called *coperta,* was applied and the pottery was refired.

Earliest *maiolica* colors were copper green and manganese purple on a white background, with later additions of cobalt blue, antimony yellow, and iron red. Opaque white designs were produced on background colors of white or bluish-white (*bianco sopra bianco*), or on light or dark blue (*berettino,* or *bianco sopra azzurro*). Shapes included large chargers, which provided generous space for decoration, and massive storage jars, many of which were of Florentine production. To meet the demands of new hospitals in the region, Florentine potters also produced drug or apothecary jars, including *albarelli* (cylindrical and gently waisted) for dry drugs, and spouted jars for wet drugs. Florence also contributed a series of wares decorated in a dark inky blue, in a thick impasto style.

In the early part of the fifteenth century, although there was still evidence of Middle Eastern influence, *maiolica* designs in Italy concentrated on details of Greek and Roman ornamentation—acanthus leaves—as well as armorial devices. Mythological figures, sphinxes, griffins, and *putti* were also important decorative ele-

ments. Italian *maiolica* was sometimes inaccurately called Raphael's ware or Raffaele pottery, a tribute to the painter Raphael (1483–1520), although it was never established that he had designed or painted for pottery. Oak leaves came into popular use some time before 1450; this motif relates to the Della Rovere family of Urbino, because the family name signifies "oak tree." Patronage of affluent and ducal families was important to the development of Italian *maiolica.*

By the early sixteenth century, Renaissance ornament on *maiolica* gave way to *istoriato* decoration. The central part of the ceramic surface, and later the entire surface, was covered with a narrative scene, which for the first time included realism and perspective. *Istoriato* subjects included historical, mythological, Biblical, and genre themes, as well as exact copies of works by Raphael, Dürer, and the engravings of Marcantonio Raimondi. These pieces were more decorative than utilitarian.

Each of the major centers for the production of *maiolica* developed individual designs and colors. Florence, considered by many authorities to be the birthplace of important Italian *maiolica,* was the native city of Luca Della Robbia (1399/1400–1482). No other tin-glazed pottery has displayed the sculptural strength or perfect *maiolica* glaze of Della Robbia's work. Luca Della Robbia, at the age of fifteen, was apprenticed to a goldsmith. With other young sculptors he left Florence and traveled to Rimini to complete sculpture commissions for noble families. On his return to Florence, Della Robbia produced his now familiar *tondi* as well as semicircular and rectangular pieces; his earliest polychrome terra-cottas were commissioned by the Medici. His first known piece was a medallion with a religious subject, the first of many, surrounded by a heavily modeled frame of fruits and flowers (1438). Early relief designs included scrolls, masks, birds, and other Renaissance motifs. *Putti* and *amorini* were included in many of his scenes; figures were white on a celestial blue background, perfectly glazed. Other polychrome motifs included green leaves, yellow lemons, and orange fruits, with occasional polychrome glazed flowers. He sculpted similar pieces in marble. His work in the Medici palaces earned him much acclaim and many assignments from Florentine merchants.

Luca Della Robbia's brothers, Ottaviano and Agostino, abandoned sculpture for *maiolica.* Luca's nephew Andrea Della Robbia (1435–1525) and his sons Giovanni

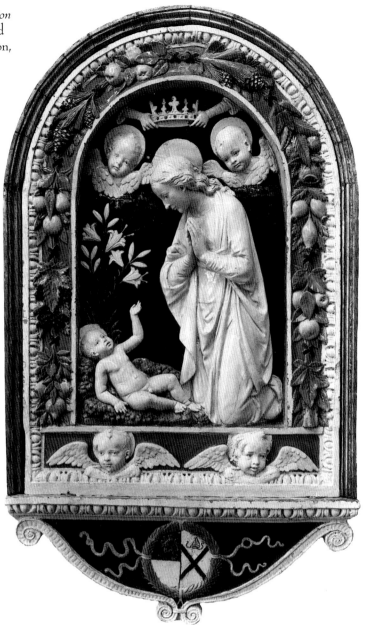

Luca Della Robbia. *Adoration of Child.* c. 1460. Enameled terra-cotta. Kress Collection, National Gallery of Art, Washington, D.C.

(1469–after 1529) and Girolamo (1488–1566) continued to produce similar tin-glazed earthenware. In 1529 Girolamo Della Robbia was employed by François I of France to decorate the Château de Madrid in the Bois de Boulogne near Paris, and also at Fontainebleau. These commissions marked the beginning of Italian influence on French faience. The magnificent Château was demolished in 1762 and the *maiolica* was sold to a pavior, who crushed them for use in cement.

Other Italian towns contributed to the development of *maiolica* as well. Deruta had produced pottery in the Middle Ages and, in the Renaissance, was the first to produce the special pale yellow lustreware with a mother-of-pearl iridescence. Polychrome *maiolica* in blue, green, and orange appeared toward the end of the century. At Gubbio, Maestro Giorgio Andreoli developed a renowned ruby lustre, and applied it to *maiolica* forms made in Deruta, Faenza, and Castel Durante. The lustre, from a gold oxide, varied from pale yellow to brilliant ruby. Gubbio soon manufactured its own *maiolica*.

Urbino, an important *maiolica* center in the late

fifteenth and sixteenth centuries, was under the protection of the Della Rovere family. Pieces were elaborately painted with Renaissance symbols. The most beautiful Urbino ware had been designed by the artists of the Fontana family; the best known was Nicola da Urbino. In the 1560s that family produced a new style of *maiolica* with grotesques painted in various colors, including orange, on a milk-white ground. The vases, basins, pitchers, and platters created in Urbino were more dramatic and displayed greater sculptural techniques than other *maiolica* of the period.

Siena, in 1509, began the production of magnificent tiles covered with stanniferous enamel and ornamented with polychrome designs of chimera, dragons, *amorini,* masks, birds—all in brilliant colors, especially orange and yellow, on black backgrounds. Several hundred tiles that once covered the walls and floors of part of the Petrucci Palace in Siena are now in the Victoria and Albert Museum and the Louvre. Sienese pottery factories continued into the eighteenth century, with production consisting chiefly of dishes and vases decorated with copies of old master paintings. In 1847 Bernardino Pepi, an apothecary, established a small factory and produced imitations of Luca Della Robbia pieces.

Although Venetian *maiolica,* made between the sixteenth and eighteenth centuries, was not as well executed as that of other Italian centers, Venetian styles were more varied. In that major seaport ceramic artists were exposed to the influence of imports and designs from the Middle East and China. Venetian *maiolica* did not appear to be as important a commodity or art form as the glass from the nearby island of Murano. The Bertolini brothers, glassmakers in Murano in the seventeenth century, produced a new type of *maiolica* known as *alla porcellana,* because the thin and bright earthenware was decorated with paint and gilt enamel and somewhat resembled Chinese porcelain. Although the pottery was not well received and the shop closed in seven years, examples are in the Musée National de Céramique, Sèvres, as a ceramic curiosity.

Maiolica was produced in Faenza before the fifteenth century, under the patronage of the Manfredi family. The first pieces were white, brilliantly glazed jugs, decorated with the Manfredi coat of arms. Early sixteenth-century pieces were ornamented with grotesques in opaque white on pale lavender-blue or dark blue tin-glazed backgrounds. Other pieces included wide-bordered plates decorated with religious subjects and apothecary jars. A special feature was the decoration on the undersurface, consisting of concentric rings in blue or white. Potters from Faenza introduced the art of *maiolica* in the sixteenth century into France, Spain, and the Netherlands, and from there it reached England. The name of the ware in northern Europe thus became faience (or fayence), and that term was first used in France early in the seventeenth century.

France

In France, as in all European countries, there were small potteries in the Middle Ages. Primitive vessels were decorated with modeled ornaments and brown, yellow, and green glazes. Ducal patrons in France, as in Italy, sponsored the growth of pottery techniques. The Duc de Bourgogne employed *ouvriers en quarreaux* (tile makers) to decorate his palace in the late fourteenth century. In 1384 the Duc de Berry imported Valencian pottery for his palace at Poitiers. *Sgraffito* ware was produced at Beauvais and at La Chapelle-aux-Pots. In the sixteenth century, French ceramic history was dominated by Bernard Palissy, who advanced the art of the potter to a degree equaled only by Luca Della Robbia in fifteenth-century Renaissance Italy.

Palissy, like Della Robbia, was passionately dedicated to the artistic and scientific aspects of his work. Both men had previous training in a related field and both produced glazed ceramics that were never seen before—nor surpassed in later centuries. They are well represented in the world's museums. The student of Palissy should make a special pilgrimage to see the Soulages collection at the Victoria and Albert Museum, remembering also to compare it with the Palissy-inspired Minton Victorian majolica in the same museum.

Bernard Palissy was born at La Chapelle-Biron near Agen, eighty miles from Bordeaux, in 1509 or 1510. In his youth he was apprenticed to a glassmaker in Saintes, seventy miles north of Bordeaux. His work with glass at Saintes led to the glazing experiments that were to be the central theme of his life's work. In the mid-1540s Palissy discovered for himself the chemistry of brilliant lead glazes, especially cobalt blue and greens. To the casual student of tin-glazed pottery the name Palissy conjures up visions of reptiles and beetles swimming on the

surface of a shallow pond. Palissy's work, however, can be divided into distinct phases. The first includes simple pieces covered with brilliant and beautiful enamel, without embellishment. It is interesting to note that in the nineteenth century the early majolica made by both Minton and Wedgwood was also simply modeled and decorated with lustrous monochrome or mottled glazes.

In the second phase (1548) Palissy produced oval platters, dishes, ewers, salt cellars, and large urns; and for their decoration he turned to his scientific interest in naturalism. His *figulines rustiques* (from the Latin *figulus*, potter), or rustic wares, were covered with strikingly realistic snakes, insects, lizards, snails, shells, and leaves modeled in high relief. Oval platters simulated cobalt-blue ponds surrounded by a variety of creatures along the grassy "banks." After Palissy moved to Paris in 1565 he modeled aquatic creatures taken from the Seine River basin, and leaves and flowers from the environs of Paris. His lead glazes approximated the natural colors; undersurfaces were covered with a mottled blue-brown manganese glaze, which was later adapted by English and American potters. Other platters and vases were covered with Biblical or bacchanalian scenes, on either blue or white background glazes. A magnificent Palissy cistern, in the Victoria and Albert Museum, is modeled with medallions of a man and a woman and with handles of large dolphins holding rings in their mouths. The cistern, strewn with flowers, conch shells, garlands, acorns, and leaves, is supported on a pedestal decorated with acanthus leaves. These motifs appear later in the Minton Palissy ware, superbly glazed, in a somewhat more sophisticated design.

In his third phase, c. 1580, Palissy worked with geometric patterns in relief with *ajouré*—pierced or perforated—borders. Other pieces were modeled in low relief after the Mannerist designs of François Briot, a metalworker. Briot (c. 1550–1616), born in Lorraine, produced metal ewers and basins decorated with figures, scrolls, and grotesque motifs. Both men were Huguenots and shared a history of religious persecution, which no doubt reinforced their artistic liaison.

Palissy, influenced by the teachings of the Reformation in south-central France, had become a "heretic," a Protestant Huguenot, by 1555. Fortunately, at this time, the Connétable Anne de Montmorency commissioned him to decorate a grotto at the Château d'Écouen. The

rustic grotto was never installed, but Montmorency patronage and protection continued. In 1562, when the Parlement of Bordeaux ordered the seizure of all Protestant property, Montmorency intervened for Palissy. Although his kilns were destroyed, Palissy was safely transported to La Rochelle and there continued his work as *inventeur des rustiques figulines du Roy et de la Royne mère*. In 1565 Palissy established his pottery in the shadow of the Louvre, on the grounds of the Palais des Tuileries, this time under the patronage of Cathérine de Médicis, who commissioned him to produce a *grotte rustique* for the garden of the Palais des Tuileries. Surviving fragments of this grotto, excavated in 1878, are in the Louvre.

Honors in geology, natural history, and philosophy came to Palissy. In 1575 he spoke to Parisian scientists on natural history, and in 1580 published his *Discours admirable de la nature des eaux et fontaines, des métaux, etc.* His protection by the nobility ended in 1585, when he was betrayed by a lapsed Protestant. No longer defended by Cathérine de Médicis, Palissy was thrown into the Bastille by Henri III. Palissy was offered his life if he returned to Catholicism, but he refused. After four years in the Bastille, Palissy died in 1589 at the age of eighty.

All Palissy work is unmarked. After Palissy's death, his sons Maturia and Nicholas and his nephew continued to work in his style at a pottery in Avon, near Fontainebleau. Even though Palissy molds were used and his designs imitated, the modeling and glazing of pieces made by the second generation were not as perfectly executed as those by Bernard Palissy. Another ceramic artist, Pierre Reymond (c. 1513–1584), produced oval platters and ewers similar to Bernard Palissy's wares, decorated with mythological scenes. In the latter part of the nineteenth century, Palissy ware was made in France with great skill by Georges Pull and Charles-Jean Avisseau.

The French pottery contemporary with Palissy and alternately known as Saint-Porchaire, Henri Deux, and *faïence d'Oiron* originated about 1524 at Saint-Porchaire in a workshop on the estate of Hélène d'Hangest, governess of Henri II. A potter named Cherpentier—of whom nothing else is known—developed a technique that consisted of decorating fine white earthenware with a clear lead glaze, and then impressing designs into the

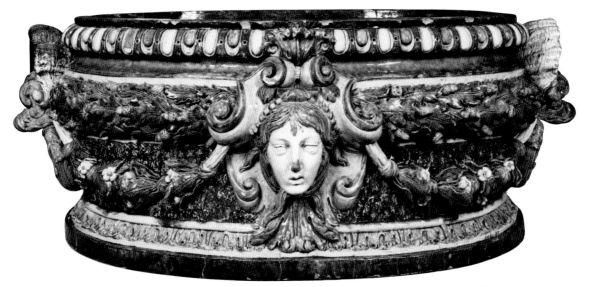

Bernard Palissy. Cistern. c. 1570. Courtesy Board of Trustees of the Victoria and Albert Museum

clay with metal stamps similar to bookbinders' stamps. The impressed designs were filled with colored slip of red, yellow, and brown, with an occasional use of blue, purple, and green glazes. Some pieces were elaborately modeled with inlaid designs of scrolls, coats of arms, masks, and cupids. Others were decorated with lizards and frogs similar to Palissy motifs. Symbols of François I (a salamander), Diane de Poitiers (interlaced crescents), and Henri II (his monogram) were also used. The pieces were complex and decorative rather than utilitarian. In the second half of the sixteenth century, tablewares, including saltcellars, goblets, basins and ewers, were made and Mme d'Hangest presented these tokens of friendship to her favorites. Sixty-four examples of Saint-Porchaire ceramics are known to exist.

The use of each of the three names for this ware— Henri Deux, *faïence d'Oiron,* and Saint-Porchaire— reflects the progress of research in ceramic history in the late nineteenth century. After 1864 it was thought that pottery had been made at Oiron, hence the name *faïence d'Oiron.* Because no wasters (discarded inferior pieces) of Saint-Porchaire wares were ever found in Saint-Porchaire, the correct place of origin of these wares was not verified until 1888. Blacker wrote in 1913, "[Saint-Porchaire] is without father, without mother, without descent" (J. F. Blacker, *The A.B.C. of Collecting Old Continental Pottery,* p. 26). The latter is not entirely true:

in 1858 Léon Arnoux reintroduced the technique at Minton, and Charles Toft continued to make reproductions of Saint-Porchaire ware at Minton from the late 1850s to the 1870s.

Other French pottery was influenced by the migrations of Italian artists. In 1512, soon after Palissy's birth, Italian Renaissance potters established factories in Lyons, and also influenced production in Rouen (1526) and Nevers (1595). Lyons boasted four *fabriques,* including the pottery of Maestro Giorgio Andreoli (fl. 1492–c. 1553) of Intra in northern Italy. Maestro Giorgio settled in Gubbio in 1498 and in 1521 emigrated to Lyons, bringing his ruby-lustre glazing technique with him. In 1553 the marriage of Henri II and Catherine de Medici, daughter of the duke of Urbino, further encouraged Italian artists to emigrate to France. In the second half of the sixteenth century, French faience imitated *maiolica* made in Urbino and Venice. Rouen, the most active French faience center, produced tiles, pilgrim bottles, dishes, and platters. Much of the polychrome pottery was exported and the industry flourished until the development of the porcelain industry, toward the end of the sixteenth century.

In 1709 a historical event occurred that gave new importance to faience in France. Louis XIV and his court melted down their silver tableware to help pay for the War of the Spanish Succession and the court was

21

looking for a less expensive substitute. Faience was innovative, attractive, and available from a number of centers in France. Soon after that, faience production began in Strasbourg, where what many connoisseurs consider the most beautiful and important French faience was made. The most famous name associated with Strasbourg faience is that of the Hannong family. Carl-Franz Hannong, a Dutchman of Spanish extraction born in Maastricht in 1669, began as a maker of clay pipes. In 1720 he took as a partner a German faience painter named Johann Heinrich Wachenfeld, who after two years went on to found the Durlach pottery. Charles-François Hannong, as the founder became known, was succeeded at the potteries he began at Strasbourg and Haguenau by his son Paul-Antoine and later by his grandson Pierre-Antoine. Their faience was as delicately modeled as most porcelain and decorated with high-temperature-enamel floral designs in a rich blue-red, dark blue, and yellow on a near-white body. Strasbourg manufactured tableware designed for its specific use: dishes modeled with vegetable and fruit motifs, as well as a variety of tureens made in the forms of cabbage, cauliflower, and boars' heads. These wares served as inspiration for English and American formal and rustic majolica in the nineteenth century.

Spain

Because of the growth of Italian-influenced Spanish *maiolica,* and because many Moorish craftsmen had been driven out of Spain by the Reconquest, the mid-sixteenth century saw the end of the production of Hispano–Moresque lustrewares. New important pottery centers were developed in Seville and Talavera de la Reina. Seville factories produced dishes, drug vases, and tiles using the Near Eastern *cuerda seca* (dry cord) technique, in which a finely applied line of grease and manganese prevented the opaque tin-glaze colors of a design from flowing together.

Talavera pottery was coarsely made, with decorations imitating Italian *maiolica,* as well as Chinese and Delft wares. By the seventeenth century, under Italian influence, Talavera ceramic output was excellent, and almost every useful and decorative example of pottery was made: large basins, ewers, dishes, and flat-bottomed jugs. High-temperature green, orange-yellow, and purple appeared in designs incorporating landscapes, Biblical scenes, birds, animals, and hunting scenes. By the mid-eighteenth century, potters in Alcora, near Valencia, made fine faience resembling French styles. Production gradually became inferior and after three centuries the golden age of Spanish faience came to an end. Echoes reached the other side of the Atlantic, however. In 1526, several decades after Christopher Columbus claimed the New World for Spain, Dominican friars sent from Seville to Puebla, Mexico, instructed the natives in the useful art of tin-glazed pottery. Production continued in Puebla for three centuries. A large urn made there between 1775 and 1800 in the style of Talavera is in the Metropolitan Museum of Art.

Portugal

Few pieces of Portuguese *maiolica* were marked: it is therefore difficult to distinguish from *maiolica* produced in Spain or the Netherlands. Most of the Portuguese examples were made in Braga and Lisbon, with Italianate versions of blue-and-white Chinese motifs.

The Netherlands

The Dutch had been familiar with tin-glazed wares since medieval times, although many of the pieces found in the Netherlands were of German origin. In 1512 Guido Andries (d. c. 1541) of Castel Durante, Italy, organized a successful *maiolica* factory in Antwerp, from which potters then migrated to Middleburg (1564), Haarlem (1573), and Dordrecht (1586). Other factories were established in Amsterdam, Delft (1584), and Rotterdam (1612). Surviving examples of this period are in the tin-enameled Italian style.

In the seventeenth century the Dutch East India Company, chartered in 1602, imported Chinese wares in great quantities, as well as some Japanese. By 1640 England and Portugal could no longer trade with Japan and the Dutch enjoyed a monopoly in importing from the Japanese. The resulting influx of goods from the Far East stimulated the Dutch pottery industry, which flourished until the mid-eighteenth century. Oriental motifs, rather than the heritage of Luca Della Robbia and Palissy, dominated Dutch faience.

Delft became the center of Dutch pottery production. By the mid-seventeenth century the Delft breweries began to decline because of competition from the English; the old brewery buildings in Delft were used for

the faience industry. Ceramic manufacturers retained the names of the old breweries, such as the Three Golden Ash-Barrels and the Golden Jug. The town, near major waterways, was well situated for the import of raw materials and the export of the finished product.

Early Delft pieces included large jugs and urns as well as utilitarian tablewares. Oriental porcelain designs were closely imitated on tin-glazed earthenware in a technique similar to that of Renaissance *maiolica*. Later Delft ware was decorated in faience colors, with the outline (*trek*) first drawn in with blue, black, or manganese. Red enamel and gilding for special pieces of Delft *dorée* required additional firings.

By 1720 patterns inspired by the Chinese *famille rose* were produced. Delft *noire,* reflecting Chinese lacquerwork with a black background, also had polychrome decoration. In the latter years of the seventeenth century, oriental themes were supplemented with Biblical scenes, mythological motifs, and genre scenes from Dutch life. Brilliant *maiolica* colors were replaced by blue-and-white glazes on tablewares, tiles, fountains, vases, *tulipières,* and pipe holders.

Marks on Dutch Delft ware are scarce and unreliable. Many nineteenth-century copies bear the marks of earlier, more important factories.

Other European majolica precursors

Germany, more noted for stoneware and porcelain, produced earthenware dishes from 1526 to 1555, tin-glazed and painted in the Venetian *maiolica* style. Most of these pieces were made at Nuremberg. *Eulenkruge,* Tyrolean owl-shaped drinking vessels, were painted in a high-temperature blue tin-enamel glaze. Blue-and-white faience jugs, many with pewter lids, were popular in the seventeenth century.

In the second half of the seventeenth century and in the eighteenth century the German *Hausmaler,* or independent home painter, purchased undecorated faience from factories and ornamented it with low-temperature enamel and gilt glaze. The glaze was fired in small muffle kilns (700–900°C. *petit feu* ranges), later used for the more elaborately decorated majolica pieces.

In Scandinavia the mid-eighteenth-century "bishop's bowl" was manufactured in Herrebøe, Norway, in a factory established in 1753 by Peter Hofnagel, and in a Schleswig–Holstein factory established by Johann-Christoph-Ludwig von Lück in 1754. The bowl, in the shape of a bishop's mitre, was colorful and decorated in relief with lemons and grapes, two of the ingredients of "bishop's punch."

In Russia the production of tin-enameled earthenware was known as early as the twelfth century. During the sixteenth and seventeenth centuries highly colored relief tiles decorated walls and stoves. Tin-enameled earthenware objects were called *zenin* wares, from the German word *zinn,* or tin. Manufacture of tin-enameled earthenware became more widespread in Russia in the eighteenth century. In 1700 Peter the Great invited Delft potters to emigrate to Saint Petersburg and establish potteries there. Articles produced included bowls, chargers, saltcellars, inkstands, and tobacco pipes. By the mid-eighteenth century, large *kvass* jars, pitchers, washing basins, flowerpots, and statuettes were made. Decoration, which included local floral and animal motifs, was painted on the raw, unfired tin-enamel background glaze.

The ceramic caravan next traveled from northern Europe to England, with a cargo of shapes, ornamental motifs, clays, and glazes that were antecedents of Victorian majolica. English potters profited from these examples—and went on to create the distinctive world of English ceramics.

Chapter 2

EARLY ENGLISH CERAMIC HISTORY
AND MAJOLICA ANTECEDENTS

England, the birthplace of Whieldon, Wedgwood, and Minton, played little part in the early development of artistic pottery. Neolithic specimens of the New Stone Age (2500–1900 B.C.) have been found. Later examples—after the introduction about 75 B.C. of the potter's wheel, which was developed during the Roman occupation (c. A.D. 43–450)—are not distinguishable from specimens from other regions. After the Romans retreated, artistic advancement in England was curtailed by the complicated wars between local secular and religious rulers that devastated the population and the land. There was no evidence of trade as there was in the Near East and on the Continent. With the Norman invasion of 1066, under William I, England developed a more stable economy.

It was in the Middle Ages that English pottery began to develop. Conditions were poor, however—tools were few, workshops were small, and there was little communication among isolated craftsmen. Before the thirteenth century a glaze technique thought to be imported from France was used, predominantly in potteries associated with abbeys. Glaze colors included yellow-brown, a rich green, and a deep manganese brown. In the thirteenth century relief and inlaid decoration were used, as well as brushed slip in simple patterns.

An important development occurred in the early sixteenth-century potteries of the Cistercian monasteries in Yorkshire. Monks produced a metallic brown-black glaze for use over earthenware fired to stoneware hardness. The Malling jugs, of controversial origin, were made in this period and were among the earliest examples of tin-enameled English earthenware. The name is derived from an example found in a church in West Malling, Kent, although the piece was thought to be of London origin. The earliest example, dated 1549, is in the British Museum. The jugs, dated by hallmarks on the silver or pewter mounts, resemble in shape the stoneware jugs of the Rhineland and are tin glazed in a speckled blue, purple, and brown.

In the mid-sixteenth century emigrating Flemish and Dutch potters brought tin-glazed earthenware to England. These potters derived their knowledge of tin enameling from eight centuries of Islamic, Spanish, Italian, French, and Dutch craftsmen. This new import, known in England as "galleyware," was significant because its tin-enamel surface provided the British potter with a white ground on which to apply individual high-temperature glazes in bright colors. The English term "galleyware" (or "gallyware") is said to come from the word "gallipot" used in fifteenth-century Holland for a small pot for unguents or sweetmeats. The latter term reflected the Dutch importation of such tin-glazed earthenwares in galleys from Spanish and Italian ports in the Mediterranean.

In 1571 the first English galleyware factory was established at Aldgate, London, by a Jacob Jansson and Jasper Andries, son of Guido Andries, a leading potter in Antwerp. Galleyware continued to be produced in and around London, at Southwark, Lambeth, Bermondsey, and Bristol. The pieces were both practical for tableware and decorative, with blue-and-white ("blue-dash") Italianate borders around the central ornament depicting Biblical subjects, English monarchs, ships, armorial designs, or historical scenes. Other galleyware—almost three centuries before Victorian majolica—included tin-glazed, barrel-shaped mugs and jugs. Many pieces were decorated in blue-and-white oriental style, inspired by Chinese porcelains made available to the potteries in the Netherlands by the Dutch capture in 1602 of a Portuguese ship carrying Chinese wares made during the

24

reign of the Ming emperor Wan-li (1572–1620). The Dutch inundated northern Europe with these oriental treasures; James I of England availed himself of the cargo, and English potters hastened to copy royal fashion.

By 1650 further Dutch influence had crossed the English Channel with the second generation of emigrant Dutch potters. English potters' blue-and-white decorations continued to resemble Delft ware and, perhaps to increase the value of the English pieces, tin-glazed earthenware made in England took on the name "delftware." In 1689, when William of Orange was invited to ascend the English throne and resolve religious and political conflicts, Dutchmen continued to emigrate to take advantage of this new opportunity. Seventeenth-century English delftware was difficult to distinguish from Dutch Delft ware, although London potters did produce larger and more colorful pieces. In addition to tableware, English medical needs were served with the production of apothecary jars, bleeding bowls, and pill slabs. Most were decorated in cobalt blue, although there was also some use of the high-temperature polychrome glazes.

The production of English delftware came to an end with the introduction of the new neoclassical styles of the late eighteenth century. The forms and decoration of the new style—which reflected the discovery in the 1750s of Herculaneum and Pompeii—were less suitable for tin-enameled pottery than for the new and exciting development of Wedgwood creamware and basalt.

Other seventeenth-century antecedents to Victorian majolica were slipware and stoneware. Slipware was produced in Wrotham, Kent, from 1612 to 1740 and in London from about 1630. Slip was applied to cover a poorly colored local clay, "icing" the earthenware with a more attractive, rich lead glaze. Pieces were then decorated with dotted or trailed slip designs in relief or incised with geometric *sgraffito* patterns.

The early prominence of Staffordshire in English ceramic history is due to the production in the late seventeenth century of slipware by the Toft family and stoneware by the Elers family. The name of Thomas Toft is synonymous with the production of excellent slipware. Thomas Toft and his relatives James, Charles, and Ralph are thought to have moved from Leeds, on the Staffordshire border, to North Staffordshire. More than thirty pieces of slipware signed by Thomas Toft and Ralph Toft in the 1670s are known. The white slip applied over the upper side was decorated in patterns of brown, black, orange, or red slip, and then the entire piece was covered with a yellowish glaze to blend the design together. The largest pieces included platters from twelve to twenty-two inches in diameter. Designs included insignia and portraits of the royal family, and sometimes the name of the potter. A slipware cradle, symbolizing fertility, was a marriage gift.

The history of English stoneware is less clear. In 1671 John Dwight, registrar to the Bishop of Chester at Wigan, was granted a patent for what he claimed he had discovered: "the Mistery of Transparent Earthen Ware, commonly knowne by the Names of Porcelaine or China and Persian Ware, as alsoe the Misterie of the Stone Ware vulgarly called Cologne Ware" (Llewellynn Jewitt, *The Ceramic Art of Great Britain,* rev. ed. 1883, p. 75). Having displeased the bishop, Dwight moved to Fulham, in West London, and continued the production of brown stoneware mugs, cups, and wine bottles. He also imitated Chinese red ware teapots, which were very much sought after, as tea was infused, stored, and reheated in the pot.

In 1693 Dwight brought suit against James Morley, a stoneware potter in Nottingham, three members of the Wedgwood family in Burslem, and two recently emigrated brothers, David and John Philip Elers. The Elers had arrived from Holland about 1686 and worked with Dwight in Fulham from 1690 to 1693. After a dispute about stoneware, the Elers left to work in Bradwell Wood, Staffordshire. The Elers claimed to have learned the art of pottery in Delft and Cologne and therefore to be exempt from Dwight's accusation that they were infringing on his patent to produce stoneware. In Staffordshire, together with Dwight's former workman, John Chandler, the Elers produced thin, fine red stoneware such as teapots ornamented with prunus sprays (flowering plum), fleurs-de-lis, and geometric forms. Their teapots were made with great skill, and may have reflected their earlier occupation as silversmiths in Holland. Because the pieces were rarely marked, it is impossible to make a definite distinction between Dwight and Elers pieces. Wasters from the site of the Elers factory at Bradwell Wood established their activity there. Indeed, they set new standards and have been credited with the establishment of the renowned pottery industry in

Staffordshire. They also developed a black stoneware similar to the later black basalt developed sometime before 1769 by Josiah Wedgwood.

Recognizing others' vulnerabilities, the Elers tried to protect their own manufacturing formulas and employed workmen of low intelligence whenever feasible. John Astbury, the English potter who was to carry on the historic production of earthenware, posed as an idiot and worked there long enough to come into possession of the Elers' formulas and technical improvements. He soon established his own manufactory. The Elers' dominant place in pottery history was short-lived; business declined and the Elers left Staffordshire about 1710.

In the mid-eighteenth century, new ceramic techniques were developed that would contribute to Victorian majolica. Tin-glazed earthenware factories grew and spread from London to Bristol, Wincanton, and later to Liverpool. Liverpool was also the site of the invention of transfer-printed ware, as claimed by John Sadler and Guy Green in 1756. (A prior claim, in 1753, was voiced by John Brooks of the Battersea Enamel Works.) The process involved the inking of an engraved copperplate with monochrome or polychrome metallic oxides, then transferring the design to paper. With the ink still wet, the design was pressed to the surface of undecorated earthenware or prepared delftware and fixed by firing in a low-temperature muffle kiln. Liverpool potters introduced red and yellow enamels to the existing blue, green, brown, and purple.

Mention should be made of several craftsmen whose work with enameling on salt-glazed stoneware and porcelain contributed to the glazing techniques of majolica. Except for Warner Edwards of Shelton in the mid-eighteenth century, who is said to have been the first Staffordshire potter to use enamels on salt-glazed wares, until about 1750 much Staffordshire pottery was sent to Holland to be decorated with enamel. About 1750 William Duesbury established a studio in London for the enameling of white wares. At about the same time William Littler, a partner with Aaron Wedgwood at the Brownhills pottery factory, developed a rich blue glaze used as a ground color called Littler's blue. The glaze, sometimes also called Littler-Wedgwood blue, was used for jugs, coffeepots, and teapots. The Staffordshire ceramic industry worked to fill the new needs of the English population, which was now committed to drinking tea as a major part of social activity. Teapots, dishes, and tureens were produced in great numbers, delighting the public with colorful designs.

By 1730 the English potter's apprenticeship was over. The development of English ceramics, so long guided by Continental craftsmen, was now fully in the hands of men born and raised in the environs of Staffordshire. Families of Astburys, Whieldons, Woods, and Wedgwoods were talented and perspicacious enough to utilize the natural resources of the Staffordshire area: clay, flint, coal, wood, and water. The six pottery towns of Staffordshire were to be Hanley, Longton, Burslem, Tunstall, Fenton, and Stoke-on-Trent. Other towns in the area known for their ceramic production included Longport, Shelton, Lane Delph, and Cobridge. With the development of a canal system and the opening of the Liverpool and Manchester Railway in 1830, transportation was available for raw materials, finished products, and for the arrival of English and immigrant workers to man the potteries. The region became world-renowned for its ceramic production.

John Astbury

John Astbury (1686–1743) of Shelton was an enterprising, talented potter whose reputation was based on the production of red stoneware, a technique he learned surreptitiously from the Elers brothers, and on the development of creamware containing flint. He was foremost, however, in the production of small lead-glazed earthenware figures and utilitarian tableware. Decorative details in relief were stamped from pads of white clay or "sprigged" (applied with slip) onto the body and then colored with yellow, tan, red, brown, and orange glazes. Tablewares were produced from about 1730 and the figures from about 1740. John Astbury's wares were not marked; "ASTBURY" impressed, used from about 1760 to 1780, signified his son Thomas Astbury.

The Astburys developed lead-glazed earthenware, which was known first as creamware and then later, when it had been improved by Wedgwood, as queensware. Agateware and black stoneware were also specialties of Astbury. In agateware clays of different colors were pressed together into slabs, then repeatedly reworked and rekneaded, so that the resulting pieces had a marbled effect, like the veining of a hard stone. Plates made of clays colored blue and brown were particularly popular.

The attribution to Astbury of the discovery of the importance of flint in the ceramic process is still in question. According to Jewitt, Astbury discovered the use of flint in 1720 (p. 84). Flint, when added to dark shades of clay, whitened and hardened the clay body. Astbury had first used the light-colored, costly Devon clay in a pure creamlike suspension as a covering dip (engobe), but when flint was added to the body of darker clay at the start of the potting process, the dip was no longer necessary.

Many of the Astbury pieces showed the humor and whimsy which the later Victorian majolica developed. These were naive statuettes of townspeople, musicians, soldiers, and men or women on horseback, modeled of fine, thin earthenware, and glazed with a smooth polychrome lead glaze. Teapots (c. 1730) were especially delightful, some resting on three feet in the shape of masks or claws, with lid finials in the form of birds with outstretched wings. Others have handles and spouts modeled as tree branches and some were made with Chinese Fu dog or acorn finials. Other teapots were in the shape of houses, squirrels, or a kneeling camel. Many teapots were decorated with leaves, vines, and hops. Astbury jugs were decorated with harps, animals, and coats of arms.

John Astbury was an active, creative teacher. In addition to his son, his students included the next two significant figures in Staffordshire history, Thomas Whieldon and Ralph Wood the elder. Astbury had the honor of his family name becoming the generic term for much of the wares of the first part of the eighteenth century, until he was eclipsed by his former pupil Thomas Whieldon.

Thomas Whieldon

Thomas Whieldon (1719–1795) was born at Penkull, Stoke-on-Trent. Little is known of Whieldon's early life. At the age of twenty-one Whieldon established his first factory, at Fenton Low, near Stoke-on-Trent. His earliest pieces were of slipware, agateware, or marbled ware, especially used for knife handles. Other pieces included snuffboxes, toys, and chimney ornaments, all either biscuit or lead-glazed in black, red, or white. Wasters documenting the existence of the factory have been found at Fenton Low. Since it is difficult to distinguish between the work of the two potters, unmarked pieces of this period are referred to as "Astbury–Whieldon type." By 1749 Whieldon enjoyed success, and he moved his

pottery to Fenton Vivian, also called Little Fenton. He owned a great deal of land and leased a series of potworks, or small factories, to others. Whieldon was the first of the potters to rent accommodations to his workers, and his are the earliest account books and memoranda of an English pottery that survive.

Plates, teapots, and jugs were glazed by Whieldon in a tortoiseshell effect by using green, gray-yellow, and purple-brown manganese colors mottled or "clouded" together. Pieces from the period of 1747 to 1760 were decorated with details that can be recognized as inspiration for the shapes and designs of Victorian majolica: rabbit-shaped finials (or knops) on tureens, black-glazed teapots with bird feet, cabbage-leaf spouts on tea- or coffeepots, platters with mottled undersurfaces. Punch pots were appropriately decorated with applied motifs representing grapes and vine leaves, and dessert plates were covered with raised fruit designs. The City Museum and Art Gallery at Hanley has a fine exhibition of Whieldon pieces, including a game-pie dish that is a forerunner of a Minton majolica piece. There were many examples of well-modeled animals found among the Whieldon wasters: dogs, lions, unicorns, pelicans, frogs—all are seen a century later in Victorian majolica. The ubiquitous squirrel is on a salt-glazed teapot made by Whieldon and in great naturalistic style on nineteenth-century Minton, George Jones, and American nut dishes.

Whieldon came to be designated as the father of potting, not only because of his technical innovations, but also because of his apprentices and employees who carried the craft to even greater heights. Josiah Spode was hired in April 1749. William Greatbach—whose descendant Daniel Greatbach was to design the first of the hound-handled pitchers—was another valued apprentice. Young Josiah Wedgwood, together with his partner, John Harrison, came to Whieldon in 1754. Harrison soon left, but Whieldon and Wedgwood were in partnership from 1754 to 1759. During those years both men contributed to the development and production of brilliant colored glazes. The green and yellow glazes inspired the formation of wares in the shape of cauliflower and pineapples, the most renowned of the Whieldon–Wedgwood wares.

Ralph Wood

The family of Ralph and Aaron Wood, somewhat eclipsed in English ceramic history by their predecessor

Whieldon and their successor Wedgwood, nevertheless made a special contribution to Staffordshire history.

Ralph Wood was born in Burslem in 1715; his brother Aaron, two years later. Their early career in ceramics involved mold-making at other potteries, but about 1745 Ralph Wood established the Hill Pottery at Burslem. They produced utilitarian pieces in colored glazes, some of which were forerunners of majolica glazes, but the factory was best known for figure groups and Toby jugs. Ralph Wood's figures also include deer, goats, sheep, and other animals, some of which may have served as inspiration for Victorian majolica.

Josiah Wedgwood

The name of the "great Josiah" conjures up images of elegant two- and three-color jasperware, black basalt, and queensware made for Queen Charlotte, as well as for the English middle class. Wedgwood's impeccable artistry with clay also produced agateware, stoneware, and *rosso antico,* or red stoneware. Of particular interest are the colored lead glazes that Wedgwood perfected during his partnership with Thomas Whieldon (1754–1759). During that period Wedgwood predicted that the public would tire of agateware, tortoiseshell, and the variegated colored glazes of Whieldon. He observed that workers no longer produced well-crafted pieces and that lower prices for the familiar earthenware indicated decreased interest.

Trials to develop colorful glazes were conducted and duly recorded in his *Experimental Book.* With Experiment No. 7, on March 23, 1759, green glaze was perfected. Essentially the green glaze was a soft lead glaze to which copper oxide was added. Yellow could be achieved by the addition of iron oxide to the lead glaze. These green and yellow glazes—which decorated the naturalistic earthenware forms of tea services representing pineapples and cauliflower—were the link between the Palissy lead glazes of the sixteenth century and the lead glazes of the nineteenth century. During the first half of the nineteenth century, Wedgwood and imitators such as Baker, Bevans and Irwin in Swansea, and John and William Brameld at the Rockingham pottery and porcelain factory in Swinton, Yorkshire, were producing green-glazed plates with foliate designs. From 1850 to 1860 Wedgwood's green-glazed dessert services, with translucent color, were very popular and imitated by many of the major pottery competitors such as William Taylor Copeland and William Adams. Today majolica dealers and collectors enjoy the unsettled controversy: are Wedgwood's green-glazed plates produced before 1850 true majolica? The Wedgwood Museum archivists consider such pieces made at Wedgwood between 1850 and 1860 transition pieces, since the earlier Wedgwood green-glazed plates predated the Minton majolica production date of 1851 and the ware that the Wedgwood factory first classified as majolica in 1860. The chemistry of the nineteenth-century green glaze was based on the same lead glaze used in the eighteenth century. Raised designs on most of the eighteenth-century green-glazed plates were, however, in very low relief, not at all in the spirit of more dramatically modeled Victorian majolica.

Josiah Wedgwood, the youngest of thirteen children, was born in 1730 in Burslem. His father, Thomas, was a member of the Staffordshire pottery family that had been involved in the suit brought against the Wedgwoods and the brothers Elers by John Dwight. When the senior Wedgwood died, Josiah was nine years old. He worked for his brother until the age of fourteen, at which time he was apprenticed to him. In 1751, at twenty-one, Wedgwood entered into a partnership with John Harrison of Newcastle, the partnership that also included Thomas Whieldon for a short period. The union with Harrison was terminated after two years; in 1754 Wedgwood and Whieldon entered into the exclusive, productive partnership that led to the development of green-glazed wares. In 1759, however, feeling that Whieldon was not sufficiently involved in the new developments of glazes or creamwares, Wedgwood established his own business at the Ivy House Works in Burslem, and engaged his cousin Thomas as a journeyman potter.

In the early 1760s Wedgwood improved upon his formula for cream-colored, glazed earthenware (*Experimental Book,* March 28, 1760). The composition of ground flint and pipe clay resulted in a whiter, lighter body. Brilliantly glazed with a fine, smooth lead glaze, the creamware was quickly accepted both in England and abroad. It replaced delftware, salt-glazed stoneware, and tin-enameled pottery. Royal patronage was bestowed upon him for the creamware dinner service (queensware) he presented to Queen Charlotte in 1765. This resulted in a tremendous increase in business, multiplying the number of orders.

Queensware, in all shades of yellow, was decorated

Thomas Whieldon. Mottled and cauliflower wares. c. 1755

with transfer printing or painted enamels. It was not only well designed and easily decorated but, because of improvements worked out by Wedgwood, the delicate pieces could stand sudden alterations of heat and cold. The many forms included—in addition to large dinner services and tea and coffee services—leaf-dishes, sauceboats with stands, honey pots, pitchers, tureens, and chestnut baskets. Designs were modeled on the body of the piece or, later, painted in brilliant enamels. The apples, pears, quinces, cauliflower, pineapples, and leaves that appeared on these utilitarian wares were to reappear on Wedgwood Victorian majolica.

In January 1764 Wedgwood married a distant relative, a seventh cousin, Sarah Wedgwood. Sarah was the heiress to estates of both her father and her brother, and so the young couple came into a fortune of some twenty thousand pounds. Josiah used the windfall wisely. As business continued to increase over the next years, the Bell Works (1765) were added to the Churchyard Works and the Ivy Works. In 1766 he purchased an estate in Shelton, two miles from Burslem, to be used for the production of black basalt. The factory, and the village itself, came to be called Etruria, honoring the Etruscan designs he used on black basalt.

In 1768 Wedgwood took Thomas Bentley, a Liverpool merchant, into partnership. Bentley (c. 1730–1780) was an astute businessman and Wedgwood's agent in Liverpool. Bentley left Liverpool and took charge of Wedgwood's business in London. On June 13, 1769, the Etruria Works were formally opened: Bentley turned the wheel and Josiah Wedgwood himself "threw" three vases of Etruscan form. Bearing the legend *Artes Etruriae renascunter* and the names of the partners, these pieces heralded a rebirth of the art of classical pottery (Jewitt, p. 516).

In 1774 Wedgwood produced early examples of "fine white terra-cotta," which was the early form of the famed jasperware. By 1775 jasperware had reached its state of perfection, and was produced in two- and three-color combinations. John Flaxman was the outstanding artist and sculptor at Wedgwood during this period. Tablewares, tea services, jugs, plaques, busts, figures, medallions, intaglios, cameos, vases, and urns flowed in endless profusion from the artistry and skill of Wedgwood. Many of the molds are intact and, together with the pieces themselves, may be viewed at the Wedgwood Museum in Barlaston. Eighteenth-century molds used for jasperware and black basalt were also used again for the production of Wedgwood Victorian majolica.

Josiah Wedgwood's contributions to the political, industrial, and scientific aspects of Staffordshire were of importance equal to his artistic creativity. His chemical

29

understanding of glazes was outstanding. In 1786 he invented a thermometer that could sustain the highest amounts of heat that clay vessels could tolerate. He recognized the need for efficient and cheap transportation of raw materials and finished products, far beyond the tradition of potters and pack horses traveling through the countryside with fragile merchandise. Together with his friend the engineer James Brindley, Wedgwood supported the building of the Grand Trunk Canal from the Mersey to the Trent rivers, thus linking Staffordshire potters more swiftly to the outside world. With the canal, the cost of shipping pottery decreased some four hundred percent.

Wedgwood was successful beyond any expectation: he had started his career with ten pounds and when he died in 1795 he left a worldly fortune of five hundred thousand pounds. His family continued the work of one of the most important industries in the decorative arts. Wedgwood left other legacies: the son of his firstborn child, Susannah, and her husband, Dr. Robert Darwin, was Charles Robert Darwin, the author of *The Origin of the Species by Means of Natural Selection* (1859). Wedgwood's grandson Francis Wedgwood later became head of the Etruria firm. Francis in turn had three sons—Godfrey, Clement, and Lawrence—all of whom were deeply engaged in the production of Victorian majolica at Wedgwood.

Tragically, during World War II, Wedgwood's Etruria Works were totally destroyed. The Wedgwood Works were transferred to Barlaston, Stoke-on-Trent, where the many phases of production of modern Wedgwood may be seen today.

Chapter 3

MINTON

It sometimes seems as if the artistic ability of a great potter manifests itself early in life and is inherited by other family members, as witness the Astburys, Woods, innumerable Adamses, Spodes, and Wedgwoods. In the late eighteenth century and throughout the nineteenth, the family of Thomas Minton also exercised hereditary prerogatives. Three generations led to the creation and development of Victorian majolica.

Thomas Minton was born in Shrewsbury in 1765 and was educated at the Shrewsbury Grammar School. After an apprenticeship and employment as an engraver at the Caughley China Works, at Broseley, he moved to London and worked as an engraver of blue-painted earthenware for Josiah Spode. He married in 1789, returned to Staffordshire, and used Thomas Whieldon's Bridge House as his residence and engraving shop. It was there that he made many successful designs, especially for Josiah Spode, including the work most familiar today— the blue Willow pattern.

In 1793, together with Joseph and Samuel Poulson and William Pownall, at first as a silent partner, Minton purchased land in Stoke-on-Trent and in May 1796 the Minton works opened. In addition to blue-printed earthenware, Minton produced cream-colored earthenware, bone china, stoneware, and Egyptian black. Minton fared well, but bone china was not produced between 1811 and 1821, thus decreasing the firm's profits. Perhaps the decision to interrupt the production of bone china reflected the decrease in foreign markets, since England was at war with both America and France during that decade. In addition, the Corn Laws of 1815, which established a high tariff on imported grain, also depressed all forms of international commerce. Despite economic difficulties, however, Minton was able to continue. His investments in land yielding clay, stone, and

tin—although not profitable financially—supplied Minton with raw materials.

Minton's marriage to Sarah Webb, of London, provided him with four sons, six daughters, and a mother-in-law who kept the business accounts with such vigilance that Minton was free to spend all his time in the development and production of ceramics. Two of his sons, Thomas and Herbert, were introduced into the business about 1808. Herbert Minton, who was to lead the firm in the Victorian era, was only sixteen when he represented the firm as a salesman in London and the provinces. Some years later he worked at the pottery. In 1821 the elder brother, Thomas Webb Minton, left the secular world to study for the ministry and was ordained in 1825.

Herbert Minton was born in 1792, at the house attached to the pottery works, in Stoke-on-Trent. He was educated at a local school, together with his brother and sister, then sent to Audlem Grammar School in Cheshire. On the death of his father, in 1836, Herbert Minton capably assumed control of the business. He soon took in a partner, John Boyle, who was to have an effective role in other pottery works as well. In 1841 Boyle left Minton and joined Wedgwood in partnership. He was replaced in 1845 by a nephew of Mrs. Herbert Minton, Michael Daintry Hollins, who had joined Minton and Company in 1842. In 1849 a nephew of Minton, Colin Minton Campbell, joined the firm, and became its head after Herbert Minton's death in 1858.

At the time of Thomas Minton, Sr.'s death in 1836, the pottery had expanded to such an extent that the Minton firm was the largest and most important in the district. Herbert Minton carried the business to even greater heights. Minton excelled in the trinity of talents necessary: he was an astute man of commerce, he had the

scientific and technical knowledge to improve production, and he possessed the creative and aesthetic spirit necessary to integrate the beauty of the past with the glories of the Victorian era.

Herbert Minton, who had taken over the firm one year before Queen Victoria ascended to the throne of England in 1837, enjoyed a period of prosperity that paralleled the nation's improvement. The repeal of the Corn Laws benefited both agriculture and industry. Railways, as well as the new postal and telegraph services, helped unite urban and provincial areas. The growing middle class achieved better standards of living. With the Trade Union Acts of 1847 came the limitation of working hours for women and children, better housing, and safer working conditions. Minton was one of the first English employers to offer opportunities for education to potters and their families.

The political turmoil in Europe during the 1840s further aided the situation at Minton. Because of the conflicts in France and Italy that resulted in Napoleon III's new monarchy and the unification of Italy under Garibaldi, many potters and artisans left the Continent to seek asylum in England. The Industrial Revolution had produced utilitarian ceramics, but with rising prosperity the Victorian era called for, and achieved, new and decorative designs for a more sophisticated public.

During those years there was great interest in botany, gardening, science, travel, and commerce with distant parts of the world. Scientific and horticultural advances came from Matthias Jakob Schleiden and Theodor Schwann, who in 1838 and 1839, respectively, were the first to describe the cell theory of the structure of plants and animals. The great botanist Robert Brown discovered the process of plant reproduction. English gardeners vied with each other, filling greenhouses with rare blossoms and perfect specimens. To enhance these displays Minton artists produced colorful majolica urns and cachepots ornamented with floral fantasies as colorful as nature herself. Ornithology also provided decorative motifs: John James Audubon's exact renderings were duplicated on glazed earthenware, combining inhabitants of the skies and the gardens below. Animals were also frequently portrayed, especially those commemorating Victorian events. Elephants celebrated the new empress of India. Monkeys—giving shape to pitchers, teapots, and garden seats—paid homage to Josiah Wedg-

wood's grandson Charles Robert Darwin and *The Origin of the Species.*

With the opening of world trade with Japan in 1854, due to the successful efforts of Commodore Matthew Calbraith Perry and the United States Navy, once again English and Continental firms used oriental motifs on earthenware and porcelain. All of these world events found expression in Minton's wares, during Herbert Minton's lifetime and beyond.

There were two episodes that were particularly important in the twenty-two-year development of the Minton factory under Herbert Minton. One was the production of encaustic tile—earthenware squares decorated with inlaid colored clays, pressed, and fired. The other was Herbert Minton's meeting with Léon Arnoux. As to the first, Jewitt wrote: "In 1828, Herbert Minton turned his attention to the subject [of tiles], but was prevented by circumstances from fully developing his plans" (p. 402). Since 1828 is the date given for the temporary dissolution of the partnership of Thomas and Herbert Minton, one can wonder if there might have been some dispute between father and son over the production of tiles. Nevertheless, Herbert Minton continued to be involved, and in 1844 he purchased the patent rights for the manufacture of ornamental tiles and bricks from Samuel Wright, when the latter's business proved unsuccessful. Minton's venture was also not profitable and Minton invested and lost a great deal of his personal capital. What he gained was a tremendous understanding of the use of hydraulic presses, steam hammers, and most important here, a greater knowledge of enameling techniques in decorating china and glass, which he soon used for majolica.

Augustus Welby Northmore Pugin, leader of the Victorian Gothic Revival style, a venerated architect, and a friend of Herbert Minton, was the first to use Minton encaustic tiles, in the palace of Westminster and on the walls of the smoking room in the House of Commons. In 1845 Michael Daintry Hollins and Herbert Minton formed a separate concern dealing exclusively with tiles: Minton, Hollins and Company. That company, under Hollins, continued to produce not only tiles for architectural use but also majolica tiles for flower boxes and fireplace exteriors. Motifs included floral, geometric, mythological, fantastic, and allegorical subjects—all in rich and brilliant colors.

The second historically important episode took place in 1848, when Herbert Minton met Léon Arnoux, the son of a manufacturer of hard-paste porcelain in Toulouse. Joseph-Léon-François Arnoux (1816–1902) was born in Toulouse and studied engineering in Paris at the École des Arts et Manufactures. He also studied pottery at the Royal Manufactory of Sèvres. Before coming to England he managed the family factory at Valentine. Because of business difficulties, as well as the political upheaval of the Revolution of 1848, he responded to an invitation from Herbert Minton. He played a major role at Minton's from 1848 until his retirement in 1892, and then continued as a consultant until his death. In 1878, he was awarded the Austro–Hungarian Order of Franz Joseph and made Chevalier of the French *Légion d'Honneur.*

As both chemist and art director, Arnoux was responsible for the mechanical, chemical, and aesthetic development at Minton. Creating the Minton Patent Oven, Arnoux improved earthenware production by conserving fuel, increasing oven space, and assuring proper distribution of heat. Arnoux's knowledge of the chemistry of clay, including how to make enamel adhere to the less calcareous British earthenware, resulted in Minton's tremendous success in the production of majolica. Arnoux inspired both French and English artists at Minton to devote their considerable talents to developing original designs for majolica.

On a trip to France in 1849 Minton serendipitously saw green-glazed flowerpots in Rouen and encouraged Arnoux to develop new colored glazes. Both Minton and Arnoux were deeply interested in the art of the Renaissance, including *maiolica,* and this committed alliance brought forth the Minton "imitation majolica," first displayed at the Great Exhibition of 1851. Herbert Minton had originally designated the term "imitation majolica" out of deference to his ware's Italian Renaissance forebears, but this term was soon altered to "Victorian majolica" as a statement of its own individuality. Other terms used interchangeably at the time for this new ware were *"maiolica,"* "Della Robbia," "Palissy ware," and "faience." (Although from the late 1850s to the 1870s Charles Toft at Minton made reproductions of Saint-Porchaire, or Henri Deux, wares, these should not be confused with majolica because, despite the use of lead glazes, the technique of glazing the hard, less porous, and heavier earthenware of the reproductions does not result in the lustrous glaze characteristic of Victorian majolica.)

The display of Minton majolica at international exhibitions in subsequent years assured a worldwide reputation. These exhibitions included the 1853 New York Crystal Palace Exhibition, where among the firm's majolica was a large flowerpot in bright colors with lilies of the valley and ferns in relief, in a deep, wide-rimmed saucer to match; the 1855 Paris exhibition, which had the largest display of majolica that had yet been seen and for which Herbert Minton was awarded the Cross of the *Légion d'Honneur;* the London exhibition of 1862, noted for the great Saint George and the Dragon fountain; 1867 (Paris), 1871 (London), 1873 (Vienna), 1874 (London), and the Philadelphia Centennial in 1876. At the Paris

33

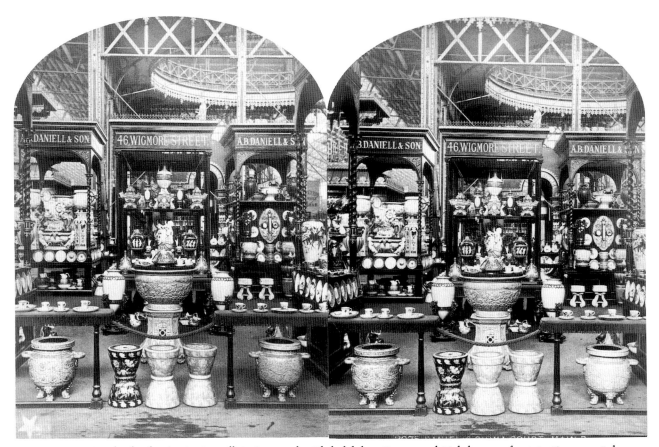

A Minton & Co. display by A. B. Daniell & Son at the Philadelphia Centennial Exhibition of 1876. Courtesy Library of Congress

exhibition of 1878 Paul Comolera's fountain, designed for Minton, seventeen feet high, was the largest single piece of majolica ever displayed. The fountain was surrounded by storks, palm trees, and tritons, with a Negro girl as the terminal figure. The eighty-four-inch-high pair of majolica elephants (#2907, 1889) that Minton displayed at the 1889 Paris exhibition was another magnificent contribution to majolica. Except for the howdahs, which were fired separately, the elephants are the largest pieces of majolica ever made in one piece, and a special kiln was built for the purpose. (Numbers given here in parentheses after Minton wares indicate (1) the ornamental shape number entered in the Minton shape books the first time a form was made, and (2) the production date of a particular example (not necessarily the first), as indicated by the date code symbol in the table of Minton date marks.)

After Herbert Minton's death in 1858 his enterprising spirit was continued by his nephews Michael Daintry

Hollins and Colin Minton Campbell. World trade was encouraged and Minton's received special commissions from important retailers in London and abroad. Also, Thomas Goode and Company of London purchased all the Minton majolica shown at the Paris exhibition of 1878 (except for the Comolera fountain) and displayed the pieces at the company's South Audley Street showrooms. The shop was decorated with Minton majolica tiles, and still is today. Thomas Goode also bought the spectacular pair of Minton majolica elephants from the 1889 Paris exhibition. Except for an appearance of one of the figures at the 1976 Minton exhibition at the Victoria and Albert Museum, the elephants have graced Thomas Goode's windows for the last hundred years.

Much of the subject matter of Minton majolica served as inspiration for other English as well as American majolica. For example, Minton oyster plates, pond-lily designs, and life-sized storks and herons were imitated by other potters. Majolica is a vivid example of how ideas

are transferred from one point in history to another, from one country to another. With improved transportation and increased commercial activity, England and America produced the same designs within a few years of each other. Outstanding examples of Minton's majolica inspired American production through the display of Minton's wares shown by their distributor A. B. Daniell and Son of London at the 1876 Philadelphia Centennial. The most impressive piece Minton exhibited there was the forty-eight-inch-high Prometheus Vase (#1328, 1867).

The Minton firm furthered the study of majolica, and ceramic production in general, by setting up the Minton Art Pottery Studio in London in 1871 in conjunction with the company's participation in the ceramic decoration of the interior of the South Kensington Museum (now the Victoria and Albert Museum). Minton majolica tiling was used on the staircase to the former Ceramic Gallery and throughout the museum's Old Refreshment Room. The decoration includes a beautiful frieze of majolica tiles spelling out the inscription: "THERE IS NOTHING BETTER FOR A MAN THAN THAT HE SHOULD EAT AND DRINK AND THAT HE SHOULD MAKE HIS SOUL ENJOY GOOD IN HIS LABOUR XYZ." Each letter is ornamented with an ebullient cherub. Although Minton's Art Pottery Studio existed only four years, it greatly influenced both technical advances and public awareness and appreciation of original styles of ceramic painting. William Stephen Coleman, a fine artist, employed by W. T. Copeland and Sons for a short time, was hired by Minton in 1869. Coleman directed the studio, which attracted the male painters from Minton's in Stoke and artists of both sexes from the London schools of art. The Minton studio was located near the Royal Albert Hall and the South Kensington Museum. The artists developed painting and glazing techniques on biscuit pottery brought to the studio from Minton's in Stoke. Complex layers of underglaze and overglaze were executed and art styles were freely developed by the painters at the studio. The studio not only contributed to the development of professional ceramic techniques but also was a factor in the interest in amateur ceramic painting during the 1870s. Important ceramic artists who were trained at the studio included Edward Reuter, who went on to work at Minton for twenty years; Hannah Barlow, one of the first artists at Doulton, starting there in 1871 and best known for her

animal drawings in *sgraffito* on stoneware pottery; and William Wise, who was responsible for the design and engraving of Minton tiles. Unfortunately, the studio was not immune to the pottery's greatest enemy: in 1875 fire destroyed it and it was never rebuilt.

In the 1870s Minton had introduced *pâte-sur-pâte*, brought from Sèvres by its originator, Marc-Louis-Émmanuel Solon (1835–1913). Solon had left Sèvres during the Franco–Prussian War in 1870 and brought with him the technique of painting on porcelain with a semifluid slip. Solon was art director at Minton's and remained with the company until 1904.

Although Minton continued to make majolica until 1897 and advertised it as late as 1902, by the mid-1880s Minton had decreased the output of that ware. A notable exception was the unprecedented pair of eighty-four-inch-high elephants made for the Paris exhibition of 1889.

At the turn of the century, Minton designs were in the Art Nouveau and Secessionist styles, both of which grew out of the Aesthetic Movement, and both of which were successfully interpreted in ceramic forms. Pottery in the Art Nouveau style was designed for Minton between 1900 and 1909 by Léon Victor Solon (1872–1957), the son of M.-L.-E. Solon. Abstract floral and leaf motifs were outlined by raised moldings or trailed slip, and decorated with Minton majolica glazes. Later styles of art were also reflected at Minton's in decorative pieces, but dinner services continued to be Minton's most commercially successful venture. In 1926, because of insufficient storage space, the great majority of Minton majolica molds were destroyed. All Minton earthenware production was discontinued after 1940 and almost all remaining molds were discarded at that time. In 1968 Minton's became a member of the Royal Doulton Tableware Group.

It was with its production of Victorian majolica, however, that Minton's made a particularly innovative and influential contribution to the field of ceramics. The *Art Journal* of 1878, describing the Minton display at the international exhibition in Paris that year, wrote: "In majolica, no manufacturer has surpassed them in the sharpness of details, purity of colour and excellence of glaze." It was the glaze to which Léon Arnoux referred when he wrote in 1855: "when the arts . . . were raised by the Greeks to their summit, polychromy was regularly

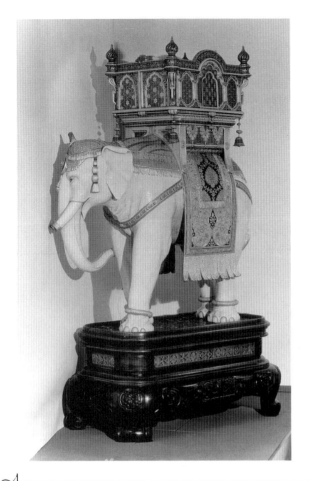

Minton & Co. Elephant. 1889. Height 84″. (No. 2907). Courtesy Thomas Goode and Company, London

practised; and that, instead of regarding it as prejudicial to form, colour was used in such a way as to help it, and to give it more value" (pp. 10–11). It is the luminous, brilliant color that gave Minton majolica its great appeal in 1851 and that has reawakened public affection today.

STYLES AND SHAPES

The Minton archives at Stoke-on-Trent contain the Minton shape books, which record over five thousand different designs, beginning in 1826. Sometimes the same shape was used at Minton for majolica, Parian, and porcelain wares, a practice that was also followed at Wedgwood. Most of the shapes designed specifically for majolica, however, were not used for other types of ware, because white Parian and hard porcelain could not express the bold exuberance and lustrous color of the artist's conception. Some shapes that had been designed

before 1850 for Parian or porcelain, however, were used later for majolica.

Minton majolica styles encompassed artistic influences from Gothic to Renaissance, from Europe to the Orient, and included the stylized and naturalistic, humorous and heroic, fantastic and realistic. The brilliant, infinitely smooth glazes were applied to a cream-colored body, pieces were superbly modeled, and designs were executed by some of the leading artists of the day. Some pieces exhibit an eclectic combination of styles and subject matters, but most examples conform to one of the following categories.

Renaissance style

The earliest pieces of Minton majolica were nineteenth-century derivatives of the Renaissance. Minton artists studied Italian *maiolica* as well as Palissy and Henri Deux wares in the collection of Minton's patron the duke of Sutherland, and the pieces in the South Kensington Museum. Minton Renaissance majolica displays pure

No 2137
Tray

No 2315
Tray

No 1457
Pickle Tray

No 1572
Cucumber Tray

No 1330
Strawberry Plate

No 1960
Strawberry Plate

No 2279
Strawberry Plate

No 1545
Butterfly Plate

No 2335
Asparagus Plate

No 1323
Oyster Plate

No 1324
Oyster Plate

No 2239
Oyster Plate

Pages from the Minton & Co. shape book. 1884. Courtesy Minton Archives, Royal Doulton Ltd.

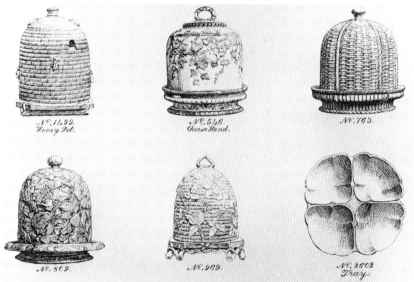

No 1499.
Honey Pot.

No 546.
Cheese Stand.

No 763.

No 809.

No 909.

No 2602
Tray.

37

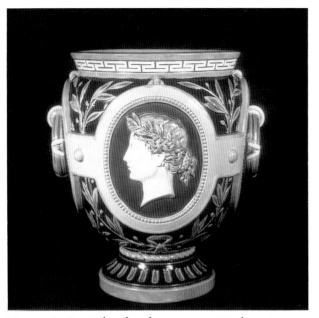

Minton & Co. Pedestal cachepot. 1871. Height 14″.
(No. 1379)

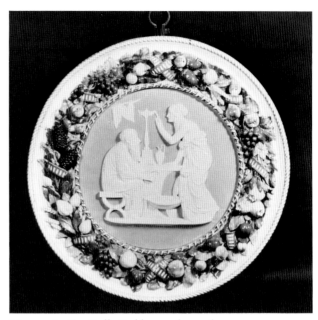

Minton & Co. Della Robbia-style tondo. c. 1870.
Diameter 32½″. Courtesy Minton Museum, Royal
Doulton Ltd.

jewel-toned glazes that compare favorably with those of
Della Robbia. Minton made use of Renaissance motifs
such as lions, rams, gargoyles, grotesques, satyrs, mytho-
logical figures, flower garlands or festoons, oak and
acanthus leaves, cartouches, masks, ropes, medallions,
and strapwork. Majolica designs brought together the
Renaissance revival of Greco–Roman art and the
sixteenth-century versions of Byzantine and Islamic fea-
tures, such as arabesques and scrolling forms. Despite
these derivative details—and indeed some were almost
exact copies of Palissy pieces—Minton majolica was
more elegant than its predecessors. Pieces were heavily
modeled, many of them with ribbed or geometric
borders. Early examples had more gilt decoration than in
subsequent majolica styles at Minton. Also, early pieces
were decorated with opaque tin glazes, not the translu-
cent lead glazes of later years.

Minton Renaissance majolica may be divided into two
categories: one includes boldly modeled sculptural deco-
ration, the other comprises painted scenes in the *istoriato*
tradition.

38 An important example in the first category is the
matching platter and ewer (inspired by the work of the
sixteenth-century sculptor and goldsmith Benvenuto
Cellini) produced in 1860 to honor the Crystal Palace

Art Union. Crisp fluting surrounds the platter's central
panel portraying Juno, which is encircled by the inscrip-
tion "Crystal Palace Art Union." A Della Robbia-like
border features six portrait medallions of Renaissance
men. The ewer is decorated with medallions of the
powerful Renaissance women Elizabeth I, Diane de
Poitiers, and Marie de Médicis, with a fourth space
containing a cartouche proclaiming "Crystal Palace Art
Union." A winged mermaid, with an acanthus-leaf "tail,"
forms the ewer handle. Lions' heads, laurel wreaths,
garlands of fruit, rosettes, acanthus leaves, geometric
designs, and arabesques complete the tribute to the
Union, which was so important to the development of
British art.

Mythology is also represented on a Minton Renais-
sance ewer with a bearded satyr below the spout. Diana,
goddess of hunting, and her faithful whippet are por-
trayed on one side of the barrel-shaped body of the piece,
while the doomed Actaeon is depicted on the reverse side
(1863). A graceful flower bowl, which also echoes Cel-
lini, is in the shape of a scallop shell carried by two
mermaids (#1182, 1868). A pedestaled vase (#1379,
1871) is decorated with classical and Victorian female
heads on opposite sides, with ring handles on the re-
maining sides; the upper rim is ornamented with an

incised Greek key motif. Similar vases have four female portrait heads symbolizing Europe, Asia, Africa, and America. Background glazes may be turquoise or cobalt blue. The vases were made in graduated heights, the largest eighteen inches high. One of the best known of the Minton Renaissance pieces is a large garden pot named Ram's-Head and Festoon (#727, 1851), modeled by Baron Carlo Marochetti. Its spirally fluted, tapered body was glazed in cobalt, turquoise, or brown, with swags of polychrome flowers in high relief suspended from the ram's-head handles. The piece should be accompanied by a matching underplate. The first garden pot of this type was shown at the 1851 Crystal Palace Exhibition, and the jury commended it for its design, colors, and large size. The piece continued to be produced and displayed for the next two decades. The twenty-seven-inch-high amphora-shaped Queen's Vase also has ram's-head handles (#649, 1881). The body, glazed in yellow or cobalt, is decorated with vine leaves and grapes. The most dramatic example of Minton Renaissance majolica is an exquisite large Della Robbia-style tondo, glazed in celestial blue and white, with an allegorical scene in the center and a border of fruits and leaves in relief (c. 1870). Luca himself would have had to examine the maker's marks to identify the century.

The second category of Minton Renaissance majolica—pieces with painted decoration—is well represented at both the Minton Museum and the Victoria and Albert Museum. Many of these wares were produced under the direction of Léon Arnoux and the leading painters of the factory. Edward Rischgitz, Thomas Kirkby, and especially Alfred George Stevens gave to Minton Renaissance majolica the style so reminiscent of Italian Renaissance *istoriato* painting. The shapes of these pieces were traditional versions of plates and vases from conventional tabletop size to "palace" dimensions of forty-two to sixty inches tall. In some examples almost the entire surface is occupied by geometric or figural designs, as in the work of Stevens. In the Minton Museum there is a vase, known as the Aziglio Vase, twenty-two and seven-eighths inches high (#788, 1865), painted by Rischgitz, who was influenced by the landscapes and figures of Émile-Aubert Lessore, a ceramic artist who had moved to Wedgwood. The Aziglio Vase is decorated with panoramic scenes of French cavaliers in seventeenth-century dress. Two graceful double-tailed mermaids (melusines) form the

handles. Another large vase, painted by Kirkby, displays a group of celestial figures and has handles in the shape of winged mermaids. Kirkby also painted, in the style of Urbino, the charming Renaissance plaque of the young Queen Victoria (1855). The dramatic Prometheus Vase is completely covered with painted scenes of warriors and horses on each side; bound figures of soldiers are chained to the handles of the vase. A figure of Prometheus being attacked by an eagle forms the finial. This vase, modeled by Victor Simeon, was also produced in solid colors of the purest cobalt or brown glaze; both the painted and the solid-color vases were made in "palace" dimensions. Two Minton Renaissance cachepots combine both sculptural detail and beautifully painted scenes. A square example with caryatids at each corner depicts naval battles (#602). The other, with lion's-head handles, portrays pastoral idylls. Because of the difficulties of producing painted majolica, few examples were made, fewer survived, and one can anticipate that this form of Minton majolica will greatly increase in value.

Palissy style

The sixteenth-century French ceramic artist Bernard Palissy inspired artists at Minton to duplicate the deep cobalt-blue Palissy glazes and to use the Palissy marine-life motifs in a more sophisticated nineteenth-century mode. In addition to being able to study the Palissy collection of the firm's patron, the duke of Sutherland, Minton artists were further aided by Minton's acquisition of Palissy pieces from the duke of Buckingham. Minton produced platters, urns, ewers, and nautilus shells, not by using the natural sea objects for molds as did Palissy, but by sculpting them with great skill and creativity. George Savage, in his *Dictionary of 19th Century Antiques and later objets d'art,* suggests that because Palissy had referred to his colored glazes as "*maiolica*," factories such as Minton and Sèvres named their earthenware decorated with colored glazes "majolica" (p. 237). It is somewhat confusing that in the late 1850s the term "Palissy" was interchangeable with the word majolica, and was used for all ceramics with high-relief modeling and colored glazes. The Palissy name attached to figures of French-inspired cupids modeled with seahorses or nautilus shells is equally misleading. These are in the charming French tradition and not in the original sixteenth-century Palissy style.

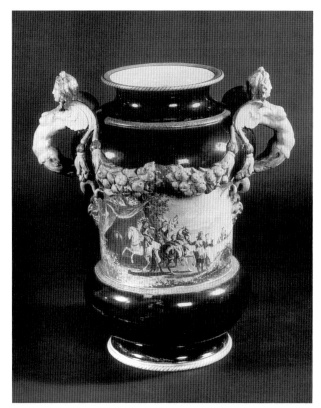

Minton & Co. (Edward Rischgitz). Aziglio vase. 1865. Height 22⅞″. (No. 788). Courtesy Minton Museum, Royal Doulton Ltd.

Minton & Co. (Thomas Kirkby). *Victoria Regina* plate. 1855. Diameter 21½″. Courtesy Minton Museum, Royal Doulton Ltd.

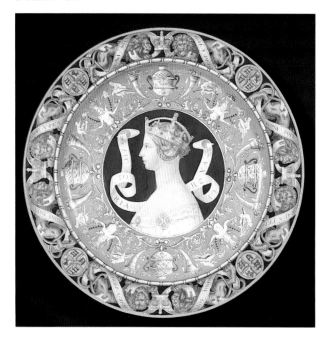

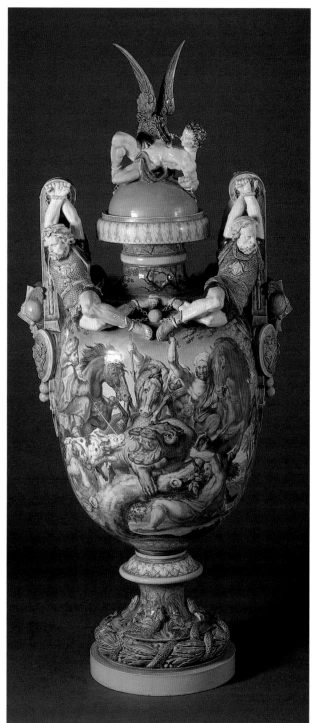

Minton & Co. (Victor Simeon). Prometheus Vase. 1867. Height 48″. (No. 1328). Courtesy Sotheby's, New York

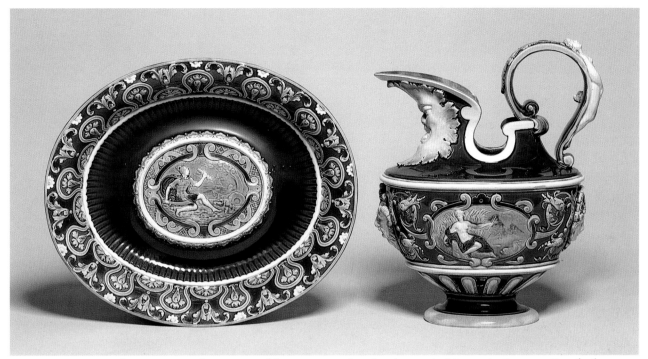

Minton & Co. (Hamlet Bourne). Palissy ewer and basin. 1858. Ewer height 10½". (No. 732). Courtesy Board of Trustees of the Victoria and Albert Museum

Minton & Co. Palissy ornamental platter. 1870. Length 14". Courtesy Sotheby's, London

Minton & Co. (Hugues Protât). Protât jug. 1862. Height 15". (No. 900); Palissy ewer. 1868. Height 14". (No. 1136)

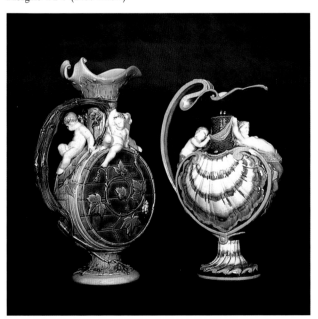

41

An almost exact copy of a Palissy ewer and matching basin, modeled by Hamlet Bourne, was produced by Minton in 1858 (#732). On a ground of intense cobalt there is a head of a triton below the spout, a mermaid draped along the handle, and elaborate cartouches and crustaceans decorating the body of the ewer. In 1860, one year after the South Kensington Museum purchased the Minton ewer and basin, it acquired the Palissy originals.

Other Minton Palissy ware, with magnificently colored glazes and high-relief modeling, includes a handsome Palissy ewer designed by the French sculptor Hugues Protât (#1136, 1868), which pays homage to the Palissy sea world. The body is modeled with a large scallop shell on each side; a young triton is trying vainly to reach the beautiful melusine posing seductively beneath the spout; the neck of the jug is modeled in deep green lizard markings and the body is a rich cobalt blue. The handle, decorated with sea-shell and acanthus-leaf designs, is marked "H.P." near the base. Another Minton ewer designed by Protât (#900, 1862) is sometimes called a Palissy vase but is actually a ewer (or jug), in a barrel shape, glorifying a bacchanalian scene. It is also a rare example of majolica marked with the artist's monogram.

Palissy's work directly influenced the oval Minton Palissy ornamental platters (#537, c. 1870), which have a large central well decorated with solid or mottled glazes. A specific sixteenth-century Palissy piece, *La Fécondité,* as well as a painted enamel oval plaque (c. 1560) by the Palissy contemporary, Pierre Reymond decorated with mythological scenes, inspired these Minton platters. In one version, around the broad rim, which represents the banks of the central "pond," are four concave ovals glazed in a contrasting color. Strapwork with geometric patterns encircles the large and small wells, and is glazed in a contrasting color: blue, green, or buff. Around the perimeter, between the four shallow wells, are high-relief figures of Juno, Neptune, Mercury, and Ceres against a low-relief landscape. Unlike the sixteenth-century Palissy trays, some Minton Palissy trays are glazed in monochrome blue or green. The undersurface of the tray is mottled in the cobalt-blue and brown-black pattern seen on sixteenth-century Palissy wares.

Other Minton Palissy pieces include a spoon warmer (#1837, 1874) modeled as a large conch shell supported by three feet in the form of coral, and a flower holder (#1560, 1870) formed as two scallop shells on a rock base covered with seaweed and shells. Large nautilus shells, supported by seaweed-covered bases (#437, 1867) or by entwined dolphins (#902, 1865), were imitated by other English and American majolica factories. The Minton Palissy piece that most exemplifies the dramatic modeling of the sixteenth century, together with the great humor of Victorian majolica, is a Minton fish teapot (1878). The body of the teapot is modeled as a fish; the dorsal fin forms the finial of the lid; the spout and handle, representing coral branches, are decorated with seaweed. A snail rides on the handle as the "fish" swims through well-modeled aquamarine waves.

Historical Renaissance figures

The most appropriate to list first is a jug commemorating the tricentennial of William Shakespeare's birth. On it are medallion portraits of Queen Elizabeth I and Shakespeare, simulated-metal strapwork, and—most unusual for majolica—the commemorative message "WILL SHAKESPEARE BORN 1564 TERCENTENARY 1864." An eleven-inch charger features portraits of the French king and queen Henri IV and Marie de Médicis, with an egg-and-fleur-de-lis border (#771, 1858).

Gothic revival and medieval style

Inspired by the work of A. W. N. Pugin—the architect and designer who championed the Gothic revival style, and whose work included furniture for the House of Parliament and for the Medieval Court of the 1851 Crystal Palace Exhibition—Minton produced majolica reminiscent of the medieval period. A circular, footed revolving luncheon tray (#799, 1859), produced with stained clays in the encaustic technique, has a Gothic pattern based on tiles designed by Pugin. The tray was also glazed in solid turquoise. A garden seat (#588, 1868) was made in a similar design. Pugin's Bread Tray in majolica (#368, 1856), twenty-two and a half inches in diameter, bears the admonition in Gothic letters around the border "Spare Not Waste Not Want Not." The most elegant example was glazed in five different colors.

Villagers in medieval dress are portrayed on the Minton Tower Jug (#1231, 1869). The cylindrical, heavily modeled body of the pitcher is in the image of a castle tower; men and women dance between borders of twisted ivy vines. Heavy vines extend and unite to form a

42

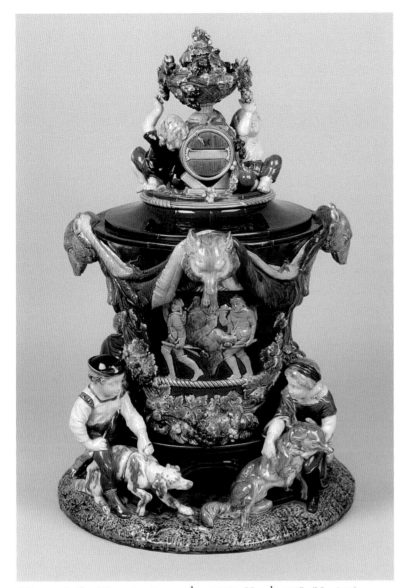

Minton & Co. Victoria wine cooler. 1851. Height 25". (No.631)

Right: Minton & Co. Tavern jug. 1873. Height 10". (No. 487) Courtesy Sotheby's, London

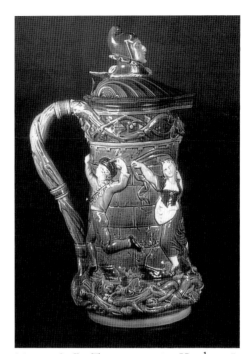

Minton & Co. Tower jug. 1869. Height 14". (No. 1231)

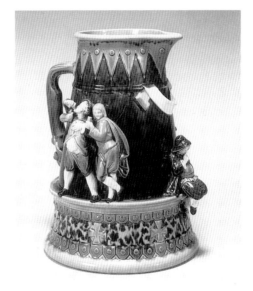

handle. This design is found both on a pitcher and on a lidded version in which the pewter cover is decorated with a jester's head. The Tower Jug may have been inspired by the spirit of a late seventeenth-century Baroque carved-ivory tankard made in Augsburg.

A series of tavern jugs (#487, 1873), modeled in high relief, depict two carousing couples and a besotted observer. On all the jugs, which range from eight to sixteen inches tall, the figures are the same height but are scaled in depth to the size of the individual piece.

Naturalism

Minton's ceramic artistry and the creative Victorian imagination came together to produce many of the most memorable pieces of Minton majolica, those with naturalistic motifs. Greenhouse and forest, zoo and open

43

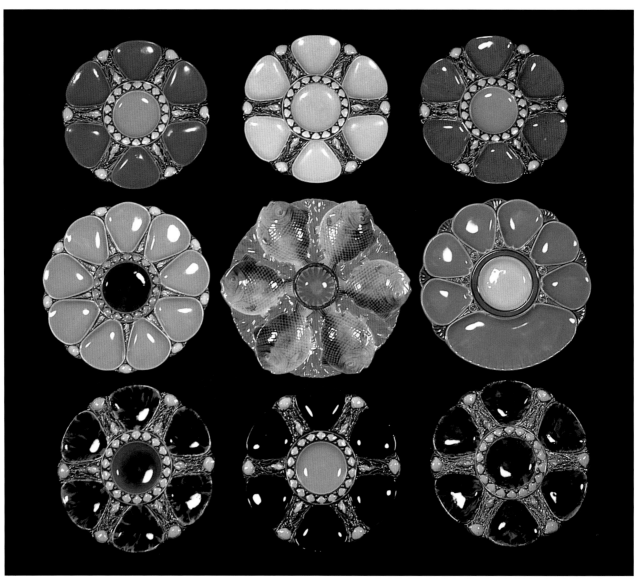

Minton & Co. Oyster plates. *Top row:* 1867. Diameter 9″. (No. 1323). *Middle row:* 1883. Diameter 10″. (No. 1324); 1881. Diameter 11″. (No. 2366); 1883. Diameter 10″. (No. 2239); *Bottom row:* 1867. Diameter 9″. (No. 1323)

terrain, all inspired interpretive forms in majolica. Flora and fauna embellished even the small inkwell. The new middle-class status symbol—the opulent Victorian dinner table—was enlivened by majolica, no longer called "the poor man's porcelain." The grapevine was ubiquitous on pitchers; shellfish designs swam on seafood platters; fruits and vegetables decorated serving dishes. In the nineteenth century Minton majolica artists imitated eighteenth-century Chelsea and Wedgwood fruit- and vegetable-shaped pieces. Early nineteenth-century

silver "beeskips" and cow-finialed butter dishes also inspired colorful majolica.

A collection of naturalistic Minton majolica helps one envision the Victorian banquet, which could be heralded by Minton's majolica menu holders. Oysters were served on individual oyster plates smoothly glazed and divided into segments by six (#1323) or nine (#1324) radial spokes encrusted with shells and seaweed (1867). Background glazes include cobalt, turquoise, malachite green, emerald, yellow, pink, and lavender. Rarer oyster

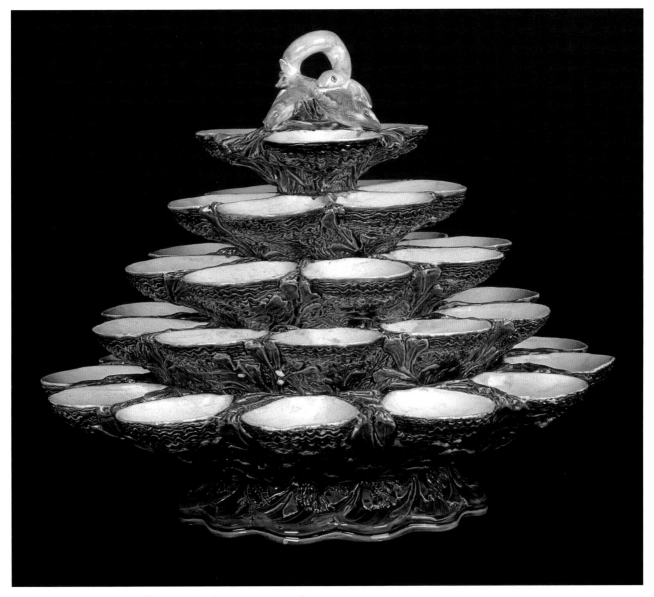

Minton & Co. Five-tiered oyster stand. c. 1856. Height 14″

plates have seven spokes (#2239, 1883), with a large section at one side to accommodate sauces. Rarest are the oyster plates in which each concavity is modeled in the shape of a fish (#2366, 1881). Each oyster plate has a central well, usually glazed in a color that contrasts with that of the body of the plate. The Minton oyster plate was often imitated by other majolica potters, both English and American (see Chapters Five through Nine).

A magnificent display of oysters revolves on the rare five-tiered oystershell pyramid in the Palissy mode. Thirty-one concave surfaces of the shells are glazed oyster white, with the backs of the shell modeled in dense green seaweed on an aubergine-brown shell exterior. A crossed-fish finial rests on top. A four-tiered stand, ten inches high, with twenty-seven shells on a revolving base (#636, 1856), was also produced.

Sardines, a favorite Victorian teatime staple, if one is to judge by all the sardine boxes available, were served in a rectangular box with or without an underplate. The body of the box is decorated with seaweed; the cover has

a pattern much imitated, that of three sardines molded in high relief and lying on a bed of rushes (#1383, 1870). The body of the box is turquoise or cobalt blue. Individual, and very rare, sardine plates are decorated with spokes of small sardines.

A fish service is decorated with scallop shells and silver trout swimming around the brown rim of a fish platter and matching dozen plates (#1496, 1869). The centers are glazed a brilliant turquoise blue.

Lobsters and crabs were displayed at a buffet on a twenty-three-inch-long oval platter (#2044, c. 1876) with realistically modeled shellfish and ceramic garnishes of lemon slices and parsley. On a bed of seaweed a life-size lobster sprawls on the lid of an oval lobster dish (#1523, 1870). Scallop shells decorate the lid and serve as handles for the dish. An impressive crab presides over a large twelve-lobed round platter (1859).

Pigeon pie, a nineteenth-century favorite, but certainly not twentieth-century *nouvelle cuisine,* was sumptuously served in the pigeon tureen (#777, 1864). It is an impressive example of the imitation-wickerwork pieces in which Minton excelled, with the tureen resting on three delicately modeled and realistically colored gray fantailed pigeons roosting on oak branches. The tureen cover is crowned by a white pigeon finial. An equally impressive detail is the cerulean-blue lining.

The wicker design is also seen in some of Minton's game-pie dishes. A wickedly humorous example, very rare, is a game-pie dish in the shape of a pâté mold on a wicker tray. Two hares and two mallards are entrapped in the cobalt-blue lid, and the ears of the hares join to form the handle (#1990, 1877). The most popular Minton game-pie dish was made in four sizes from twelve to eighteen inches in length (#899, 1873); the straw-colored wicker exterior is strewn with oak leaves and branches. The well-modeled cover—with a hare, a mallard, and a pigeon all resting on a bed of ferns and oak leaves—gives an indication of what the banquet might include. (One example of this game-pie dish has an intriguing provenance: it belonged to the late culinary master and majolica collector James Beard and was sold at auction in New York in 1986.) Another game-pie dish—made in sizes ranging from twelve to sixteen inches in length—of white wicker covered with holly and berries, rests on four canine feet; a cartouche on one side depicts a pheasant in flight; on the other is a hare on the run. On the white cover, bordered in blue, a sleeping hunting dog on a fern bed guards his master's hunting horn and gun. A net lies ready for the catch (#964, 1864). A rare game-pie dish in the form of a tree trunk with a mushroom finial dramatizes the pursuit of frightened ducks by two predatory foxes (#2062, 1877). Each game-pie dish was made with a plain off-white ceramic liner in which the game was baked. Although the presence of the liner hides the beautiful inner glaze of the game-pie dish, it increases the value of the piece.

Throughout the Victorian banquet wine and ale were served in beautifully modeled jugs and pitchers. The Palissy-style ewer (#1136), the barrel jug (#900)—both designed by Protât—and the Tower Jug (#1231) have been mentioned. Simpler designs include jugs styled as a naturalistic oak-tree trunk decorated with oak leaves and acorns, the handle formed by a large branch (#553, 1862), in five-to-nine-inch models. These oak-tree pitchers have been widely copied in many English and American majolica factories. Other Minton pitchers include those in a traditional jug shape, with geometric motifs (#605, 1870), or decorated with water lilies in a stylized oriental-inspired pattern (#586, 1866). In the 1860s and 1870s Minton produced pitchers based on animal forms. The Minton cat pitcher (#1924, 1874) sits upright; the tail forms the handle, and a paw traps a helpless mouse. Minton decorated a Christmas Jug (#580, c. 1863) with mistletoe and holly over a cobalt-blue body, shaped a handle as a holly branch, and placed a Renaissance bearded-satyr mask below the spout. Minton also made other special pieces for Christmas festivities, such as the elaborate plate for plum pudding commissioned by the Crystal Palace Art Union (#864, 1859). The pierced rim of the dish is modeled with holly branches, the center is filled with mistletoe and a stylized white rose. At each of the four compass points of the plate a cherub is occupied with the Christmas pursuits of plucking a goose, preparing the baking ovens, carrying the food to the table, and, finally, toasting the Art Union and us all.

Other examples of naturalistic design adorned the Victorian feast. Vegetables and fruits paradoxically appear to have received short shrift on the Minton design board. Asparagus, however, was duly celebrated with plates (#2335) and an asparagus "cradle" (#1549, 1871), modeled in a semicircle of parallel stalks tied with red

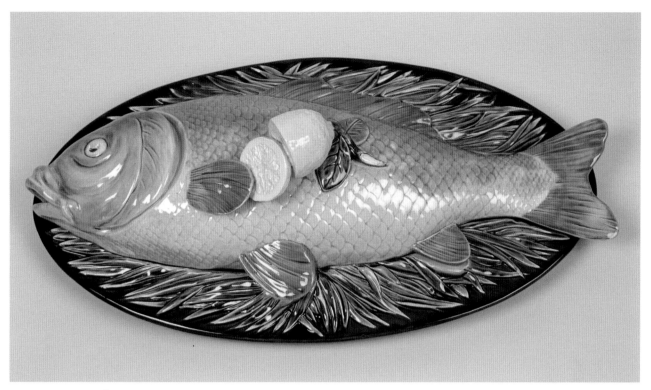

Minton & Co. Fish tureen. 1875. 25″ x 7″. (No. 1979)

pimiento and resting on an attached green plate decorated with red and white flowers of an oriental design. Chestnuts were served from a bowl (#594, 1855) with a "hood" of large green chestnut leaves, decorated with an open chestnut flower. In the center of the blue-glazed inner surface of the bowl is a depression for the round brass box containing a metal heating disk, to keep the chestnuts warm. The collector should be aware that the chestnut serving bowl is incomplete without the brass box and its disk, and that a pink- or blue-beribboned majolica spoon appropriately fashioned from chestnut leaves accompanies the bowl. There is also a marron-glacé bowl, which does not need a brass heating disk. The inner surface of this bowl, therefore, has no depression in the center, but the spoon is mandatory.

Minton majolica dinner and dessert plates were not produced in any great quantity, perhaps because Minton's specialty was its renowned bone-china services. There are accessory plates, such as the asparagus plates, or butterfly plates (#1545, 1870) modeled with a large butterfly occupying most of a green lead-glazed plate.

Bread was served on Bell's Bread Tray (#367, 1878), a fourteen-inch circular majolica platter with symbolic ears of barley, corn, and wheat around a mottled center. Salt, the ancient measure of a man's worth, was kept in the Minton Stag salt dish (#973, 1867), on which a stag's head with antlers sweeps up to form a pedestal on an oval base to support the shallow open salt. Acanthus leaves decorate the stag's head.

One of the last courses at the Victorian banquet was the cheese, usually a twelve-inch-high, blue-veined round of Stilton, which was brought to the table in a cheese bell, also called a cheese keeper or cheese stand. English cheeses were safely kept in larders or on sideboards in these fantasies of majolica, usually fourteen inches high and eight to nine inches in diameter. The Minton cheese bell that appeared at the 1862 international exhibition in London was shaped as a beehive, decorated with blackberry branches and fruit, with heavier branches forming the finial and the legs of the cheese stand (#969, 1865). Other Minton cheese bells (#546 and #809) were modeled and glazed with colorful floral

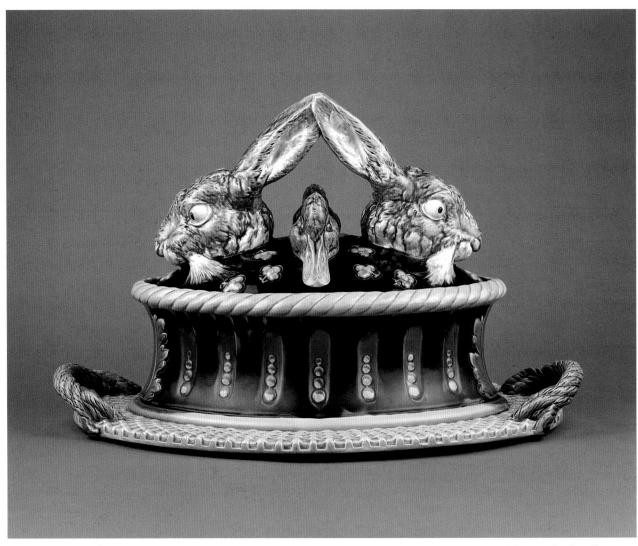

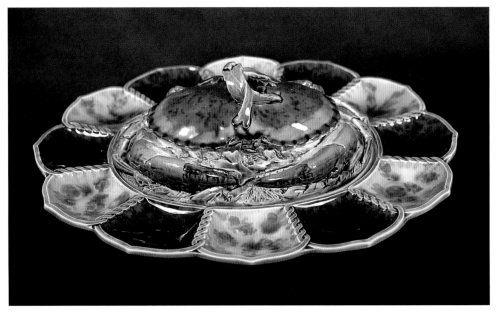

Minton & Co. Game-pie dish. 1877. Length 18″. (No. 1990). Courtesy Jeremy Cooper Ltd., London

48

Minton & Co. Crab platter. 1859. Width 16″

Minton & Co. Covered lobster dish.
1870. Width 14″. (No. 1523)

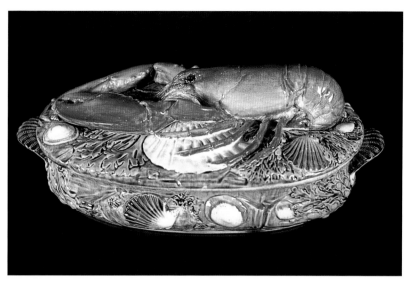

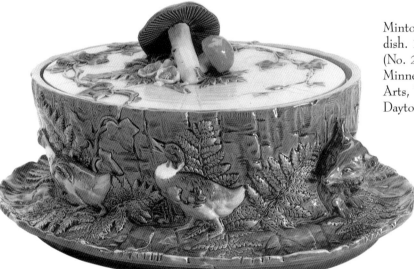

Minton & Co. Game-pie
dish. 1877. Length 16¼″.
(No. 2062). Courtesy The
Minneapolis Institute of
Arts, The David Draper
Dayton Fund

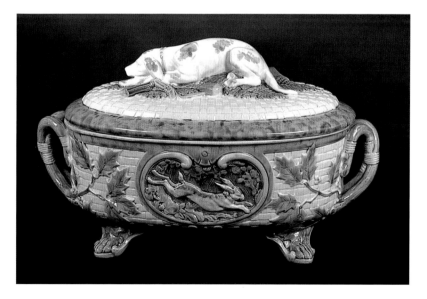

Minton & Co. Game-pie dish.
1864. Length 13½″. (No. 964)

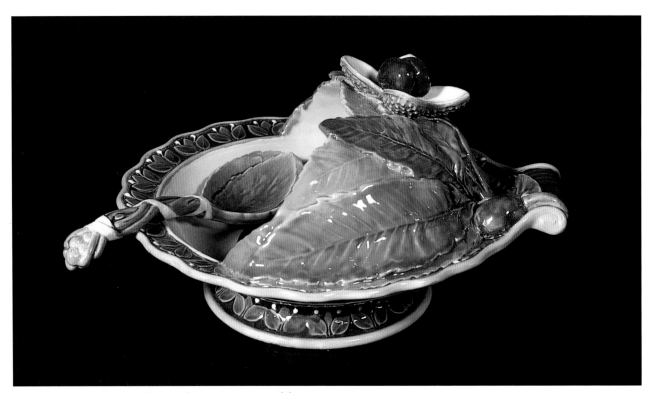

Minton & Co. Chestnut dish and spoon. 1855. Width 11″. (No. 594)

designs; #762 is an elegant imitation-wicker pattern, which would be spectacular at a summer picnic. The smallest cheese dish, five inches high, is modeled as a round of cheese being devoured by several mice, while their leader perched on top serves as the finial (#620, 1876). An intriguing piece, often misidentified as a cheese bell, is the Minton honey pot (#1499), or "beeskip," which represents a functioning beehive, with a tiny bee approaching the entrance at the edge of the lid.

Serving dishes for strawberries are well represented in the Minton shape books. One is modeled as a shallow yellow oval wicker bowl, supported on crossed twigs with round wicker creamer and sugar baskets attached at each side (#1330, 1855). An accompanying small creamer spoon is decorated with a strawberry blossom on the bowl. A small perforated spoon, complete with a blossom on the outside of the bowl of the spoon, sifts the sugar over the berries. A large strawberry-leaf spoon, with a blue ribbon entwined about the handle, completes the set. (The chestnut spoon and the strawberry spoon, despite their superficial resemblance, were specifically decorated with appropriate leaves modeled in low relief.) Minton also produced smaller strawberry services with

cobalt-blue, turquoise, or white backgrounds and decorated with strawberries and blossoms. Matching plates were modeled with small concavities for individual servings of sugar and cream.

At informal luncheons, Victorian tables were frequently set with dishes and platters that utilized the pond-lily motif on a deep emerald-green background. Some serving pieces were three-lobed, with a deeply modeled pond lily at the center (#1010, 1863); others were large oval or round platters (#1041), with pond lilies strewn about. The appropriate accompaniment to these pieces might be the Minton pitcher in the form of a frog amusingly astride a dolphin (#1971, 1877). Post-prandial sweets and nuts were served on blossom-laden platters or in a nut dish, modeled with overlapping filbert leaves and presided over by a squirrel (#1522, c. 1870).

A striking and most original piece of Minton majolica, dedicated to the British hunt (#1146, 1865) is an ice stand. Very much like a miniature Victorian fountain, it is fourteen and a half inches high and eighteen inches in diameter. The circular base is made up of six segments or troughs. The outside rim of the piece is modeled and glazed in a quilted green-and-white gingham design,

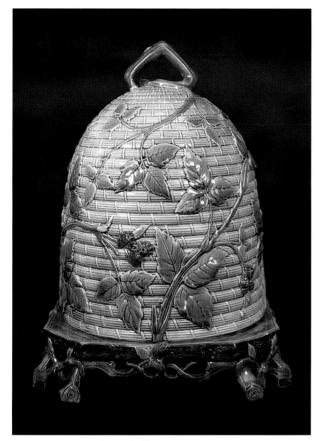

Minton & Co. Cheese bell. 1865.
Height 13″. (No. 969)

Minton & Co. Cheese dish. 1876.
Height 5″. (No. 620). Courtesy
Jeremy Cooper Ltd., London

Minton & Co. Strawberry server with spoons. 1855.
Height 7½″. (No. 1330)

with daisy blossoms at the corners of the checks. Around the outside of the base, equidistantly spaced, are eight fox heads, sneaking under brown drapery swags, with each fox's paws gripping the rim of the piece. The tall center column of the piece is decorated with three deer heads, all encircled with continuous garlands of leaves. The deer antlers support the top of the piece, a ripple-edge platter glazed in cerulean blue. Although the fox motif has been used on other pieces of majolica, the complex modeling and the humorous narrative quality of this piece make it spectacular.

The Minton fox also appears on a majolica wine cooler and cover (#631, 1851), a companion to the Victorian dessert service. (A wine cooler in this pattern, made by Minton in porcelain, was part of a large service purchased by the queen.) The body of the piece represents a green-and-brown mottled landscape, where a vintner and his wife sit on a wooden bench. The two are petting their dogs, no doubt praising them for keeping the fox away from the grape arbor. At the top of the cooler, four Minton foxes peer out from beneath grape-purple swags, as if to say the fox is not yet trapped. The finial of the

51

wine cooler lid is a marvelous young Bacchus, garbed as a workman, resting against a keg of wine and plucking grapes from a nearby compote.

Classic Minton tea services, such as one decorated with flowers, glazed in whites, pinks, and greens on a cobalt-blue background (#642), are charming; but more dramatic are the individual teapots in which naturalism was pushed beyond convention into excessive, at times malevolent fantasies. One teapot, designed by Colonel Henry Hope Crealock, is in the shape of a secretary bird, the long-legged African bird known for its fearless habit of attacking snakes (1874). Here a serpent is coiled around the bird, but the serpent's head (which forms the spout) is clamped between the bird's powerful hooked beak. Perhaps the title is "Who can strangle whom? First?" Another teapot, in the shape of a flatiron (#1924, 1874), probably designed by Dr. Christopher Dresser, stages a cat-and-mouse game: the cat is hanging on the teapot handle waiting for the right moment to pounce on the mouse; the mouse is on the teapot lid, just beneath the cat, munching on a carrot, looking up and trying to judge his position. An army of mice scurry around the border of the teapot, waiting for their leader's signal. There are teapots designed as roosters (#1909, 1872) and lemons (#1710, 1861). Teapots in the shape of turtles plod along (#629, 1878), while other teapots with cobalt bodies, monkey-shaped handles, and cockerel spouts race ahead on green feet (#624, 1877).

A special example of Minton majolica is the pair of vases modeled by John Henk as a cockerel and hen (#1982 and #1983, 1876), each with a wooden tub nearby. With detailed modeling and glazes in naturalistic colors, the figures stand on a base of grass and arrowhead leaves. Alternately used as flower holders, the pieces served originally as spill vases—cylindrical vases used for holding spills, which were paper tapers or wood splinters used to obtain light from a fire to light lamps or pipes.

In the Victorian conservatory Minton majolica was displayed in dramatic naturalistic forms. Most prominent are the forty-one-inch-high walking-stick stands formed as freestanding storks (#1916, 1875) and herons (#1917, 1876) in a beautifully modeled and glazed natural setting. Each bird is standing next to a clump of large bulrushes, which forms the stick stands. There are brown cattails, blue and white irises, and pond-lily pads

among the rushes, and arrowhead leaves on the rocky base. The long-necked heron has caught a fish in his beak. The stork, with an eel curled around his beak, has captured an unfortunate frog beneath his foot. These figures were also modeled twenty-six inches high by John Henk, complete with all details of the larger examples, and were useful as flower holders or garden ornaments. A smaller heron (twenty-two inches high) was modeled in the shape of a ewer by Hugues Protât. There is a large pike in its beak and it is glazed in the naturalistic polychrome coloring of the other figures (#1241, 1871). This group is reminiscent of the Meissen porcelain figure of a stork with a fish, modeled by Johann Joachim Kändler in 1732, who in turn may have been inspired by a sixteenth-century woodcut of a stork carrying an eel (*White Stork,* illustrated in Pierre Belan's *Pourtraits d'oyseaux,* 1557). The Minton stork and the heron appear on many forms, such as pitchers and cheese bells, but none of the figures on those examples shares the drama of the freestanding pieces.

In addition to the Minton stork and heron figures, Minton produced a majestic peacock, a favorite motif of the Aesthetic Movement. The sixty-two-inch-tall peacock (#2045, 1873) was modeled by the French sculptor Paul Comolera, who was famous for his life-size renditions of birds. (The peacock was also made in a smaller size, eleven inches high.) The peacocks that are known to exist today (about twelve) bear the impressed signature "P. Comolera." The peacock, resplendent in polychrome glaze, stands on a mass of rocks decorated with vines, leaves, flowers, and lichens. The peacock breast is cobalt blue; the wings and legs are in naturalistic colors. The long peacock tail is a shimmering, elegant mass of peacock feathers—a fantastic display of majolica glaze and Minton expertise. One of these peacocks is known as the Loch Ard Peacock. It was shipped to Australia for the 1880 international exhibition in Melbourne, but the ship, the *Loch Ard,* was wrecked fourteen miles from the Australian coast. The packing case was salvaged, and to Minton's credit, the bird was found in perfect condition.

The shy Minton fawn standing beside a hollow tree trunk (#2077, c. 1870) is gracefully designed. The piece is glazed in naturalistic colors. Horses (#286, 1875), magpies, and cockatoos swinging on perches are also represented.

A Minton Victorian hand vase is in the shape of an

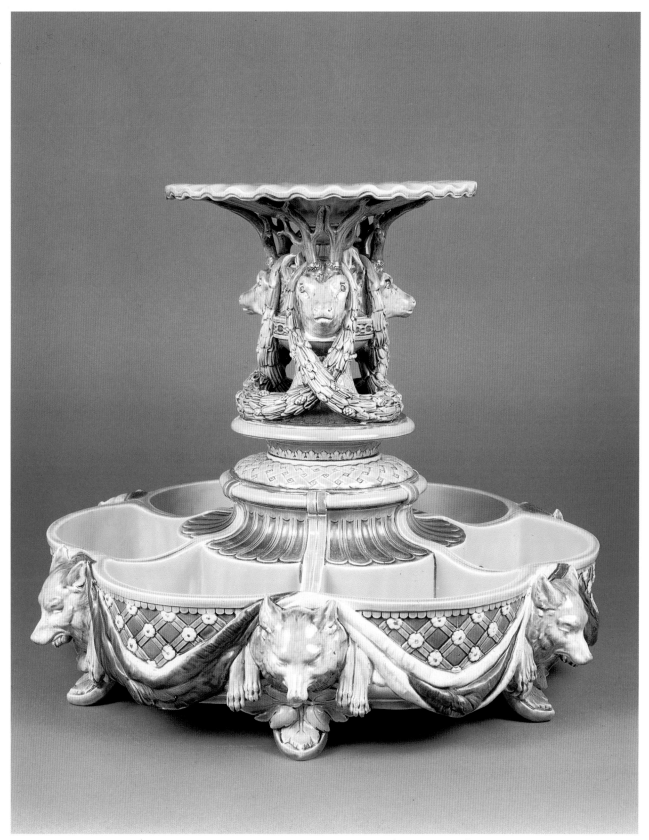

53

Minton & Co. Ice stand. 1865. Diameter 18″. (No. 1146). Courtesy Christie's, London

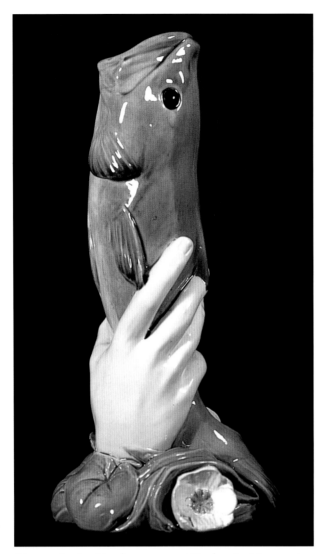

Minton & Co. Hand vase. 1869. Height 9″. (No. 1321)

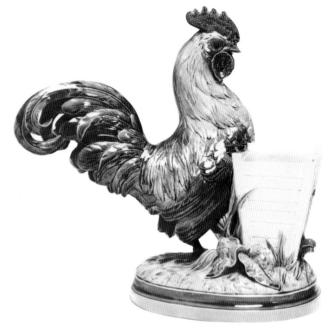

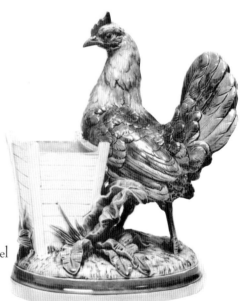

Right: Minton & Co. (John Henk). Cockerel and hen spill vases. 1876. Cockerel height 13½″. (No. 1982); hen height 12¼″. (No. 1983). Courtesy Sotheby's, London

open-mouthed salmon trout clutched by a hand cuffed in water-lily leaves and blossoms (#1321, 1869).

Naturalism in the conservatory was resplendent in the many garden seats and urns produced by Minton. The Minton Museum displays a garden seat, for example, in cobalt blue strewn with magnolias so well crafted that they appear to be alive. Another garden seat is much more stylized (#982, 1872): the columnar pedestal body is decorated with deeply modeled passionflowers alternating with stylized lily blossoms. The base, resting on

three rectangular feet ornamented with a key pattern, is encircled by a guilloche border and, above that, a border of stylized leaves. The pedestal top is decorated with a garland of passionflowers. The body of the piece is glazed turquoise, cobalt, or maize. The Minton monkey garden seat (#589, 1860) is modeled as a monkey seated on a rectangular rush mat with canted corners and holding yellow-skinned pomegranates. The monkey's head supports a buttoned, tasseled cushion in cobalt blue with pale green braiding. The monkey may be indicative

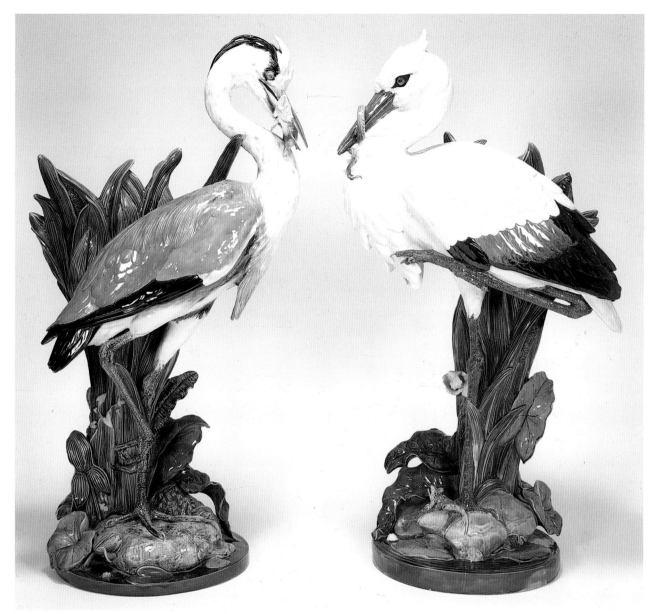

Minton & Co. Walking-stick stands. Heron. 1876. (No. 1917); Stork. 1875. (No. 1916). Each 41″ in height. Courtesy Sotheby's, London

of Minton humor: does a monkey play a secondary, supporting role to *homo sapiens* or is the Darwinian monkey responsible for the origin and stability of our world?

The contemporary gardener would find great pleasure in the series of graduated Minton garden urns and cachepots. Some are decorated with stalks of foxgloves (#1056, 1875) or lilies. Glazed with backgrounds of cobalt, turquoise, or brown, they were produced with matching underplates. A spectacular garden pot is decorated with deep pink and white passionflowers and

tendrils intertwined in a lattice pattern, with lion's-head handles and a matching underplate, all on a pale blue ground (1858). Other garden pots include a turquoise-blue-glazed example with serpent handles (#532, 1865); a massive cobalt-blue pot decorated with oak leaves and acorns in low relief (#650, 1878); and a large cachepot decorated with a trellis festooned with large roses. Small flower arrangements could be displayed in the Minton quintal (#1107), a five-chambered, fan-shaped vase, which owed its origin to the tin-glazed Delft *tulipière* of

the late seventeenth and early eighteenth centuries. Pedestaled jardinieres of palace dimensions are quite spectacular and incorporate naturalistic and Renaissance designs with other motifs (#2227). One such example, designed by Albert-Ernest Carrier-Belleuse, a massive bowl with a turquoise background, is supported by three Herculean figures (#1366, c. 1855). The body of the bowl is decorated with high-relief cornucopias and garlands laden with fruits and nuts. The three handles are modeled as lions' heads.

Oriental and Islamic styles

Examples of oriental art and ceramics presented at the 1862 London exhibition were very well received. Public interest, which had already begun with the opening of Japan to world trade in 1854, increased during the Aesthetic Movement of the 1870s and 1880s. Because of these trends, and because of Léon Arnoux's personal interest in oriental and Islamic decorative arts, Minton artists produced majolica which incorporated designs from these cultures. Colin Minton Campbell, with his interest in Persian tiles, supported Arnoux's artistic decisions.

Minton drew inspiration from oriental theater motifs, naturalistic subjects, and ancient metalwork designs. There are three intricate teapots: the Chinaman teapot (#1838, 1874) is modeled as a benign-faced Chinese actor whose pigtail forms the handle and whose head is the lid. He holds his fierce actor's mask over the teapot spout. The teapot comes in graduated sizes and is usually seen in polychrome glazes, but was also made in majolica in monochrome colors. The monkey teapot (#1844, 1875) is modeled after a Japanese design in which the body of the teapot is formed by the monkey clinging to a coconut; his head is the lid and his tail is the handle. The spout is a bamboo shoot, decorated with bamboo leaves. The monkey's coat is cobalt blue and decorated with pink and yellow fans. Here again Minton has produced this model in monochrome glaze, and also in polychrome porcelain. The mushroom teapot (#642, 1864) has a lemon-shaped body, decorated with leaves that also form the spout and handle. A precisely fluted mushroom cap is the lid and a smaller mushroom is the teapot finial.

In the conservatory, garden seats and jardinieres with oriental designs were possibly the work, according to the Minton archivists, of the botanist, Dr. Christopher Dresser. A barrel-shaped jardiniere (#1797, 1878) has elephants'-head handles and rests on four dolphin-head feet. Between two bands of stylized leaf ornament are six colorful butterflies in lobed medallions on a turquoise background. Dresser's "signature," stylized owls' heads, appears in the recessed band beneath the rim. Owls' heads decorate an owl vase (#1390, 1871), which is also attributed to Dresser. A Japanese garden seat (#1219, 1885) is modeled in a waisted cylindrical shape and decorated with flowering branches, cloud bands, and flying cranes. Flying cranes, another Dresser motif, were adapted by lesser majolica factories, such as Joseph Holdcroft in England and the Eureka Pottery Company in the United States, and by unidentified manufacturers. A large jardiniere (1882), in a flattened barrel shape, is decorated with stylized flowers made of shells and with heavy branches traveling across the body to form the two handles. Its colors of dark and light blue on a white background are reminiscent of early blue-and-white oriental porcelain. A most striking piece, inspired by both Chinese lacquer and metalwork, is what is known as Chinese Ornament (#1625, 1872), patterned after an ancient oriental bronze shape, with four legs decorated in Chinese style, with the lid guarded by a coiled dragon finial. Background colors are pale and dark blue.

Islamic art is represented in Minton majolica chiefly in tiles and garden seats. Persian and Moorish influences contributed to the vast expanse of Minton tiles used in the South Kensington Museum. A Minton garden seat (#940, 1868)—a tapering cylindrical shape on three rounded legs, with large and small openwork areas—is decorated with Islamic arabesques and interlace designs. The polychrome glazes are on an aubergine ground.

Figural pieces: human and mythological

Although the repertory of Minton majolica has relatively few human figural pieces in it, each has an individual charm.

The use of Sèvres molds, possibly imported or stolen by French émigrés who joined Minton, was important in the development of Minton figures. Sèvres, long an outstanding manufacturer of porcelain and Minton's chief international rival, had attempted to produce majolica during the early years of Minton's development of

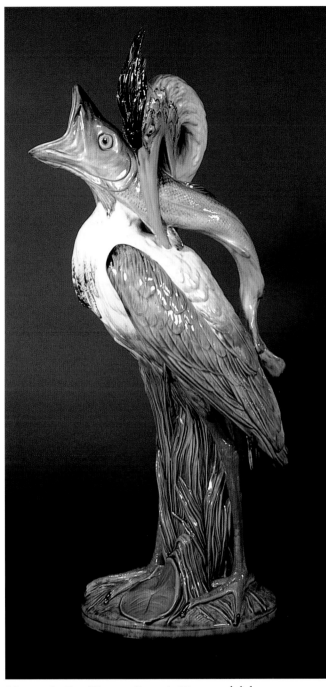

Minton & Co. (Hugues Protât). Heron and fish ewer.
1871. Height 21″. (No. 1241)

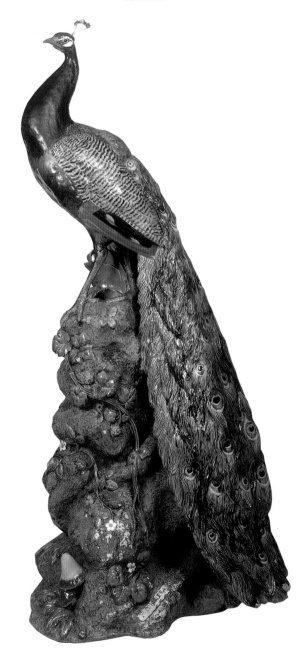

Minton & Co. (Paul Comolera).
Peacock. 1873. Height 62″.
(No. 2045). Courtesy Christie's,
London

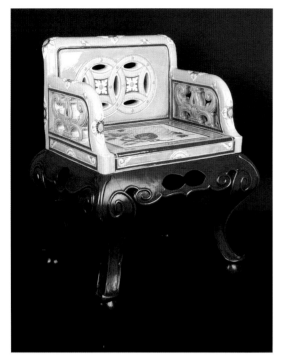

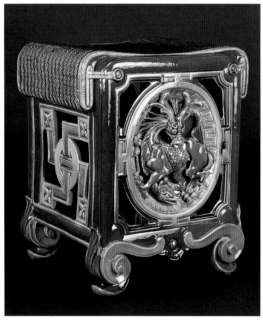

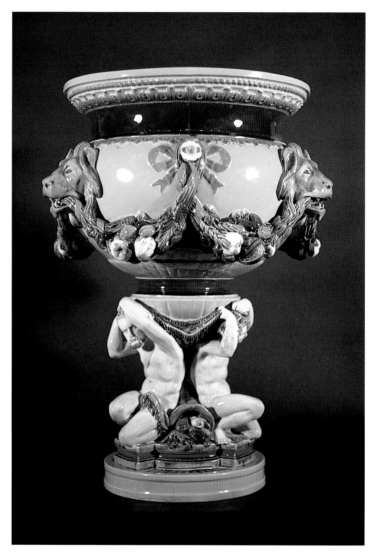

Minton & Co. Pedestal jardiniere. c. 1855. Height 20½".
(No. 1366)

Top: Minton & Co. Chair of Chinese design.
Shown at the 1867 Paris exhibition.
One is now known to exist. c. 1865. Height 31".

Above: Minton & Co. Garden seat of Oriental
design. c. 1880. Height 18". (No. 786)

Minton & Co. Jardiniere. 1882.
Height 12". Courtesy Christie's,
London

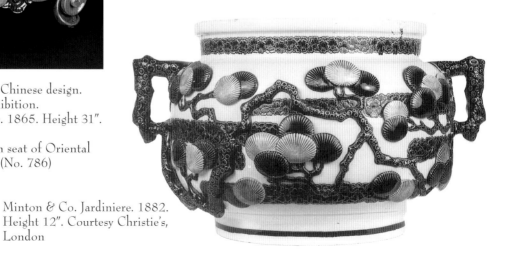

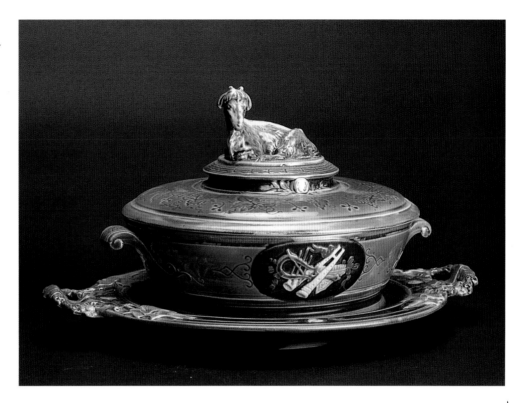

Minton & Co. Butter dish. 1867. Height 7¼". (No. 485)

majolica, but Sèvres was not successful. The Sèvres techniques for fine porcelain did not lend themselves to majolica. Minton welcomed the experienced Sèvres artists, and with their help produced figural pieces similar to Sèvres porcelain and very different from other Minton styles. A pastoral pair, Boy Resting on a Basket (#421, 1865) and Girl Resting on a Basket (#431, 1867), are dressed in eighteenth-century rustic clothes, he with a green hat and she with flowers and ribbons on her hat, each leaning on a wicker basket, standing on oval bases decorated with grapevines. Other figural pieces portray the vineyard scene: Vintager with Basket in Each Hand (#376, 1865) and Man with Wheelbarrow (#413, 1871). Both figures are dressed in rustic garments of the Elizabethan period. The pieces are decorated with either grapevines or hop branches—clues to each man's occupation. The source of inspiration for these figures is Continental rather than British. It is difficult to trace exact design sources because many factories adopted similar designs, both in England and on the Continent. One pair, however, the Hogarth Match Boy and Hogarth Match Girl (1873), is based on eighteenth-century Staffordshire models, with appropriate costumes, including the boy's tricorn hat; they carry wicker baskets.

Minton also portrayed the human form as a Toby jug. Traditional Toby jugs were in the form of a seated man holding a pipe and a mug and wearing a tricorn hat. Very few represented a woman, but Minton produced both female and male Toby jugs (#1139 and #1140, 1865), as standing figures. They were exquisitely modeled, with details of hair and clothing much more precisely rendered than in the usual Staffordshire Toby jug. In another example of Minton majolica depicting the human figure, a British tar seated on a coil of rope serves as the finial on a tobacco jar (#716). Minton also produced standing figures with nodding heads, representing familiar forms such as coachmen, about eight inches high (1864).

The most dramatic of the Minton figural pieces were the majolica blackamoors (#1157 and #1158, 1865), seventy-two inches tall, which were displayed at the 1867 Paris exhibition. They were based on a pair of gilt-bronze candelabra designed by the French sculptor Albert-Ernest Carrier-Belleuse that had been exhibited at the Paris exhibition of 1862. (They were adapted from a seventeenth-century design by Jean le Pautre, 1617–1682.) (Aslin and Atterbury, p. 47.) The imposing majolica figures, with magnificent polychrome glazing,

59

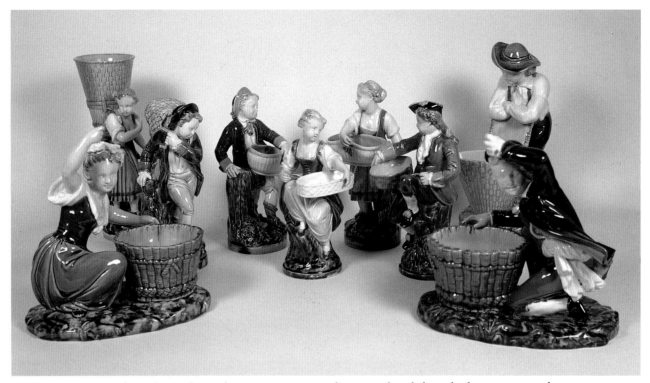

Minton & Co. Figurals. *Left to right*: Girl vintager. 1868. Height 8″; Girl with large basket. 1868. Height 7½″; Boy with bundle. 1870. Height 7¾″. (No. 438); Boy with basket. 1867. Height 8″. (No. 280); Hogarth match girl. 1863. Height 7½″. (No. 294); Girl with basket. 1867. Height 8″. (No. 281); Hogarth match boy. 1863. Height 7½″. (No. 293); Boy resting on basket. 1870. Height 10¼″. (No. 421); Boy vintager. 1868. Height 8″

were superior examples of Minton's work. Both the male and the female figures supported baskets on their heads and were used as gigantic jardinieres. The female figure was draped with ropes of pearls over her exotic garments. The male wore a lion pelt over his head and back and was equipped with a long bow and a quiver of arrows. Both figures were mounted on square pedestals decorated with satyrs at each corner of the base.

Other Minton figural pieces explored the realm of romantic fantasy. The arrival of Albert-Ernest Carrier-Belleuse in 1850 inspired Minton to produce pieces enlivened by *amorini* (cherubs, or winged infant cupids) and *putti* (infant boys without wings). Young tritons, mermaids, or satyrs (#526, 1861) support vases or urns on bases decorated with shells and seaweed. *Putti* carrying baskets symbolize wheat or grape harvests; others celebrate Art, Science, and Industry. Water sprites riding on dolphins' backs form ornamental vases. Carrier-Belleuse created beautifully modeled examples: a *putto* balancing a shell on his shoulder as he rides a winged

seahorse through the waves (#326, 1872—this was first made in the 1850s in Parian); two *putti* on a rocky base covered with seaweed and a fishing net, with one *putto* holding the dolphin fountain on his shoulder (#911, 1868); and a large plant stand on which three *putti* shoulder a straw basket (#949, 1871). Each of the components of these pieces was modeled separately and they were used over several decades in different combinations for a variety of forms.

The most important and monumental work of majolica was Minton's Saint George and the Dragon fountain, a magnificent construction of stone and majolica that was erected under the Eastern Dome at the London International Exhibition of 1862. Designed by John Thomas (1813–1862), and consisting of 379 pieces, the fountain was thirty-six feet high and thirty-nine feet in diameter. Towering over the fountain were larger-than-life figures of Saint George and the Dragon, on a crowned central column surrounded by four winged Victory figures holding laurel wreaths. An inscription

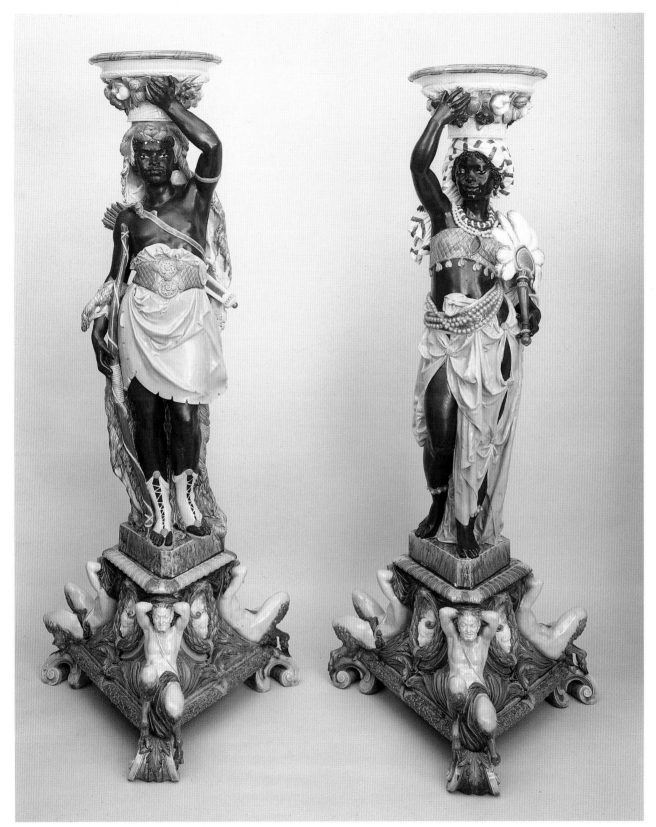

Minton & Co. (Albert-Ernest Carrier-Belleuse). Blackamoors. 1865. Each 72″ in height. (Nos. 1157, 1158). Courtesy Sotheby's, London

Minton & Co. Toby jugs. Lady. 1865. Height 11".
(No. 1139; Barrister. 1867. Height 11".
(No. 1140). Courtesy Sotheby's, London

Right: Minton & Co. Triton vase.
1861. Height 17". (No. 526).
Courtesy Jeremy Cooper Ltd.

around this section read "For England and for Victory." Below, heraldic British lions supported small fountains. On pedestals attached to the lower part of the structure were additional small fountains, each composed of a large stork carrying a shell in which a sea nymph bathed. Water, scented by A. Rimmel, a prominent French perfume company, poured forth from the individual fountains into the surrounding basin. The rim of the stone basin was decorated with majolica oak-leaf garlands and roses symbolic of England. At the close of the 1862 exhibition the fountain was moved to the grounds of the Bethnal Green Museum in East London. It was destroyed in the 1920s, ostensibly because no permanent space could be found for it. Despite its ignominious demise, the Saint George and the Dragon fountain was the greatest work of majolica ever produced, and even a shard of its past glory is treasured by collectors of Minton majolica.

62

MINTON ARTISTS

English and Continental painters and sculptors responded to the inspiration of Herbert Minton and Léon Arnoux and were invited to Stoke-on-Trent to make their own contributions to Minton majolica.

Thomas Kirkby (1824–1891) was born in Trentham, Longton. Kirkby's father was employed by the duke of Sutherland, at Trentham Hall. Because the duke was a patron of Minton's, Thomas Kirkby's early artistic talents became known to Minton. Kirkby was employed at Minton's as a painter throughout his career (1841–1887) and was responsible for the first paintings of Renaissance scenes on Minton majolica. His first work, a continuous panel of angels painted around a large urn (1864), is at the Minton Museum. Another piece by Kirkby is a classical tazza made for the 1862 London exhibition, now in the Victoria and Albert Museum.

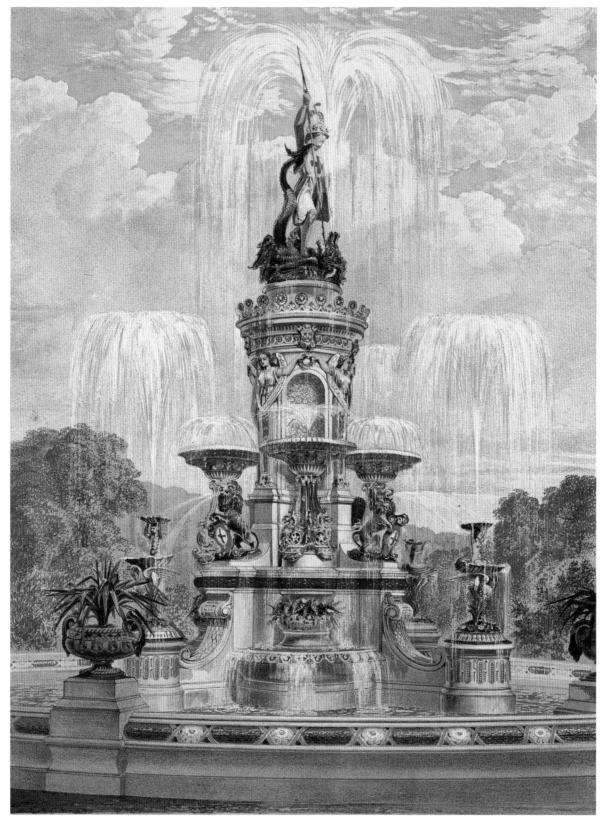

63

Minton & Co. St. George and the Dragon. 1862. Chromolithograph. Courtesy Minton Archives, Royal Doulton Ltd.

Edward Rischgitz (1828–1909) was responsible for the dramatic paintings on Minton's Prometheus Vases, as well as on the Aziglio Vase. Born in France, Rischgitz was a member of the Barbizon school of artists, who painted landscapes at Fontainebleau, near Paris. He worked at Minton from about 1864 to 1870. His scenic style resembled that of his countryman Émile-Aubert Lessore.

Émile-Aubert Lessore (1805–1876) studied with the French painter Jean-Auguste-Dominique Ingres, and then worked at Sèvres, where his success was said to have aroused the jealousy of his colleagues. Lessore worked at Minton from 1858 to 1860 before joining Wedgwood. His achievements as a ceramic painter will be detailed in the chapter on Wedgwood majolica.

Thomas Allen (1831–1915) was born in Stoke-on-Trent and worked at Minton's for two decades (1854–1875), but completed his painting career at Wedgwood. His specialty at Minton's was figure and flower painting on porcelain, but he also decorated majolica and tiles, and contributed to the work on the South Kensington Museum.

Francis Woolaston Moody (1824–1886) was also a designer and painter who was involved with the tiling work at the South Kensington Museum, as well as in painting majolica.

Alfred George Stevens (1817–1875) was a painter, sculptor, and designer who had studied in Italy before he joined Minton. He followed quite faithfully the styles of Renaissance *maiolica*. Stevens was at Minton between 1859 and 1864 and worked closely with both Arnoux and Kirkby. Some of his pieces were displayed at the 1862 London exhibition and are now at the Victoria and Albert Museum.

Eminent French sculptors, encouraged by Léon Arnoux to meet the challenge of the new majolica forms, came to Minton. Pierre-Émile Jeannest (1813–1857) was both a ceramic artist and a silver designer. The son of the sculptor Louis-François Jeannest and a student of Paul Delaroche (a French painter of historical subjects), the younger Jeannest left Paris for London in 1845. He worked at Minton from 1846 to 1852 as a modeler and was a modeling instructor from 1848 to 1852 at the Potteries School of Design in Stoke. He worked in porcelain as well as majolica. His outstanding pieces of Minton majolica include a compote with a pedestal

decorated with graceful classical figures garlanded with roses, and a thirty-five-inch-wide cistern ornamented with cherubs, rams' heads, and foliate scrolls (#614, c. 1852). Many of his pottery designs were reproduced in the *Art Union Journal*. From 1852 until his death in 1857 he worked as a designer at the electroplated-silver factory Elkington, Mason Company of Birmingham.

Albert-Ernest Carrier-Belleuse (1824–1887) succeeded Jeannest at Minton's. Carrier-Belleuse had studied at the École des Beaux-Arts in Paris in the 1840s and worked at Sèvres before his employment at Minton in 1850. He also taught at the Potteries School of Design in Stoke. He worked in Parian, porcelain, and majolica; his large majolica pieces bore his signature or are documented in the Minton shape books. At the 1982 exhibition of Minton majolica in the London gallery of Jeremy Cooper, there were several superlative examples attributed to Carrier-Belleuse, three of which are illustrated in the exhibition catalogue written by Victoria Cecil (Nos. 33, 40, and 60). All were graceful representations of *amorini, putti,* and tritons in naturalistic garden or marine settings. Carrier-Belleuse returned to France in 1855, and in 1875 became art director at Sèvres, although he continued to execute freelance commissions for Minton's and other English firms such as William Brownfield and Sons.

With the departure of Carrier-Belleuse, Hugues Protât (fl. 1843–1875) was promoted at Minton. Protât, a multitalented French sculptor, modeler, furniture designer, and carver, exhibited at the Paris Salon between 1843 and 1850. He was employed by Minton from 1845 to 1858, and was also a modeling instructor at the Potteries School of Design in Stoke from 1850 to 1864. In 1855 he replaced Carrier-Belleuse as chief modeler at Minton's, and his work warranted his monogram or name on the handles of his pieces. In 1858 he joined Wedgwood and worked with Émile Lessore on several projects. A majolica jardiniere by the two colleagues was displayed by Wedgwood in the 1871 London exhibition. A special ewer, illustrated by Jewitt (p. 536, Fig. 1575), modeled by Protât and painted by Lessore, included a *putto,* a maiden, four deeply carved medallions of women's heads, swags, gargoyle heads, leaf and gadroon moldings, and a central painting of a woman and a child. Protât also established himself as a free-lance artist, worked for various factories, including William Brownfield and

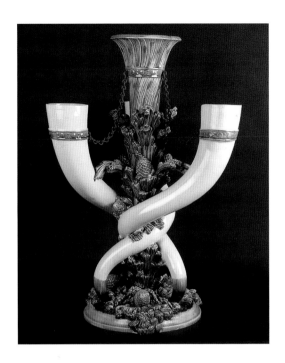

Minton & Co. Neo-Medieval horn flower holder. 1862. Exhibited at the 1862 International Exhibition in London. Height 28″. (No. 778)

Sons and Samuel Alcock and Company. His work in porcelain at those two factories, modeling dessert services and candelabra, made him much sought after in Stoke. Many commissions also came to his London studio. One of his last works before he returned to France was the execution of the stone statues that adorn the India Office in London.

Hamlet Bourne, a pupil of Protât, worked first at Minton and in the mid-1860s at Wedgwood. At Minton he modeled an almost exact copy of a Palissy ewer and matching basin in 1858.

Paul Comolera (1818–1897) was born in Limoges and became well known as an *animalier,* a sculptor of animals and birds. He was a student of the sculptor François Rude and exhibited at the Paris Salon in 1847. Employed at Minton's from 1873 to 1880, he sculpted life-size examples of animals and birds that won him great recognition. His best known work of Minton majolica is the great peacock (1873) previously described, which possibly was inspired by the diminutive (18 cm.) peacock of English porcelain by Bow (c. 1756, see Savage, *English Ceramics,* plate 117). He also created faience pieces for the ceramics factory at Choisy-le-Roi in France.

John Henk (1846–1914) was the son of a German painter, Christian Henk, who also worked at the Minton factory. The father decorated majolica with landscapes in the style of the eighteenth-century French artist Jean-Antoine Watteau. John Henk was apprenticed to Minton in 1859 and spent the rest of his working life at Minton's. He studied at the Potteries School of Design in Stoke from 1863 to 1868 and was promoted to chief staff modeler at Minton's, specializing in animal figures. His majolica cockerel and hen spill vases served as the inspiration for life-size French majolica freestanding cockerel and hen figures.

Minton artist Henry J. Townsend had been a master at the Government School of Design. He was commissioned by Henry Cole—virtual director of the science and art departments at the South Kensington Museum—to create what became one of the most familiar pieces of mid-Victorian pottery, the Hop Jug. It was designed and modeled in high relief with scenes of men, women, and children gathering the hops, supervised by *putti.* The earthenware jug was first produced by Minton in 1847. It was originally decorated with a monochrome glaze, and in 1855 with polychrome glazes and called "imitation Palissy ware." This piece is important for several reasons. It was "probably the most ambitious of all the mid-Victorian jugs with raised decoration" (Hugh Wakefield, *Victorian Pottery,* p. 48). Also, it could be considered a transitional piece from Victorian pottery to Minton majolica because it was one of the first pieces that had

65

been designed in the 1840s for another ware and produced later in majolica.

Charles Toft (1832–1909) was the Minton artist most closely associated with the re-creation of the sixteenth-century majolica precursor known as Henri Deux or *faïence d'Oiron*, the "Saint-Porchaire" of the nineteenth century. He was able to apply the technique characteristic of that earlier ware—inlaid colored clays—to complex designs on tazzas, ewers, vases, and ornamental pieces. Toft's pieces (which, of course, were not majolica, although they were covered with similar glazes) were first attempted in the late 1850s, under the direction of Léon Arnoux, and displayed at exhibited in the London exhibitions of 1862 and 1871. Toft's greatest example of Saint-Porchaire ware for Minton is a frame for a barometer and thermometer set (#1770), exhibited at the Philadelphia Centennial and purchased by Sir Richard Wallace, the founder of the Wallace Collection in London. The Minton Museum in Stoke-on-Trent and the City Museum and Art Gallery in Hanley have great examples of these wares. In 1877 Toft became chief figure modeler at Wedgwood.

Baron Carlo Marochetti (1805–1868) was an Italian sculptor who studied in Rome and Paris and emigrated in 1848 to London. He modeled several large pieces of majolica for Minton, including the Ram's Head and Festoon jardiniere (#727) and a vase (#723), both displayed at the 1851 Crystal Palace Exhibition, and a water cistern (#614) shown at the 1855 Paris exhibition.

Painters who worked at Minton during the latter part of the nineteenth century include Antoine Boullemier and Louis M. Jahn. Boullemier (1840–1900) was born in Sèvres and studied in Paris with Hippolyte-Étienne Fragonard, grandson of the famous eighteenth-century painter Jean-Honoré Fragonard. In 1871 Boullemier joined Minton's and was known for his figure paintings. He applied a delicate touch, in the eighteenth-century style of François Boucher, to cupids and *putti,* which were enhanced by the soft Minton glaze. Examples of his work were praised and purchased on both sides of the Atlantic, and Queen Victoria was one of his patrons. He was employed by Brown-Westhead, Moore and Company, and also did freelance work. A plate, modeled at George Jones's factory, complete with a border of Jones's acanthus leaves, has a central painting of cherubs by Boullemier. Owned by the City Museum and Art Gallery

in Hanley, the piece surprises the twentieth-century majolica collector because of the unexpected juxtaposition of the French art style and the well-recognized Jones modeling. Boullemier would buy undecorated, sometimes marked, modeled pieces and paint them to order. Perhaps his entrepreneurial spirit conflicted with his assignments as a Minton employee, for he left Minton under less-than-amicable circumstances.

Louis M. Jahn (d. 1911) was a Minton painter destined for more executive positions. Born in Oberweisbachein, Thuringia, he was trained in Vienna and employed at Minton's from 1862 to 1872. At Minton he displayed his skill in painting on porcelain in the style of Sèvres, depicting cupids in the manner of Boucher. Jahn also decorated Minton majolica. From 1872 to 1895 he was art director at William Brownfield and Son, a pottery works that under his guidance increased the production of excellent majolica and porcelain. In 1895 he returned to Minton and served as art director until 1900. He was curator of the City Museum and Art Gallery in Hanley from 1900 until his death in 1911.

Colonel Henry Hope Crealock (1831–1891), a skilled draftsman, recorded animals, sporting subjects and events during his military service in various parts of the world, including South Africa. The wildlife of such regions is reflected in his work as a painter and decorator at Minton, and also at Wedgwood, where he made animal paintings and designs from 1874 to 1877.

John Bell (1811–1895) studied sculpture at the Royal Academy Schools. His work for Minton included Parian figures and Bell's Bread Tray.

Augustus Welby Northmore Pugin (1812–1852), prophet of the Gothic revival in architecture and the decorative arts, designed tiles (from about 1840) and other wares (from 1849) for Minton. Among these were a bread tray and a garden seat. He organized the Medieval Court at the Crystal Palace, which featured objects he designed, including Minton ceramics.

As has been stated, many artists at Minton's worked in ceramic wares other than majolica. Pattern numbers found on pieces of majolica by these artists might refer back to the number listed in the shape books designating the original design for other earthenwares, before the production of majolica began in 1849. Among these artists were John Bell, A. W. N. Pugin, and Henry J. Townsend. Examples include Bell's Bread Tray (#367),

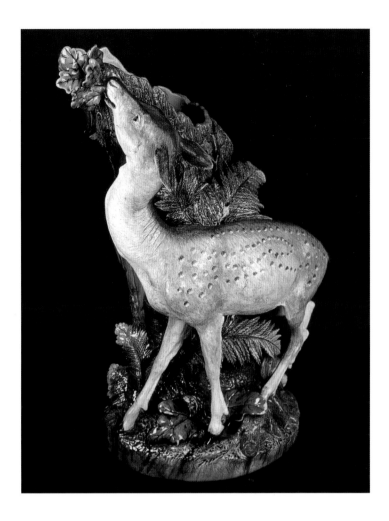

Minton & Co.
Fawn with tree trunk
flower holder. c. 1870.
Height 33". (No. 2077)

designed by Bell in 1848 and executed in majolica in 1861; Pugin's Bread Tray (#368), designed in 1848 and produced in majolica in 1856; and the aforementioned Townsend Hop Jug, first produced in earthenware in 1847, and in majolica in 1855.

Two other Minton artists deserve mention here: George Jones and Joseph Holdcroft. Chapter Five is devoted to these two men, as each founded his own pottery works.

MINTON MARKS

Minton majolica can be fully identified by a system of impressed marks, one or more of which is on the great majority of Minton pieces. Marks on Minton pieces include:

1. Factory mark: "MINTON" or "MINTONS" impressed.

The "s" was added about 1871; its significance is not clear.

2. British registry mark (see Appendix): This mark was used on many, but not all, pieces of Minton majolica.

3. Date code symbol: Since the British registry mark used the date on which a given design was first registered, and was not changed on later examples of that design, Minton also used a date code symbol to indicate the date of production of individual pieces. Impressed symbols of a different design for each year from 1800 to 1900 exist, but the table below refers only to the years of majolica production. As with Parian and porcelain, some majolica pieces were produced over an extended period, apparently until 1897, although Minton advertised its majolica as late as 1902.

4. Ornamental shape numbers: The Minton shape books specify the number of each design chronologically, beginning in 1826. If the impressed date code symbol is

67

absent or is obscured by the glaze, the year of design can be estimated by consulting the ornamental shape number in the shape books. The production of any individual piece might, of course, have been made years after the design was first entered in the shape books.

5. Artist's mark: It was not the policy for Minton majolica pieces to be marked by the individual artist, except for the most outstanding painters, sculptors, and modelers already noted. Arnoux, Lessore, and Rischgitz signed the Renaissance-style pieces decorated with panoramic scenes. Carrier-Belleuse, Comolera, and Henk carved their names. Protât's monogram or name appears on his work. The designers of some individual pieces are identified in the Minton shape books. Designers of all majolica shown in international exhibitions are listed with each entry in the exhibition catalogues.

1850	1851	1852	1853	1854	1855	1856	1857
1858	1859	1860	1861	1862	1863	1864	1865
1866	1867	1868	1869	1870	1871	1872	1873
1874	1875	1876	1877	1878	1879	1880	1881
1882	1883	1884	1885	1886	1887	1888	1889
1890	1891	1892	1893	1894	1895	1896	1897

Minton date code table

Other identifying characteristics

Most Minton undersurfaces are blue, green, or pink, except for the Palissy-style pieces, which sometimes have a densely mottled blue-brown-black glaze like the sixteenth-century Palissy wares. The undersurface of Minton Renaissance-style pieces may have a mottled yellow and green glaze. Pieces with naturalistic designs may have white, pale pink, turquoise, or blue undersurfaces, but the majority have a rich emerald green.

The unmarked majolica of George Jones is the most likely to be confused with that of Minton, but the undersurface of a Jones piece has its own characteristic mottled green-and-brown glaze. Joseph Holdcroft also imitated Minton patterns, but the undersurfaces of most Holdcroft pieces have an irregular celadon or gray glaze.

One of the special features of majolica is the attention paid to the glaze of the interior surface. In majolica made by the major potteries the interior and exterior surfaces were glazed in contrasting colors. This is a feature that greatly enriches Victorian majolica and that is not characteristic of other ceramic wares. Some interiors of Minton pieces are glazed in blue or turquoise, occasionally green, or, rarely, white. Most, however, are glazed majolica pink. The collector may be curious about what might have determined this choice. Perhaps the answer becomes apparent as one travels throughout the Stoke-on-Trent area in the summer and sees the five-to-six-foot-tall wildflower rosebay willow growing there in great profusion. Rosebay, or *Epilobium angustifolium,* is a plant with tall stalks covered with blossoms the exact color of rose-pink majolica linings.

Chapter 4

WEDGWOOD

Wedgwood, a greatly celebrated ceramic establishment in England from the eighteenth century to the present day, did not enter into production of Victorian majolica until 1860, a decade later than its esteemed rival Minton. Considering the vast experience of Wedgwood in the field of ceramics, it is important to understand that ten-year period, because it reveals the intricacies of the ceramic industry itself.

Nineteenth-century descendants of the "great Josiah," who had founded the Wedgwood pottery in Burslem, Staffordshire, in 1759, believed that Wedgwood had already conquered the mystery of colored glazes. In 1759, in partnership with Thomas Whieldon, Wedgwood wrote of Experiment No. 7 in their *Experimental Book* that he had introduced "a new species of a color'd ware to be fired along with the Tortois-shell [sic] and Agat [sic] ware in our common gloss ovens to be of an even, self-color, and laid upon the ware in the form of a color'd glaze" (Maureen Batkin, *Wedgwood Ceramics,* p. 32). (This green glaze is still in production at Wedgwood, but modern green-glazed plates are lighter weight than the nineteenth-century examples and have less lead content in the glaze.) Wedgwood also made colorfully glazed naturalistic earthenware in the pineapple and cauliflower designs of the Whieldon–Wedgwood era, pieces that Wedgwood continued to produce in the mid-nineteenth century and still makes today.

It seems that from an aesthetic point of view Wedgwood did not, in the 1850s, wish to compete in the race for the production of what a Wedgwood employee termed vulgar and coarse majolica pottery, having seen it displayed by Minton in the London Crystal Palace Exhibition of 1851 and the Paris international exhibition of 1855. From Wedgwood's inception the firm had chosen themes and designs rooted in classicism and had used monochrome decoration with low-relief ornament in contrasting colors. With its precise shapes and elegant two- or three-color motifs, Wedgwood thought it artistically inappropriate to combine its formal shapes with the flamboyant colors and whimsical styles of Victorian majolica.

In addition, a half century of serious administrative and financial difficulties prevented Wedgwood from experimenting with the production of majolica. Wedgwood was almost destroyed in 1811 by lack of family involvement in the firm, and the Napoleonic wars caused further financial damage to the business. By 1828 Wedgwood's London showroom could no longer be sustained. The stock of wares and molds was sold for 16,000 pounds, far less than its true value, a disaster from which the firm was not to recover for many years. On the death of Josiah Wedgwood II in 1843 his third son, Francis Wedgwood, was in control of both the Wedgwood factory and the Etruria estate. The company was in severe financial difficulty, because it had not been managed with the necessary artistic and business initiative. In 1843, in order to reorganize and modernize the factory, Francis Wedgwood sold a half share in the company to John Boyle, who had been associated with Minton from 1836 to 1841. Boyle raised capital by the painful decision to sell the Etruria estate, Wedgwood Hall, and various works of art. In 1844 Francis Wedgwood and John Boyle modernized the plant but, with Boyle's death six months later, Wedgwood sought a new partner. Robert Brown, a successful potter in Shelton with land investments in Staffordshire, was able to work well with Wedgwood. From 1846 to Robert Brown's death in 1859, the two men were equal partners, improv-

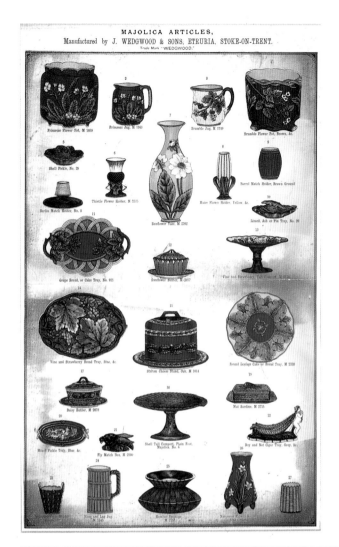

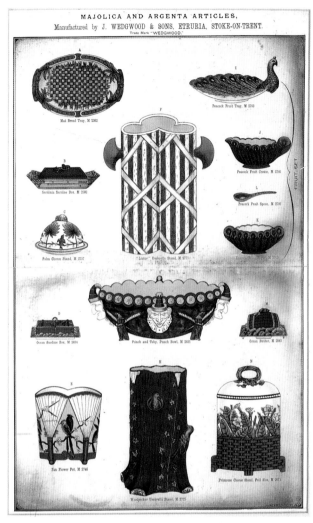

Josiah Wedgwood & Sons.
Pages from a Wedgwood advertising catalogue. c. 1876. Courtesy Trustees of the Wedgwood Museum, Barlaston, Staffordshire, England

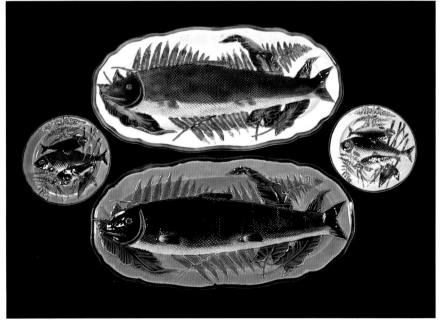

Josiah Wedgwood & Sons.
Salmon trout platters and plates. c. 1879. Platter length 26″. (M2605). Plate diameter 9″. (M2606)

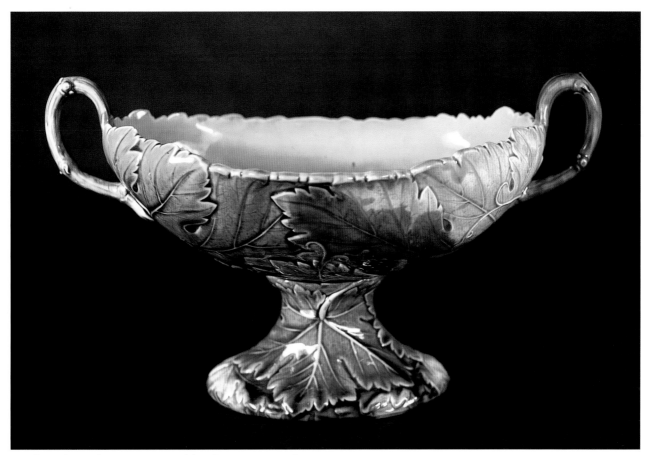

Josiah Wedgwood & Sons. Footed bowl. c. 1860. Height 6″

ing the plant and encouraging the production of new and competitive styles with which to regain Wedgwood's leading position in the ceramic world.

In 1858 Francis Wedgwood appointed his oldest son, Godfrey, to the partnership. In 1863 and 1865 Godfrey's younger brothers, Clement Francis and Lawrence, joined the firm. The increase in creative energy, especially generated by Godfrey Wedgwood as art director, led to the greater production of Parian ware, the revival and further development of jasperwares, and ultimately to Wedgwood's entrance into the field of majolica. As art director Godfrey Wedgwood was able to engage the talents of the ceramic artist Émile Lessore, the botanist and designer Christopher Dresser, the painter and illustrator Walter Crane, the ceramic artist Thomas Allen, and the sculptor Hugues Protât as freelance sculptors and modelers. Italian artists and artisans, because of economic changes in Italy, came to Staffordshire and Etruria for secure employment. Godfrey Wedgwood,

with his associations among the leading artists, was also able to attract the better artists and modelers from the London art and pottery schools.

It now remained for Wedgwood to perfect its knowledge of the production of majolica, and to this end Minton cooperated with Wedgwood. Although during the early years of majolica production Minton guarded its formulas, by the late 1850s Minton shared both chemical knowledge and artistic help. Perhaps this came about because of Léon Arnoux's fraternal respect for Wedgwood's accomplishments. Arnoux had written, in 1855 in an article on ceramics: "The most important article of English ceramic manufacture is, undoubtedly, earthenware, and . . . in this our potters had only to follow the line traced by Wedgwood" (p. 16). Working with Clement Francis Wedgwood, the firm's ceramic chemist, Arnoux was helpful with instructions about firing the special majolica glaze. Indeed, in 1875 his invention, the Minton Patent Oven, was installed in the

extensively modernized Wedgwood factory. Another source of assistance was Émile Lessore, who left Minton for Wedgwood in 1860.

With the confluence, of greater financial stability, more unity of goals, a better staff of artists and potters, and the help of their very competitors, Wedgwood continued to produce excellent majolica well past the close of the century. It is comforting to know that at the time of Francis Wedgwood's retirement in 1870 his three sons and partners were in a position to buy back for the company the Etruria estate, the buildings, and the art works that had been sold after the death of Josiah II. A private family agreement was reached in order to try to safeguard the future of the company and to avoid the apathy and mismanagement of Josiah II's era. Each partner was allowed to introduce as his successor one son, who was at least twenty-three years old and had worked in the company for at least three years.

Wedgwood majolica is often compared with that of Minton. Minton created extravagant "palace" or fantasy pieces such as the thirty-six-foot-high Saint George and the Dragon fountain, or seventy-two-inch-tall jardinieres to be used in royal residences and in large country houses. Wedgwood pieces also included giant fountains and large urns, with excellent design and modeling, but they were not quite so dramatic. The comparative adjective "better" is hard to assign in an absolute degree. Jewitt wrote: ". . . it is necessary to state that the true Italian majolica [sic], as well as Minton's reproductions, were made with a coarse cane-coloured body and decorated with opaque enamel colours; but that Wedgwoods [sic] were the first to use a white body and transparent coloured glazes. By this process much greater brilliancy of effect is produced" (p. 531). Whatever the glazing technique, both factories produced perfectly painted pieces, with no glaze running outside of its appointed design area. As for modeling, some collectors and/or authorities consider Minton technique to be finer and Minton designs to be more innovative. Despite these points of comparison, Wedgwood majolica has many devotees. In the American publication *Crockery and Glass Journal,* an unnamed writer reviewing the 1878 Paris exhibition said, "In majolica, Mintons exhibit the largest pieces, but Wedgwood's colors are the most brilliant and pure. . . . on the whole, Wedgwood's is superior to anything in the majolica class, and although the pieces are not so large the colors are unapproached, and the execution of their work is unsurpassed." Recognition has recently been awarded by the members of Wedgwood societies, who have added pieces of Wedgwood majolica to shelves already filled with meticulous Wedgwood jasperware, black basalt, and the gossamer fairyland lustre.

Wedgwood ornamental majolica had several antecedent and contemporary examples. Monochrome dipped wares—including green, Rockingham-brown, and mazarine-blue glazes—spanned the firm's production from the end of the eighteenth century into the 1860s. Wedgwood's Vigornian ware—pieces glazed with Rockingham brown or mazarine blue and then etched or engraved with naturalistic designs—was popular in the 1870s. Mottled wares, in browns, blues, greens, and yellows, were direct descendants of eighteenth-century Whieldon-Wedgwood designs. Many of the handsome mottled majolica pieces of the 1860s and 1870s, such as tankards and biscuit barrels, were combined with pewter tops and other metal ornamentation. Mottled glazing was also combined with majolica designs and used especially in the centers of serving platters.

A study of the Wedgwood majolica pattern books, which are in the keeping of the Wedgwood Museum in Stoke-on-Trent, gives the reader excellent insight into Wedgwood's majolica designs and glazes. The three large pattern books (eighteen by twenty-four inches) are striking in the simplicity of their early records, but the later entries are works of art in themselves. Early notations are brief and unillustrated, and give only the pattern name and number. Later entries list the name of the pattern and include a delicate watercolor painting, with full description of the modeling and color of glazes used, as well as the pattern number and patent number. Each patent number certificate is beautifully printed and illustrated with a sketch of the object. Book I, from 1867 to 1876 (recording designs from No. 1 to M1863), contains few pieces specifically of majolica, and most striking of these are the Caterer Jug (#674, 1867) and the Seahorse Jug (#1055). Book II (1876–1888, with numbers M1684 to M3385) shows the influence of the Aesthetic Movement in the Sunflower pattern and the more formal Luther pattern, with its panels of geometric designs alternating with floral bouquets in large vases. Another pattern in Book II, which echoes the mottled

and monochrome glazes of the Whieldon-Wedgwood era is *Pecten japonicum:* large scallop-shell plates, tazzas, and compotes in monochrome green or mottled green-and-brown glazes. The third pattern book, from 1888 to c. 1896, indicates that Wedgwood added new designs and continued old ones as well (K3484 to K4189). The important Protât ewer and the Protât jardiniere (#M1684) are recorded in Book II, complete with the HP monogram, for Hugues Protât. Not only did few artists sign a piece of majolica, but Protât was one of the rare artists who had signed pieces for both Wedgwood and Minton.

It is in the latter two pattern books that Wedgwood gives full expression to majolica strawberry dishes, fish and lobster and shell patterns, fruit plates luxuriously evocative of the taste of the fruits, vegetable and salad bowls with servers, game-pie dishes, and cachepots. Wedgwood majolica fulfilled many and varied roles in both the dining room and the greenhouse. Complete dinner and dessert services, tea and coffee services, as well as more specialized services for fish and lobster salad were used to stage colorful Victorian banquets. Serving pieces included pitchers, bread trays, butter dishes, butter pats, sardine boxes, game-pie dishes, oyster barrels, salad bowls, cheese bells, ice-cream services, punch bowls, tazzas, and compotes. Tall polychrome ewers, first modeled in black basalt by the renowned sculptor John Flaxman (1755–1826), were specifically designed for water or wine: the water ewer was decorated with a water sprite and swags of sea grass; grape-leaf swags and a fruit-laden figure of Bacchus ornamented the wine ewer. Other ewers were shaped as helmets (#1415). Candlesticks lit up mantelpieces, ring stands adorned dressing tables, and cigar stands served the master of the house. Garden seats, fountains, urns, vases, cachepots, and umbrella stands completed the Wedgwood majolica inventory. (Wedgwood majolica may be seen at the Nassau County Museum System, Sands Point, New York.)

Many Wedgwood patterns were copied by lesser majolica manufacturers both in England and America, but the Wedgwood pieces were more sharply modeled and more brilliantly and carefully glazed. Familiar naturalistic patterns include Aster, Bird and Fan, Blackberry Bramble, Butterfly and Sprig, Cattails, Cauliflower, Chrysanthemum, Daisy, Dolphin, Dragon, Fern and Bamboo, Fruits, Garland, Geranium, Gypsy, Ivy, Lotus, Maize, Maple Leaf, Morning Glory, Narcissus, Oak Leaf, Palm, Pansy, Partridge, Passion Flower, Pineapple, Pond Lily, Primrose, Sea Life, Shell and Seaweed, Sunflower, Thistle, Thorn, Tiger Lily, and Vine and Strawberry. Other patterns include Alaska, Boston, Brachen, Caterer, Chicago, Classical, Doric, Early English, Elizabethan, Grosvenor, Mayo, Peacock, Raleigh, Reed, Rosette, Rustic, Saint Louis, Sutherland, Trentham, Tunbridge, Versailles, and Volute. Although records indicate that a large quantity of Wedgwood majolica was manufactured, and that by 1870 majolica outnumbered other Wedgwood ornamental wares, surviving examples of each individual pattern are surprisingly rare.

Wedgwood majolica of the 1860s and 1870s had brightly glazed blue, green, yellow, or brown backgrounds with carefully modeled motifs. Wedgwood artists also combined several different techniques, such as embellishing a base of celadon drabware with majolica designs, or filling the centers of majolica plates with dramatic animal paintings from transfer prints. Shapes of Wedgwood majolica, easily identified by Wedgwood collectors, were frequently the same traditional shapes used for other types of ornamental Wedgwood, although majolica pieces including *amorini* or Punch and Toby figures are quite whimsical.

STYLES AND SHAPES

Wedgwood, like Minton, took inspiration for its majolica wares from Palissy designs, from nature, from oriental and Egyptian motifs, and from mythological and historical figures. Some designs are one of a kind; some pieces fall into more than one category; and others are best defined by a particular decorative technique—for example, Émail Ombrant and Argenta ware.

Palissy style
Wedgwood's marine designs include crustaceans or fish on a bed of seaweed or ferns suggestive of Palissy's renderings of sea creatures, snakes, insects, and foliage modeled in high relief. Wedgwood's designs in a modified Palissy mode, however, were more formally handled and were modeled in low relief. Wedgwood also used Palissy's cobalt-blue ponds and, in appropriate instances, undulating rims of platters evoking the motion of waves.

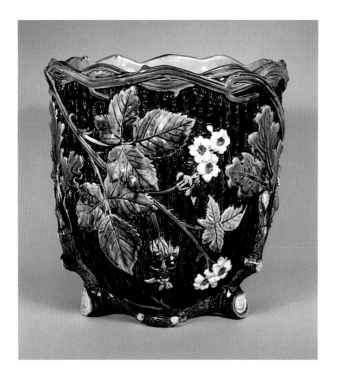

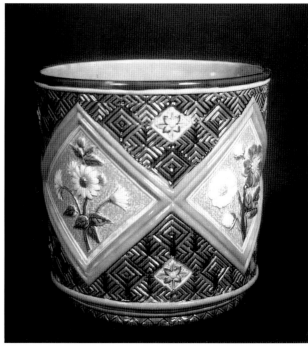

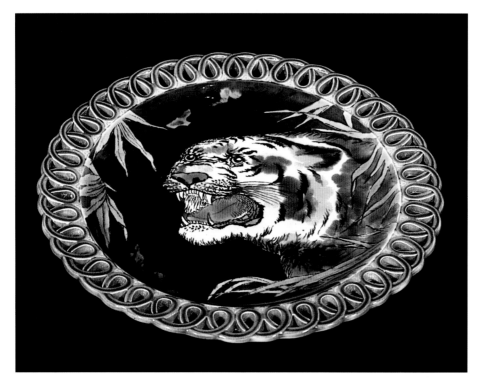

On a salad bowl (#2916, 1884) and accompanying plates in the Crustacea pattern, red and gray lobsters garnished with vegetables float in a cobalt-blue sea. Another piece in the Palissy mode is a fish platter twenty-six inches long (#2605, 1879) presenting a realistically modeled and glazed salmon trout on a bed of ferns and sea grasses. The accompanying plates (#2606) matched to the turquoise, cobalt, off-white, gray, or brown background of the platter are decorated with a trio of small trout.

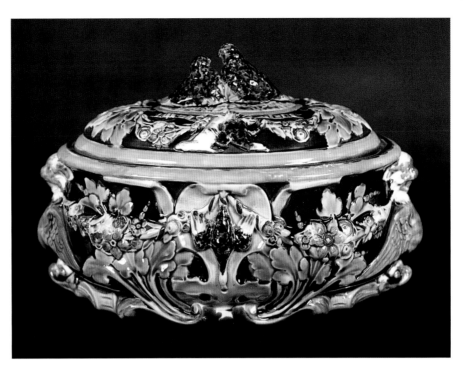

Josiah Wedgwood & Sons. Game-pie dish. c. 1874. Length 13″

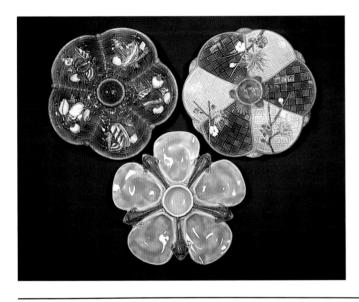

Josiah Wedgwood & Sons. Oyster plates. 1878. Shell pattern, diameter 9¼″; Prunus pattern, diameter 9½″; Dolphin pattern, diameter 9¼″

Naturalism

A wide variety of flowers, vegetables, fruits, and land and sea creatures embellished Wedgwood's majolica for the Victorian dining room and parlor. Primroses, black-berries, pineapples, and hops decorated cheese bells, plates, graduated pitchers, tiles, flower boxes, and cachepots. Strawberry blossoms and leaves appeared on serving dishes (#M2652) and plates. Flowers on a geo-metric background are dramatic on a cachepot. Black-berry bramble patterns are on cachepots glazed in cobalt, cream-colored, or brown (#2126, 1868).

Blue or brown game-pie dishes in graduated sizes sported rabbit or partridge finials. The most ornate Wedgwood game-pie dish, in graduated sizes and on a brown background, has a finial portraying a pair of lovebirds (c. 1874).

Naturalism was also celebrated in a series of nine-inch majolica plates, with reticulated borders surrounding the skillfully painted scenes of hunting dogs and birds, or heads of animals, such as tigers, rams, bulls, dogs,

75

wolves, horses, all in outdoor settings. These central figures were also used on tiles. Colors are vibrant and true to life. Tazzas were part of each set of twelve assorted plates. Émile Lessore did much of the outlining and painting of the plates in majolica glazes, and he was assisted by other artists, notably Henry Brownsword.

From the sea world came the dolphin, symbol of friendship. These appeared on a series of oyster plates or entwined to form the base of double-dolphin centerpieces (c. 1865). Wedgwood also created nautilus-shell compotes and graduated pitchers with the body in the form of a large snail shell (1870). A great variety of oyster plates included chrysanthemum, oyster, shell, Ocean, and oriental patterns to match Wedgwood's fish series. On an ice-cream service (#2831, 1883) brown otters cavorted in a green-and-white sea.

Mottled green-and-brown glazes were used on plates, tazzas, and compotes modeled as large shells.

A special category of naturalistic Wedgwood earthenware, which was a precursor to majolica, was glazed in monochrome green. In the shape of dessert plates, tazzas, and compotes, these pieces were decorated in a variety of patterns featuring leaves and berries in low relief. The examples made between 1850 and 1860 are considered, as discussed in the Wedgwood section of Chapter Two, transitional pieces between Wedgwood's eighteenth-century green-glazed ware and the firm's Victorian majolica.

Garden seats produced by Wedgwood are not as ornate as those by Minton, but one design is a humorous interpretation of a lady's boudoir bench. The garden seat is a cobalt tufted "cushion" supported by four legs shaped like tree limbs (#1614).

Oriental and Egyptian styles

Wedgwood artists drew on the familiar vocabulary of oriental motifs such as prunus blossoms, bamboo, fans, monkeys, dragons, and chrysanthemums. Wedgwood's Bird and Fan pattern (1881) was frequently copied by other potteries on both sides of the Atlantic. The pattern is composed of upright fans creating triangular positive and negative spaces. Between the fans are birds and prunus blossoms. A branch forms the curved handle of the pitchers, teapots, and creamers. With backgrounds of cream, turquoise, or cobalt, Bird and Fan decorated small and large bowls (#2788), graduated pitchers

(#2762, the largest and rarest sixteen inches tall), butter dishes and butter pats, platters, compotes, dinner services, tea services, cheese bells, cachepots, urns, and garden seats. The most unusual Wedgwood oriental design, executed by Hugues Protât in the early 1870s, was the Fire Dragon, displayed on teapots (1872), candlesticks, and cachepots.

Because of Josiah Wedgwood's interest in ancient Egyptian art and the Napoleonic campaign in Egypt in 1798, followed by the discovery of the Rosetta Stone in 1799 during the time of Josiah II, Wedgwood artists had long produced pieces in the Egyptian mode. Egyptian motifs in Wedgwood's Victorian majolica include a sphinx design used on candlesticks, vases, and window props. An inkstand (twelve inches long) in the shape of a barge, was decorated with hieroglyphics and included the inkpot in the form of a canopic, or funerary, urn. These pieces, because of their black glaze, resemble Wedgwood's black basalt and, indeed, many of the shapes used for that earlier Wedgwood ware were used again for majolica. Tablewares made about 1875 in the Egyptian style included tankards, sugar bowls and creamers, jam pots, sugar casters, and knife handles, in a green-and-brown mottled glaze and with plated mounts made by T. Harwood of Birmingham.

Figural pieces: human and mythological

Some of the most whimsical figural pieces in Wedgwood majolica are jewel stands. One such stand—which forms the lid of a jewelry box—incorporates a graceful medieval princess with a tall pointed cap. Her long train carried by two small pages creates a shallow dish to hold rings and other jewelry. A similarly shaped figural piece (1869) portrays a *putto* dragging a fishnet over a rocky base. Often considered a ring stand, it is illustrated in a Wedgwood catalogue of 1876, where it is titled Boy and Net Cigar Tray. (In the nineteenth century a given model of a majolica piece could be assigned several different functions.)

Patterns incorporating *amorini*, satyrs, and tritons are reminiscent of Carrier-Belleuse, and it is in these that Wedgwood majolica most resembles that of Minton and George Jones. Forsaking traditional Wedgwood shapes, the factory produced candelabra, compotes, spill vases, and flower holders embellished with mythical figures. The plates of some of the figural compotes match several

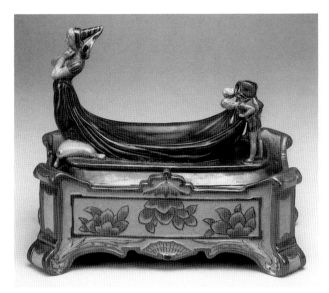

Josiah Wedgwood & Sons. Toilet box with jewel stand. 1872. Length 9½". (No. 1203). Courtesy Sotheby's, New York

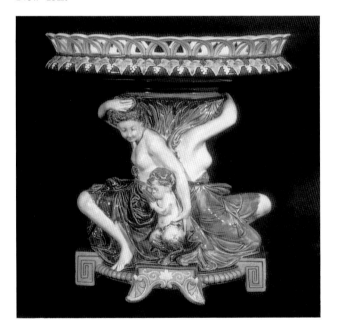

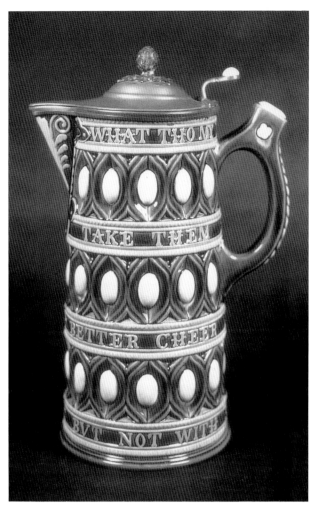

Josiah Wedgwood & Sons. (Frederick Bret Russel). Caterer jug. c. 1867. Height 11". (No. 676)

Left: Josiah Wedgwood & Sons. Compote. 1872. Height 13¼"

of Wedgwood's dessert-plate patterns. Another unexpected Wedgwood design is a lady riding a sea serpent, as the central motif on a charger. The border is ornately decorated with dolphins and stylized flowers.

A theme that is also seen in George Jones's work is depicted in Wedgwood's Punch and Toby punch bowl (#2631, 1878). Beneath a scalloped rim decorated with yellow lemon slices are four representations of Punch in high relief. Punch's dog Toby, in quadruplicate, supports the bowl. This pattern is much more grotesque and humorous than is usual in Wedgwood design. A covered sugar bowl and creamer, complete with Toby finials, are glazed in similar colors on a turquoise background.

Inscribed pieces
Inscriptions were rare on Wedgwood majolica, and indeed on any majolica. The names "Washington" and "Lincoln" appear on Wedgwood jugs with medallions

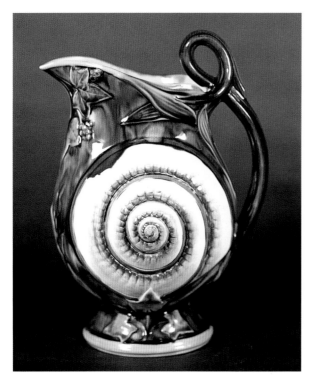

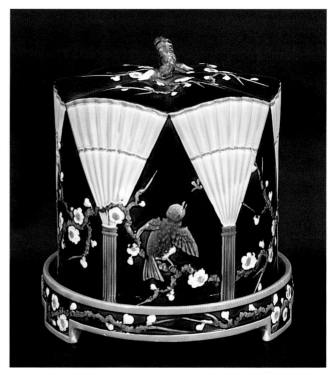

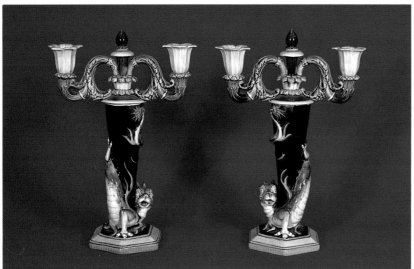

Above, left: Josiah Wedgwood & Sons. Shell jug. c. 1878. Height 8½"

Above: Josiah Wedgwood & Sons. Cheese bell. c. 1881. Height 12"

Left: Josiah Wedgwood & Sons. Candlesticks. c. 1872. Height 11½"

honoring those American presidents. The jug was made in graduated sizes and a variety of colored glazes.

A longer inscription is found on the Caterer Jug designed by Frederick Bret Russel. This jug, too, was produced in graduated sizes, a variety of color combinations, and with or without a pewter lid. The stalk of grain on the handle reflected the jug's use in taverns. The surface of the jug is well modeled in Flemish style with a geometric pattern interrupted by four spaced bands

declaiming: "WHAT THO' MY GATES BE POOR/TAKE THEM IN GOOD PART/BETTER CHEER MAY YOU HAVE/ BUT NOT WITH BETTER HEART."

Émail Ombrant

A very different type of Wedgwood majolica was known as Émail Ombrant. In Émail Ombrant the design is cut into the body of the clay in graduated intaglio depressions. The intaglio design then is flooded with a translu-

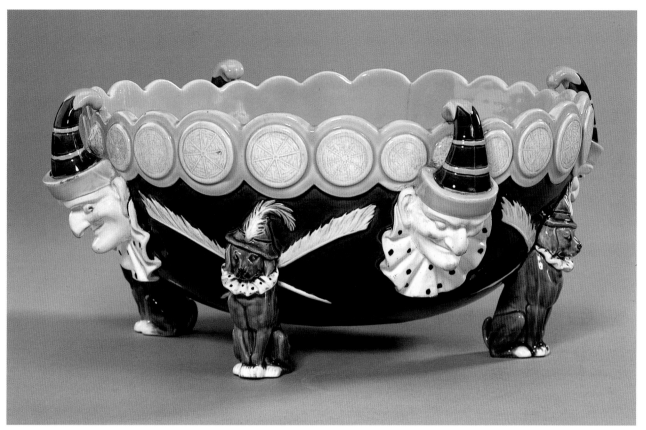

Josiah Wedgwood & Sons. Punch and Toby bowl. c. 1878. Diameter 11¾″. Courtesy Trustees of the British Museum

cent majolica glaze. The deeper cavities form the darker areas of the design, while the shallower depressions produce the highlights and outlines of the figures. The most frequently used glaze was green, but gray and blue pieces were also produced. (Émail Ombrant is an opaque variation of lithophane intaglio on semitransparent porcelain on which the design was revealed by transmitted light.)

The Musée des Arts Décoratifs, in Paris, has an excellent collection of French examples of Émail Ombrant, consisting of plates, jugs, and compotes. Baron Alexis du Tremblay of the Rubelles porcelain works near Melun developed Émail Ombrant and patented the technique in 1842. The Rubelles dessert and tablewares exhibited at the 1851 Crystal Palace Exhibition in London were awarded a gold medal and Wedgwood became interested in the process. Wedgwood was able to obtain some of the prize-winning wares, and experimented with making its own variations. In the early 1860s the modelers Rowland Morris, Thomas

Greatbach, and Hamlet Bourne were responsible for perfecting Wedgwood Tremblay ware and by 1864 pieces were sold through Thomas Goode and Company in London. In 1872 the original Rubelles molds and designs were put up for sale, because the owner of the Rubelles factory, Jules Hocédé, son-in-law of the deceased baron, had not been successful and the factory had been inactive for eight years. Henry Brownsword, Émile Lessore's renowned design assistant, inspected the molds and Alfred Lessore, a solicitor and the son of Émile Lessore, arranged for the purchase. Wedgwood obtained by this transaction over 2,500 molds and designs, the formulas for the Émail Ombrant glazes, and the original patent, for 3,200 francs. Considering that the original cost to the baron du Tremblay was 8,000 francs, the deal was spectacularly favorable for Wedgwood.

Series of Tremblay dessert plates (c. 1870) have combinations of reticulated or butterfly-design borders, with center designs of fruit or scenic views. Some of these decorated plates are octagonal, with characteristic

79

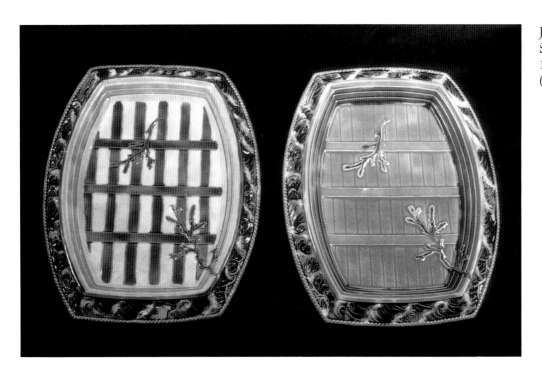

Josiah Wedgwood &
Sons. Bread trays.
1880. Lengths 12½".
(Nos. 2905 and 2906)

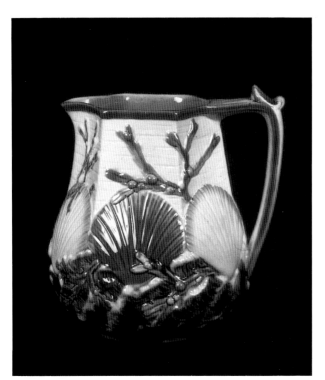

Josiah Wedgwood & Sons. Jug. 1879. Height 7½".
(No. 2936)

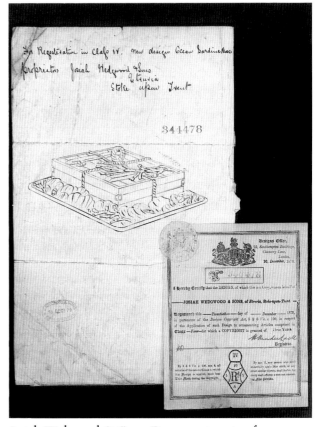

Josiah Wedgwood & Sons. Patent registration for a
sardine box. 1879. Courtesy Trustees of the Wedgwood
Museum, Barlaston

Wedgwood modeling around the periphery, illustrating the combination of techniques of two venerable factories. Since Wedgwood used both the original Tremblay molds and the others developed by Wedgwood artists, identification of French or English examples can be made only by the marks "WEDGWOOD" or "Rubelles, s. & m." in an oval, or the full mark "Fabrique de Rubelles (S. & M.) Brevet D'Invention. S.G.D.G. Pat. 89, St. Denis, Paris."

Argenta ware

Argenta ware, first made in 1878, was the last important majolica Wedgwood designed. In contrast to the vibrant color of earlier Victorian majolica, Argenta patterns were displayed on white or pale backgrounds. The backgrounds of some Argenta patterns were also glazed in rich majolica colors such as turquoise or, rarely, cobalt. Just as Thomas Whieldon and Josiah Wedgwood felt that their market, surfeited with tortoiseshell and agate ware, was ready for the brilliant clarity of the green-glazed earthenware, in 1878 the Wedgwood firm again anticipated new directions. Charles Backhoffner, Wedgwood's London manager, reported that at the Paris exhibition of 1878 little majolica was displayed in the English and French sections. He advised Wedgwood to change its decorative style in color, shape, and design; to modernize and modify to gain a new market. Perhaps this change was also brought about in part by the recent retirement and death in 1876 of Émile Lessore, a much more classical artist. The result was a new style of decoration—incorporating flowers, animals, birds, and oriental and marine motifs—that was in keeping with the Aesthetic Movement.

Argenta shell and seaweed patterns with pale backgrounds were popular enough to merit two individual designs. Confusion may arise because the Wedgwood pattern books used two different names (Shell and, later, Ocean) for the first of these two shell and seaweed patterns. According to the Wedgwood Museum, Shell and Ocean were not formal pattern names but were merely descriptive terms used by the artists. Collectors today usually favor Ocean rather than Shell as the pattern name for the first of the two Wedgwood shell and seaweed patterns. It is this Ocean pattern that influenced not only many British copies but also the most famous of all American majolica designs: Griffen, Smith and Hill's

Shell and Seaweed. The Wedgwood Ocean pattern (#2945, 1879) included plates with a scallop shell in low relief forming the entire center (#2941), garnished with a sprig of seaweed and surrounded by waves on the rim of the plate. In different services the shell was decorated in a variety of colors, including bright yellow, crimson, and lavender. An array of matching graduated pitchers (#2936) was produced in the same Argenta background, or in turquoise or cobalt blue. The Ocean pattern also decorated large oval serving platters, rowboat-shaped bread trays (#2906), sardine boxes, butter pats, butter dishes, and tea services (#2963). A matching salad bowl with servers has a silver-plated rim. Oyster plates, in a rare triangular, lobed shape, decorated with coral and seaweed on a solid background, are also part of the shell and seaweed services.

The 1880 Argenta shell and seaweed design is much bolder. Large, well-modeled, and brilliantly colored shells—including mollusks, scallops, cowries, and conchs, interlaced with kelp and seaweed—rest on a straight-edged oval platter (#3054) with a basket-weave ground glazed in off-white or turquoise. Accompanying plates (#3062) have a similar central motif.

Other Wedgwood Argenta ware patterns—most of them also on either off-white, turquoise, or cobalt backgrounds—include Bird and Fan (1879), Sunflower (#3187), Palm (1879), Fruit, and Saint Louis (c. 1880). The Sunflower pattern—which reflects the quintessential sunflower and lily motifs of the Aesthetic Movement—is seen on pitchers of graduated sizes, plates, and umbrella stands. The Palm pattern is quite rare; a cheese bell, plates, and a bread tray (#2174) in that design are the best known examples. The finial of the cheese bell is in the form of a small elephant (#2757). The Fruit pattern (#2013, 1879) with different fruits modeled on each plate of a set of eight, is particularly striking. This pattern, on a basket-weave background, was used on nine-inch plates (a size rarely seen in majolica), on six-and-three-quarter-inch plates, and on compotes. The Saint Louis pattern (1882), with an oriental design of bamboo stalks and stylized chrysanthemums on white, blue, or celadon backgrounds echoes the Aesthetic Movement. Strawberry services, salad bowls, cheese bells, umbrella stands, and garden seats are the most distinctive pieces in this pattern.

Animals are rare in Argenta patterns. A Monkey

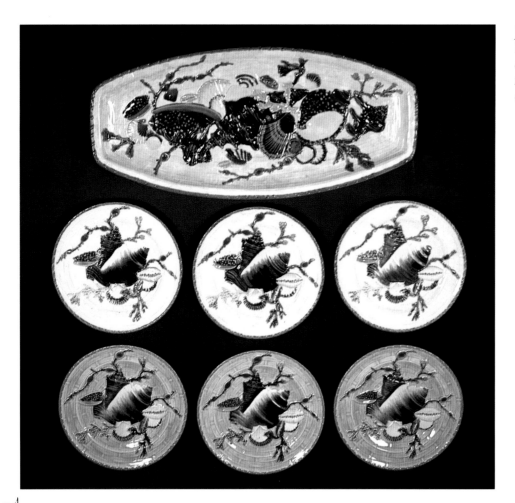

teapot (c. 1885) has the monkey climbing rather stiffly onto the branch of the teapot handle. In another piece (c. 1880), an ungainly monkey supports a bowl, which is decorated with leaping simians.

A graceful, whimsical example of Argenta ware is the Kate Greenaway pattern (1881), characterized by backgrounds simulating the plaited straw of the storybook illustrator's famous hat. An umbrella stand is embellished with a ribbon and a vibrant peacock feather (#3036).

The Athletic Jug (#2836, c. 1885) is an Argenta piece designed by Charles Toft, Wedgwood's principal figure modeler. It is one of the few Wedgwood pieces with human figures modeled on the body; one side portrays two boys playing cricket and the other side, two boys playing soccer. The top of the jug is decorated with mantling; the bottom with geometric motifs. This jug was the inspiration for one of the best pieces made by Griffen, Smith and Hill, who substituted American boys playing baseball and soccer.

82

WEDGWOOD ARTISTS

Émile-Aubert Lessore (1805–1876), the foremost Wedgwood artist, was born to a father who expected his son to follow him in the legal profession. His artistic talent, however, led him to study with Ingres and he exhibited his first picture in 1831 at the Paris Salon. From then until 1851 he continued to profit both professionally and financially from his work. In the late 1840s, at the factory of Laurin near Paris, he learned the technique of painting on ceramics. In 1851 Lessore joined the Sèvres factory and from that time worked to create new techniques of painting on porcelain. Jewitt wrote (p. 534) that because Lessore's work was so original, he caused a division among the artists, and the ensuing disputes led Lessore to leave Sèvres. In 1858, following the death of his wife, he traveled to London.

After six months of freelancing, Lessore was employed by Minton, where he struck up a friendship with

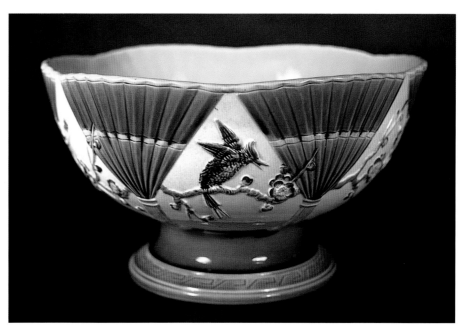

Josiah Wedgwood & Sons. Bowl. 1881. Height 6¾″. (No. 2788)

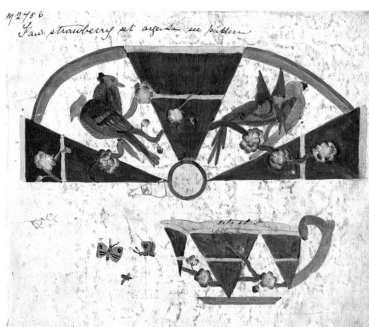

Josiah Wedgwood & Sons. Design from a Wedgwood pattern book. Courtesy Trustees of the Wedgwood Museum, Barlaston

another French ceramic painter, Edward Rischgitz. Lessore's year with Minton was not without tension. This time his quarrel was not with his co-workers but with the Minton method of close surveillance and rigid specifications for his work. This was nevertheless a productive year and Lessore became involved with majolica glazes and painting in the Renaissance style.

In the spring of 1860 Lessore transferred to Wedgwood, where, according to Jewitt, "Wedgwood . . . thor-oughly appreciated his talents and his loyal, sympathetic character" (p. 536). Lessore's pieces were awarded medals in the exhibitions of 1862 in London, in Paris in 1867, and in Vienna in 1873. He revolutionized the decoration of pottery and the results were considered more aesthetically pleasing than other painted ceramic wares of his day.

At Wedgwood Lessore benefited from greater independence and from his good relationship with Clement

83

Francis Wedgwood. The two men worked closely to perfect majolica glazes. In this benign atmosphere Lessore was also able to introduce his own style of painting. His work on pottery was more artistic and more delicate than was usual, as if it were intended for a painting on canvas. He founded a school of decorative art pottery at Etruria, enhancing Wedgwood's knowledge both of modeling and of glazing techniques. He augmented the usual classic style of Wedgwood with motifs influenced by the paintings of the eighteenth-century French artists Jean-Antoine Watteau and François Boucher. Lessore's innovative artistic faience was decorated with pastoral scenes, cupids, and figures, which often almost entirely covered the surface.

By 1863 Lessore was no longer able to tolerate the cold, damp Staffordshire climate. A mutually beneficial agreement was reached whereby Lessore worked at his studio in Marlotte, near Fontainebleau, during the winter and in London during the summer. His summer commitment included operating the Wedgwood showroom in London and spending ten days each month at Etruria. He greatly influenced both design and production. In 1864 the *Art Journal* reported that Lessore had designed a "full dinner service in majolica of unique pattern with figures and foliage on the rim [which] . . . will no doubt prove very successful."

In 1865 and 1866 Lessore worked with Clement Francis Wedgwood in an attempt to re-create the ruby lustre of the Renaissance. Lessore also worked independently and built a reduction kiln in his home in France, but neither Lessore nor Wedgwood was able to reproduce ruby lustre as fine as that of Maestro Giorgio during the Renaissance. The formula remained a mystery, despite the increased chemical knowledge and the more modern production skills of the finest Victorian ceramic artists.

The year 1867 brought other disappointments to Lessore. New Wedgwood production and new styles of pottery decreased the demand for Lessore's work. Although both Wedgwood and Lessore were reluctant to restructure their relationship, by 1869 Lessore worked at Etruria in a very limited fashion. Lessore's children, Jules and Thérèse, however, were involved with Wedgwood and decorated pottery at Etruria. Lessore and his friend Hugues Protât visited the 1871 London exhibition, in which both artists were represented. Correspondence between Lessore and Godfrey Wedgwood indicated that their friendship continued harmoniously until Lessore's death in 1876. During his last years Lessore returned to his oils and watercolors, writing to Godfrey Wedgwood that he regretted that he had neglected Wedgwood "for more easy works, untouched by my old enemy, the fire!" (Batkin, p. 53).

Other Wedgwood ceramic artists known for their work in majolica include Henry Brownsword, Christopher Dresser, and Frederick Bret Russel; the modelers Hugues Protât, Hamlet Bourne, Joseph Theodore Deck, Joseph Birks, and Charles Toft; and the ceramic painter and designer Thomas Allen.

Henry Brownsword (c. 1825–1892), in addition to his position as a ceramic painter, became Lessore's invaluable assistant and liaison with Wedgwood. He was responsible for tracing and painting Lessore's designs on many tableware services. By 1863, when Lessore was in France much of the time, Brownsword's visits to him there became more frequent. He encouraged the ailing Lessore to continue his work and assisted him in the painting of Wedgwood pottery. After Lessore's death, Brownsword continued to paint at Wedgwood, through the 1870s.

Christopher Dresser (1834–1904) brought his botanical knowledge to new designs for Wedgwood (1865–1868), including floral patterns for majolica. Dresser also created new shapes for Wedgwood majolica, and, as an independent artist, worked for Minton as well. It was in the last quarter of the century that Dresser became most renowned for his work not only in pottery but also in metalwork, wallpapers, glass, furniture, and textiles reflecting the Aesthetic Movement.

Little is known about the artist Frederick Bret Russel, who designed a number of majolica pieces for Wedgwood in the late 1860s, among them the Caterer Jug and the Flowering Rush Jug. Some of his pieces bear his impressed monogram on the undersurface.

Hugues Protât (fl. 1843–1875), an innovative sculptor and modeler, had begun his career in majolica design in 1855 at Minton's, where he replaced Carrier-Belleuse as chief modeler. After 1862 Protât moved to London and established a successful design studio. He did freelance work for Wedgwood during the 1860s and 1870s, collaborating on some pieces with his friend Émile Lessore. Protât was responsible for the dramatic orientalizing

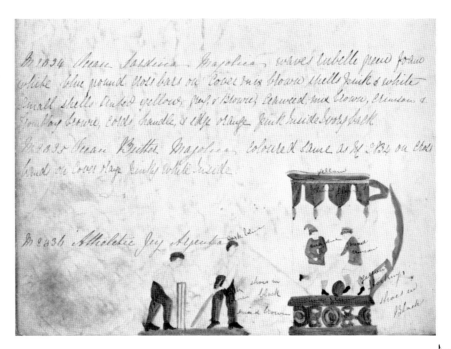

dragon pattern on a flowerpot (c. 1870), a tea kettle (1872), and a pair of candlesticks for Wedgwood.

Hamlet Bourne, a pupil of Hugues Protât, also worked first at Minton and then at Wedgwood in the mid-1860s, where he modeled Tremblay wares in the Émail Ombrant technique.

Joseph Theodore Deck (1823–1891), an important Wedgwood designer and modeler, worked at Etruria from the late 1860s to the 1870s. He was responsible for the series of dessert plates with reticulated borders surrounding low-relief designs of birds in natural settings (c. 1870).

Joseph Birks was a modeler at Wedgwood from 1867 to 1875. One of his best-known pieces is the large Blackberry Bramble cachepot (1868), with a cobalt-blue, brown, or cream-colored background. The cachepot as well as a graduated series of pitchers in the same pattern have been copied by unknown potters, both English and American.

Charles Toft (1832–1909), born in Stoke, enjoyed an outstanding career at Minton in the 1860s and 1870s. He was the principal figure modeler at Wedgwood from 1877 to 1888. In 1885 he modeled the Argenta Athletic Jug.

Thomas Allen (1831–1915), a ceramic painter and designer who had studied at the Potteries School of Design in Stoke and at the South Kensington School of Design, worked at Minton from 1854 to 1875 as a flower and figure painter. He then joined Wedgwood, where he remained until 1906. Allen worked as art director and chief designer until 1900 and furthered the productivity and artistic accomplishments of Wedgwood. With the increased production of tablewares and tiles, Allen helped to assure Wedgwood's security at the close of the century.

In the 1870s Wedgwood produced more majolica than any other ornamental ware, and majolica continued to be a major factor in the firm's output in the 1880s. Wedgwood suffered at the end of the century because of changing demands of the domestic market. Also, with the concurrent economic and political upheavals due to the Boer War in South Africa and the Spanish–American War, the Wedgwood staff was depleted and the export markets were curtailed.

In 1904 an energetic new art director, John Goodwin, realizing that the public was ready for a return to Wedgwood's more classical patterns, re-created the eighteenth- and early nineteenth-century shapes and decoration for the twentieth-century market. Gone were the lavish ornamental styles of the Victorian era. Old molds were destroyed. Wedgwood produced very little majolica after 1910, and no new majolica patterns were introduced. An earthenware pattern (not majolica) similar to

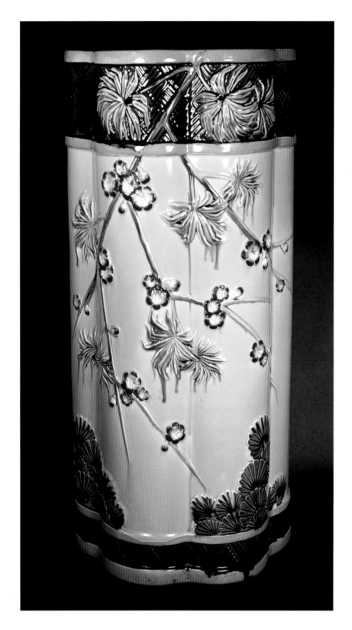

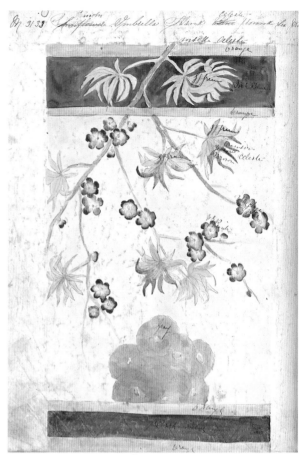

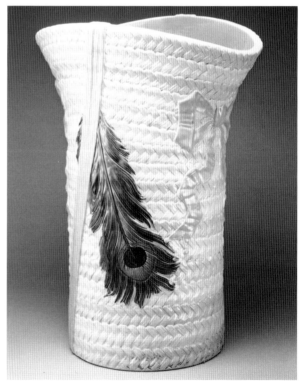

Above: Josiah Wedgwood & Sons. Umbrella stand. c. 1880. Height 22″. (No. 3133)

Above, right: Josiah Wedgwood & Sons. Design from a Wedgwood pattern book. Courtesy Trustees of the Wedgwood Museum, Barlaston

Right: Josiah Wedgwood & Sons. Umbrella stand. 1881. Height 21¾″. (No. 3036). Courtesy Sotheby's, New York

the "great Josiah's" Cauliflower of the late 1750s was introduced in 1920, however, under the name Etruria, harking back to the eighteenth-century green-glazed ware that had been a Wedgwood forerunner of Victorian majolica. Wedgwood remained strong in the next decades. In November 1986 the firm was bought by the Waterford crystal company, thus creating a virtual worldwide tabletop monopoly, under the name Waterford–Wedgwood.

WEDGWOOD MARKS

Wedgwood majolica marks include WEDGWOOD, impressed, sometimes obscured by excess glaze. The British registry mark appears on many, but not all, pieces of Wedgwood majolica. The Wedgwood date code letters, adopted in 1860, were also impressed on the undersurface—indicating the month and year of production of each individual piece—and the potter's mark. In 1871 Wedgwood began to add prefix letters to new pattern numbers. An impressed "M" signified majolica produced between 1873 and about 1888. An impressed "K" indicated majolica made from 1888 to about 1920. "Q" was used for tiles printed with majolica glaze, about 1884. Many pieces are also marked with red or black numbers designating the pattern-book number, with a letter indicating the identity of the painter. If different examples of the same design bear different pattern numbers, this designates a variation in the glaze colors. Some pieces are impressed with the mark of the designer.

WEDGWOOD CODE LETTERS FOR THE YEARS OF MAJOLICA PRODUCTION

A code, consisting of three capital letters impressed on the undersurface of the ware, was introduced at Wedgwood in 1860 to indicate the date of production of earthenware. In 1907 a number denoting the cycle (used with the year letter) replaced the month letter in the date mark. Before 1907 the date marks must be used in conjunction with the pattern numbers and other distinguishing features to determine the cycle of the year letter.

The first code letter indicates the months, until 1907.

	1860 to 1863	1864 to 1907
January	J	J
February	F	F
March	M	R
April	A	A
May	Y	M
June	T	T
July	V	L
August	W	W
September	S	S
October	O	O
November	N	N
December	D	D

The second code letter was the potter's mark.

The third code letter indicates the year.

Years	1st Cycle	2nd Cycle	3rd Cycle
A		1872	1898
B		1873	1899
C		1874	1900
D		1875	1901
E		1876	1902
F		1877	1903
G		1878	1904
H		1879	1905
I		1880	1906
J		1881	1907
K		1882	1908
L		1883	1909
M		1884	1910
N		1885	1911
O	1860	1886	1912
P	1861	1887	1913
Q	1862	1888	1914
R	1863	1889	1915
S	1864	1890	1916
T	1865	1891	1917
U	1866	1892	1918
V	1867	1893	1919
W	1868	1894	1920
X	1869	1895	
Y	1870	1896	
Z	1871	1897	

MINTON DISCIPLES:
GEORGE JONES AND JOSEPH HOLDCROFT

The collector's appreciation of Minton and Wedgwood majolica is enhanced by knowledge of the history of the two factories. In contrast to the considerable amount of information available about those firms, very little is known about George Jones (c. 1824–1893) and Joseph Holdcroft (born c. 1832). Both of these men had worked for Minton before starting their own successful potteries. Much of the historical information about Jones and Holdcroft comes from Jewitt; more has recently been gleaned from issues of the nineteenth-century *Pottery Gazette,* other periodicals of the Victorian era, census reports, parish records, and city directories. The works of Jones and Holdcroft may be recognized by distinctive patterns, colors, undersurfaces, and—when used—marks. Some pieces may never be positively identified; but, as with other unmarked pottery and porcelain, although this may detract from the value of the pieces, their charm is not diminished.

George Jones

Jones was employed by Minton for about a dozen years but, while much is known about Émile Lessore and Hugues Protât, no information about Jones's history at Minton's is presently available, such as which pieces he designed or why he left. It is often difficult to distinguish between Minton's and Jones's naturalistic designs, and one may assume that Jones's work at Minton was primarily in that category.

After his training and employment at Minton, George Jones established the Trent Pottery in 1861, in Stoke-on-Trent, just behind the Minton factory, originally for the production of Parian ware. The 1871 census shows that Jones was forty-seven years old, lived at Stokeville, Stoke-on-Trent, and employed 570 workers. Three sons, George H. (23), Frederick A. (19), and Charles S. (16),

were all described as "potters manager." A daughter (Frances L., 17) and two younger sons (Alfred H., 11, and Edgar W., 4) are listed, but not the Horace O. whom Geoffrey A. Godden mentions in his revision of Jewitt (*Jewitt's Ceramic Art of Great Britain 1800–1900,* rev. ed. 1972, p. 127), but who is not mentioned in Jewitt's 1883 edition. Godden credits Horace, who was trained at the South Kensington Art School, with many of the firm's designs and says some pieces may be marked "H.O.J." Apparently Horace was an older son who had left his father's home by the time of the 1871 census. George Jones's obituary states that seven sons attended his funeral in Stafford on December 3 (*Staffordshire Advertiser,* December 9, 1893).

Two recently discovered pattern books bearing the name George Jones and Sons are now in the Wedgwood Museum. They are undated, but must have been started in or after 1873, when the firm name changed from George Jones to George Jones and Sons. Part of the George Jones factory—and pattern books—were bought in 1907 by E. Brain and Company, Ltd., in Fenton (1903–1967), which in 1967 was acquired by Wedgwood. George Jones's designs are recorded in the pattern books by early hand-tinted photographs, drawings, and watercolors. Many of the designs are easily recognized as being in the Jones style. The illustrations include ornate centerpieces modeled as figures of Neptune, cupids, mermaids, and naiads decorated with shells and fish. The stems of elaborate naturalistic compotes incorporate giraffes (#3227), dogs chasing quail (#3205), cows, lions, camels (#3206), and bison. The latter three forms are labeled in the George Jones pattern book, respectively, "Africa," "Asia," and "America." A deer is the finial on a game-pie dish, which is further decorated with cupids and dead game. Another page of the pattern book

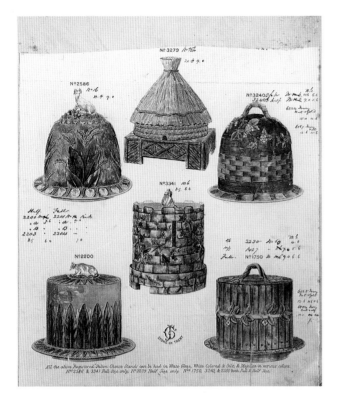

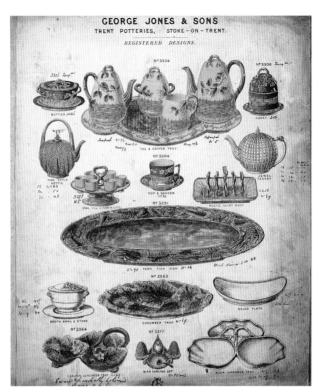

shows a series of cheese bells, the most whimsical of which has a goat finial and was also designed with a serpent finial. The pattern book also depicts breakfast-table serving pieces such as marmalade jars, egg-and-toast stands, bread trays, and butter dishes. The Wedgwood Museum is also in possession of an unillustrated George Jones salesman's catalogue, which consists of three pages listing designs and prices of the majolica pieces. The price for some examples is given for a version in majolica as well as versions in other wares made from the same mold.

From the beginning of the new pottery, the Jones mark ("GJ" in monogram or, after 1873, "GJ & sons") was associated with excellent earthenware of all descriptions, including colorful articles for Africa and South America, Parian and white granite for the United States, and printed, enameled, and gilt ware for both English and foreign sales. It is for the production of majolica that the firm is best known among collectors today. The many different bodies and designs were impeccably modeled and brilliantly glazed, comparing most favorably with those of Minton and Wedgwood. George Jones pieces

were exhibited in Paris (1867), London (1871), Vienna (1873), and Sydney (1876), and were awarded medals in the European expositions.

To many majolica collectors, the works designed by George Jones are most desirable. Naturalistic themes, beautifully depicting flora and fauna, predominate in George Jones majolica. Strawberry blossoms and fruit, apple blossoms, lilies of the valley, magnificent three-dimensional pond lilies, shy deer, and predatory foxes ornament perfectly glazed surfaces of plates, platters, game-pie dishes, cheese bells, compotes, bread trays, butter dishes, butter pats, napkin rings, wall pockets, tiles, urns, and cachepots. Playful cupids and sly-eyed satyrs support candelabra, compotes, and sweetmeat dishes (#2282). Many pieces such as sardine boxes and game-pie dishes are edged with a twisted yellow-gold rope design, a detail frequently copied by lesser potteries. George Jones pieces are almost always lined in either majolica pink or turquoise glaze, in shades lighter than those used by the Minton factory.

Many Minton and George Jones pieces are similar in design, modeling, and glaze, but Minton's are more

89

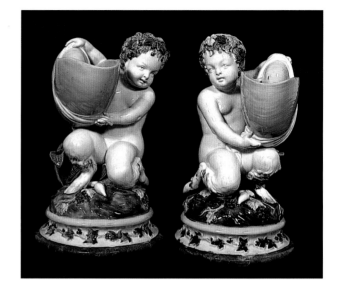

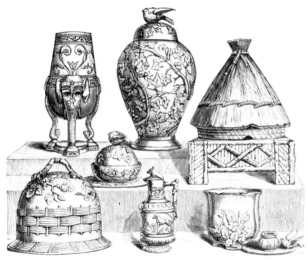

Left: George Jones & Sons. Illustration from Llewellynn Jewitt's *Ceramic Art of Great Britain*, 1883

Above: George Jones (Trent Pottery). Sweetmeat dishes. c. 1865. Height 9″. (No. 2282)

Below, left: George Jones & Sons. Cheese bell. c. 1873. Height 12″. (No. 2200)

Below: George Jones & Sons. Garden seat. c. 1875. Height 19″.

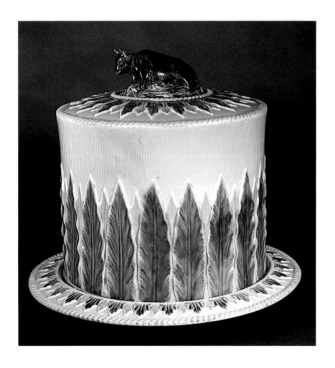

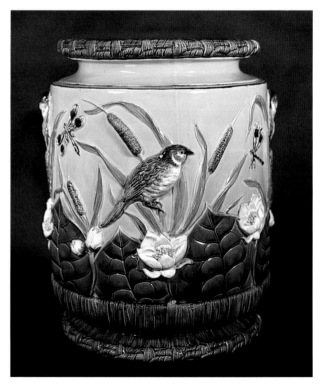

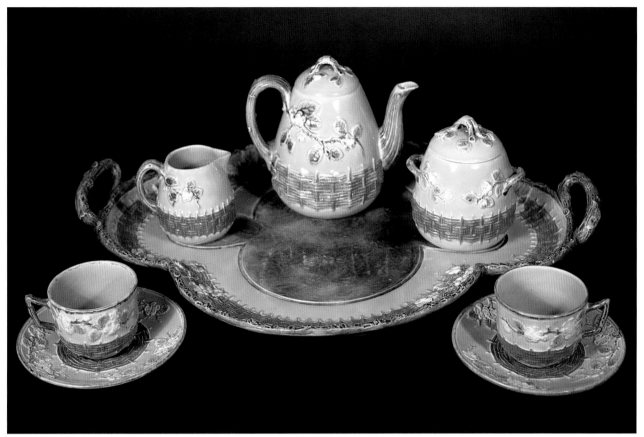

George Jones & Sons. Tea service. 1873. Tray length 19¼"; teapot height 5½". (No. 3304)

formal. Pieces that come readily to mind to illustrate the differences include the Minton squirrel dish (1869) and the George Jones squirrel nut dish (1870). Each has a squirrel resting on a rim of overlapping filbert leaves, but the Jones piece is embellished with colorful blossoms. Minton urns and cachepots are also more formal than those of George Jones. Minton's are decorated with elegant floral motifs, whereas the Jones pieces are designed not only with flowers but with birds and dragonflies (#3326), swans, and butterflies. Jones pieces evoke joyous imagery and, like Minton's, are executed with perfect ceramic techniques.

Much of Minton and Wedgwood majolica may be categorized according to different art styles, but George Jones's work is best discussed by grouping specific patterns and motifs. The acanthus leaf is seen at the edges of cheese bells (#2200), square cachepots (#2557), butter dishes, plates, and garden seats. Green pond lilies float on cheese bells (#3412), garden seats, and cachepots (#3226), accompanied by sparrows and drag-

onflies (1874); lilies on urns share a pond with fleets of swans (#3568, 1877). Apple and strawberry blossoms and leaves, great favorites of Jones, are strewn on cheese bells of varying sizes, and on tea services (#3304, 1873), plates, mugs (#1869), graduated pitchers, bread trays (#1855), and butter dishes, but are most luxuriously displayed on the many strawberry serving dishes, each accompanied by a sugar bowl, creamer, and matching spoons. One version of the strawberry server is decorated with the popular Victorian napkin motif (#2263, 1872), with the napkin design (in pink, blue, or white) repeated on small individual fruit dishes and seven-inch dessert plates (#2254). A footed strawberry dish with two large and two small baskets, is decorated with strawberry blossoms (#3300, 1873). The handle, the four feet, and the rim are modeled as gnarled branches. A sparrow alights on another strawberry dish between the two "nests," which hold the sugar bowl and creamer. A more complex strawberry dish is modeled as a wooden trough (#3423) with removable wooden "buckets," each con-

91

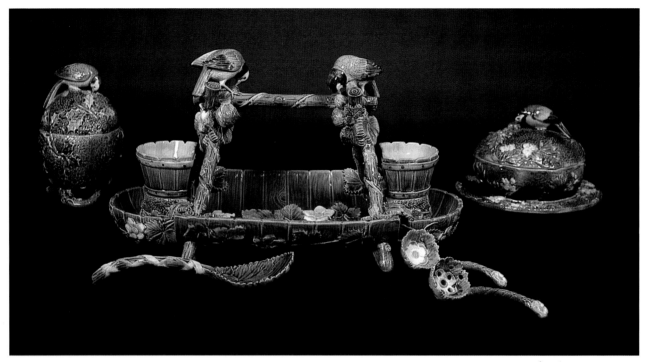

George Jones & Sons. Strawberry service. 1873.
Length of server 15½". (No. 3423)

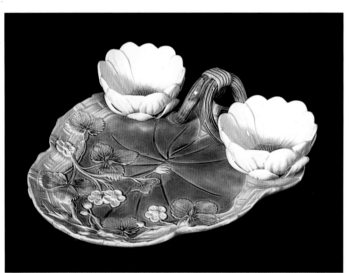

George Jones & Sons. Strawberry basket. 1876.
Length 10". (No. 3501)

taining a spoon for cream and sugar. The trough supports a trestle of twigs, on which perch two yellow-breasted finches feasting on the strawberry plants entwined along the trestle. Yellow-breasted finches also serve as finials on matching butter dishes (#3370) and marmalade pots. The yellow wickerwork design of Minton appears in a lighter shade on a Jones strawberry basket (#3230). The sugar and cream containers attached to the outside of the basket are glazed in turquoise, as is the interior. The twig handle is adorned with

a pink ribbon. Illustrated in the Jones pattern book is another strawberry server, also in a yellow basket-weave design (#3216). It is modeled on a Minton example, except that Jones's creamer and sugar bowl each have a pedestal-shaped foot instead of the flat bottom on the Minton creamer and sugar bowl. On other strawberry serving dishes deer, rabbits, or birds nestle between a pair of shallow bowls decorated with strawberry blossoms. A large dish in the form of a single leaf (#3501, 1876), strewn with strawberry blossoms and

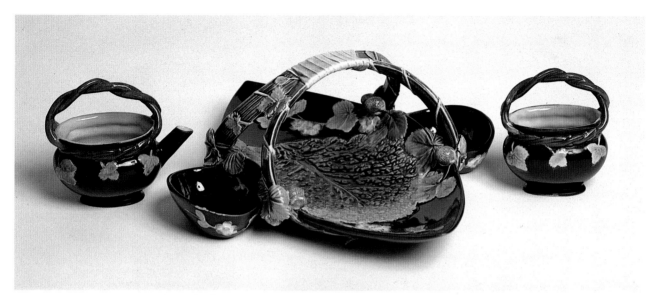

George Jones & Sons. Strawberry basket with creamer and sugar bowl. Length 14″. (No. 3546). (Courtesy Fenouil, Biot, Côte d'Azur)

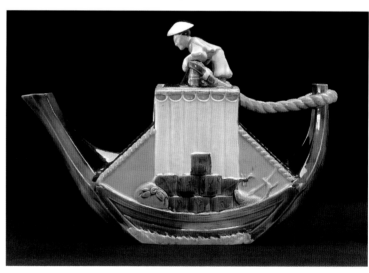

George Jones & Sons. Chinese Junk tea pot. c. 1876. Height 12½″ (Courtesy Christie's New York)

edged in blue, pink, or white, is modeled with cream and sugar cups fashioned as large white strawberry blossoms with deep yellow centers. At the end of the 1870s the strawberry servers became more dramatic. One version is cobalt blue, in an angular form (#3546) with a sugar bowl and a creamer in the shape of a teapot. Another (#7266, 1882) is in the shape of a large leaf with rippling edges, glazed emerald green, with matching sugar bowl and creamer. The handle is decorated with large white strawberry blossoms with yellow centers, and there are buds at the tips of the spoons.

Some George Jones luncheon and dessert services— complete with tall compotes and tazzas—are decorated with pond lilies (#2245) or a large, naturalistically modeled chestnut leaf in the center, on a pink, blue, or white-glazed background (#1804). Other plates are decorated with overlapping maple leaves and ferns (#2584). Large oval or round platters with rim and handles modeled as branches also have verdant overlapping leaves and ferns.

Animals are humorous or narrative components of many George Jones designs. Tea services are enlivened by rooster (c. 1875) and monkey (#3465) figural teapots. Large filbert, cherry, or grape leaves form the modeled center motif of the squirrel-ornamented nut dish (#2521), a bird-and-cherry cherry dish (#3219, 1869), and a fox-and-grape dish (#2396, 1869). The fox appears on a variety of George Jones pieces; all are

93

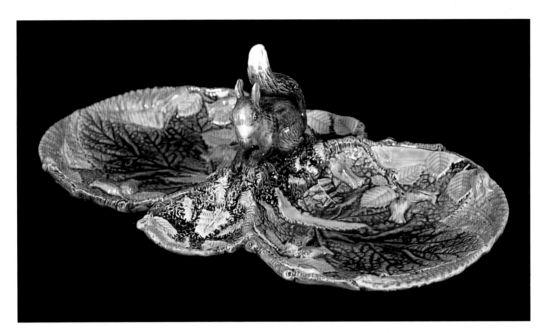

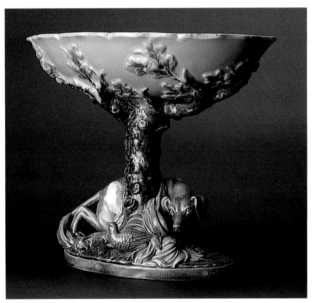

George Jones (Trent Pottery). Compote. 1867. Height 11". (No. 3205)

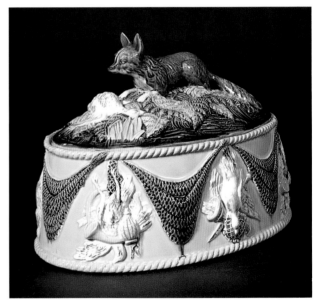

George Jones & Sons. Game-pie dish. c. 1875. Length 11". (No. 2296)

intricately modeled and many tell a story. The fox-and-grape dish, illustrating one of Aesop's fables, is unusual in that the fox's tail appears to pierce through the serving dish and curl around the mottled undersurface. A small open salt, without the central leaf, is in the same design. The fox appears again on one of a series of compotes of varying heights, designed en suite. The stem of each compote is a gnarled oak tree, with branches and acorns on the undersurface of the bowl. At the base of the largest, sixteen inches tall, stands a proud buck. A doe, buck, and bunny nestle on the base of another compote. On yet another, the bunny trembles under the surveillance of a predatory fox (1869). A hunting dog chases a pheasant at the base of a companion piece. On the smallest compote of the series the tree stands alone. A game-pie dish decorated on the turquoise- or brown-glazed sides with symbols of the hunt displays the Jones fox with his pheasant quarry (#2296). Another fox

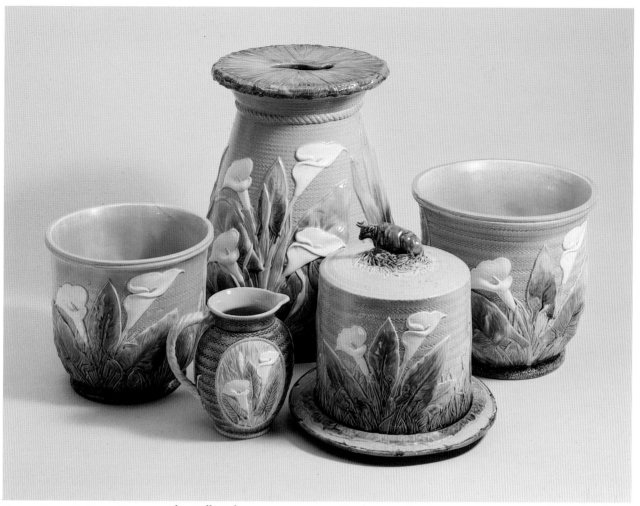

George Jones & Sons. Pieces in the Calla Lily pattern. c. 1873. Garden seat, height 19". (No. 5220); cachepot heights 10", 12"; cheese bell, height 11¼". (No. 5229); pitcher. Height 7". Courtesy Britannia, London

celebrates the hunt from the pewter lid of a claret or beer jug (#3328, 1872). The body of the jug is decorated with two cartouches: in one, a hunting dog is flushing out a water fowl; on the other, the fox is stalking the rabbit in his hiding place. Appropriately, the handle of the jug is modeled as a riding crop. The same design appears on a large cup with two handles modeled as riding crops (#3228).

Cows are another well-recognized motif of George Jones. They are found as finials on the acanthus leaf-decorated cheese bells (#2200) and butter dishes, which are produced in several sizes, with pink, blue, and occasional brown or white background glaze. Another cheese bell with a cow finial is decorated with deeply modeled calla lilies, not on a smooth ground, but on an unusual incised herringbone background (#5229). Unlike other underplates, the top surface of the accompanying plate in this design is modeled and glazed as the large single leaf seen on other Jones pieces. Calla lilies also decorate planters, pitchers, and garden seats (#5220). Cheese bells with cow finials were imitated by both English and American factories.

Jones gave attention to favorite domestic pets with his interpretations of dog troughs (#1842) and cat dishes. The dog trough is modeled as a shallow bowl with arch-shaped supports. The handles of the cat dish depict two kittens peering into the bowl.

There is great stylistic variety in George Jones pieces portraying marine life. Fish and shell motifs are realistically modeled in high relief on top of sardine boxes

95

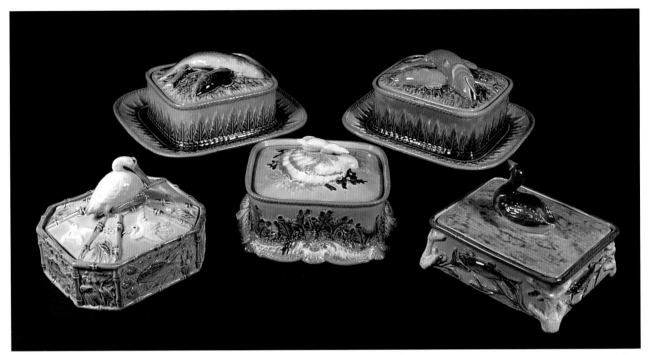

George Jones (Trent Pottery). Sardine boxes. 1865–1872. Fish finial. 1866. Length 8½". (No. 1805); Shell finial. 1865. Length 6½". (No. 1848); Duck finial. Length 6". (No. 3383); Pelican finial. 1872. Length 5½". (No. 80)

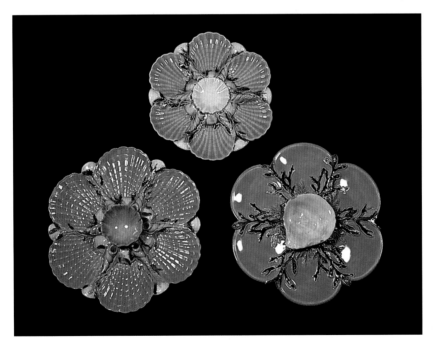

George Jones & Sons. Oyster plates. 1873-1874
Left: Diameter 10" (No. 3463).
Center: Diameter 8" (No. 3589).
Right: Diameter 10" (No. 1874).

(#1848, c. 1870) and on large wicker salmon (#2763) or mackerel baskets (#2704, c. 1880). Underwater motifs—including fish, crabs, and plant life—below white birds in a cobalt sky are rendered in low relief on urns (#5246), pitchers and cheese bells of varying sizes. Extremely realistic lobsters rest on lids of fish and pâté serving dishes (#3578, 1876). Surprisingly, the platter

under the lobster pâté serving dish is marked "STONE CHINA" and "STOKE ON TRENT" in two opposing arcs surrounding the monogram "GJ." Jones oyster-plate hollows are modeled as scallop shells (unlike Minton's, which have smooth surfaces); the dividers of Jones examples are encrusted with smaller shells (#3463, 1873). Another George Jones oyster plate has a center-

George Jones & Sons. Cheese bell.
c. 1875 Height 14″

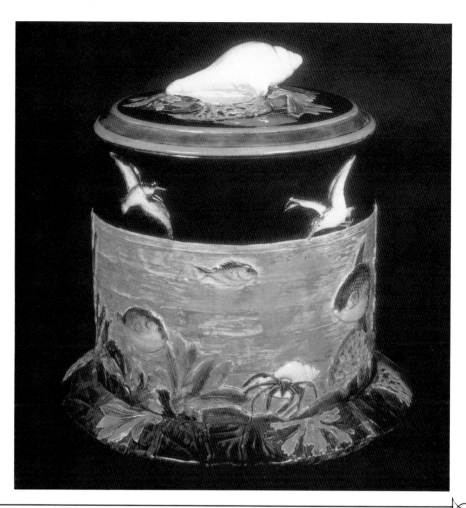

piece of a large oyster shell modeled in high relief (#3110). Jones oyster plates are in blue, pink, or white glazes, and are eight to ten inches in diameter.

Most rare among the seafood servers are the caviar bowls, one of which is illustrated in the George Jones pattern book.

Marine birds were also part of the water-life pieces made at the Jones pottery. A rounded hexagonal pitcher, with a bamboo handle and rim, depicts a heron stalking through marshes (#3404). This piece has also been copied by potteries on both sides of the Atlantic. A pelican forms the finial for a hexagonal sardine box and under plate, which has fish decorating the sides of the box (#80, 1872). A duck paddles on the cover of another sardine box, which is encrusted with coral (#3383). A cobalt sea is the background for sea grasses and fish swimming on an elegant umbrella stand (1882).

The French influence of Carrier-Belleuse is seen in the George Jones large sweetmeat dish with a cherubic water

sprite astride a cheerful dolphin, surrounded by pink and blue shell-shaped serving dishes (#2244). On some George Jones plates decorated with marine motifs the human form is introduced (c. 1875). The center of one such rare majolica plate portrays a young woman, dressed in pink and green, with a basket on her back, spearing fish in an aquamarine sea. A distant white sailboat gives perspective to the scene. On another plate, inscribed "Biarritz," a young sailor is rescuing a maiden from the sea. The wide aubergine borders of the plates are modeled with naturalistically glazed seashells against a bladder wrack–seaweed background.

Birds, butterflies, dragonflies, pond lilies, and cattails are part of the George Jones landscapes on cobalt or turquoise urns (made in graduated sizes), garden seats (#3380), and cheese bells (#3412). In one rare example of a cheese bell, from which the birds and dragonflies have flown, the under plate is set in a separate, beautifully modeled wicker container. Butterflies alight as the

97

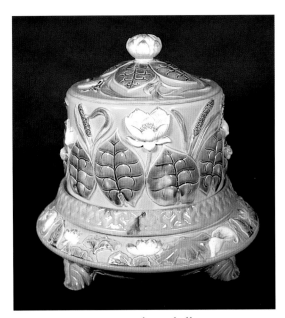

George Jones & Sons. Cheese bell. c. 1875.
Height 14″

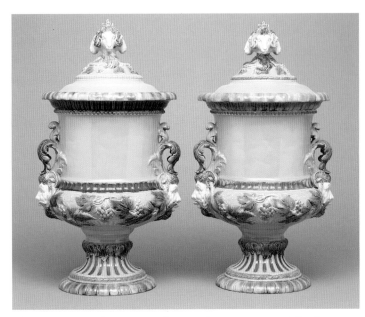

George Jones & Sons. Pair of covered urns. c. 1875. Height
of each 24″. (No. 342). Courtesy Sotheby's, New York

finials of flower-strewn cheese bells and butter dishes, and on the edge of inkwells. Large monarch butterflies soar across rectangular (#3470) or triangular (#3477) serving trays decorated with wheat; two butterflies hover on an oval plaque (1876) among a mass of Phalaenopsis orchids growing on a background of sphagnum moss. These orchids, together with those on a matching George Jones pitcher with an orchid-leaf handle (#3439), are the only known portrayals of orchids on majolica. An unseen bee is anticipated in the George Jones cheese bell whimsically modeled as a beehive (#3278, 1873). This piece was made in three sizes.

Some George Jones designs were influenced by styles of the past. The heritage of Bernard Palissy is acknowledged in a large Jones ewer, complete with sea-moss body, seashells, and a serpent handle (#1459). An aforementioned coiled serpent forms an incongruous finial on a slope-shouldered Jones cheese bell (#2586). A large pair of Jones covered urns (#342, c. 1875) are in the Renaissance style. Deeply modeled satyr's-head handles are topped by acanthus-leaf clusters. Each of the finials is in the form of three rams' heads, with interlocking horns; heavily laden grapevines are intertwined with the rams' horns. Ropes, beads, stripes, and laurel leaves complete the Renaissance design.

Egyptian motifs are also reflected in George Jones

pieces. Most handsome are the cobalt-blue rectangular planters with sphinxes modeled at each corner, and with striated green-and-yellow borders around the cobalt sides (c. 1870). Decorated in the French style, similar to work of Carrier-Belleuse, large vases, about twelve inches high, are supported by cupids and *putti* in floral or marine tableaux. Tall, two-branched candlesticks are supported by pairs of garlanded cupids at the base, and decorated with cupids' heads beneath the two bobeches. Compotes are balanced above similar cupids (#2557), with both the cupids and the serving bowls swathed in well-modeled draperies. These pieces are harmoniously glazed in pink and turquoise.

Collections of majolica are enhanced by pairs of fragile spill vases, candlesticks, and vases—and delicate George Jones examples are particularly desirable. Jones spill vases, about six or seven inches high, are in the form of tapering cylindrical wicker vintners' harvest baskets, trimmed with grapes and leaves and lined in majolica-pink or light blue glaze. Some Jones candlesticks are in delicately modeled figural shapes. Narrow vases are in the form of bird's nests decorated with sparrows and strawberry blossoms (#3466). Cornucopia-shaped bud vases (#3456), resting on stilt supports, are decorated to match the traditional strawberry servers.

George Jones majolica for the conservatory is impres-

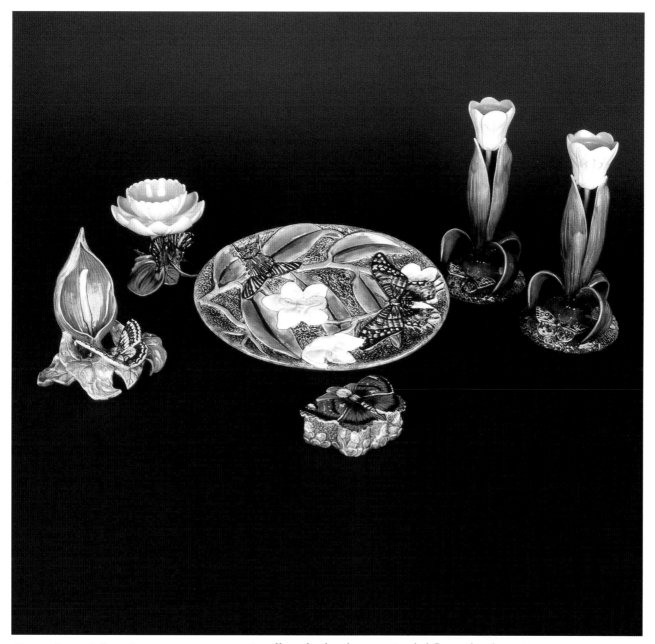

George Jones & Sons. Dressing set. c. 1875. Candlesticks: height 8¾". Petaled flower: height 4½". Single-stamen flower: height 5½". Oval dressing table plate: length 11¼". Beauty-patch box: length 4"

sive, although no piece is known that rivals the majestic Minton or Wedgwood examples. Jones produced eighteen-inch-high garden seats, eleven- to twenty-three-inch cachepots, and twenty-four-inch-high umbrella stands. It is not unusual to find any given Jones majolica pattern—such as the calla lily or pond-lily-and-dragonfly pattern on cobalt or turquoise backgrounds—applied to several of these different forms, as well as to cheese bells, pitchers, or baskets. Another design, which includes daisies and banana leaves on a simulated-bark background in blue, pink, or brown, appears on umbrella stands (#5250), cachepots, and cheese bells. An opulent and deeply modeled cachepot (1867) has a scalloped rim and white floral sprays, from which heavy leaves extend down to form the three legs; birds soar on a cobalt-blue background. Also dramatically sculpted is the garden seat with strikingly realistic calla lilies on a cobalt-blue background (#5220).

99

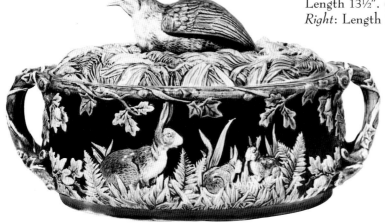

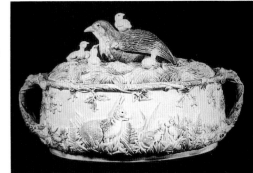

George Jones & Sons. Game-pie dishes. 1873. *Left*: Length 13½". (No. 3416). Courtesy Christie's, London. *Right*: Length 14½". (No. 3371)

Certain examples of George Jones majolica are particularly noteworthy, although they may have a familiar shape and function. Not only are these pieces rather rare, but they are striking examples of the charm, humor, and exquisite art of George Jones. In this group are four game-pie dishes, inventive and intricate: the woodcock and rabbit game-pie dish (#3371, 1873), the circular sportsman and dog game-pie dish (#3268), a fawn-finialed game-pie dish (#3264), and a game-pie dish with hunt scenes. The oval woodcock and rabbit game-pie dish, which was made in three sizes, has handles of entwined oak branches, complete with acorns, which extend around the rim of the piece. Around the body of the dish rabbits frolic through ferns and oak leaves. On the lid, decorated with grasses and ferns, a woodcock as the finial watches over her brood of chicks. The polychrome glazes are extremely realistic and contrast well with the cobalt, or turquoise, body. Another version of this pattern portrays the woodcock finial without chicks, enduring, one might say, the "empty-nest" syndrome (#3416). The sportsman and dog game-pie dish is decorated on the sides of the cobalt body with hunting horns and arabesques; the center of activity is in the finial of the kneeling hunter, his gun, and his dog. Another circular game-pie dish, decorated on the sides with stags and angels, is completed by a fawn finial. A ferocious boar's head is trapped as the finial of the fourth game-pie dish, ornamented with scenes of the hunt in cartouches around the turquoise or cobalt sides of the dish.

A cheese bell in the shape of a castle tower has a furled banner in the center of the crenelated top (#3341, 1873). The majolica "stone walls" of the tower are covered with ivy vines and moss; grasses grow along the bottom border. Narrow gray windows near the top complete the tower, and the under plate conjures up the image of a moat. This design was also effectively used for a cachepot with a turquoise inner lining and the requisite drain hole. The underplate has a lip to support the cachepot and allow for drainage (#3340). Another cachepot, with the same ivy-covered stone walls, is imaginatively shaped as a fort with a round tower at each of the four corners (#3357).

A rare George Jones wine caddy, of which perhaps only one has surfaced, consists of two wine-bottle coasters, reticulated and appropriately adorned with grapevines. A young Bacchus lying on the connection between the two coasters is enjoying the grapes and, by example, encouraging all to partake.

On a majolica base decorated with leaves trudges the George Jones camel, his dark brown body weighted down by the blue saddle bags he carries (#2782, c. 1868). The saddle bags, bound with yellow cord and lined with pink glaze, were designed to carry sweetmeats. The base is marked "GJ" and, enigmatically, "Kumassie."

Small pieces by George Jones are exquisite examples of his work in miniature. A napkin ring is modeled as a bouquet of lilies of the valley on a ring formed of a lily leaf (#3401, 1881). A butter pat, glazed pink, has strawberry blossoms and leaves around the scalloped

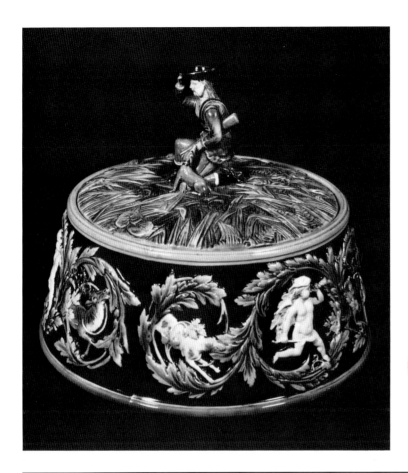

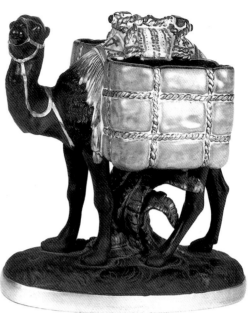

George Jones & Sons. Game-pie dish. c. 1873. Diameter 9". (No. 3268)

George Jones (Trent Pottery). Sweetmeat dish. c. 1868. Height 9¼". (No. 2782). Courtesy Christie's, London

edge. Spoons to accompany strawberry services are decorated on both sides of the spoon bowl with a strawberry blossom. Delicate boxes are shaped as butterflies.

George Jones contributed special designs for Yuletide celebration, as did Minton. There is similarity between the Minton Christmas charger and the Jones Christmas platter (#2282), in that both are wreathed in well-defined holly leaves glazed the same deep shade of emerald green. The Jones platter has a central figure of a robin, festively red-breasted. Jones also produced both a cobalt-blue and a pink, two-tiered Christmas sweetmeat server, decorated with holly and mistletoe (#2504, 1869). A spectacular George Jones punch bowl, encircled by holly and mistletoe, is without peer (#3468). The figure of Punch that forms the base, lying on his back on a round bed of leaves, is colorfully dressed in traditional guignol costume with red-and-white striped pantaloons, blue stockings, pointed black shoes, a green doublet, and a blue-and-white pointed foolscap. His hawk-nosed profile is close to the bowl as it rests on his body. The bowl,

with careful modeling simulating an orange rind, was glazed in deep cobalt, turquoise, orange, or yellow, with inner glaze of the most perfect majolica pink. The piece was made in two sizes.

The first mark of the Jones factory, "GJ" in monogram, impressed, was used from 1861 until 1873, when George Jones was joined by his sons and the mark became "GJ" placed between the horns of a crescent inscribed "& SONS." The company marks and the British registry mark were on the undersurface of some, but not all, Jones pieces. About 1870 a small, raised, irregular seal (or pad) bearing the "GJ" monogram and the words "STOKE on TRENT" were also used. On two pieces—a cheese bell and the lobster pâté dish mentioned above—the perplexing mark is "STONE CHINA" above the monogram "GJ," with STOKE on TRENT" below. The mark "H.O.J." was sometimes used, for Horace O. Jones, George Jones's son.

George Jones majolica can almost always be recognized by the typical mottled green-and-brown glazed undersurface, but the inclusion of the company marks makes identification a certainty. It should be noted that

101

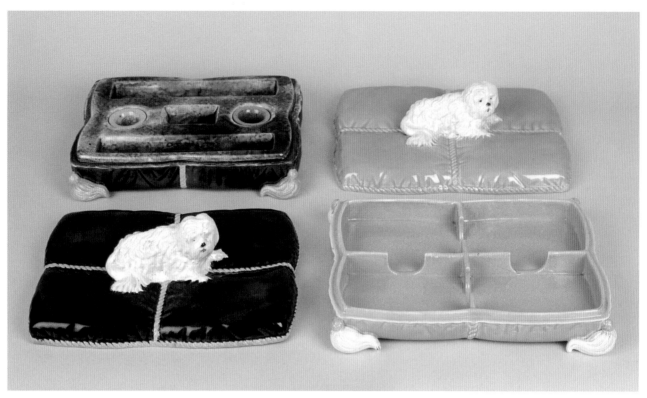

George Jones & Sons. Inkwell (left) and card box (right). c. 1873. 9¼ x 8″

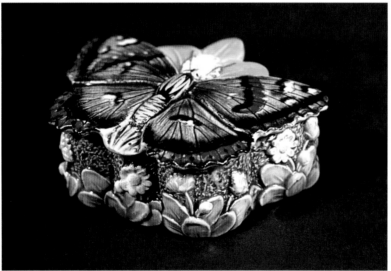

George Jones & Sons. Beauty patch-box. 1874. Length 4″

both English and American firms copied the Jones mottling pattern, but did not execute it with the finely controlled technique of George Jones. Jones also pressed a thumbprint mark on the mottled base (creating a white space), on which the pattern number and a letter were added in black paint. (The significance of the letter is not yet understood.) Different glazes as well as different sizes of the same model were given different pattern numbers. The collector should be aware, however, that some Jones pieces that have been separated from their under plates have a pink-glazed undersurface, with no marks. Sugar bowls and creamers, from long-gone strawberry servers, may have unmarked green-glazed undersurfaces. Small pieces that belong to larger groups, such as the fox open salt, may have unmarked pale turquoise undersurfaces.

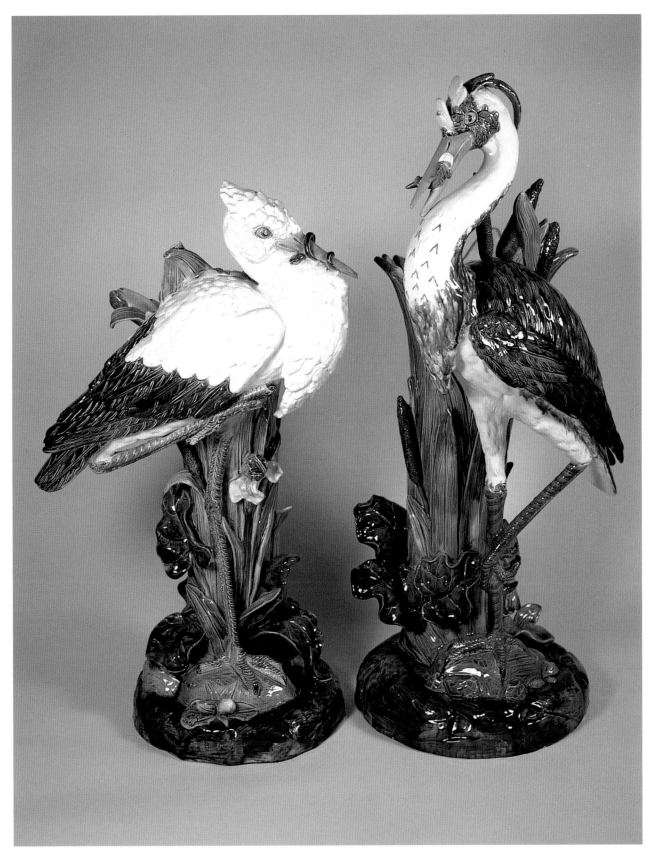

Joseph Holdcroft. Flower stands. Stork height 26". (No. 8B); heron height 33". (No. 6)

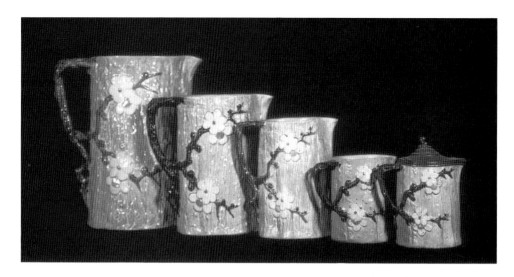

Joseph Holdcroft. Pitchers and syrup jug. Heights of pitchers 8¼″, 7¾″, 6½″, 4½″; height of jug 5½″

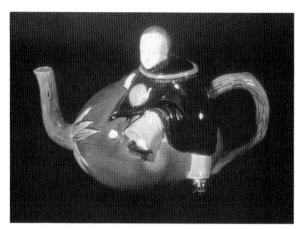

Joseph Holdcroft. Teapot. Height 7″

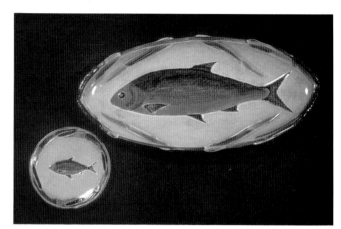

Joseph Holdcroft. Fish platter and plate. Platter length 26″; plate diameter 8¾″

The last advertisement of George Jones and Sons' Trent Pottery in the *Pottery Gazette* that listed majolica was in 1886. Before George Jones's death in 1893, in addition to majolica, the firm produced a very fine earthenware, *pâte colorée* (1880), which was much like bone china. *Pâte-sur-pâte,* somewhat more ornate than the Minton pieces, was produced from 1870 to 1886. In 1907, when part of the firm was bought by E. Brain and Company, Ltd., the Trent Pottery was renamed the Crescent Pottery and continued until 1951.

In all pieces, large or small, George Jones majolica is unified by perfectly applied glazes of pink, blue, and leaf green, with occasional touches of golden yellow. Crisply modeled subjects embody grace, charm, and humor. Jewitt wrote, describing Jones's work, that it was "just such a careless, elegant, and surpassingly beautiful ob-

ject as a naïad or a water nymph, in one of her happier moments, might have improvised, as she rose from the lake, to present to some favoured mortal" (p. 420).

Joseph Holdcroft

Of Joseph Holdcroft's history even less is known than of George Jones's. Jewitt writes (p. 550) that in 1870 Holdcroft established the Sutherland Pottery, at Daisy Bank, in Longton, after briefly operating a pottery in St. Martin's Lane, in Longton. The 1881 census for Red Bank, Florence, near Stoke, shows that Holdcroft, born in Stoke, was then forty-nine. His father, also named Joseph, was a potter. The younger Holdcroft's firm continued under the name J. Holdcroft until 1906, when it became Holdcrofts Ltd., which continued until the 1920s.

Holdcroft manufactured not only majolica but also Parian and silver lustreware for English, Continental, South American, and Australian markets. It was majolica, however, which he had become proficient at creating during his eighteen-year employment at Minton's, that provided him with a measure of immortality. The production of the Sutherland Pottery was considered by Jewitt to be of a "high class, both in design, in quality and in workmanship" (p. 550). Jewitt also stated that "His productions rank deservedly high." Holdcroft's specialty was the Wren Vase, with well-modeled birds, flowers, and foliage. His marks were (1) "JH" in monogram, impressed, and encircled and (2) "J. HOLDCROFT" impressed. There is rarely a British registry mark, pattern number, or potter's mark on the undersurface of Holdcroft's pieces, therefore dating examples of his work is almost impossible.

The undersurfaces of Holdcroft's majolica were usually glazed in a celadon green, not always evenly applied. Some collectors consider that color characteristic enough of Holdcroft to attribute to him all well-modeled majolica with celadon undersurfaces. Unless the design is recognized from a similar piece with one of the above two marks, assumptions may be risky, as other potters also used celadon for undersurfaces. It should also be noted that some Holdcroft undersurfaces were gray, brown, black, or mottled brown and black.

So much for known facts. It is interesting to contrast the styles of the two ceramic artists who were most closely associated with Minton's and who went on to establish their own potteries. George Jones produced the quintessential Victorian majolica with brilliant color, superb design, and, above all, whimsy, charm, and humor. Joseph Holdcroft's work, in a way, represents a darker interpretation of Minton's designs. His pieces are more somber, more subdued in color and glaze, and, if truth be told, Holdcroft's modeling is less accurate and less artistic than the magnificent technique at Minton. Probably the best example of these differences is to be seen in the comparison of the Minton and Holdcroft storks and herons. Minton's forty-one-inch-tall stork, devouring an eel and simultaneously crushing the life out of a hapless frog, is perfectly modeled and glazed. Beautifully colored irises, bulrushes, and arrowhead leaves reflect sunshine. In the Holdcroft rendition (twenty-six inches high), the stork's glaze is somewhat

dull and the modeling is less crisp. The eel, instead of trying to pull away (as in a tour de force of Minton modeling), is lying flat and helpless against the Holdcroft stork's beak; the flowers are insignificant. No frog is present to add to the drama. Holdcroft's imitation, in this case, was not successful, perhaps because of the magnitude of the piece. The Holdcroft heron, with a fish in its beak, is somewhat more distinctly modeled than its companion piece.

Despite the fact that many of Holdcroft's designs were derived from Minton, Wedgwood, and George Jones, collectors of Holdcroft pieces believe that Holdcroft's technique had a strength of its own. Although Holdcroft designs and modeling were more primitive, there were few defects in the firing of the pieces, and the glaze was quite good.

It is interesting to trace the genealogy of majolica motifs. The flying cranes, pond lilies, oyster shells, and dead game used in Holdcroft designs are undoubtedly related to Minton. Flying cranes, of oriental inspiration via Christopher Dresser's designs for Minton, are seen on Holdcroft plates, compotes, and tea services. (The third generation of these cranes appeared on American cobalt-blue tea services and plates.) Pond lilies, perhaps the best modeled of Holdcroft works based on Minton designs, appear on pitchers, platters, urns, deep bowls, plates, sardine boxes, and cheese bells. The traditional pond-lily background is emerald and smooth on Holdcroft's work, but some pieces have deep brown, cobalt, turquoise, or cream background glazes. Holdcroft also used the pond-lily pattern on syrup jugs with pewter lids, and on mugs, but in these pieces the pond-lily design is less well-defined than in Minton's examples. Holdcroft's oyster plates derived from Minton and George Jones have scallop-shell concavities separated by shell-encrusted spokes, less distinctly modeled and glazed than Minton's or Jones's examples. A teapot, reminiscent of a Minton figural teapot, sets a young Chinese boy scampering to the top of the coconut body, with the head of the figure as the lid of the teapot. A graceful Holdcroft pitcher emulates a Minton design, with a bulbous body formed of broad, striated green leaves of narcissus flowers at the neck of the pitcher. There is a majolica-pink glaze at the neck and base of the pitcher, and the brown-glazed handle is simply cast. It is this latter detail, which might have been a charmingly sculptured leaf handle in a piece

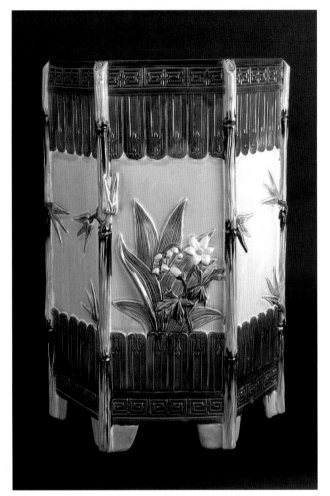

Joseph Holdcroft. Hexagonal garden seat.
c. 1875. Height 18″

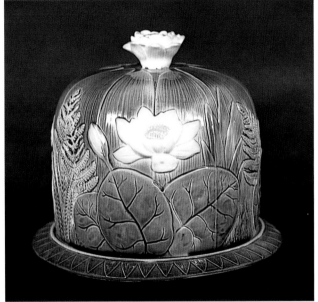

Joseph Holdcroft. Cheese bell. Height 8″

by Minton or George Jones, that shows the ever-present difference between Holdcroft and the major potters. A large Holdcroft game-pie dish, however, with a finial formed as a dead partridge whose wing rises perpendicularly to the cover, is almost as intricate as its Minton counterpart.

Holdcroft was also inspired by Wedgwood's marine and floral motifs. A twenty-six-inch turquoise Holdcroft platter decorated with a large salmon trout—primitively designed, incised, and realistically glazed—is reminiscent of Wedgwood's platter depicting a salmon trout. Holdcroft modeled four well-defined cattails at the ends of the oval platter, with four more cattails on the undersurface to serve as feet for the platter. Matching plates

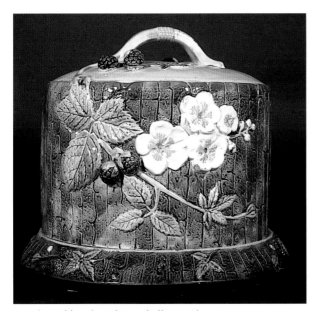

Joseph Holdcroft. Cheese bell. Height 10½″

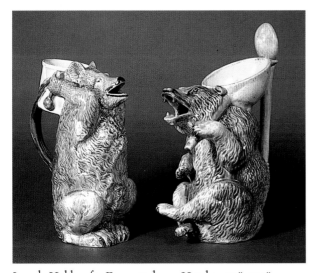

Joseph Holdcroft. Bear pitchers. Heights 10″, 8½″

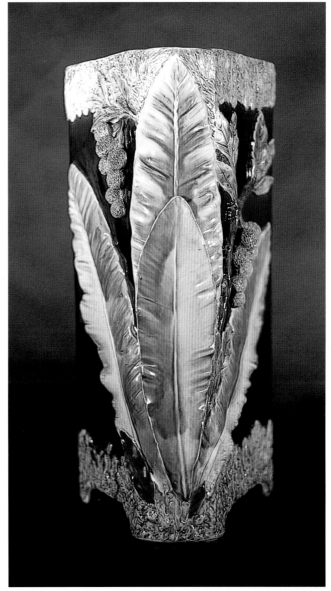

Joseph Holdcroft. Umbrella stand. Height 21½″

have less well-modeled cattails around the edge. A more original Holdcroft fish plate—with turquoise, cobalt, or brown glaze, and a border of a stylized leaf pattern—is the background for a butterfish frolicking above a sea anemone. Fish also swim over the flattened round body of a cobalt-and-turquoise pitcher. Holdcroft produced a series of graduated oval pitchers with primitive dogwood branches and blossoms, similar to a more elegant Wedgwood pattern. The body, modeled to simulate bark, is glazed blue, brown, or ivory, and the handle is a continuation of the brown dogwood branch. Occasionally

the branch handle is incorrectly glazed the color of the blue or ivory background. Matching plates, tea services, syrup jugs, cheese bells, umbrella stands, planters, and ice-lip pitchers eleven inches tall were made in the same pattern. Holdcroft also adapted the Wedgwood blackberry pattern on tea services and cheese bells.

Holdcroft borrowed the George Jones sparrow for bowls, strawberry servers, and sweetmeat dishes. Holdcroft's sparrow, however, is not as well and plumply modeled, nor are his strawberries as pink and delicate as the George Jones examples. The Holdcroft floral and

basket-weave-patterned plate and compote, with pink blossoms growing on the gnarled brown branches on the rim of the plate, are also similar to the Jones strawberry plates. The glaze over the basket-weave-patterned plate is not as brilliant as the Jones glazes and the blossoms are less crisply modeled on Holdcroft's pieces.

There are, however, many Holdcroft pieces of great originality, and these are also the examples that display excellent technical skill. Holdcroft produced graduated mouth-pouring brown-bear pitchers, modeled as charmingly as Steiff toy counterparts. One Holdcroft bear is on parade and carries a military drum; the other is more domesticated and is equipped with a honey pan and a spoon that forms the handle of the pitcher. Many factories, including Minton, paid homage to the corn plant and produced pitchers in realistic imitation. Holdcroft, however, fashioned tea services, pitchers, plates, butter dishes, butter pats, and bowls with an irregular pattern of white corn kernels bursting onto a beautiful blue background. Holdcroft ice-cream services with shallow rectangular platters and matching small round plates were well decorated. One ice-cream service has a row of pond lilies around the narrow rim of the turquoise-glazed serving platter.

Small Holdcroft pieces include match strikers, some in the shape of drummer boys. Small oval plaques depicting running dogs carrying envelopes in their mouths are perhaps part of a cover for a writing set. One of the smallest and best formed Holdcroft pieces is a six-section plover-egg holder, with a finial in the form of a plover similar to a piece by George Jones.

Holdcroft's scallop-shell-shaped bowls, inspired by George Jones, were, in turn, imitated. Holdcroft's bowls rest on flat, stemmed, or shell-footed bases and are handsome in green, brown, or blue glazes with majolica-pink interior linings. Another Holdcroft bowl, with gently rippling sides, stands on a circle of twigs. It was made in various sizes and glazed in green or brown. Holdcroft, who used brown glaze more than any of the other potters, produced a handsome charger, sixteen inches in diameter, with a brown background and four large leaves at compass points, together with matching small plates. An unusual brown-glazed set of teapot, sugar bowl, and creamer is modeled as a trio of chestnuts

in their shells. Blossoms and leaves on the covers of the teapot and sugar bowl cascade onto the bodies. The creamer is similarly decorated. This tea service was also produced with a light blue or an ivory glaze. A straight-sided coffee service was made in the same pattern.

Two umbrella stands are especially noteworthy for their strong Holdcroft modeling. One, about thirty-six inches tall, is shaped and naturalistically glazed as a hollow tree trunk, with a guardian bird at the rim. The artist's signature—"T. Fay, Sculptor"—only serves to intrigue the collector about the entire Holdcroft history and staff. The other umbrella stand is in polychrome glaze and is dramatically modeled, with huge banana leaves, coconut-palm leaves, and coconuts. The stand is complemented by a pair of planters, and the trio is quite formidable. One of the most massive examples of Holdcroft majolica is an oriental-inspired peacock urn, sixteen inches high. A polychrome-glazed peacock struts on each side of the turquoise-lined cobalt body. The urn rests on three rectangular feet with oriental motifs.

Not only was Holdcraft inspired by designs of the major manufacturers, but he also made use of their molds. A striking example is a graduated series of centerpieces. It is difficult to distinguish between the George Jones and Holdcroft works because the glaze is excellent in both. There will be another mention of Holdcroft's use of the molds of others in chapter six.

A bread tray trimmed in a green-gold wheat pattern, with a central area of brown glaze (or cobalt blue in other examples), has an inscription in raised brown letters around the sloping sides: "EAT THY BREAD WITH THANKFULNESS." Since this bread tray is a form familiar to collectors, albeit usually unattributed, it was quite surprising to find "JH" impressed in the mottled under-surface of a recently examined piece. Not only surprising, but thought-provoking, because it raises the question of what other unmarked pieces might be Holdcroft's work.

Holdcroft may be considered to represent the midpoint of the majolica era. His production from 1870 to 1885 was not quite as magnificent as that of Minton or George Jones, but it was far more artistically and technically interesting than much of the majolica made in the last two decades of the nineteenth century.

Chapter 6
OTHER BRITISH POTTERIES

Thomas Forester

The Church Street Majolica Works was established in 1877 at High Street, Longton—and soon after on Church Street—by a man mentioned in Jewitt (pp. 545–546) as Thomas Forrester, but whose last name is spelled Forester in *Pottery Gazette* advertisements and by all other authors. In 1879 Forester replaced his original buildings with the Phoenix Works, a new manufactory, on the same Church Street site. He soon expanded further by purchasing an adjoining china factory. Jewitt wrote that Forester "may take rank among the more important pottery establishments of the locality" (p. 546). An unsigned article in the February 1, 1883, issue of the *Pottery Gazette* said that "every week [Forester was] bringing out new designs, keeping two modelers constantly employed for this purpose." By 1883, when the firm became Forester and Sons, four hundred workers were employed. Majolica production ceased by 1888, but Thomas Forester and Sons continued to make other ceramic wares until 1959.

Considering the output, it is surprising that no majolica has been found bearing either the firm's marks—a phoenix and the letters "T.F. & S. LTD."—or a British registry mark identifying the factory's work. (There is no record of any application made by Forester prior to 1883; pieces of majolica bearing a post-1883 registration number are very rare. See Appendix.) Illustrated advertisements in the *Pottery Gazette* provide a certain amount of information, however. The *Gazette,* a trade paper, included articles on the growth and development of the pottery industry, sales in England and abroad, working conditions, and union-management controversies, as well as human-interest stories and obituaries. Bound volumes of the journal from 1878 to 1905 are in the Gladstone Pottery Museum in Longton, Stoke-on-Trent.

Although the advertisements indicate that Forester produced a full range of majolica tablewares and garden pieces in the English style, the firm's most unusual majolica was called "à la Barbotin" (Jewitt, p. 546), similar to nineteenth-century French majolica decorated with raised flowers made of slip. Forester's vases and baskets were ornamented with tortoiseshell or marbleized backgrounds and with barbotine flowers. Thirty-six-inch-high cornucopias encrusted with these flowers were skillfully made but few survive, because of the fragility of the floral decorations. Forester also produced examples of sanded majolica with barbotine floral ornament on a rough-textured, sandy background. Whether Forester's sanded majolica was influenced by similar examples produced in Poland, or vice versa, is not known. Other manufacturers in England made sanded majolica during this period, but not as well as Forester.

Forester's chef d'oeuvre was a life-size Saint Bernard dog thirty-nine inches high, in naturalistic polychrome glazes. It was modeled from life by William Wood Gallimore (who later worked in the Trent Tile Company in Trenton, New Jersey—see Edwin A. Barber, *The Pottery and Porcelain of the United States,* pp. 363–364). Other Forester majolica, judged by Jewitt to be "remarkably firm and good in body, the colouring well managed, the glaze very satisfactory, and the modelling of the floral decorations masterly in the extreme" (Jewitt, p. 546), includes many designs inspired by more famous factories. Indeed, all the motifs of English majolica come together for a grand finale at Forester and Sons, the last of the major English producers of majolica. Minton storks and herons appear on Forester cachepots and large cheese bells. Wicker-patterned pieces, less intricate than Minton's, include cheese bells and tea services. Tall tankards, graduated pitchers, and cheese bells with mot-

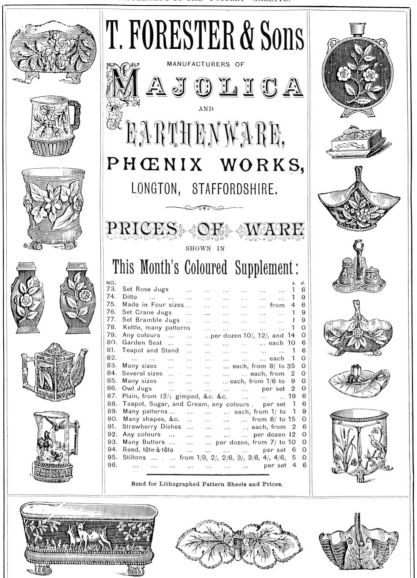

Thomas Forester & Sons.
Advertisement in the *Pottery Gazette*.
February 1, 1883

tled glaze are in the Wedgwood style. Strawberry services and baskets are more rustic than those of George Jones. Tea services with chestnut motifs were made by both Forester and Holdcroft. Forester produced egg-cup trays, gurgling-fish pitchers, dishes and bowls decorated with begonia leaves, and pitchers and baskets depicting hens and cockerels. Also attributed to Forester is a series of cheese bells in various sizes ornamented with eight large single leaves. Each leaf resembles a Christmas tree and is surmounted by an arch of twisted ropes tied with bows. This motif was also used to decorate planters. The background glazes include cobalt, pink, or mauve; the

undersurfaces are cream, deep yellow, or a carelessly glazed yellow-green. A Forester dinner service in a mottled green-and-brown glaze was completed by cheese bells and a series of graduated pitchers. These mottled pieces were decorated with sprays of mauve wild roses. Rectangular sardine boxes and round butter dishes in cobalt blue with attached underplates were decorated with pond-lily motifs, dragonflies, butterflies, and finials in the form of fish, swans, or sparrows. These are reminiscent of George Jones, but not as well modeled or accurately glazed. In many Forester pieces, the undersurface colors matched those used by the firms from which

110

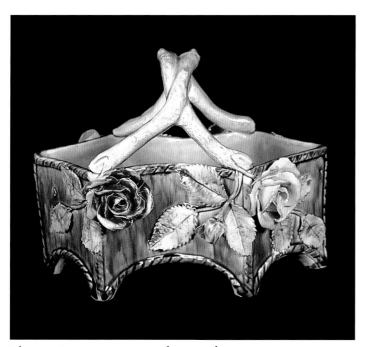

Thomas Forester & Sons. Basket. Height 9"

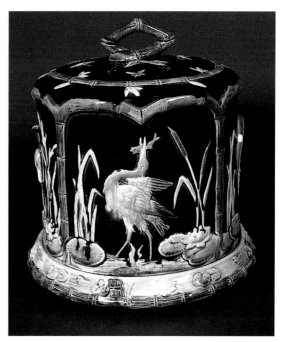

Thomas Forester & Sons. Cheese bell. Height 12"

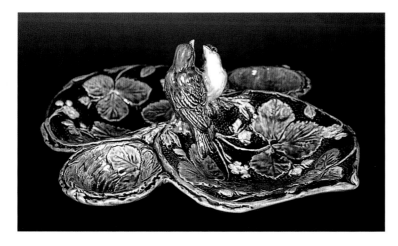

Thomas Forester & Sons.
Strawberry server.
Length 15"

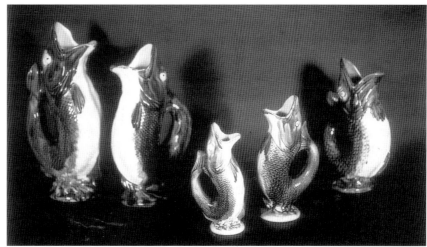

Thomas Forester & Sons. Gurgling-
fish pitchers. Heights from 11" to 7"

111

Forester drew inspiration. For example, strawberry services have mottled green-and-brown undersurfaces—coarser than those of George Jones pieces in a similar pattern. Other undersurfaces are white, gray, yellow, or mottled green and brown with yellow centers. Contrary to Jewitt's comments quoted above, the modeling, glaze, and colors of Forester's pieces are not quite as accomplished as those of the major factories, but Forester's majolica is prized today by collectors for its decorative appeal.

Samuel Lear

About 1877 Samuel Lear erected a small china works on Mayer Street in Hanley, where he manufactured domestic china and earthenware. In 1882 a new factory was added on High Street and the additional output included jasperware and majolica similar to that of Wedgwood. During these five years Lear produced some of the most charming patterns of the period. In 1886, because of business reverses, Samuel Lear's creditors closed both the Mayer Street and the High Street works.

Samuel Lear's majolica may be recognized by the relatively light weight of the pottery, and the specific patterns Lily of the Valley, Pond Lily and Rope, and Sunflower and Urn. Although only one marked piece is known, other Lear pieces can be identified by his illustrated advertisements in the *Pottery Gazette*. The marked piece is a yellow sanded-majolica vase decorated with barbotine flowers; the mark is the incised name "Lear" in script or impressed capital letters. Some Lear pieces carry only the British registry mark on the white undersurfaces. Painted blue dots may signify the identity of the artisan. The Sunflower and Urn as well as the Pond Lily and Rope patterns are thought to have been also produced in American majolica factories, but were not as skillfully made. Without marks it is difficult to identify the country of origin of these pieces.

The Lily of the Valley pattern, with its small bouquets of flowers and ferns, is accented by twisted yellow rope. This pattern is used on a series of graduated pitchers and on a large and a small cheese bell. Pieces are glazed in pastel colors on a white or pale blue finely stippled background, somewhat reminiscent of the light colors of Wedgwood's Argenta ware. Pond Lily and Rope, which is less well modeled but attractively glazed, appears on a set of graduated pitchers, as well as on plates, cups, and saucers both large and small, butter dishes, and tea services with trays. Sunflower and Urn is the most unusual pattern, in which yellow flowers, urns, and fans are curiously combined with pink, blue, or lavender propeller-like "rays" and geometric designs. A similar pattern combines stylized deep rose-colored chrysanthemums scattered among the blue "rays." Plates, compotes, tea services, mustache cups, butter dishes, sardine boxes, planters, pin trays, and cuspidors are seen in these distinctive patterns. Many Lear pieces, especially cuspidors, feature geometric backgrounds.

S. Fielding and Company

One of the most creative of the majolica potteries was that of S. Fielding and Company. First established in 1870 on Sutherland Street, Stoke-on-Trent, as the Railway Pottery, the company produced Rockingham and general earthenware, including green-glazed ware. It was not particularly successful until the participation of Simon Fielding (d. 1906) in the early 1870s. Fielding, not a potter himself, was a poulterer for the duke of Sutherland at Trentham Hall (some time after young Thomas Kirkby of Minton fame benefited from the duke's encouragement). Fielding was an expert on raising poultry and dogs, but chose to put his savings into the Railway Pottery. When the management of the pottery was taken over in 1878 by Fielding's son, Abraham (1855–1932)—who had apprenticed at the Blythe Colour Works—the pottery's fortunes improved. Abraham Fielding began the production of majolica at S. Fielding and Son. The factory was expanded in 1885 and 1892, at which time the firm manufactured glaze for its own use and for sale to other majolica makers. The production of majolica was continued until 1900, at which time the pottery turned to the production of vellum ware. The firm remained in the hands of the Fielding family until at least the 1950s. (Jewitt's information on this company is significantly updated by an article entitled "Romance of a Family Firm," in the British periodical *Pottery and Glass,* August 1956, pp. 252–255).

Jewitt records (p. 626) that by the early 1880s Fielding introduced his version of "Majolica argenta," using the Wedgwood term Argenta. Fielding's argenta pieces were less well modeled and glazed than Wedgwood's. The special appeal of Fielding's work, however, comes from charming naturalistic motifs and textured backgrounds.

Samuel Lear. Advertisement in
the *Pottery Gazette*

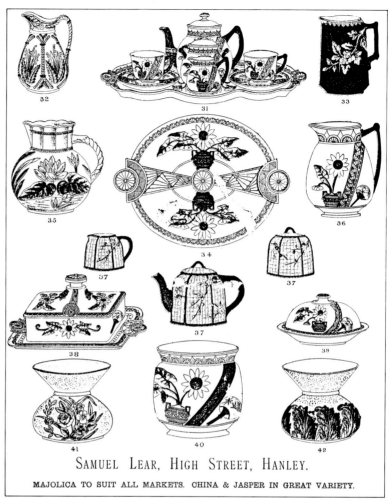

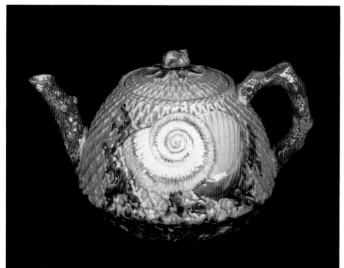

S. Fielding & Co. Teapot. 1882. Height 4½″

Right: S. Fielding & Co. Pitcher. c. 1883.
Height 7⅜″

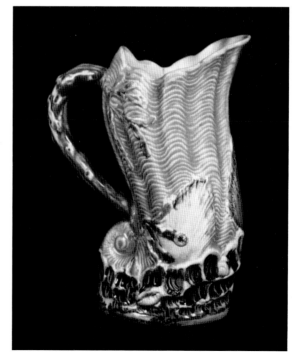

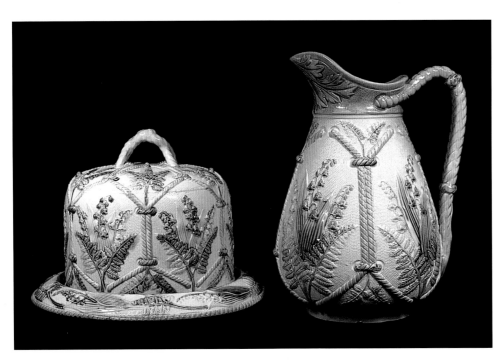

Samuel Lear. Cheese bell and pitcher. Bell height 8½"; pitcher height 12½"

S. Fielding & Co. Butter dish and punch bowl. 1882. Butter dish height 4½"; bowl diameter 9"

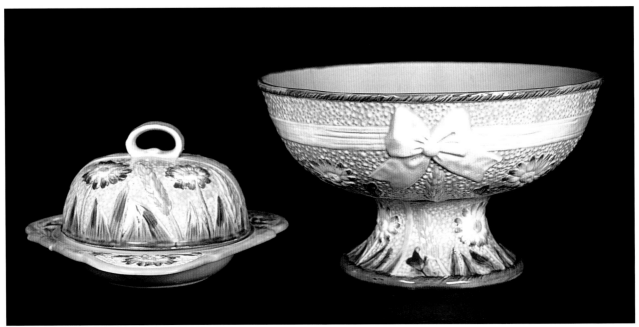

Glazes, although not as brilliant as those on majolica from major potteries, are of good hue and intensity. Fielding pieces, in turn, have been imitated, but without the intricate details, the characteristic background textures, or the well-modeled edgings.

Patterns include Shell and Net, Bow and Floral, Ribbon and Leaf, Fan and Insect, Fan and Scroll, and Fan and Bird. Tablewares were produced in abundance:

dinner and tea services, bread plates, butter pats, butter dishes, platters, mugs, mustache cups, pitchers, oyster plates, syrup jugs, ice-cream services, footed goblets, and punch bowls. Dressing table sets, wall brackets, and cuspidors were also manufactured. Although argenta white was the most frequent background, the alternatives included pale and cobalt blue, yellow, and gray.

Fielding's textured backgrounds added a welcome

114

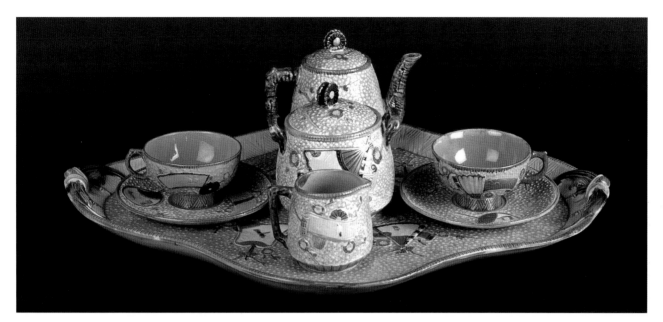

S. Fielding & Co. Fan and Scroll tea set. c. 1875. Tray: 20¾" x 16". Teapot: height 6".
Creamer: height 3". Sugar bowl: height 5½". Cup height 2¼". Saucer: diameter 6"

variety to the repertory of late Victorian majolica patterns. The Shell and Net pattern, in an excellent tea service, has a raised netlike background and a multicolored variety of snail, conch, and scallop shells, entangled with brown-black seaweed, all caught in the net. Inspired by Wedgwood's Ocean design, blue waves swirl at the base of each piece; the handles and spouts simulate red coral; and a small snail shell forms the finial. A set of graduated pitchers, copied by American potters, has a background of undulating lines of blue waves, with a base of large shells and a coral handle. The Bow and Floral pattern has a rough, papillated background, with borders of red, yellow, blue, and white daisies or blue and pink morning glories around the base. White, pink, blue, or yellow ribbons near the top of the piece are tied in a bow. Ribbon and Leaf features leaves, strawberry blossoms, and a superimposed ribbon and bow on a well-modeled basket-weave background.

The oriental influence is seen in the several fan patterns. Backgrounds are either stippled or smooth. Fans in the multicolored designs are pleated or paddle shaped, decorated with insects and butterflies and placed at random among prunus blossoms and stylized chrysanthemums. One of the most carefully modeled and glazed pieces is the Fielding's fan-patterned oyster plate on which the yellow paddle-shaped oyster concavities encircle a cobalt-blue space for sauce. The Fan and Scroll design on a large platter also includes insects and prunus blossoms. On the scroll there is an incised clipper-ship motif, no doubt in honor of the international trading fleets.

Other Fielding patterns include a series of graduated hexagonal pitchers in a Bird and Bamboo design, on a simulated woven-straw background. The handle is a large bamboo reed and the background colors are brown, pale or cobalt blue, ivory, or yellow. Fielding baskets with large twig handles are decorated with a moss-rose motif on a woven-straw background. Jewitt (p. 626) described a Fielding vase more than twenty-four inches tall, with handles formed of rose branches and with roses gracefully arranged along the sides. The cover of the vase is in the form of a robin on a bed of roses. Jewitt judged this piece to be one of the highest achievements in majolica. Other large pieces included a garden seat and an umbrella stand, each decorated with storks in a marshy landscape.

Considering that Fielding was one of the better potters of the era, it is unfortunate that all of his firm's work was not fully marked. Marks include "FIELDING" impressed, or the name of the pattern on a ribbon, with "S.F.

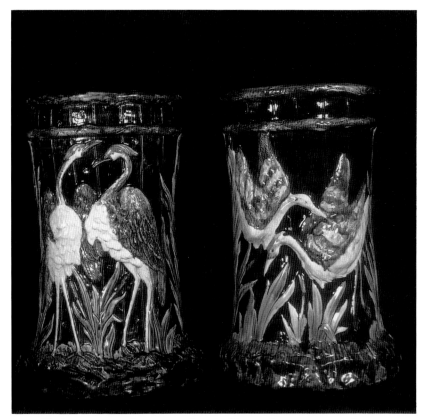

S. Fielding & Co. Garden seat and umbrella stand. c. 1880. Heights 19¾"

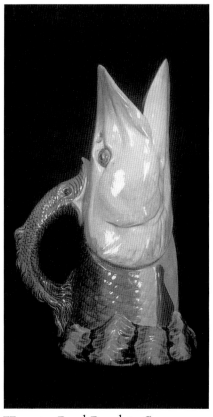

Worcester Royal Porcelain Company Ltd. Fish pitcher. 1886. Height 11½"

& Co." printed. Many pieces had a British registry mark, without the Fielding name, and others had a small black factory code number with the registry mark. Jewitt reported that the mark of the company also included a gamecock. S. Fielding and Company, Limited, using the trade name Crown Devon, continued until at least the early 1950s. The firm had produced an excellent line of hand-painted vases, as well as good quality earthenware. A majolica collector would recognize an earthenware ewer, with its handle in the shape of a riding crop, as borrowed from George Jones. This motif reflected the sporting interests of both Abraham Fielding and his son A. R. Fielding, chairman of the board of directors until his death in 1947.

Worcester

In 1852 the Worcester Porcelain Works (founded in 1751) were directed by new partners, R. W. Binns and W. H. Kerr, who continued in the fine tradition of Worcester. Jewitt said of Worcester majolica that "The body is finer and more compact than that frequently used by manufacturers, and the colouring faultless and in the purest taste" (p. 147).

Collectors of majolica have only recently become interested in Worcester products. Worcester's majolica is more refined and less vigorous than that of almost all other potteries. The pieces are lighter in weight and the clay used is whiter than Wedgwood's. Majolica pieces produced by Worcester include dinner and dessert services, tea and coffee services, pitchers, floral table decorations, spill vases, wall brackets, and shell-shaped compotes incorporating dolphins.

Most typical of the Worcester style are the examples described here. The mouth-pouring fish pitcher (1886) is modeled as an open-mouthed pike leaping out of the blue waves at the base; the pitcher handle appears to be a mythical fish. Although the glaze is brilliant, the coloring is not as accurately applied to the design areas as it is in the work of the major majolica firms, and the color palette is more subdued. A thirty-six-inch-high heron

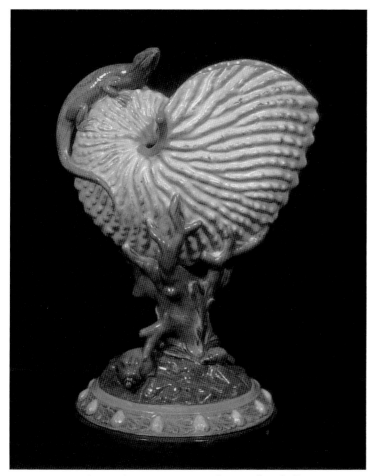

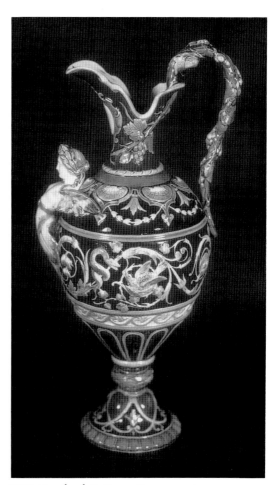

Worcester Royal Porcelain Company Ltd. Nautilus shell. c. 1880. Height 9"

W.T. Copeland & Sons. Ewer. c. 1870. Height 14"

walking-stick stand is similar to the Minton stork and heron examples, but the foliage on the Worcester piece is less ornate and the stick stand is a simple cylinder in the form of a hollow bamboo stalk. A dolphin compote sweetmeat dish is a miniature version of a Minton piece and an antecedent of the American version produced by Griffen, Smith and Hill. Minton's nautilus shell is reinterpreted by Worcester, with the amusing addition of a curious lizard climbing on the shell. Amid ocean waves, a ring stand in the shape of an antique boat, with an eagle-head prow, is steered by a *putto*. As did Minton, Worcester also produced ceramics in the Henri Deux style, although the inlay technique was not as frequently used as at Minton.

The firm's mark, which has been in use from 1862 to the present, and which was also used on majolica, is an incised rosette of four "w"'s, with a "c" in the center, a crown above the rosette, and, from 1862 to 1875, a double-digit number below the rosette indicating the year (66 = 1866). From 1867 to 1889 alphabet letters were also used to indicate the year (not all letters were used, and not always in sequence). The significance of several brown dots, which appear on some pieces, is not known. From 1892 to 1915 various arrangements of dots, up to twenty-four, signified the year. The business is now under the name of the Royal Worcester Porcelain Company Ltd.

Copeland

The Copeland-Spode Museum in Stoke-on-Trent has only three or four pieces of majolica made by W. T. Copeland & Sons, but the technique is of excellent quality, with delicate modeling and jewel-like glazes. Copeland, like Worcester, specialized in fine porcelain,

117

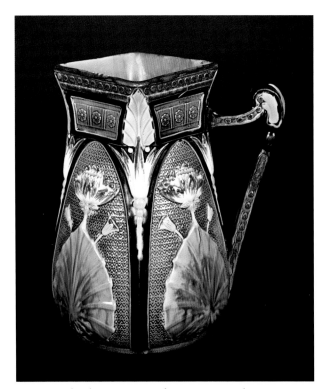

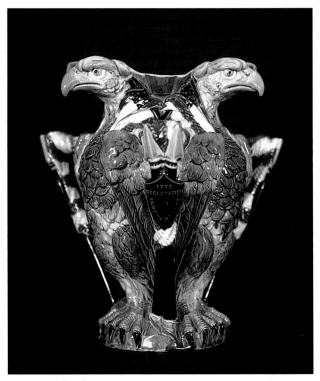

W.T. Copeland & Sons. Pitcher. 1877. Height 7¾" W.T. Copeland & Sons. Tricorne vase. 1876. Height 9½"

Wm. Brownfield & Sons. Isle of Man teapots. c. 1880: Union Jack teapot. Height 8½"; Gentleman teapot. Height 10"; Rope teapot. Height 9½".
Joseph Holdcroft. Isle of Man tobacco jar. Height 9½"

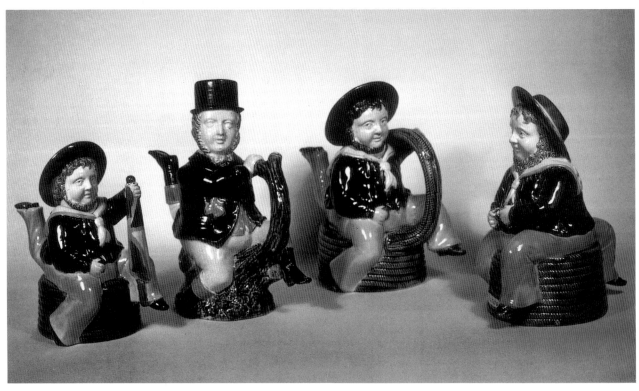

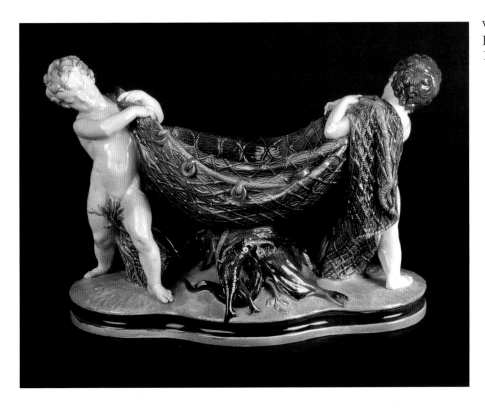

W. T. Copeland & Sons.
Fishermen centerpiece.
1877. 9 ¼ x 14 ½"

John Adams & Co. Illustration of Adams's
Productions, Exhibition of 1871, from Jewitt,
Ceramic Art of Great Britain, 1883

Wm. Brownfield & Sons.
(H. Evans) Illustration of
fountain from Jewitt, *Ceramic
Art of Great Britain*, 1883

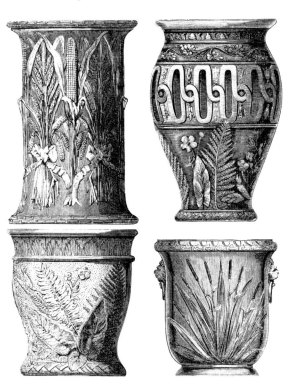

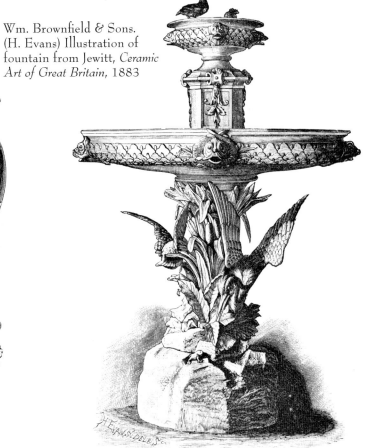

119

and produced majolica as well. Jewitt, in his discussion of Copeland, does not mention majolica production, despite the fact that a majolica example of his Figure 1045 (upper left), which illustrates a ewer in the Renaissance style, is known in a private collection. This ewer is very similar to the Minton example in the Cellini style. Pieces of Copeland majolica in the Copeland-Spode Museum include a pair of large, elegant Renaissance-inspired bottles and a symbolic representation of Sloth and Mischief, portrayed by a naturalistically glazed tortoise carrying a monkey (#631, 1877). Copeland also produced pairs of garden seats in the Renaissance style.

Green-glazed leaf plates, baskets, and compotes, usually unmarked and very similar to those of Wedgwood, were also a specialty of Copeland. Possibly the most frequently encountered marked Copeland majolica is a series of graduated pitchers in the Egyptian Lotus pattern (1877), with the impressed marks found on Copeland majolica: the name "COPELAND" and the British registry mark. The marks on the pitchers also include a number indicating specific gill measurements. These pitchers are decorated with four lotus flowers and leaves on a tiny overall geometric background, with the subtle diamond shape of the pitcher's body defined by cobalt-blue panels and lotus blossoms near the flaring pitcher opening. The other colors include Copeland improvements in glazes—cerulean blue, Sardinian green, and a rich vermilion.

Of historical importance is the tricorne Copeland vase, with boldly modeled eagles at each corner, produced for the 1876 Philadelphia Centennial Exhibition. Three shields proclaim: "1776/Declaration of Independence"; "1876/Centennial Memorial"; and "Washington/Father of Our Country." The piece is marked "Manufactured by W. T. Copeland and Sons Solely for J. M. Shaw and Company, New York."

The Copeland-Spode reputation has always been based on the production of fine porcelain, Parian, and earthenware, and the firm continues that tradition to the present. The continuity of active participation by English pottery families is once again demonstrated by Robert Copeland, historical advisor to Spode Ltd. and a direct descendant of the William Taylor Copeland who had been Josiah Spode II's partner from 1813 and who in 1833 acquired the Spode pottery, founded in 1776 by Josiah Spode.

120

Brownfield

In 1836 the firm of Robinson, Wood and Brownfield established a manufactory in Cobridge at the Cobridge Works on the site of an older pottery that had been erected by Brownfield's father in 1808. Robinson died later in 1836, and after Wood retired in 1850 the firm was headed by William Brownfield alone. In 1871 his oldest son, William Etches Brownfield, became a partner in the firm, which was then known as Wm. Brownfield and Sons. William Brownfield, Sr., died in 1873. William Etches Brownfield retired about 1890. The business was reorganized in 1891 as a cooperative enterprise by Arthur Brownfield and was known as Brownfields Guild Pottery Society, Ltd., but by 1900 the works had been demolished.

Although the firm had originally produced ordinary earthenware of the white, sponged, or blue transfer-printed variety, by 1850 Brownfield had so improved production that their earthenware, enameled, and gilt pieces were considered to be excellent. About 1871 Brownfield started the production of majolica, supported by the talents of Protât and Carrier-Belleuse (who had worked on majolica at Minton and Wedgwood) and by the arrival from Minton in 1872 of Louis Jahn, who served as art director at Brownfield until 1895. The factory employed about six hundred people in the 1880s and enjoyed trade with Europe, Russia, and the United States.

Jewitt wrote that "Majolica is another of the specialties of Brownfield's manufacture, and this they produce of the highest class of excellence both in body, in firmness of glaze, in brilliancy of colour, and in design" (p. 475). The most impressive example of Brownfield majolica was a fountain more than sixty inches high. It is powerfully modeled, with an intricate base of birds with outstretched wings surrounded by bulrushes. Above the base is a wide and tranquil fountain with a center column supporting a bird bath, complete with two birds. Although the firm's original output included all the "usual ornamental and useful articles known to the trade" (Jewitt, p. 475), the Brownfield pieces most frequently seen today are bird-shaped pitchers with monkey handles, urns, dessert services, and figural teapots.

The best known of Brownfield's figural pieces of majolica are the Isle of Man teapots, in the shape of a three-legged British tar seated on a coil of rope. The

third leg is the teapot spout. As with many figural teapots, the head serves as the teapot lid. In the more common version (eight and one-half inches high), the handle of the teapot is fashioned as an umbrella in the form of a furled Union Jack. In the rarer version (nine and one-half inches high), the teapot handle is formed as a length of uncoiled rope. At the corners of each sailor's collar is a "Manx," the motif composed of three legs radiating from a central point that is the symbol of the Isle of Man. Rarest of the three-legged teapots is one of a gentleman in riding attire complete with top hat.

On the undersurface of many of these Isle of Man teapots an advertising message is inscribed in slip: "W. Broughton, China Room, 50 Duke Street, Douglas." Peter Kelly, secretary of the Manx Heritage Foundation, wrote in a letter to the authors (dated 9 December 1986) that Samuel Broughton, dealing in glass, china, and earthenware, opened a shop in 1845 in Douglas, the capital of the Isle of Man. W. Broughton, who commissioned the teapots from Brownfield, appears in Douglas city directories after 1885 and was listed in Brown's Directory of 1894, advertising his china shop and the three-legged teapots. Directory advertisements were not unusual, but it is rare to find a piece of English majolica itself used as an advertising medium. There is, however, the George Jones plate inscribed "Biarritz," and several pieces of American majolica are marked to promote banks, theaters, tobacco, and so forth. Souvenir pieces in the shape of the Isle of Man teapot were produced in German factories in the nineteenth century as well as in recent years.

An interesting reprise of this unusual three-legged figural form appears as a jar inscribed "TOBACCO" with the same decoration as the sailor teapots—marked "JH" on a celadon undersurface, undoubtedly the work of Joseph Holdcroft, using the Brownfield mold.

The Brownfield mark on earthenware from 1850 to 1891 was the printed, impressed, or molded Staffordshire knot enclosing the initials "W" and "B." From 1871 to 1891 the mark was "W.B. & S." The impressed name "BROWNFIELD'S" or "BROWNFIELD & SONS," often with a crown, was also used. A printed double-globe mark was used from 1876 to 1891. From 1891 to 1900 the impressed mark "B.G.P. CO." designated Brownfields Guild Pottery Society, Ltd. The short-lived Brownfield's Pottery, Ltd. (c. 1898–1900) used a printed monogram "BPC" or the printed name "BROWNFIELDS." (See Cushion, *Marks,* pp. 128–129; and Ralph and Terry Kovel, *Kovels' New Dictionary of Marks,* p. 220.)

Brownhills Pottery Company

The Brownhills Works, in Tunstall, were bought in 1871 by James Eardley, of Alsager, and continued by his son and four sons-in-law under the name Brownhills Pottery Company until 1896, when Salt Brothers took over the firm. From 1872 to 1896 Brownhills made earthenware, stoneware, buff, turquoise, and cream-colored ware. On ornamental pieces the marks included the pattern name and the letters "B.P.CO." printed (Jewitt, p. 471). A majolica pitcher with a stippled, cobalt background is decorated with white herons standing among bulrushes and cattails. The modeling is not as dramatic as in pieces from the major manufactories, but the glaze is excellent and the colors are bright. The marks are "HERON" and "B.P.CO." printed. Among the firm's other wares are salt-glazed stoneware tea services and toilet sets with a bamboo pattern in brown, tan, pink, and green on a beige background, which have mistakenly been considered majolica.

Adams and Bromley

The Adams family had been active in pottery making in Staffordshire since the fifteenth century. Victorian majolica was a specialty of the firm of John Adams and Company, Victoria Works, St. James Street, Hanley. From 1864 to 1873 the company produced earthenwares, stonewares, and majolica of great quality. Two examples are especially important. One is a cylindrical garden seat that has simulated woven straw at the top and bottom, and, around the sides, ears of corn alternating with sheaves of wheat adorned by pink bows, on a brown background. The other is a large jardiniere with a cobalt- or brown-glazed and stippled background on which there are well-modeled ferns, leaves, and yellow primroses. The jardiniere, with an under plate trimmed with a stylized leaf border to match the top of the jardiniere, was produced in three sizes, all of which were reproduced by lesser majolica potteries. The marks on other wares of the firm were either "J. ADAMS & CO." or "ADAMS & CO." impressed, but many pieces, especially majolica, were not marked. Although the garden seat and the jardiniere mentioned above are not marked, they can

121

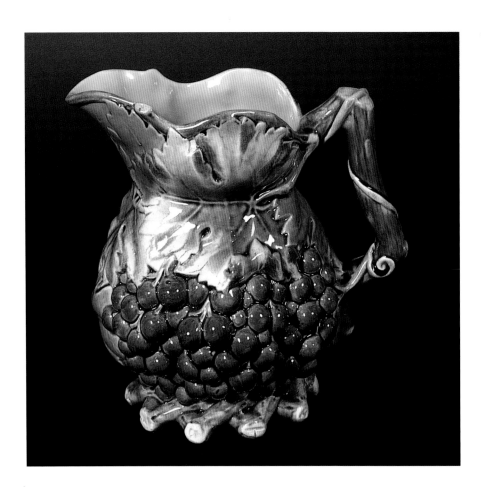

be attributed to John Adams and Company because they are illustrated in Jewitt (p. 502) as that firm's production and were displayed at the London exhibition of 1871.

From 1873 to 1886, with the introduction of a new partner from one of the many Staffordshire potting families, the company was known as Adams and Bromley. The factory produced majolica, jasper, and Parian. The marks, printed or impressed, were "ADAMS & BROMLEY," "A. & B.," or "A. & B./SHELTON." The entire output of the manufactory was considered by Jewitt (p. 502) to be of "high class, both in quality and design." Majolica was a major part of Adams and Bromley's production. In the absence of marked pieces it is possible to gain an idea of the extent of the firm's output from Jewitt (pp. 502–503), from advertisements in the *Pottery Gazette,* and from the catalogue of the 1878 Paris exhibition. Adams and Bromley produced bread trays, cheese bells, teapots, candlesticks, and vases with naturalistic themes, heavy modeling, and color applied accurately to the design areas. Dessert services were produced with leaf patterns

in a monochrome green glaze, and in polychrome glazes with water-lily or pear motifs. Cuspidors were decorated with handsome designs which belied their plebian purpose. Major pieces displayed at the 1878 Paris exhibition included a naturalistically colored British lion, twenty-four inches high by fifty-one inches long, in a couchant attitude with head erect; a cupid fountain thirty-eight inches high; and a forty-eight-inch-high pedestal fountain decorated with female busts terminating in lions' claws. One of the best-known pieces made by Adams and Bromley is a lily pitcher (1882) in an interesting hexagonal shape with a scalloped rim. The pitcher has a white background decorated with dragonflies and the base is shaped as a lily pad.

T. C. Brown-Westhead, Moore and Company

When T. C. Brown-Westhead, Moore and Company operated the Cauldon Place Works, Hanley, beginning in 1862, Cauldon had already had a long history. Founded by Job Ridgway in 1802, the firm went through a series

122

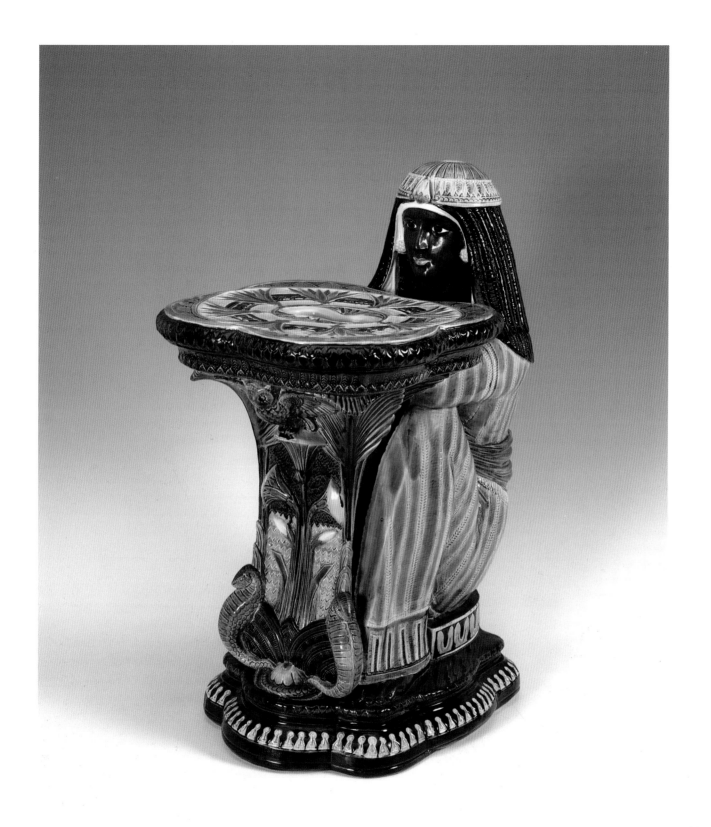

T.C. Brown–Westhead, Moore & Co. Garden seat. c. 1875. Height 22". (No. 1223). Courtesy Sotheby's, London

of partnerships until 1855, when it became J. Ridgway, Bates and Company. From 1858 to 1861 the name of the enterprise was Bates, Brown-Westhead and Company. In 1862, with the addition of William Moore, the business was called T. C. Brown-Westhead, Moore and Company. From 1862 to its reorganization in 1905 as Cauldon Ltd., the manufactory produced a wide variety of pottery and porcelain with great artistry. The output included majolica in the 1870s and 1880s. The factory was enlarged frequently and a great showroom was built, with a stone staircase of considerable grandeur. Over a thousand workers and artists were employed, including Antoine Boullemier, who had been employed at Minton. Indeed, Brown-Westhead majolica resembled that of Minton more than that of any other manufacturers.

Although Brown-Westhead, Moore's interest in majolica was limited, the pieces were excellent. An ornamental vase in the Palissy style was exhibited at the 1876 Philadelphia Centennial. The company is represented in the Victoria and Albert Museum by a majolica pitcher formed as a well-modeled cluster of sun-ripened grapes ready for the picking. Outstanding among the firm's pieces of majolica—which were two years in production and each was fired six to eight times—were two candlesticks, nine feet tall. Designed by Joseph Brown, each candlestick held seven branches of light on columns seventy-two inches tall. The bases were forty inches in diameter. Heavily sculpted, with floral and geometric designs, one was decorated with polychrome glazes and the other was colored blue and white. Joseph Brown also designed life-size tigers, which were naturalistically colored and rested on bases ornamented with jungle foliage. These impressive ceramic sculptures, sixty-four inches long and forty-six inches high, were modeled by a Mr. Marshall of the London Zoological Gardens. Brown-Westhead, Moore also produced life-size swans, dogs, and cats. A sculpture depicting an Arab resting beside his camel is dramatically modelled and naturalistically glazed.

Smaller pieces of Brown-Westhead, Moore majolica include a compote fashioned out of a simulated-wicker bowl decorated with blossoms and lined with a beautiful blue glaze, resting on a tripod of twigs. It bears some resemblance to a Wedgwood compote, but the twigs and the blossoms are not as detailed. A trivet shaped as a crocheted doily is the essence of Victoriana. A series of

graduated pitchers with a cobalt-blue background decorated with ferns and blossoms is as crisply executed as Minton workmanship, as is a game-pie dish with a simulated-wicker body. The cover of the dish—decorated with straw, ferns, and arrowhead leaves on a brown background—depicts a barnyard chick about to drink rainwater out of a fragment of a bowl on the ground. An oak tree nearby lends its branches for the handles of the dish, and its leaves and acorns provide further decoration. A garden seat marked "T.C. Brown-Westhead, Moore & Co." is exotically modeled with Egyptian motifs. An Egyptian slave girl supports the seat, which is decorated with palm fronds, lotus blossoms, cobras, and an owl. One example of this design, without the firm's name, is marked "1256" in black paint. Another special Brown-Westhead, Moore piece is a wall pocket designed for a Christmas hearth. On the brown, bark-textured plaque, complete with *trompe-l'oeil* nail, there is a tightly woven long wicker hamper decorated with holly and berries, resting on a Yule log. Less thematic pieces include large vases with floral designs, glazed in turquoise or mazarine blue.

The marks on the majolica game-pie dish are "T.C. Brown-Westhead, Moore & Co." with "30" beneath it, and "1223" in black paint, perhaps the stock number. The wall pocket is marked "T.C. Brown-Westhead" with "486" incised and "447 B" painted in black. Marks used between 1862 and 1904 also included "B.W.M." and "B.W.M. & CO." impressed or printed.

Banks and Thorley

The firm of Banks and Thorley, established in 1873 at the Excelsior Works, New Street, Hanley, left that site in 1879 and built a new manufactory, the Boston Works, on High Street. In 1887 the business became known as Banks and Company, and then as Edward Banks, from 1888 to 1889. Banks and Thorley, according to Jewitt (p. 506), used no manufacturer's marks. Identification of occasional pieces can be made, however, if they bear the British registry mark. Most of Banks and Thorley's pieces with registry marks were of the mid- to late-1880s. The undersurfaces of these pieces are white, cream, or yellow. The pottery's excellent reputation rested on its production of majolica, terra-cotta, jet, and stoneware. Jewitt pronounced that "Many of these [majolica pieces] are of a high degree of merit in design and their

production is faultlessly good" (p. 506). Pieces included cheese bells, bread trays, dessert and tea services, jugs, egg-cup trays, jardinieres, and ornamental articles. Jewitt singled out for praise one tea-service pattern with a rich chocolate-brown background, decorated with ivy, ferns, and anemones. The deep-brown background was repeated on a series of graduated jugs, decorated with green thistle leaves between buff-colored twisted ropes.

Two designs that have been identified from the British registry marks as made by Banks and Thorley are Bamboo and Basketweave (Mariann K. Marks, *Majolica Pottery*, p. 66) and Fern, Floral, and Bow (Marks, p. 107). Both are delicately modeled. The first pattern, glazed in buff on a basket-weave background, is decorated with green-and-pink bamboo flowers and stalks. This design was used for tea services, syrup jugs, pitchers, butter dishes, plates, and baskets. The second pattern, glazed in pastel colors, with a blue geometric border, is ornamented with pink flowers and light green ferns. Two yellow curved lines punctuate the white basket-weave background.

Wardle and Company

Wardle and Company, Hanley, was active in the production of earthenware and majolica from 1871 to 1910. The company was unfortunately not documented in either the 1878 or the 1883 edition of Jewitt's *Ceramic Art of Great Britain*. In Geoffrey Godden's 1972 revision of Jewitt's book (p. 81), the name of Wardle and Company is listed with pottery firms that were active in 1900. The firm, in William Street, Hanley, was founded in 1868 by James Wardle, who died in December 1871. Trade directories indicate that the pottery produced majolica and Parian and that the business, under the name Wardle and Company, moved in 1884 to Victoria Road, Hanley. After Wardle's death the manufactory was operated by his widow, Eliza, and her son-in-law, David Jones, who died in 1908 (Alfred Huntbach, *Hanley, Stoke-on-Trent, 13th to 20th Century*, p. 143). The firm's mark was "WARDLE" impressed. The production date can be determined from the British registry mark on the glazed white undersurface.

Wardle designs include the naturalistic plant and sea motifs that appeared on earlier English majolica. The modeling of Wardle pieces is excellent, albeit less detailed than that of major potteries, and the glaze is less

brilliant. The familiar Fern and Bamboo pattern is rendered on a background of a deep-brown glaze over parallel bamboo stalks. There are also examples with ivory or pink backgrounds. Large glistening green ferns undulate their way across the surfaces of the pieces. (The American Griffen, Smith and Hill Bamboo pattern resembles both the Wardle and the Banks and Thorley pieces, but is more simply executed.) Fern and Bamboo appeared on dinner and tea services, syrup jugs, graduated pitchers, bowls, cheese bells, mustache cups, and spittoons. A dramatic piece is the Wardle bread plate with its oval cobalt center surrounded by green ferns on a brown background.

Wardle's Bird and Fan is one of the more colorful versions of this familiar orientalized pattern. On the conventional assortment of majolica forms, the Wardle hummingbird darts across blue and pink fans, flying toward branches of prunus blossoms. Rough-textured backgrounds are white, perhaps inspired by the Wedgwood Argenta patterns, which this Wardle design most resembles. Linings are lavender, and the undersurfaces are white.

The Sunflower pattern, on a pebbly blue or ivory background, might more accurately be called Sunflower and Lily, as both flowers are represented on each piece. A branch-handled platter that displays both sunflower and lily, reminiscent of Oscar Wilde, is attributed to Wardle (Marks, p. 77). On hollow pieces, such as bowls and teapots, the two flowers decorate opposite sides. These pieces are not marked, and attribution is made by comparison with documented pieces. A question of identification sometimes arises from confusion of the Wardle Sunflower pattern with other English and American sunflower designs.

A beautifully modeled but unmarked Pineapple bread tray with an oval brown center has also been attributed to Wardle and Company (Marks, p. 88). There are many variations of both the Pineapple and the Corn majolica patterns — English and American — which are not marked, and they represent the need for further research.

Wardle's contributions to the many shell and seaweed designs include an extremely attractive tea service (1882) decorated with large pink-and-white scallop shells in an aquamarine sea with modeled waves. Small cowrie shells float near coral and seaweed; handles and cover finials simulate branches of coral; and the lids are edged with

125

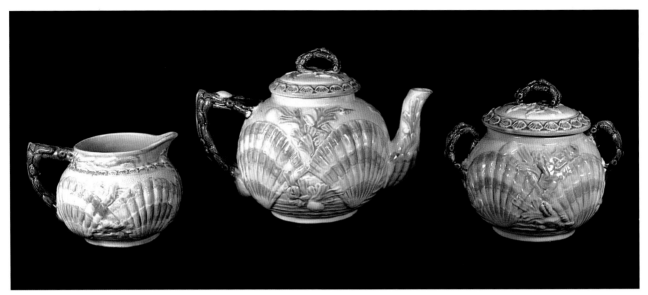

Wardle & Co. Tea service. 1882. Teapot height 5¼″

tiny yellow scallop shells. There is little visible of the stippled white background. The teapot has either a ceramic or a pewter lid. The handsomest piece of Wardle shell and seaweed majolica is the large bread tray, in which the oval interior depicts brilliantly colored scallop shells, seaweed, and coral against blue waters. The everted rim is decorated with golden scallop shells, coral, and seaweed.

Shorter and Boulton

At the Copeland Street Works (formerly Billington and Company) in Stoke-on-Trent, Shorter and Boulton began the production of majolica in 1879, with patents registered through 1882. Their wares, primarily for the American and Australian markets, included breakfast and tea services, trays, jugs, vases, and flower stands. The white undersurfaces were not marked with the company's name, but frequently bore the British registry mark. All known pieces have factory numbers and letters in heavy black enamel.

Although Jewitt describes this majolica as "strikingly original" (p. 423), the most outstanding pattern is the familiar Bird and Fan (1881). A well-colored hummingbird, a brown-and-blue fan, and a sprig of prunus blossoms are placed on a pebbly, irregularly glazed blue or ivory background. Inner surfaces are glazed pale majolica pink.

Victoria Pottery Company

The Victoria Pottery Company, listed in Jewitt (p. 427), was established in 1882, in Lonsdale Street, Stoke, by Robinson, Leadbeater, and Leason for the production of ornamental and useful earthenware and majolica. Despite the fact that the manufactory's output was of "more than average excellence" (according to Jewitt), the pottery was short-lived. The mark on the firm's majolica is "VP/C" impressed, surrounded by a triangle of swords.

The pieces are meticulously modeled and glazed. A sardine box, with attached under plate, has a finial of three crossed fish resting on pond-lily leaves, with two other fish partly hidden by the leaves; bamboo leaves grow from bamboo stalks around the edge of the box and under plate. The body of the dish is deep brown and modeled in the same basket-weave design as the Brown-Westhead, Moore game-pie dish previously described. The interiors of both pieces are glazed in the same turquoise hue. The undersurfaces, however, are different: the sardine box has a gray glaze and the game-pie dish has a white glaze.

A cheese bell made by the Victoria Pottery Company is decorated with bamboo stalks and leaves on a cream-colored basket-weave background. The bell is topped with a twig finial. The inner surfaces are glazed in an unusual way, with the inside of the dome and undersurface of the plate white, but the top of the plate blue.

126

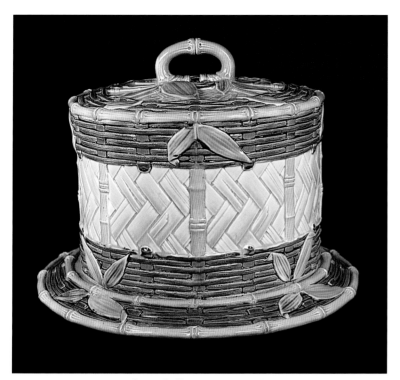

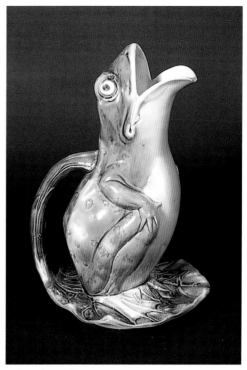

Victoria Pottery Co. Cheese bell. c. 1882. Height 11″

Edward Steele. Frog mouth-pouring pitcher. c. 1880. Height 12½″

Warrilow and Cope. Pitchers. c. 1882. Heights 5″ and 16″

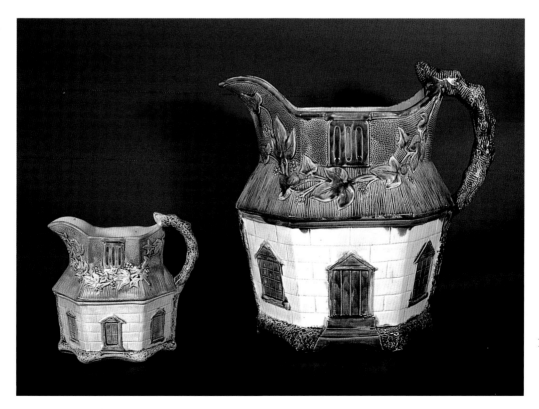

Samuel Alcock and Company

The Hill Top Pottery (also called the Hill Pottery)—formerly owned by Ralph Wood—was operated in Burslem from about 1828 to 1859 by Samuel Alcock and Company, which rebuilt and enlarged the works in 1839. The firm produced porcelain, Parian, and earthenware. Two simply decorated but well-modeled and well-glazed majolica examples marked "S. Alcock & Co." are known. One is a pitcher; the other, a marmalade jar.

Edward Steele

A lesser-known producer of majolica was Edward Steele of the Cannon Street Works, Hanley. The factory, owned by Thomas Ford and his descendants from the early nineteenth century, was operated by Steele from 1875 to 1900. The 1881 census for Basford Bank shows that Steele, then forty-three years old, employed sixty men and boys in his earthenware manufactory. Jewitt reported that, in addition to stoneware and Parian of good quality, the enterprise produced both useful and ornamental majolica of "average excellence" (Jewitt, p. 500). No company mark was used. A well-modeled, graduated series of frog-shaped, mouth-pouring pitchers have been identified by means of the British registry mark as having been made by Steele. The figural frog pitchers, in emerald green and brown, portray the frog sitting upright on a lily pad; the stem of the lily pad curls up to form the pitcher handle. Steele also produced elaborate centerpieces and a colorfully glazed Toby jug celebrating Shakespeare's Falstaff.

Sandford Pottery

The Sandford Estate Pottery Clay Co. Ltd., established in 1859 by John Lawes, was primarily responsible for fireclay bricks and tiles but also produced a limited amount of decorative majolica and stoneware. Located in Wareham, Dorset, the factory fashioned three similar forms of relief-molded commemorative jugs in stoneware and in well-glazed majolica. An example of this rare majolica is a pitcher commemorating the reviews of the Crimean War volunteer troops by Queen Victoria, with a portrait of the queen surveying four figures representing her armed forces. "1860" is modeled at the lip; beneath the portrait is a ribbon inscribed "THE DEFENDERS OF OUR QUEEN AND COUNTRY." The inscription

around the base of the pitcher reads "OUR ARMY AND NAVY/BRAVE VOLUNTEERS." There is a monogram "I. G." within the design, but the modeler is unknown. The manufacturer's mark "SANDFORD/POTTERY" is incised on raised pads. The British registry mark indicates that the piece was patented in September 1860, soon after reviews of the volunteer troops took place in London and Edinburgh in June and August of that year (Henrywood, *Relief-Moulded Jugs 1820–1900,* pp. 211-213).

Warrilow and Cope

Warrilow and Cope took over the Wellington Works, Stafford Street, Longton, in 1880 and operated the pottery until 1894. It had been established in 1862 by G. L. Robinson and W. Cooper and by 1871 was known as Robinson, Repton and Robinson. Warrilow and Cope primarily made a great variety of china, but added majolica of "good artistic and commercial" merit (Jewitt, p. 549). An article on majolica in the February 1, 1882, issue of the *Pottery Gazette* described a tea service in the shape of cottages, produced by Warrilow and Cope, made in conventional sizes. Unmarked examples of cottage-shaped creamers and sugar bowls are known in private collections. An unmarked jug in this design, sixteen inches high and sixteen inches wide, is spectacular.

Winton Pottery

This pottery was established in Stoke by Grimwade Brothers about 1886. The name of the company changed about 1890 to Grimwades Ltd. Useful and decorative earthenwares were produced. An article in the February 1, 1889, issue of the *Pottery Gazette* illustrated a Grimwade majolica pitcher with flowers and leaves. An unmarked majolica example of the same design in a private collection has red flowers and green leaves on a brown background.

The same article also illustrated a majolica pitcher with a bulbous bottom and a cylindrical neck, decorated with a floral motif. A similar example in a private collection, with an illegible British registry mark but no maker's mark, is ornamented with a wild rose in pink and white with green leaves, on a white ground; the neck is blue with a geometric pattern.

Burmantofts

Burmantofts, established by Wilcock and Company, in Leeds, was a relative latecomer to the field of majolica (Jewitt, p. 300; Godden's revision of Jewitt spells it "Wilcox," p. 202). From about 1880 to 1904 the pottery produced large flower bowls and vases, dessert services, bowls, compotes, and cake stands, all well modeled and colorfully glazed. Ornamentation included *sgraffito* designs, barbotine flowers, and the familiar Victorian foliage motifs. Large plaques with central medallions, as well as ornamental pieces shaped as huge conch shells supported on coral bases, are glazed in pale marine blues. These early pieces were in the spirit of Victorian majolica, but later examples anticipated art pottery. The impressed marks were "BURMANTOFTS FAIENCE" or "BF" in monogram.

J. Roth

If indeed the incised mark "J.R./L." is that of J. Roth of London (Cushion, *Marks*, pp. 194–198), who registered designs at the Public Record Office from 1879 to 1881, it is a loss that more of Roth's works did not survive. It is intriguing to note that a London firm named Whittman and Roth advertised in the *Pottery Gazette* in December 1880 as producers of majolica. Could this be the same Roth? Examples of majolica with the "J.R./L." mark are humorous, well modeled, and well glazed. Known pieces include a wall pocket, a pitcher, a sardine box, and a saucer. A mottled blue, green, and yellow-glazed bird perches on the brown wall pocket modeled as a nest of twigs. On the cobalt-blue body of the pitcher a naturalistically glazed fish rises from a pale blue sea and returns into the sea on the reverse side. At the neck and spout there is an incised fretwork pattern on a brown border. Similar, smaller fish have been mounted as the finial of a handsome sardine box, also cobalt blue, with branches and flowers decorating the realistic "wooden" box. A George Jones-inspired yellow rope ornaments the edges of the box and the attached under plate. Both the sardine box and the lone saucer have yellow-green undersurfaces. In addition to the "J.R./L." mark in an octagon, there are four brown dots on the undersurface of the saucer. The significance of the dots has not been clarified. The saucer, which conjures up visions of a tea or dessert service, is rimmed with overlapping begonia leaves.

UNATTRIBUTED ENGLISH MAJOLICA

Just as there are many beloved anonymous English ballads and sonnets, so are there treasured pieces of English majolica of unknown origin. Jewitt lists numerous manufactories that included majolica in their inventories, but there are no known marked pieces by which to identify their production. In addition to the unknowns in English majolica, there is also the question of distinguishing anonymous English from anonymous American majolica. Efforts toward identification may be knowledgeable, arbitrary, or intuitive. Most collectors believe that, with the exception of the work of the American firm Griffen, Smith and Hill, English majolica is better modeled and glazed than American pieces, that the color of the English examples is more intense, and that English undersurfaces are most frequently deep yellow, cream, or finely mottled. Pieces with large-scale sponged patterns on the undersurfaces, and with much white-glazed space between the sponge marks, are often considered to be American. At one point it seemed that undersurface dots in twos or threes, or casually brushed letters or numbers, might indicate American potters, but that now seems an arbitrary decision. The quality of large pieces seems to indicate that they are English.

At this time, despite all research efforts, there are pieces that defy identification as to both country and maker. There are at least two familiar patterns of which some unmarked examples may never be identified accurately: a pond lily and a shell and seaweed. The pond lily design was produced by the better English manufacturers, most beautifully by Minton and George Jones. Anonymous pieces were not executed as gracefully. Leaves rigidly surround the pond lily on plates of various diameters. Matching compotes (six to thirteen inches tall) have pedestals composed of a single secretary bird or of a group of three stylized storks. (The designer of this majolica piece undoubtedly saw a table with a similar design shown by the London furniture manufacturer G.J. Morant at the London Crystal Palace Exhibition of 1851. The table is illustrated in Helena Hayward's *World Furniture*, figures 793 to 795.) A tazza in the pond-lily pattern has a base in the form of either two-inch-high birds or dolphins. The white, gray, yellow, or mottled green-brown undersurfaces yield no clue to the factory or

Unattributed. Platter.
Diameter 10½″

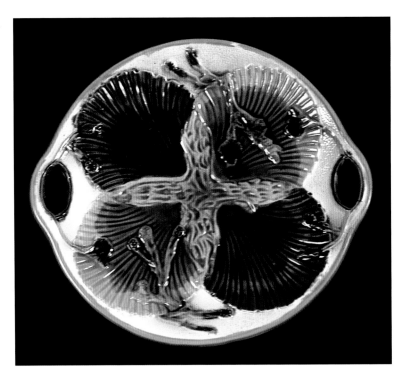

the country of origin, but the pieces are probably English.

Anonymous pieces in the shell and seaweed pattern are heavily modeled with scallop shells on a white or cobalt stippled background. The shells, nestled in aquamarine waves and strewn with seaweed, are carefully colored yellow and deep rose. Tea services, compotes, plates, platters, and cuspidors are found in this pattern, many with yellow rims. A butter dish, with a pink lining, has a deep border of waves around the dish, and a fish finial on the dome. Undersurfaces are white, gray-green, or mottled brown, either with black-enamel numbers or with no numbers. Some anonymous pieces in this version of the shell and seaweed pattern bearing a small "jc" in black ink have been erroneously attributed to James Carr, a British-born New York City potter. The pattern, executed with varying degrees of skill, and in different color palettes, was undoubtedly derived from the 1879 Wedgwood Ocean design.

Another unidentifed pattern, of asters on a white or blue stippled background, is frequently attributed to James S. Taft and Company of Keene, New Hampshire. Joan Pappas, an authority on Keene pottery, feels, however, that pieces in the aster pattern are not by Taft, and she considers them to be English.

Pineapples flourish on many majolica shapes. They are inspired by an exquisitely modeled Minton example. In the anonymous pieces the quality of the modeling and color vary greatly and are much less precise than Minton and Wedgwood examples. Pieces include dinner services, tea services, cruet sets, bread trays, egg-cup trays, sardine boxes, pitchers, carafes, compotes, cheese bells, hand vases, and cuspidors. Finials are in the shapes of blossoms, fruits, and geometric forms.

The corn pattern appears on a more limited range of anonymous majolica pieces. One factory, James Ellis and Son, of Hanley, has recently been identified, by examples bearing a British registry mark, as having produced a series of corn-cob jugs in 1869. (Private communication from Ian Smythe.) Forms made in the corn pattern include pitchers, syrup jugs, bread trays, tea services, and hand vases. It is sometimes difficult to determine whether pieces in the pineapple and corn patterns are of English or American origin.

Although anonymous pieces can be appreciated for their own intrinsic merits, if the collector can recognize the source of inspiration, interest in the piece may be greater. For example: a cheese bell with a cow finial and sprays of blackberry brambles owes its design to both George Jones and Wedgwood. The modeling of the cow

130

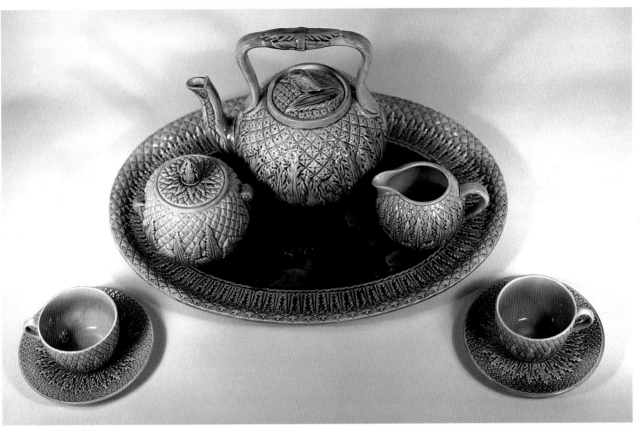

Unattributed. Tea service. Tray length 18″

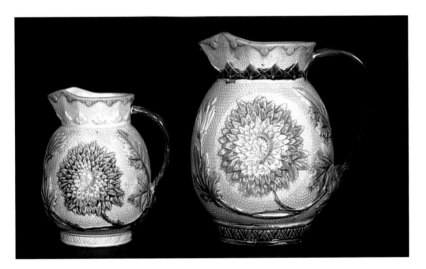

Unattributed. Pitchers. Taller height 7¼″

on the derivative example is primitive and the glazes of the blackberry brambles on the blue or brown bark background are not as brilliant as their predecessors, but the piece has great charm. Other well-executed anonymous cheese bells are also impressive, especially if the background is cobalt. These have been decorated with full-blown yellow and pink roses, herons in marshy settings, airborne butterflies, and pastoral scenes. There are also unmarked butter dishes, many of which match the patterns of the cheese bells. Triangular cheese keepers are rare in majolica. One, with a green and yellow-brown undersurface, is encrusted with white lilies and ivy leaves.

Unmarked sardine boxes often adopted the Minton or

131

George Jones finial of three crossed fish as well as side decorations of acanthus leaves, floral sprays, pond lilies, or marine scenes. Backgrounds are cobalt, brown, or white; inner surfaces are glazed white, pink, or deep green.

Bread trays anonymously dispense wisdom: "Eat Thy Bread With Thankfulness," "Waste Not, Want Not," "Give Us This Day Our Daily Bread," "Eat to Live, Not Live to Eat," and, most judiciously, "Where Reason Rules, The Appetite Obeys." Bread trays are almost always oval, but occasionally round. Corn, wheat, begonia leaves, floral displays, and oriental patterns are handsomely colored and set against backgrounds of cobalt, white, brown, or green. A separate category of bread tray is dedicated to man's best friend. A geranium leaf-bordered round tray has a central design of a dog and his doghouse; an oval tray bordered with stylized flowers portrays the dog and his own dish. It is not certain if these pieces are English or American, but a third tray, depicting a dog with a deer, is believed to be American.

Crescent-shaped oyster plates, with good modeling and yellow undersurfaces are considered English. Round oyster plates, nine inches in diameter, with cobalt or brown stippled backgrounds, probably from the same factory, have either yellow or mottled brown-and-white undersurfaces. (Because of the stippled backgrounds and workmanship, these could perhaps be attributed to John Adams and Company.) Large oyster plates, with concavities of alternating pastel shades of blue and pink, are considered American. Egg-cup trays, rarely found complete, are probably of English origin, especially those with a tortoiseshell pattern on the egg cups and on the upper surface of the frame. The body of the tray may be oval or round, and it is usually in a yellow or yellow-green basket-weave pattern, emulating a Minton design. Some are embellished with blue bows or medallions of cherubs' faces. Undersurfaces are white or yellow.

The many anonymous pitchers and their diminutive offspring, syrup jugs, are very difficult to identify unless a related piece with a British registry mark is found. A veritable forest of pitchers with "bark" and "tree trunk" backgrounds exists, decorated with wild roses, blackberry brambles, dogwood blossoms, or ivy tendrils. These patterns (without the butterfly spout) had been made by Minton, Wedgwood, and George Jones, and copied by other English potteries. One wild rose pattern featured a butterfly spout. A third generation of all the motifs appeared in American majolica, most notably the wild-rose pitcher with a butterfly spout made by Griffen, Smith and Hill. Pitchers in the above patterns were made in graduated sizes with pink, white, cream, turquoise, and cobalt backgrounds as well as the more naturalistic brown. The only vegetable design known on a pitcher is that of pea pods on a leafy vine trailing the length of the pitcher. Pitchers in all sizes and designs frequently were elevated to the status of ewers by the addition of a pewter lid. Pitcher undersurfaces were glazed white, cream, yellow, and mottled shades — some with black numbers and some with brushstrokes of numbers, letters, or dots.

Pitchers with bird motifs are frequently seen, especially in the bird-in-nest design. Here again there is confusion between unmarked English and American versions. The English series of graduated pitchers have irregularly modeled bodies, flaring out toward the base, and are glazed white, light brown, or gray. One or two birds fly to a nest to feed the newly hatched chicks. In the American series, the pitcher is more rounded, tapering at the base, with two birds sitting on the edge of the nest, waiting for the eggs to hatch. The body of the pitcher is irregular, glazed white or brown, and decorated under the spout with a large colorful begonia leaf. Some pitchers, in graduated sizes, are in the shape of owls and parrots. Less frequently seen are pitchers portraying vultures or eagles. Other pitchers depict hanging game, such as birds and deer, either in monochrome or polychrome.

Animal and amphibian motifs are rarely seen on pitchers, but fish designs appear more frequently. Elephants or deer parade around the bases of straight-sided vessels. Rustic examples depict a child and his faithful dog. On another, a fox eyes a bunch of grapes. The famous hound-handled pitcher, which originated in Staffordshire (and was duplicated at the American Pottery Manufacturing Company in Jersey City, New Jersey, in 1839 by the English potter Daniel Greatbach) was anonymously reproduced in monochrome and polychrome majolica. The body of the pitcher is decorated in relief with hunting scenes and the handle is in the form of a greyhound, front paws on the rim, peering into the pitcher. A very rare type of majolica hound-handled pitcher, in graduated sizes, is modeled with a woman

seated in front of a cottage, feeding three dogs, in naturalistic polychrome glazes. Anonymous imitations of the Minton cat mouth-pouring pitchers are not as well modeled or colored as the original. Graduated pitchers in the shape of crouching monkeys each carrying a sheaf of banana leaves were made by many manufacturers. The glazes and modeling vary considerably in quality. Pitchers with amphibian motifs include one that has, in Victorian naturalistic style, a snake slithering around a tree-trunk pitcher, with a frog perched on the lip, apprehensively observing the snake's approach.

Well-glazed fish motifs are found incongruously on ice-cream servers, such as the well-modeled octagonal platter with matching five-sided individual dishes. A swimming-fish pattern is seen on tea services and plates, with undersurface glazes of white, yellow, and mottled green and yellow. Gurgling-fish pitchers, in five graduated sizes, were made on both sides of the Atlantic, with off-white or yellow undersurfaces. The English examples are, in many instances, heavier, more carefully modeled and more brilliantly glazed than their American counterparts, but absolute identification is not possible without marks. A bizarre teapot modeled in the shape of a fish pours through a spout formed as a smaller fish, which is being swallowed by the other. The tail of the larger fish curls up to provide a handle. The gray-and-white glaze of the teapot and its sugar bowl and creamer is similar to the decoration on a series of unmarked graduated fish pitchers with angular bodies and on an eight-lobed oyster plate.

Strawberry dishes and baskets have been imitated in the best of style. The Minton-George Jones sparrow that has been found on Holdcroft pieces also appears on unmarked strawberry dishes. The undersurface should be examined because an excellent but unmarked piece with a rather dense, mottled gray-blue-black undersurface may have been made by Holdcroft. There are copies of the George Jones strawberry servers, with sparrows watching over cream and sugar wells. The modeling of the unmarked copies is not as sharp, the glaze is not as brilliant, and the undersurface is not as carefully mottled as the Jones originals. The sugar and cream containers of the anonymous imitations are merely concavities in the serving dish, not separate additional pieces. Wedgwood's trilobate strawberry service was imitated by English potters, again with only wells for sugar and cream; but

the American firm Griffen, Smith and Hill copied Wedgwood's version faithfully.

Majolica baskets may be oval, round, rectangular, hexagonal, or in leaf shapes. The sides are ornamented with flowers and leaves, birds, or sea life, and also, in two whimsical designs, with corset laces or luggage straps. Backgrounds are smooth, geometrically patterned, or pebbly; inner linings are well glazed. Many anonymous baskets never quite have the elegant look of the work of the major manufacturers, but because of the fragility of such pieces they are rare and valuable in a collection.

Plates and leaf dishes were made in profusion, and a great many are unmarked. The collector may gather many six- to eight-inch plates quite easily, but the nine-inch dinner plate is most difficult to find. One such large plate has a basket-weave background, with a blackberry-bramble center decoration. The background may be white, cream, light or cobalt blue, mauve, or brown. The undersurfaces are usually mottled, and some collectors believe that the finer the mottling and the heavier the plate, the more likely the plate is to be English. Begonia leaves that cover varying amounts of the surface of seven- to eight-inch plates were made by many English and American potters. Both color and degree of modeling distinguish one potter from another, although it is not possible to determine either the specific potter or the country of origin in the case of unmarked pieces. In the begonia-leaf pattern there are gradations of green and yellow tones in some examples, and more green, brown, yellow, and attractive variations of pink in others. Undersurfaces can be entirely white, yellow, mottled green, or mottled only under the rim around a white or yellow center. Many begonia plates have matching tazzas, compotes, and bowls. Plates in the shape of begonia leaves, which are many collectors' introduction to majolica, are ubiquitous. These leaf plates were glazed according to the whim of the artisan, and were produced in varying combinations of brown, green, pink, yellow, and occasionally red.

A seemingly endless number of platters were made, with such patterns as strawberry and bow, banana leaves and bow, bamboo and bow, leaf and dragonfly, fern and basket weave, as well as with an almost infinite variety of designs with flowers, ferns, leaves, corn, and wheat. There are orientalizing platters and plates with three fans on a ridged background, platters imitating the

133

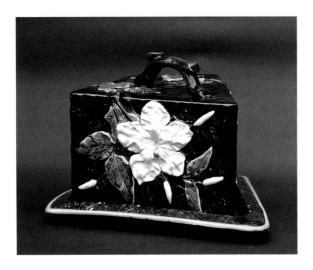

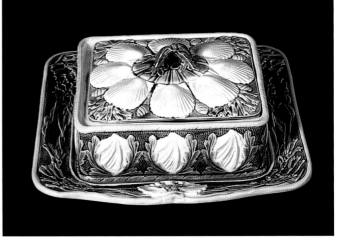

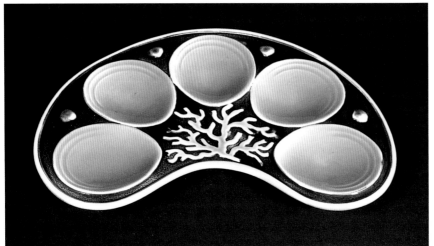

Above, left: Unattributed. Cheese keeper. Height 7½"

Above: Unattributed. Sardine box. Length 8½"

Left: Unattributed. Oyster plate. Diameter 9"

Wedgwood Ocean bread tray, platters with birds or pond lilies, platters with solid-color or mottled centers, and still-to-be-discovered platters—all attesting to the artistry of unknown Victorian potters.

Game-pie dishes for the most part were produced by the major manufacturers, and were not frequently attempted by lesser factories. Unmarked game-pie dishes in general tend to be poorly designed and proportioned, with mediocre modeling and less-than-brilliant glazing. There are, however, unmarked game-pie dishes with rabbit finials that have modeling up to the standards of the Wedgwood examples, but are poorly painted. Imitations of the George Jones game-pie dish with a partridge finial exist, with crude undersurface mottling and no marks. Game-pie dishes made in the latter years of majolica production reflect the decline of this type of ceramic ware. All of these same critical points may be made about the anonymous cuspidors, urns, and umbrella stands. These were usually decorated with floral patterns on smooth, basket-weave, or pebbly backgrounds. Undersurfaces of these latter pieces are usually white or yellow, occasionally with brown brushstrokes.

A number of unmarked mugs with naturalistic designs of flowers, fruit, and marine subjects were made by many English potteries. The most humorous of these is a type in which a realistically modeled frog crouches at the bottom, appearing to spring up as the liquid is imbibed by the drinker. These majolica frog mugs are descended from earthenware examples made in Leeds in the late eighteenth century. The exteriors of some of the nineteenth-century majolica frog mugs are decorated with ferns on a bamboo fence.

134

Illustration from the sales catalogue of importer Jones, McDuffee & Stratton, Boston

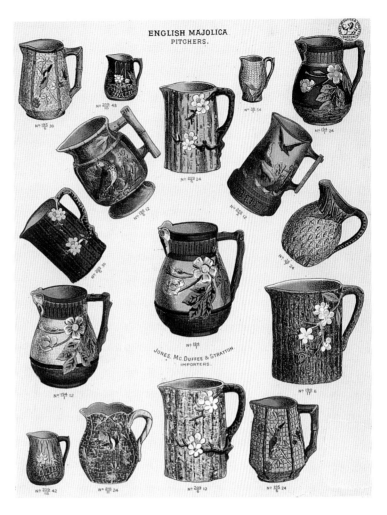

ENGLISH MAJOLICA
PITCHERS.

JONES, MC. DUFFEE & STRATTON,
IMPORTERS.

Unattributed. Monkey pitchers.
Heights from 7″ to 10½″

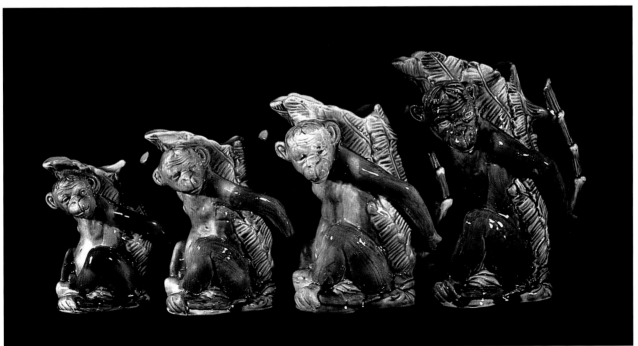

Finally, examples of the anonymous majolica pieces that are particularly characteristic of the Victorian era: the cruet set, the spoon warmer, the napkin plate, and the hand vase. Unmarked majolica cruet sets, usually in the pineapple pattern, bear little resemblance to the elegant Minton examples. The spoon warmer—a receptacle made in silver, silver plate, porcelain, and majolica—was filled with hot water to keep soup spoons warm. Originating in the 1860s, the spoon warmer was frequently in the shape of a large hollow shell or, more humorously, a hollow chick; Minton fashioned one as a dolphin with a large open mouth. One anonymous spoon warmer modeled as a sloping open shell on a base of rocks, is glazed in colors similar to those of pieces by George Jones, but is pallid by comparison. Despite the loss of crisp modeling and the poor undersurface mottling in the anonymous example, it is nonetheless engaging.

The napkin plate (modeled with a napkin in low relief) was produced in several sizes and color combinations, in majolica as well as in fine porcelain. The napkin motif is frequently embellished with flowers and leaves. These plates were used for desserts and fruit. The unmarked examples can be amusing, but are not as attractive as those by George Jones.

The Victorian hand vase of the 1850s and 1860s was produced in porcelain, Parian, and majolica. Alternatively named the "hand and cup" vase, the piece consisted of a realistically modeled hand holding a small flower vase. In English majolica the vase was most frequently in the shape of a pineapple or an ear of corn. In a rare example the vase is formed of lily-of-the-valley leaves and blossoms, and, with its Holdcroft-green undersurface, is probably English. On many hand vases the wrist was decorated with lace-trimmed cuffs and the fingers were often embellished with rings. The vogue for ornamental hands in Victorian times was inspired by the cult of spiritualism, the belief that the spirits of the departed can communicate with the living through the intercession of mediums.

POTTERIES FROM WHICH MAJOLICA HAS NOT YET BEEN IDENTIFIED

Jewitt listed in the second edition (1883) of *The Ceramic Art of Great Britain* a number of English potteries that were known primarily for the production of porcelain and pottery. In the case of the following companies, he tantalizingly indicated that they also made "majolica in all the usual variety of articles" (p. 422). Jewitt died in 1886. Godden, in his 1972 revision of Jewitt's book, added later chronology for some of the firms, but occasionally omitted Jewitt's mention of majolica among their production. The names of other English potteries that made majolica have been gathered from issues of the *Pottery Gazette* from 1880 to 1890. To date, no marked or attributable pieces of majolica have come to light from these factories. They are included here in the hope that future investigation will uncover pieces with as yet unrecognized manufacturers' marks or British registry marks that could help identify more Victorian majolica, and then, by comparison with such marked pieces, identify some of the anonymous examples.

Stoke-on-Trent

COPELAND STREET WORKS. Established in 1859 in the Albert Works, Liverpool Road, by G. Turner, J. E. Hassall, and W. Bromley for the manufacture of Parian and, ten years later, porcelain as well. In 1863 the Copeland Street Works were enlarged. In the 1870s and 1880s, the firm also manufactured majolica in the usual assortment of forms. A specialty introduced by Turner was the decoration of Parian pieces with majolica colors. In 1880 the company became Turner and Wood, and closed in 1888.

ALBERT WORKS. From about 1882 to 1895 J. and J. Snow used the Albert Works in Stoke for the production of useful and ornamental terra-cotta, jet, and majolica. The Snows also produced these same wares at the Pyenest Street Works in Hanley from 1877 to 1907.

Burslem

SNEYD POTTERY, Albert Street. The firm, which at first made earthenware under the Bennetts, was taken over in 1867 by Williams, Oakes and Company. In 1876 the enterprise was renamed Oakes, Clare, and Chadwick, and until 1894 produced Rockingham, jet, majolica, and common earthenware.

Cobridge

VILLA POTTERY. From the early nineteenth century under a Mr. Warburton, and from 1835 to about

1892 under a series of partnerships, the Villa Pottery operated by W. E. Cartlidge from 1879 made Britannia metal-mounted goods, earthenware, jet figures, Rockingham, and majolica.

LINCOLN POTTERY. Beech and Tellwright acquired the pottery in 1882, and until 1885 produced ordinary earthenware, majolica, and other wares for domestic and foreign markets. From 1885 to 1890 similar wares were made there by Frederick Beech and Company.

Fenton

PARK HALL STREET WORKS. Operated from 1863 to at least 1883 by Daniel Sutherland & Son, and produced majolica in all the conventional varieties. No marks are known on the firm's majolica, although some ceramics produced early in their history bear the mark "S & S."

Hanley and Shelton

BURTON PLACE WORKS. A manufactory operated by the family of Thomas Bevington, which produced majolica from 1862 until about 1870.

KENSINGTON WORKS. This pottery was established about 1856 by Wilkinson and Rickuss, who were succeeded in 1862 by Wilkinson and Sons, and then by Bailey and Bevington. On Bailey's retirement these works were carried on by John Bevington from 1872 to 1892. The mark on earthenwares from 1869 to 1871 was "J.B. & CO./H" (Cushion, *Marks*, p. 134). Jewitt (p. 499) lists its production only as earthenware, china, Parian, and stoneware. Mariann K. Marks (p. 49), however, identifies as majolica a swan pitcher with a British registry mark that indicates that it was registered in 1881 by J. Bevington in Hanley, conceivably John Bevington, the owner of the Kensington Works. The same design of the swan pitcher (which is based on an elegant Sèvres porcelain prototype) has been found in graduated sizes in majolica-glazed stoneware by other English potters, in Crown Derby porcelain, and in English and French majolica. John Bevington was also cited by Jewitt (p. 505) as the proprietor of the Swan Works, Elm Street, Hanley, until 1866. John Bevington had inherited this manufactory from his father, Samuel Bevington, who had established the works in 1835. Perhaps it was for reasons of filial sentiment that John Bevington copied a Sèvres-inspired swan pitcher to commemorate the name of the family's original factory.

CASTLE FIELD POTTERY. Under two managements, known as Davenport, Banks and Company (1860–1873) and Davenport, Beck and Company (1873–1880), the pottery produced "majolica in all its varieties" (Jewitt, p. 507). Both companies used a mark with a castle and "D.B & CO. ETRURIA/TRADE MARK" in an oval garter.

PYENEST STREET WORKS. J. and J. Snow (who after about 1882 also operated the Albert Works in Stoke until 1895) produced majolica, terra-cotta, jet, and other wares at the Pyenest Street Works in Hanley from 1877 to 1907.

BROAD STREET WORKS. Under George Ash the pottery produced Parian and majolica from 1865 to 1882 before Grove and Cope took over the pottery in 1883 for the production of fancy china ornaments until 1885. Grove and Cope also made majolica, according to their advertisement in the January 1, 1883, issue of the *Pottery Gazette*.

PELHAM STREET WORKS. This manufactory was established by Alfred Bullock and Company in 1881. Large quantities of majolica and jet wares were produced. They were judged by Jewitt to be of "great excellence in body and decoration" (p. 507). From 1895 to 1902 it was known as the Waterloo Pottery and as the Kensington Pottery from 1903 to 1915. The mark was A. B. & Co. or A. B. & CO. H.

HAVELOCK WORKS. A Mrs. J. Massey, one of the rare women cited by Jewitt (p. 507), moved her business from the Mayer Street Works occupied by Samuel Lear to Broad Street. There she produced earthenware jugs, teapots, and general majolica wares about 1882.

MARLBOROUGH WORKS, Union Street. Majolica of good quality and in a wide range of forms was produced here from 1881 to 1888 by Mountford and Thomas. A descendant of Mountford, Arnold Mountford, was the director, until his retirement in 1987, of the City Museum and Art Gallery, Hanley, Stoke-on-Trent.

Longton

ST. MARY'S WORKS, MOUNT PLEASANT. In 1870 Bernard and Samuel Moore inherited the manufactory from their father, Samuel Moore. Under the name

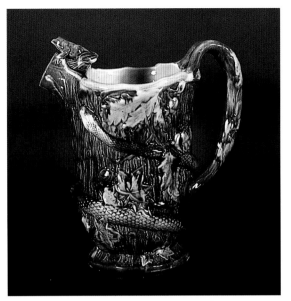

Samuel Alcock. Pitcher. c. 1858 Height 10″

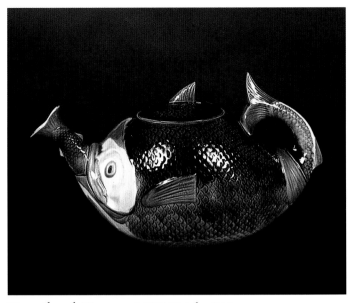

Unattributed. Teapot. c.1875 Height 6⅜″

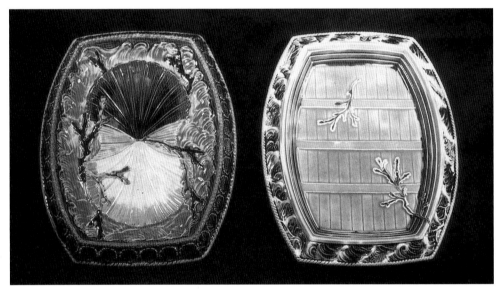

Unattributed. Bread tray.
c. 1883
Josiah Wedgwood & Sons.
c. 1880. Bread tray.
Length 13″.

Moore Brothers the company produced great quantities of china and developed excellent enameling techniques. Majolica pieces were frequently designed in Japanese style, and a Chinese ruby glaze was well imitated. The firm's Persian turquoise glaze was greatly admired by Jewitt, and he singled out a turquoise majolica jardiniere with a water-lily design as particularly effective (pp. 544–545). Much of the factory's output was marked and distributed by the London dealer Thomas Goode and Company. The maker's mark was "MOORE" or "Moore" impressed, or "Moore" incised, or "MOORE BROS."

painted on the surface; but no pieces so marked have come to light.

NEW TOWN POTTERY. This manufactory was established in 1780 and carried on by John Forrester. After almost a century of changes in ownership and production of earthenware and china it was bought by Dale, Page and Goodwin, who in 1876 moved to larger premises called New Town Works. Majolica was added to the firm's production about that time. The pottery continued until 1892 and was then known as the Blythe Works.

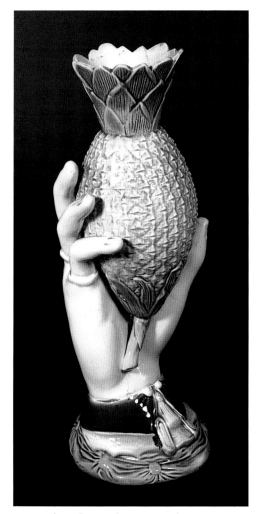

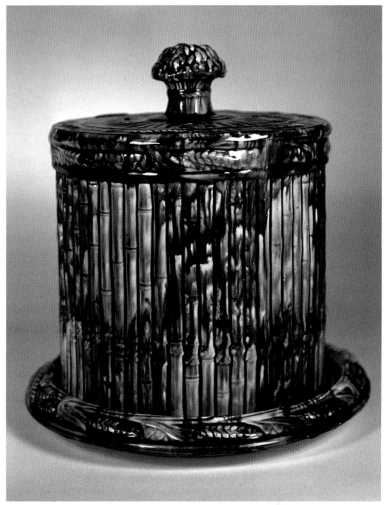

Unattributed. Hand vase. Height 10⅛″ Alloa Pottery. Cheese bell. c. 1881. Height 12½″

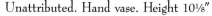

CHURCH STREET WORKS. G. A. Robinson, who was also cited as an owner of the Wellington Works in 1871, produced Parian, jasper, and majolica at the Church Street Works until the factory was leveled in 1876 for town improvements.

Swadlincote (Derbyshire)

SWADLINCOTE POTTERY. Established in 1790 by John Hunt of Swadlincote to make conventional earthenwares, the factory under James Woodward produced majolica and Rockingham wares from about 1860 to about 1888. According to Jewitt the mark was "an anchor, with a portion of cable twisted around it, forming a monogram of "J.W." (p. 376).

Listed below are other potteries that advertised in the

Pottery Gazette as making majolica, but about whom little other information is yet known and whose wares have not yet been identified. The date of the issue of that trade journal in which the advertisements mentioning majolica appeared is indicated in parentheses.

William Kirkby and Company (November 1, 1881). Marks: "W.K. & CO." and "K. & CO." (also as monogram), printed or impressed.

Hall and Miller (November 1, 1880).
Harrison and Son (December 1, 1880).
Hall and Read, George Street (January 1, 1883). Mark: "HALL & READ/HANLEY," printed.

139

Whittman and Roth (December 1, 1880).

J. Stembridge and Company (September 1, 1889).

Longton

Robinson and Chapman (December 1, 1881).

Thomas Heath, Park Hall Street Works (January 1, 1883).

Moore and Company, Old Foley Pottery (January 1, 1883).

John Tams, Crown Pottery (January 1, 1885). Mark: "J.T." (also as monogram), printed.

Colclough and Company (August 1, 1890).

Poole and Son, John Street Works (January 1, 1883).

SCOTLAND

ALLOA POTTERY. Scottish earthenware of the latter part of the nineteenth century was more rustic than that of its English contemporaries, with little production of Victorian majolica. Jewitt cites (p. 625) only the Alloa Pottery—established in 1790 in Alloa, near Glasgow, by James Anderson and bought in 1855 by W. and J. A. Bailey—as producers of majolica, after about 1860. The company was known for the artistic engraving of ferns and other decorations on teapots and jugs. The local clay contributed to the quality of Alloa's products, and Jewitt praised the density of color in the firm's wares. A notice in the *Pottery Gazette* in March 1880 stated that the firm had won medals at exhibitions in Philadelphia and Paris and that it had showrooms in London. An advertisement in the *Pottery Gazette* in January 1881 announced the production of majolica flowerpots, dessert ware, teapots, kettles, jugs, cheese bells and covers, jug stands, match strikers, sugar bowls and creamers, tobacco jars, and bread trays. A cheese bell, twelve and a half inches high,

fashioned as parallel vertical logs and glazed a rich brown, is marked "Manufactured on the Estate of/the Earl of MARA KELLIE/W. & J.A. BAILEY/ALLOA." The pottery closed about 1908.

STAR POTTERY. Cushion lists the Glasgow firm Star Pottery, producer of stoneware and majolica from 1880 to 1907. The factory's mark, impressed or printed, is the word "STAR" below a five-pointed star (p. 169).

PRESTONPANS. The Prestonpans Pottery, established by Charles Belfield in 1836, produced majolica in the last quarter of the century. An excellent example is a plate with a central area of overlapping emerald-green leaves, surrounded by a reticulated border of twigs. One mark BELFIELD & CO., impressed on a ribbon design, is on a mottled green-and-brown undersurface. The firm also produced Rockingham-glazed teapots and cane jugs.

AUSTRALIA

Lithgow Valley, New South Wales

LITHGOW POTTERY. This manufactory was established 140 kilometers west of Sydney by the Lithgow Valley Colliery Company with the help of James Silcock after 1879. Silcock was born in Derbyshire and trained in Staffordshire. The pottery developed as a part of the colliery's brick production, which began in 1876, and by about 1882 produced a wide variety of household wares, including pieces with mottled brown, ochre, and blue glazes, which the firm sold as "majolica." The pottery was not able to make a profit and went out of business in 1896 when the duty on ceramic imports was removed. Production was briefly revived from 1905 to 1907 by Edward Arthur Brownfield, an industrial chemist from Cobridge, Staffordshire. The marks included "LITHGOW" impressed and a variety of circular marks with a kangaroo and the firm's name.

Chapter 7
THE EARLY HISTORY OF AMERICAN MAJOLICA

In the second half of the nineteenth century, life in the United States changed radically because of the technological advances of the Industrial Revolution. The development of transcontinental railroads brought great economic growth. Mechanical miracles were invented: the wireless telegraph spanned half the globe, farm and industrial machinery changed the lives of workers and entrepreneurs. With its new affluence, the growing middle class provided an expanding market for the material comforts of life: better clothes, better homes, and better home furnishings. As in England, ceramic tablewares had been limited to white wares, prosaic blue-and-white transfer-printed designs, and spongeware patterns. Americans were now ready to welcome the color and imaginative designs of the new wares imported from England.

Just as Continental artisans had left their homelands for England because of economic, political, or religious difficulties, so English potters in the 1840s and 1850s emigrated to the United States to improve their lives. During the 1870s the economic unrest on the Continent curtailed the export market for English ceramics, sending to America further waves of English craftsmen. Among them were potters who brought with them the technical knowledge and creative skills that influenced the development of the American chapter of Victorian majolica.

As the 1851 Crystal Palace Exhibition in London had stimulated the most productive period for majolica in England, so the ten-year period that followed the 1876 Philadelphia Centennial represented the height of majolica's popularity in America. To encourage originality and creativity in American potters and to assure the inclusion of superior American ceramic wares at the Philadelphia Centennial, the first national association of

potters was formed in January 1875 in Philadelphia, by about seventy representatives of firms throughout the United States. In addition to the major displays of English majolica, particularly Minton's, for the first time at an international exhibition Americans presented majolica. James Carr of the New York City Pottery, J. E. Jeffords of the Philadelphia City Pottery, and John Moses of the Glasgow Pottery in Trenton, New Jersey, included majolica in their exhibits.

The World's Industrial and Cotton Centennial Exposition in New Orleans in 1884 and 1885 further exposed the public and majolica craftsmen to new designs, and to new markets. Foremost among the ceramic displays at that exhibition was the majolica of Griffen, Smith and Hill of Phoenixville, Pennsylvania, especially their beautifully modeled and glazed Shell and Seaweed pattern.

The great period of American majolica, from the late 1870s to the late 1880s, was intense but short-lived. Overproduction of an easily duplicated commodity diluted the quality of the wares; recurring strikes made it difficult for employers to continue; and the public imagination was soon captured by art pottery and bone china. By 1900 majolica was no longer produced in any quantity in America. A majolica teapot and sugar bowl are remembered, however, in the still-life *Celery and Trout* painted in 1911 by George Cope (1855–1929), now in the Corcoran Gallery of Art in Washington, D.C. American majolica was celebrated again in the exhibition *In Pursuit of Beauty: Americans and the Aesthetic Movement,* held at the Metropolitan Museum of Art in 1986 and 1987, with the inclusion of a sunflower plate by Griffen, Smith and Hill (Fig. 7.33 in the catalogue of that exhibition) and a plate with a Japanesque design of butterflies and stylized oriental flowers made by the

Eureka Pottery Company of Trenton, New Jersey (Fig. 7.34 in the exhibition catalogue).

Attribution of much of American majolica to specific potteries is not possible because of the frequent absence of manufacturers' marks. It has been suggested that many potters did not mark their work, hoping it would be more marketable if it were thought to be English. In some cases, artists used brushstrokes, letters, or numbers to identify their work for payment. (Because of the difficulty of distinguishing unmarked American majolica from unmarked English examples there will not be a section on unattributed American majolica. See chapter six on unmarked English majolica.)

Little would be known about the history of American majolica were it not for the work of Edwin AtLee Barber, Director of the Pennsylvania Museum and School of Industrial Art. (The museum later became the Philadelphia Museum of Art.) Inspired by the Philadelphia Centennial and the establishment of a pottery collection at the Pennsylvania Museum, he wrote *The Pottery and Porcelain of the United States,* which was published in 1893. Barber made a plea for the development of courses so that the public could learn about American pottery and porcelain and thus overcome the "deep-seated prejudice which had existed so long in the public mind against home productions," which he felt had decreased when he wrote the preface to the 1901 edition of his book. Barber advocated the establishment of a national school of pottery and porcelain, staffed by potters, designers, modelers, and decorators, to improve the quality of American ceramic production. He called for awards of merit to be confined to work done by American artists on American products. He believed that American connoisseurs and patrons should give their approval and their patronage to American craftsmen, thus encouraging domestic production and discouraging importation. Taking it to the highest level, Barber commended the American presidents who had commissioned dinner services for the White House and gifts for foreign heads of state from Trenton factories.

Before the advent of majolica in America, potteries had been established throughout the eastern half of the United States. Major centers included Jersey City and Trenton, New Jersey; Bennington, Vermont; New York City; Baltimore, Maryland; and locations throughout the Carolinas and Indiana, where clays and other natural resources abounded. Barber felt that the history of ceramic manufacture in East Liverpool, Ohio, reflected in miniature the history of the industry in the whole country (*Pottery and Porcelain,* p. 192). Much of that early history was associated with the work of an Englishman, James Bennett. James Bennett's brothers Edwin and William later were to introduce majolica production to America, in 1850 in Baltimore. As in England, majolica developed in the United States along with Rockingham and yellow wares, Parian ware, salt-glazed stoneware, and ironstone.

James Bennett, who was born in England on May 13, 1812, learned about the pottery industry in his home in Newhall, a pottery district in Derbyshire. In 1834 he emigrated to the United States and found employment at the Jersey City Pottery, in Bergen, New Jersey. Although the establishment was one of good reputation, in 1837 Bennett moved to Troy, Indiana. There he worked for the Indiana Pottery Company, producing white ware. In 1838 he traveled up the Ohio River to seek both better health conditions and a suitable location for the establishment of his own pottery. The proper clay for yellow ware was found in East Liverpool, Ohio, and in 1839, with the financial assistance of Anthony Kearns, he established the pioneer pottery that was the nucleus of the developing ceramics industry.

Success came quickly. Bennett leased the pottery works from Kearns for the next five years and sent for his brothers to join him in partnership as Bennett and Brothers. Daniel, Edwin, and William, all experienced potters, arrived in September 1841. They continued the production of yellow ware and were the first in the United States to manufacture Rockingham ware. The latter, a form of yellow ware, glazed in a lustrous, purple-brown lead glaze containing manganese, was developed in the early nineteenth century in Swinton, England, and named for the marquis of Rockingham, on whose properties in Yorkshire the Rockingham pottery works stood. The Bennetts originated many designs, including an octagonal spittoon, from which a majolica pattern was descended.

Business increased steadily. Successful crockery wholesalers in Cincinnati, Cleveland, Louisville, and Saint Louis sold most of the Bennetts' production. In 1844 James, Daniel, Edwin, and William moved to Birmingham, which is now part of Pittsburgh, Pennsyl-

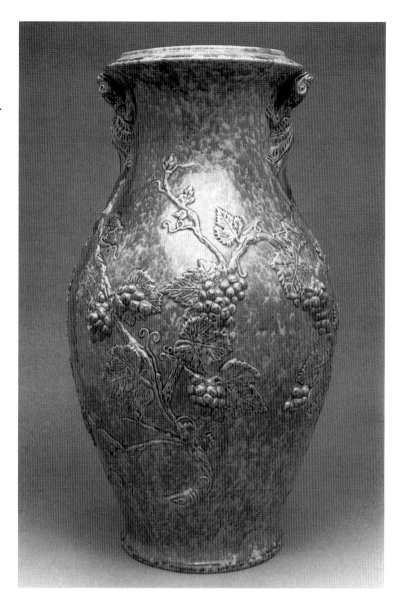

vania. Prize-winning yellow and Rockingham wares pro-
duced at that larger factory were exhibited at both the
American Institute in New York City and at the Franklin
Institute in Philadelphia. At the exhibition in Philadel-
phia Bennett earthenware won the first prize of a silver
medal, with the pronouncement that it was superior to
the English entries. An octagonal tortoiseshell pitcher
with a druid's head beneath the lip, exhibited at the
Franklin Institute, appears to be the link between earth-
enware and the Whieldon-like beginnings of American
majolica.

James and Daniel Bennett continued the Pittsburgh
pottery, despite the departure of Edwin in 1846 and

William in 1848. Daniel continued alone until 1860.
James Bennett died on July 30, 1862.

In 1846 Edwin Bennett arrived in Baltimore, Mary-
land, where he established the first industrial pottery
south of the Mason–Dixon line. The firm was called the
E. Bennett Chinaware Factory until 1848. He was joined
by his brother William in 1848, and the partners were
known as E. and W. Bennett until 1856. The Bennetts
obtained clays from the nearby Markey Creek area.
Production never faltered, even during the Civil War
when more than one hundred men and boys were
employed, producing some three thousand pieces per
week. Working at first in the familiar yellow and Rock-

143

ingham wares, the company also made graniteware and stoneware in blue and sage green. Pieces included coffeepots, pitchers, water urns, and vases. The firm won silver and gold medals from the Maryland Institute for excellent queensware. Together with Charles Coxon, the chief designer and modeler, the factory produced the well-known and often copied Rebekah at the Well teapot in Rockingham ware (1851).

In 1850 E. and W. Bennett produced the first piece of American majolica, which was, appropriately enough, a bust of George Washington. Although William Bennett became ill and left the business in 1856, he had taken part in the experiments with clays and glazes leading to the development of new Rockingham-type wares and ultimately to the commerical production of American majolica. The mark from 1850 to 1856 was E. & W. Bennett/CANTON AVENUE/BALTIMORE MD. The early years of American majolica coincided with the introduction of majolica in England by Herbert Minton. In 1853 a large octagonal majolica pitcher, designed by Charles Coxon, was executed by the Bennetts in blue, brown, and olive mottled glazes. The handle was in the form of a sea monster and the body was covered with a pattern of fish in relief. The fish were modeled on those that swam in the Chesapeake Bay, much as the fish on Palissy's works had been directly inspired by those that inhabited the Seine. The Bennetts also produced a pair of mottled yellow-brown majolica vases twenty-four inches high, with raised grape-leaf designs and lizard handles (1856). An even larger and more colorfully glazed piece of Bennett majolica, designed and modeled by Herbert W. Beattie, was a large jardiniere, thirty-six inches high, consisting of a trefoil basin supported by three griffins, in robin's-egg blue, yellow, and mottled green-and-brown. Soon Bennett produced majolica pitchers, syrup jugs, coffeepots, and serving pieces, and for two decades he had the field of American majolica almost to himself. Few pieces of Bennett majolica survive today. The mark was "BENNETT'S PATENT" encircling the month, day, and year of patent date.

Edwin Bennett's enterprise continued to be a leader in the production of ceramics, under the names Edwin Bennett Pottery (1856–1890) and Edwin Bennett Pottery Company, Inc. (1890–1936). The factory produced a wide variety of ceramic wares. In 1890 the business had become a corporation, with Henry Brunt as manager and Joseph L. Sullivan as secretary. In 1894 Kate DeWitt Berg, an artist employed by Bennett, was responsible for a new style of majolica called Brubensul ware, which combined the names of Brunt, Bennett, and Sullivan. This was highly glazed majolica in light and dark brown shades used for large jardinieres and pedestals, repositories for the obligatory plants in the corners of Victorian parlors. Deep ultramarine blue and olive green glazes were also used for jardinieres.

When Edwin Bennett retired in 1895, he left his business to his son Edwin Houston Bennett. Edwin Bennett had served as president of the United States Potters' Association in 1890 and 1891. He was one of the founding fathers of American pottery and a pioneer among majolica manufacturers. The elder Edwin Bennett was neither Wedgwood nor Minton, but by his death in 1908, at the age of ninety, he was considered one of his adopted country's most renowned potters.

GRIFFEN, SMITH AND HILL:
ETRUSCAN MAJOLICA

One hundred and fifteen miles inland from the shores of the Atlantic the Griffen, Smith and Hill potteries of Phoenixville, Pennsylvania, harvested a crop of "shells and seaweed." Inspired by this typically English majolica motif, as well as by other naturalistic details used by English potters—such as begonia leaves, sunflowers, and lilies—these Phoenixville potters in the decade from 1879 to 1889 became preeminent among the American and European manufacturers of majolica.

From 1867 to 1903 nine consecutive Phoenixville firms achieved success in various related industries, but the most famous was Griffen, Smith and Hill. The prosperity of that firm may have been due to its natural resources, to the quality of its staff, and to the "majolica mania" of the 1880s.

On May 7, 1867, the Phoenix Pottery, Kaolin and Fire Brick Company was established at the corner of Church and State streets. W. A. H. Schreiber had convinced John Griffen, the superintendent of the Phoenix Iron Works, that it would be to their mutual advantage to establish a pottery in conjunction with the iron company, using the nearby kaolin deposits for the manufacture of fire bricks for the Phoenix iron furnaces. Clay was dug from local Valley Forge and Chester Springs pits. The new company produced fire bricks and white, yellow, and Rockingham wares. Business was excellent and called for additional leadership. David Smith, an English potter from Stoke-on-Trent and Trenton, New Jersey, was hired in 1871 to manufacture crockery. (He also experimented with jet-ware, Parian, and porcelain.) By 1871 the business, which had been capitalized at $50,000, was prosperous and employed twenty adult males and fifteen children. Smith introduced the production of pottery heads of boars, stags, eagles, and dogs—favorite tavern-wall ornaments. These pieces were exhibited at the 1876 Philadel-

phia Centennial and were singled out for special praise in a contemporary publication about that show, *The Centennial Exhibition of 1876. What We Saw, and How We Saw It.*

From 1872 to 1876 the factory suffered financial reverses and sustained several changes in management. On February 11, 1876, perhaps because of the company's financial situation, or because of the lure of becoming superintendent of the United States Crockery Department at the Philadelphia Centennial, Schreiber left Phoenixville. David Smith then became the head of the firm. In 1877 John Griffen's sons Henry and George joined the partnership, together with Levi Beerbower. From 1877 to 1879 the company was called Beerbower and Griffen. On January 1, 1879, after Beerbower had left the firm, the Phoenix Pottery was leased to Henry and George Griffen, David Smith, and their new partner, a potter named William Hill. The firm was then called Griffen, Smith and Hill, and concentrated on the production of majolica, which established their reputation. The Griffen brothers, engineers educated at the Rensselaer Polytechnic Institute in Troy, New York, were excellent technicians. Smith devoted himself to designs and glazes and Hill was the master potter. Hours were long and a week's salary could be as little as five dollars. Conditions at the pottery were dependent upon the availability of raw materials and on the early union movement. A miners' strike in 1880 led to a coal shortage; a workers' strike soon after led to the temporary closing of the factory. As in all potteries, plumbism and accidents were constant threats, but, for the most part, morale was high. Pride was increased because the women who decorated the wares were permitted to sign their own work with a number.

William Hill had left the company by 1880. Early in

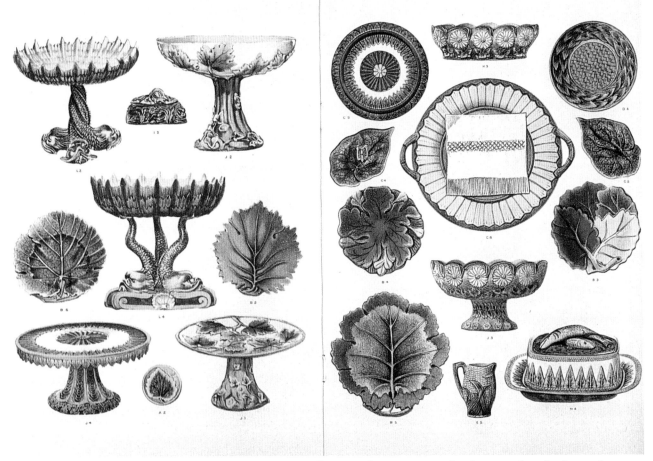

Griffen, Smith and Hill. Pages from the catalogue of Griffen, Smith & Company for their majolica display at the New Orleans exhibition of 1884–1885. Courtesy Brooke Weidner

that year the firm's name therefore became Griffen, Smith and Company, but the mark "GSH" in monogram continued to be used. Because collectors generally refer to the firm as Griffen, Smith and Hill, that form of the company name is used in this book. (Arthur E. James, in *The Potters and Potteries of Chester County, Pennsylvania*, p. 117, said that the three letters of the monogram were sometimes said to stand for "good, sturdy and handsome.") Ruth Irwin Weidner, in her excellent master's thesis (1980) on Griffen, Smith and Hill, reported that a 1950 letter from a collector to Frances Pennypacker, a granddaughter of Henry R. Griffen, shed light on the origin of the monogram. Pennypacker stated that the son of a long-time employee of Griffen, Smith and Hill named Samuel H. Gilbert said that his father designed his own monogram and, noticing the similarity of the three initials to the firm's name, offered his employers

his design for their use as a mark. (Geoffrey A. Godden, in his *Encyclopedia of British Pottery and Porcelain Marks*, p. 719, illustrated the Griffen, Smith and Hill mark with the monogram surrounded by the words "ETRUSCAN MAJOLICA" between two concentric circles and indicated that although in the past it had been attributed to Edward Steele of Hanley, Staffordshire, Jewitt stated that Steele used no mark. Godden commented that "This, or a *very* similar mark, was used by Griffin [*sic*], Smith & Hill of Phoenixville, U.S.A." The mark, in fact *is*, that of Griffen, Smith and Hill and the earlier anonymous attribution to Steele was an error.)

The addition of the name "Etruscan" in the firm's mark on its majolica reflected Wedgwood's use of the name "Etruria" for its factory. In the mid-eighteenth century, with the archaeological discoveries of various classical sites in Italy, there was a great vogue for what

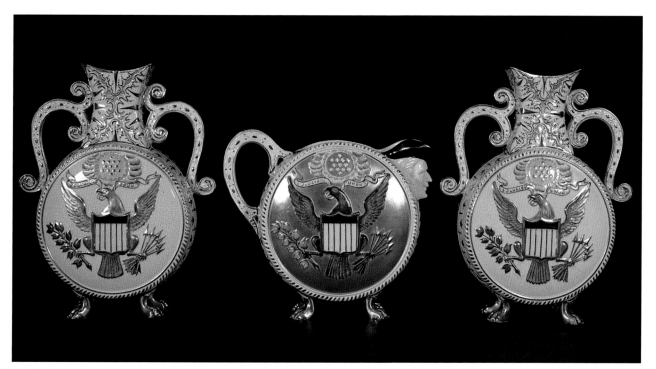

Griffen, Smith and Hill. Garniture. c. 1884. Height of vases 14″; height of jug 10″

was called "Etruscan" ornament. "Etruscan" was also the trade name of Elkin, Knight, and Bridgwood, a pottery in Fenton, England. Since Fenton was the birthplace of David Smith, that may also have been a source of Griffen, Smith and Hill's adoption of the fashionable term. Today collectors use the term Etruscan to refer to the majolica of Griffen, Smith and Hill.

Ruth Weidner documented that the production of majolica in the three-kiln factory of Griffen, Smith and Hill began in 1879 (*West Chester Daily Local News,* April 7, 1879). By 1880 large orders from Philadelphia and New York necessitated a work force of fifty-five males, nineteen females, and twenty-three children and youths. At this time a skilled laborer earned $2.50 a day. Many European artisans were employed by the company, and workers knew a ten-hour day, a six-day work week.

Activity accelerated at Griffen, Smith and Hill as a result of honors earned by the firm. At the World's Industrial and Cotton Centennial Exposition in New Orleans in 1884 and 1885, the company exhibited more than 150 pieces of majolica, including its outstanding Shell and Seaweed pattern. Its display also featured a mantelpiece set, or garniture, consisting of two vases and a jug, which was awarded a gold medal. Made of

hard earthenware (and thus not technically majolica) and bearing the Great Seal of the United States Department of State as cut from the second die in 1841, the canteen-shaped pieces are striking, with the seal printed in coin gold on an off-white background. (Another hard earthenware garniture, with a mauve-pink background, is now at the Philadelphia Museum of Art.) The firm's agents, II. C. Ramey at 59 Barclay Street in New York City and George and Johnson of 43 South Charles Street in Baltimore, were flooded with orders from near and distant markets. The pottery's work force soon tripled to accommodate the increased number of orders.

Another external factor in the rapid growth of Griffen, Smith and Hill was the entrepreneurial activity of George H. Hartford. In 1859 Hartford had opened a retail store in New York City for the sale of tea at prices lower than those charged by most merchants. By 1869, with the completed railway linking the east and west coasts of the United States, Hartford renamed his store the Great Atlantic and Pacific Tea Company, and opened branch stores in coastal and midwestern cities. Coffee, spices, and a wide variety of foods were added as the stores expanded. Learning of Griffen, Smith and Hill's majolica at the 1884–1885 exhibition in New Orleans,

147

Hartford decided that a free gift of majolica, as a premium with purchases, would attract more customers. He became the single largest customer of Griffen, Smith and Hill and distributed majolica with purchases of baking powder. A Canby, Ohio, firm also ordered Griffen, Smith and Hill majolica for premiums to be offered with purchases of their tea. In this way, large amounts of Etruscan majolica were shipped to distant parts of the country.

The year of greatest expansion was 1885. The factory, with the addition of three new kilns, was running on a twenty-four-hour schedule. Twenty women were employed solely for the decoration of majolica. Because of the high cost of hand decorating, however, and the relatively low prices that the company charged in the bulk sale of majolica to George Hartford, the manufacture of majolica was not as profitable as it was popular. By 1886 the demand for majolica declined precipitously and Griffen, Smith and Hill introduced new wares. Among them were Pandora and Venicene, which had an ivory glaze and gold details. These pieces, in the form of tableware and toilet sets, added to the firm's renewed prosperity.

The demise of the firm was heralded in 1889 by David Smith's withdrawal from the business. Henry Griffen's father-in-law, J. Stuart Love, became a partner in the new Griffen, Love and Company. In December 1890 the factory was almost completely destroyed by fire. It opened again in April 1891, as the Griffen China Company, with creditors becoming the stockholders. The plant closed in 1892 and, with George Griffen's death in 1893, an era came to an end. In 1894 the site was leased by E. L. Brownbeck under the name Chester Pottery Company of Pennsylvania. In addition to other wares a limited amount of majolica was made from the old molds but it was, according to Barber, inferior to the original and the manufacture soon ceased (p. 470).

There were other attempts to use the pottery site. In 1899 David Smith returned to become manager of the Penn China Company, but ill health forced him to retire again. His son-in-law, V. Shaffer Yarnall, took over as manager. The Yarnall family gave the Phoenixville (Pennsylvania) Historical Society the Griffen, Smith and Hill records as well as the 1884 gold-medal garniture. For about a year, in 1902, under new management (which included Samuel H. Gilbert), the firm was called the Tuxedo Pottery Company. This was the last organization to use the kilns at State and Church streets.

Although the entire history of Griffen, Smith and Hill may never be known, the information that is available comes from the efforts of Edwin A. Barber, Arthur E. James, Ruth I. Weidner, family members and collectors. Brooke Weidner (no relation to Ruth Weidner) was perspicacious enough to reprint in 1960 the catalogue that Griffen, Smith and Hill had prepared for their majolica display at the 1884–1885 New Orleans exhibition. That publication contained seven-color chromolithographic illustrations of more than 150 pieces of Etruscan majolica, a memento not left by any other American firm. The catalogue was a major factor in gaining national recognition for the company's wares. Other Griffen, Smith and Hill archival materials, as well as one hundred twenty-three pieces of the firm's majolica are in the Chester County Historical Society in West Chester, Pennsylvania.

Griffen, Smith and Hill's Etruscan majolica designs reflected the Victorian interest in plant and marine life, but not the Victorian clichés of pansies and forget-me-nots. In many instances the designs for the molds were taken directly from life: from begonia plants, oak and maple leaves, or shells from the ocean bed. Little is known about the men involved with the design process. "An Englishman named Bourne" is always mentioned in books on ceramic history, without any further identification. Barber wrote (pp. 368–369) of another Englishman, Thomas Scott Callowhill, who, for a short period in 1885, had worked at Griffen, Smith and Hill as a modeler and painter before accepting a position in Trenton. Perhaps it was David Smith, with his experience in English potteries and his penchant for experimentation, who was most responsible both for the designs inspired by English majolica and for the firm's original pieces of Etruscan ware. Smith did improve the lustre of Etruscan majolica by adding a costly stanniferous glaze to the more usual lead glaze of American majolica. He also encouraged the design and production of experimental pieces. These were straight-sided pitchers in graduated sizes—decorated with mottled glazes—and small bowls and vases, either monochrome or mottled. Although not as charming as the more familiar Griffen, Smith and Hill majolica, the experimental pieces are treasured by some collectors and study groups.

Collectors regard Griffen, Smith and Hill's 1884 ma-
jolica catalogue (which was also reprinted, in black and
white and with a price list, in Arthur E. James's *The
Potters and Potteries of Chester County, Pennsylvania,* pp.
123–140) as a baedeker to the factory's output. Design
categories include leaves, vegetables, fruits, flowers, ma-
rine motifs, oriental motifs; rare pieces feature human
and mythological figures. No design is wedded to one
color. For example, polychrome pitchers may also be
found in various monochromes; leaf colorings depended
upon the creativity of the women who applied the glazed
decoration; and the backgrounds of many of the individ-
ual serving pieces were pink, blue, or white. The inte-
riors of hollow wares were a shade of pink somewhat less
intense than the English hues or, more rarely, pale blue
or green. Shapes included all categories of Victorian
tableware, from three-inch butter pats to large serving
compotes, napkin plates, and bowls, as well as humidors,
cuspidors, and umbrella stands. Of all the American
majolica potteries, Griffen, Smith and Hill was one of
the few that produced full dinner, tea, and coffee services
and these were in Cauliflower, Bamboo, Rose and Shell
and Seaweed patterns.

Leaf designs

The most frequently found form of Etruscan majolica is
the single begonia-leaf dish, in graduated sizes, fash-
ioned from molds of leaves pressed into soft clay, and
painted in variegated glazes. These dishes were used for
pickles or as ash trays and, on today's tables, as salad
plates. The largest begonia-leaf platters—surrounded by
a simulated-wickerwork border, with or without a wicker
handle—were bread trays. Plates entirely covered with
overlapping begonia leaves were well modeled, glazed in
dense green and brown, and resembled those of un-
marked English potteries.

Realistic branches of maple leaves decorated dinner
plates and matching compotes, with background glazes
of pink, blue, or white. Compote stems were modeled as
tree trunks covered with leafy vines. Small, cup-shaped,
green-glazed nut dishes lack the sharp modeling of other
Etruscan maple-leaf designs and are rarely marked. A
piece that was copied at the George Morley pottery in
East Liverpool, Ohio—using an Etruscan mold—is a
single-maple-leaf bonbon dish, slightly concave and
glazed green with pink or yellow borders. Ruth Weidner

reports in her thesis (p. 23) that in David Smith's
manuscript notebooks there is mention of a list of glazes
that Smith said George Morley (see Chapter Nine) used
successfully. This confirms that the two factories shared
technical information.

Luncheon plates were designed with a large central
maple leaf and a wickerwork border. A bread tray, of a
large oak-leaf model, is one of the handsomest Etruscan
pieces. With the end of the stem looped to form a
handle, the body is glazed green and edged in pink and
yellow. An unmarked copy of this piece is less well
defined, glazed in a muddy yellow, and has three acorns
near the stem-shaped handle.

Fern patterns decorate a series of graduated pitchers,
with curved edges. These are glazed either in green on a
white background or in monochrome green or white.

A somber version of the leaf pieces is the oval fruit
tray with a scalloped edge, modeled with dark green oak
leaves and sinuous brown branches, and strewn with
mustard-colored acorns. It is thought to resemble the
work of Bernard Palissy because of the deep three-
dimensional modeling of leaves, branches, and acorns.

The three-inch butter pats offer a reprise of most of
the Etruscan leaf patterns: begonia, begonia and wicker-
work, geranium, and lily. These, together with pieces
decorated with smilax, pansies, and two versions of the
Shell and Seaweed pattern, complete the repertory of
Etruscan butter pats.

Vegetable and fruit designs

Collectors familiar with European ceramics will know
the antecedents of the Etruscan pieces using the cau-
liflower, corn, pineapple, and strawberry motifs. The
eighteenth-century Strasbourg and Chelsea cauliflower
tureens, the "Colly Flower Tea Pot" of Whieldon–
Wedgwood (1754–1759), and the majolica cauliflower
teapot made by James Carr of New York City, inspired
the Etruscan Cauliflower dinner service, as well as
matching tea and coffee services, compotes, bowls, and
cachepots. As in some Chelsea leaf designs on porcelain,
pink and, rarely, blue edgings highlight the contrast
between the Etruscan central white cauliflower design
and the well-modeled naturalistic green leaves around it.

Corn, important to both the British and the American
agrarian economy, is featured in Etruscan wares in the
forms of teapots, pitchers, and small vases. A large

149

pitcher with inverted kernels, has corn husks at the neck and spout and also forming the handle. The small corn pitcher with rounded kernels has the husks crisscrossing as they ascend from the bottom of the piece. Phoenixville corn pitchers were rarely marked and are hard to distinguish from unmarked English corn pitchers. The Etruscan five-inch-high cylindrical corn vases have sometimes been called hatpin holders.

The Etruscan Pine Apple pattern is poorly represented in the 1884 Griffen, Smith and Hill catalogue. The pineapple, symbol of luxury and hospitality, had been grown in the greenhouses of George III, appeared in Chelsea porcelain, and was modeled as a teapot by Wedgwood and William Greatbach in 1764. Later, unidentified companies produced a full line of majolica using the pineapple motif, but the only Pine Apple piece listed in the 1884 Griffen, Smith, and Hill catalogue is the "cuspadore."

Etruscan pieces using the strawberry motif included dinner plates and strawberry serving trays. The nine-inch dinner plate depicts strawberry fruits and blossoms on a wickerwork background glazed white, pink, mauve,

cobalt, turquoise or brown. The Etruscan strawberry serving tray is almost identical to one produced by Wedgwood in 1871. Both pieces consist of an artistically shaped shallow trefoil bowl—decorated with strawberry blossoms and leaves, in which the fruit is placed—with sugar bowl and creamer, which fit into adjacent concave spaces. The Wedgwood background glaze is frequently cobalt, but has also been seen in turquoise or brown. The Etruscan version was made in pink or white, and, as with other major pieces, occasionally with a light blue background. The only difference between the two makers' strawberry serving trays is that the Wedgwood sugar bowl has a lid.

Small serving dishes with grapevine patterns are not as dramatic as the better-known Etruscan designs. Round or oval, with sinuous reticulated or solid borders representing interlacing vines, the pieces are decorated with grape clusters in the center, on backgrounds of familiar shades of blue, pink, or white. This pattern was also used for compotes. Because of the fragility of the openwork borders, perfect pieces in this pattern are important to collectors.

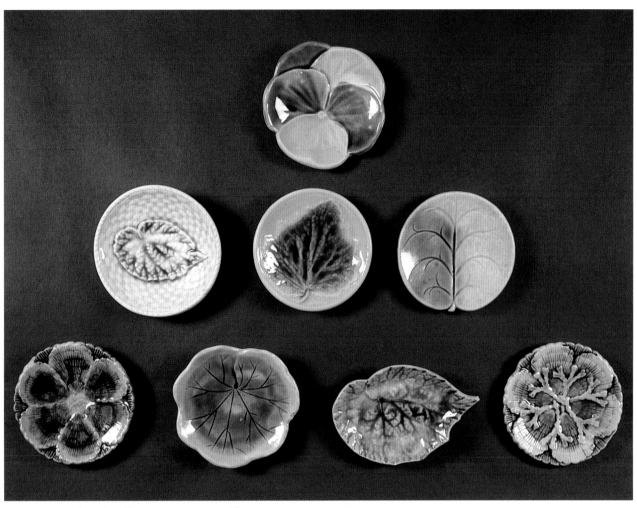

Griffen, Smith and Hill. An assortment of butter pats. c. 1880. Diameter 3″

Griffen, Smith and Hill. Tableware in the Cauliflower pattern. c. 1880. Teapot height 5¾″; dinner plate diameter 9″

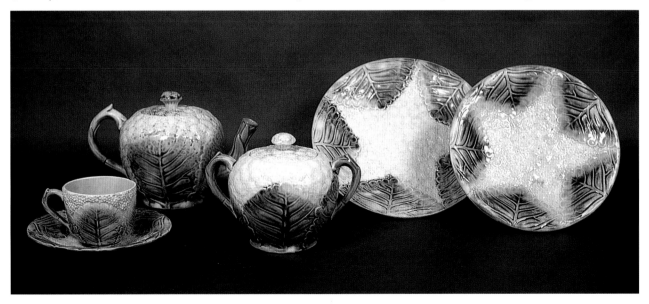

151

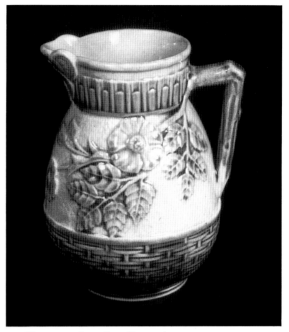

Griffen, Smith and Hill. Napkin plate. c. 1884.
Diameter 12″

Griffen, Smith and Hill. Pitcher. c. 1880.
Height 5″

Flower motifs

Etruscan artists produced particularly graceful, well-modeled floral designs, delicately and brilliantly glazed. The flowers most frequently used were the wild rose, pond lily, sunflower, daisy, pansy, cosmos, morning glory, and lotus. A wild rose is the central motif on a series of seven graduated pitchers as well as on syrup jugs with pewter lids. These forms have a butterfly spout, a neck band decorated with parallel vertical lines, a rose-branch handle, and simulated wickerwork below the central panel. They were made in a variety of background colors. Similar pitchers, in various sizes, appear in a late nineteenth-century salesman's catalogue of majolica made by unidentified English potteries. The catalogue was printed for the Boston importing firm Jones, McDuffee and Stratton. (A page from that catalogue illustrating two of these pitchers is included in Chapter Six.) The modeling, especially of the wild-rose leaves, is crisper in the English versions than in the Etruscan examples. In the English version there are two branches of leaves surrounding the rose on both sides of the vessel, whereas the Etruscan design features three branches of leaves on one side and two on the other. It is of interest that the silver firm of Bigelow, Kennard and

Company of Boston (fl. 1869–1881) produced a sterling-silver creamer with a butterfly spout, four inches high, with a neck band and wickerwork lower section similar in design to the Etruscan pitcher, but with a repoussé floral pattern on the body of the creamer. It is not known if the Boston silversmith influenced the Phoenixville potter or if they were both inspired by English silver or ceramic examples.

The lily design in tender greens and pale yellow appears on the most exquisite pieces of Etruscan majolica, usually on white or pink, and, rarely, on cobalt backgrounds. The smallest, an open salt, can also be used as a candle holder. Lily mugs, with scalloped edges and straight sides, are most often banded in yellow; the rare blue-banded lily mug is, therefore, more valued. Footed lily mugs, with white or blue backgrounds, are matched to a large footed lily bowl with deeply modeled lily blossoms and glossy ribbed green leaves. This lily design is especially handsome on a cuspidor with a cobalt background. A tall celery dish is attractively formed of lily leaves. The most elegant lily-patterned piece is the swan-finialed eleven-inch-high cheese bell, delicately ornamented with lilies, other water plants, and butterflies, on a white background. It is rarely found on a cobalt

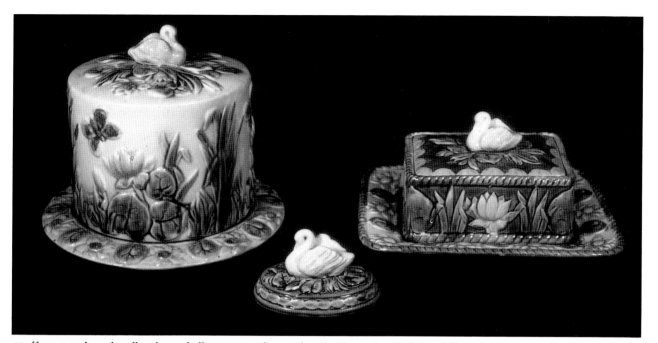

Griffen, Smith and Hill. Cheese bell, paperweight, sardine box. Height of cheese bell 7″

background; an example is at the Philadelphia Museum of Art. A rounded cheese bell with a fern and lily design is equally beautiful. The swan finial also swims on lily-patterned sardine dishes with under plates, on backgrounds of white, deep pink, or blue. The swan glides serenely on a three-inch, oval paperweight.

The sunflower, that familiar symbol of the Aesthetic Movement, was transplanted (with the lily) from England to the United States by the playwright and poet Oscar Wilde. In 1882 and 1883 Wilde made a cross-country lecture tour, and his appearance in Philadelphia was reported in the local newspapers in West Chester, Pennsylvania. Wilde appeared at all performances carrying a sunflower and lily. Griffen, Smith and Hill seized upon Wilde's notoriety and produced wares decorated with both sunflower and lily patterns. The sunflower blossom, with brilliant yellow petals and a rich brown center, was boldly modeled on cobalt, pink, or white backgrounds. Pieces with this motif included cuspidors, graduated jugs, syrup jugs, and small plates. There is a question as to the use of these small plates: some collectors use them under the pewter-topped syrup jugs and others use them as fruit plates, as listed in the Griffen, Smith and Hill 1884 catalogue.

Daisies are modeled around the top and bottom of a scalloped compote for salad and at the tops of sauce dishes in the same pattern. The backgrounds of both models are decoratively incised and covered with daisy leaves. Background glazes include various shades of blue, pink, and green on white.

The Victorian pansy motif was limited at Griffen, Smith and Hill to small butter pats. These were widely copied, but the imitations lacked the grace and the perfect glazing of the Etruscan petals. Another example of Victoriana, the napkin plate, displayed a white "napkin" on a blue or pink background.

A berry tray with a round platter eleven inches in diameter, and five-inch matching fruit plates in the "conventional" Cosmos pattern, is strikingly modern in design. The yellow center is surrounded by radiating green leaves, and the plate is edged in pink, blue, or white. The morning glory motif on compotes is, on the other hand, quite traditional.

A stylized pond-lily plate, with eight overlapping broad petals surrounding the flower, is the least original of the Etruscan floral patterns. It was inspired by a familiar but unmarked English majolica design, and differs in that the glaze used at Griffen, Smith and Hill is less uniformly green and the design is not as gracefully executed as in the English pieces.

153

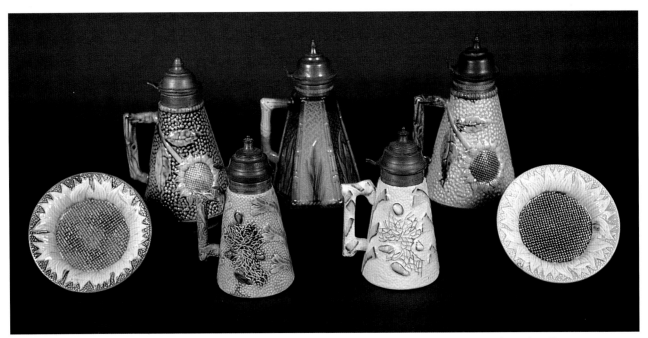

Griffen, Smith and Hill. Syrup jugs
and plates in various patterns. c. 1880.
Height of taller syrup jugs 8½".
Diameter of plates 4⅞"

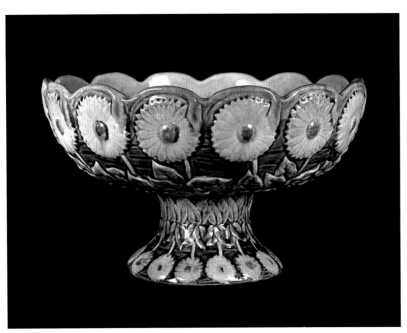

Griffen, Smith and Hill. Bowl.
Height 5½"

Marine motifs

The fame of Griffen, Smith and Hill resulted, in great part, from its Shell and Seaweed pattern and its designs incorporating shells and dolphins. Both styles were of English descent, with the former modeled after the 1879 Wedgwood Argenta shell and seaweed designs. Minton, Wedgwood, and the Royal Worcester Porcelain Works had all produced pieces using one or three dolphins balancing nautilus shells or shallow shell bowls.

Because of the thinness of the body, the slightly nacreous glaze, and the delicate modeling, Etruscan Shell and Seaweed has been compared to Irish Belleek wares (which were exhibited at the 1872 international exhibition in London), and to the American Belleek made by Ott and Brewer of Trenton, New Jersey, in 1882. First produced in a white glaze (albino) with pastel or gold edgings, Griffen, Smith and Hill's Shell and Seaweed became very successful only after it was glazed

154

Griffen, Smith and Hill. Albino sugar bowl and creamer. Height of sugar bowl 5½″

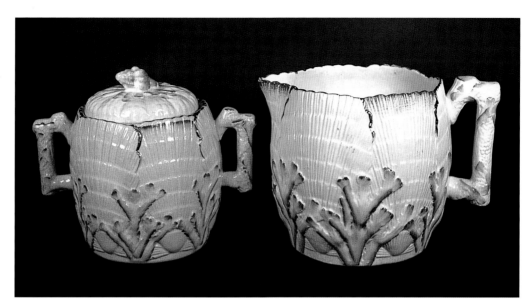

Griffen, Smith and Hill. Collection of Shell and Seaweed dinner, coffee and tea services, with accessories. Note examples of Coral pattern in first row

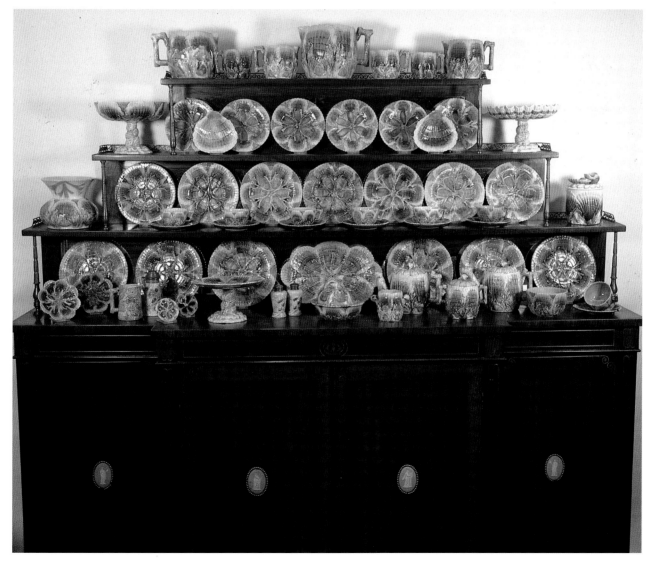

155

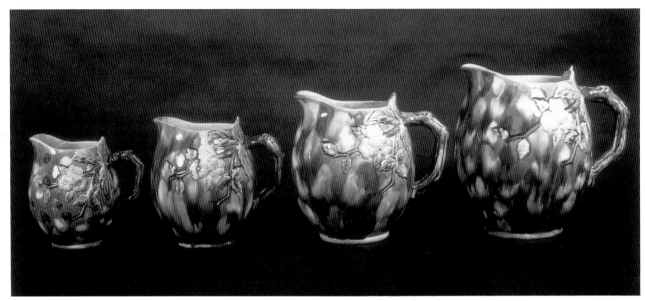

Griffen, Smith and Hill. Pitchers in the Thorn pattern. Tallest 8½"

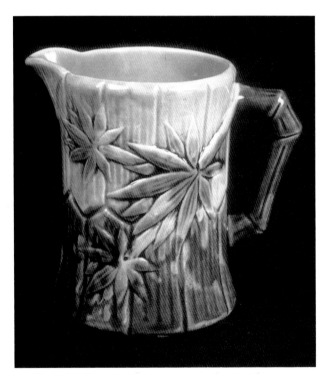

Griffen, Smith and Hill. Creamer in the Bamboo pattern. Height 4½"

156

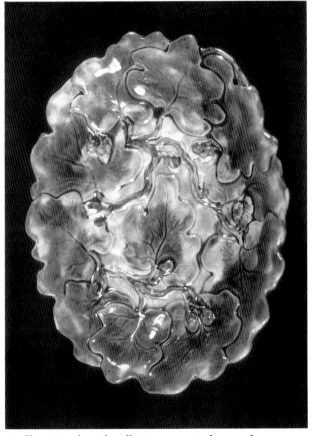

Griffen, Smith and Hill. Fruit tray, Palissy style. Length 12"

in shades of pink, brown, gray, and blue, with green seaweed accents. The pattern decorated dinner services, serving bowls in various sizes, footed salad bowls, large compotes in three different shapes, covered butter dishes, butter pats in two designs, mustache cups, cuspidors in two variants of the design, and a series of seven graduated pitchers. Tea and coffee services, each in two sizes, featured a coffeepot with a crooked spout and a teapot with a straight spout. The background of the coffeepot spout has a stippled surface, while the teapot spout has a textured linear design. Dessert services included large scalloped oval cake trays, small scalloped fruit plates, and small triangular ice-cream dishes on shell feet. Cigar humidors in this pattern have naturalistically modeled scallop and snail shells on the lid. The humidors and cuspidors are unusual in that the seaweed is modeled upside down as compared with that motif in other Etruscan Shell and Seaweed pieces.

Compotes, designed with shells and dolphins, the most exquisite and fragile of all the Etruscan productions, are rarely seen outside of the 1884 Griffen, Smith and Hill catalogue, because they seldom emerged from the factory intact. The delicate points around the rim of the bowls were easily broken. One compote has three intertwined dolphins supporting a large, shallow shell bowl, lined in Etruscan pink. Another has three dolphins' tails supporting a deeper shell bowl, with the dolphins' chins resting on a shell-decorated base. The smallest piece, a jewel tray, is composed of a single dolphin supporting a nautilus shell; the dolphin's features are quite anthropomorphic.

Other marine motifs were also included in Etruscan designs. An oyster plate, with six naturalistically shaped open oyster shells on a bed of seaweed surrounding a pink sauce well is larger and less formal than its Minton antecedent and much rarer. The Coral pattern, on a pink, blue, or albino background, decorates graduated sets of pitchers, syrup jugs, and salt and pepper shakers with pewter tops. Sardine boxes, inspired by George Jones, have finials of three fish, with boxes and matching underplates ornamented with acanthus leaves.

Oriental motifs

With the opening of trade with Japan in the mid-1850s, both English and American designs were influenced by oriental ideas of simplicity and asymmetry. Japanese

decorative and fine arts were studied at both the 1862 London exhibition and the 1876 Philadelphia Centennial. By the 1880s Etruscan patterns reflected the Aesthetic Movement in the simplicity of Japanese designs such as the Thorn (or hawthorn) pattern on a series of graduated pitchers, the Bamboo pattern on dinner services, and the Bird and Bamboo pattern on tea services. Ruth Weidner (p. 49) suggests that the bamboo designs might also have been inspired by early Chinese or eighteenth-century British chinoiserie patterns.

The Thorn pitcher (made in graduated sizes from eight and a half to three and a half inches tall) reflects oriental inspiration in its spare and asymmetrical design. Pink hawthorn blossoms grow from the branch-shaped handle and spill across the top of the pitcher. The backgrounds of the pitchers are usually mottled gray-green, purple-brown or, rarely, white. Pitchers with the Thorn pattern were also produced in monochrome brown, green, cobalt, and yellow.

The Etruscan dinner service in the Bamboo pattern was produced to complement the current interest in bamboo furniture and bamboo-styled silver tableware. The centers of the plates are glazed in brown and yellow, in imitation of Minton and Wedgwood mottled patterns. The rims are decorated with bamboo stalks and bamboo leaves. Tea services are similarly decorated and modeled with green leaves on a background of bamboo stalks. A butter dish, as with all Griffen, Smith and Hill butter dishes, has an inner liner to separate the butter from the underlying ice. Although attractive, not all pieces in this design are as well executed as the Shell and Seaweed or Cauliflower dinner services. The best modeled piece in the Bamboo pattern is the hexagonal syrup or molasses jug with a pewter top, which has bamboo borders and green leaves on a pink background.

The oriental-inspired Etruscan tea service in the Bird and Bamboo pattern depicts a polychrome bird soaring into a celestial blue background. Occasionally the tea service had a white background. The pieces are hexagonal, with simulated bamboo stalks at the corners. This service was copied by other firms, with an ivory background and much cruder modeling.

Human and mythological figures

Etruscan majolica, as with American majolica in general, rarely included human figures in its designs. The notable

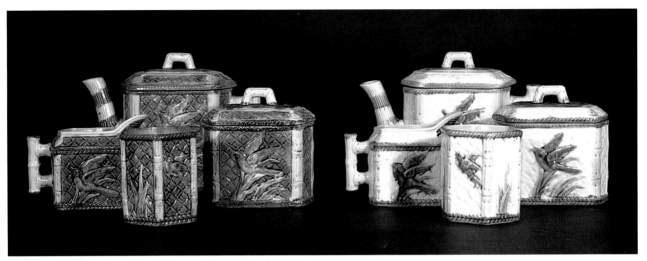

Griffen, Smith and Hill. Tea services. Teapot heights 6½″

Griffen, Smith and Hill. Baseball and soccer pitchers. Heights 8¾″

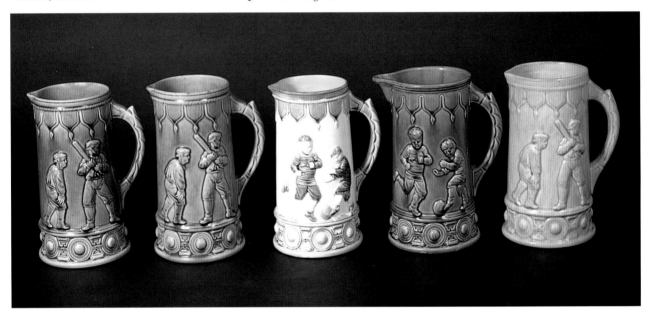

exception is the Baseball and Soccer pitcher, sometimes known as a cider jug. The piece was directly inspired by the Wedgwood Athletic jug, but adapted to the American scene. The Wedgwood version, in the 1860s, was bordered by mantling and geometric motifs, and portrayed cricket and soccer players on opposite sides of the jug. The Etruscan piece has identical borders but displays two young baseball players on one side and two boys playing soccer on the opposite side. The only difference between the soccer players in the English and American examples is that the soccer players in the latter do not wear caps. The Etruscan Baseball and Soccer pitcher has naturalistic polychrome glazes on a pale background (very like the Wedgwood prototype) and is marked on the undersurface. Unmarked examples in monochrome light blue or cobalt, brown, yellow, green, or red (the only red in the Etruscan palette) are considered by collectors to be Etruscan. Another unmarked version of this jug, always in monochrome glazes, portrays the baseball motif on both sides. Griffen, Smith and Hill also produced monochrome jugs with the same borders but no figural scenes, in cobalt or red, with

158

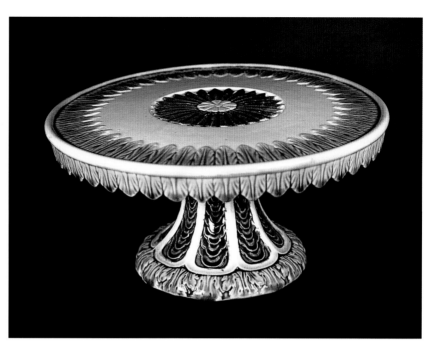

Griffen, Smith and Hill. Cake stand, conventional stylization. Height 5″

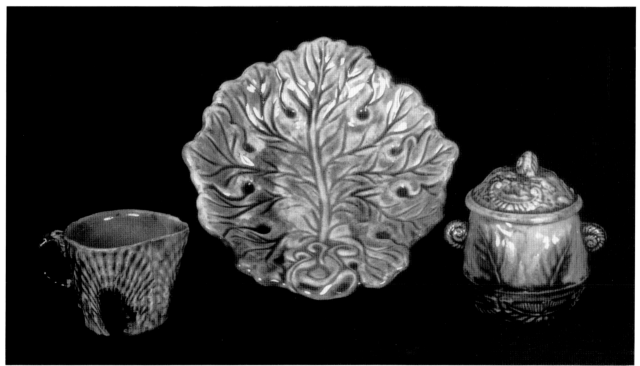

Tenuous Majolica. Creamer, dish, and mustard pot. Dish diameter 6½″

matching four-inch tumblers. An unmarked white umbrella stand, probably Etruscan, is similarly bordered.

Mythological figures appear on an Etruscan majolica pattern known to collectors as Classic. This series was produced after the printing of the 1884 catalogue and was one of the last designs to be produced at Griffen, Smith and Hill. Plates and compotes portrayed such figures as Hermes and Persephone, or cherubs clutching the mane of a flying lion. They were designed by W. H. Edge, a decorator at Griffen, Smith and Hill who had worked for James Carr of the New York City Pottery. Pieces in the Classic pattern were most often glazed in

a dusky rose—sometimes in green, terra-cotta, or yellow—and the elegant pieces approached art pottery. Bowls were somewhat more ornate, with twisting strands of pink encircling green leaves along the shallow rims of the bowls. The Classic series included the so-called potter's dog plate, in monochrome dusky rose as well as with a white background with multicolored details.

Miscellaneous patterns

Before discussing several examples of Etruscan majolica that do not fit tidily into design categories of the firm's production or into the series of patterns illustrated in the 1884 catalogue or are one of a kind, it is important to clarify an issue that has long puzzled collectors and authors. The terms "Convention" and "Conventional" have been used by collectors to designate the pattern used in two pieces of Etruscan majolica: a cake stand (J4 in the 1884 catalogue) and a teapot stand (C9 in that catalogue). A member of the Yarnall family has recently confirmed that the term "Conventional" was *not* used by Griffen, Smith and Hill to designate any particular pattern, but rather to indicate that a number of different patterns used "conventionalized" (meaning stylizations or abstractions of) motifs. For example, the 1884 catalogue lists various floral motifs by name (such as Lily or Cosmos) together with the word "Conventional," in parentheses, meaning that the flower motif of that pattern was not naturalistically depicted but was stylized. In some cases the term "Conventional" is used alone in the 1884 catalogue, without a motif name, for some pieces, including the cake stand (J4) and teapot stand (C9) mentioned above. Both of these pieces have a pattern of small acanthus leaves placed concentrically around a white background, encircling a stylized (conventional) pleated brown-and-yellow rosette. Another piece illustrated in the 1884 catalogue labelled "Conventional" but without a pattern name, is a straight-sided jug with a quite different design: an overall lozenge pattern enclosing quatrefoil devices (E4). In such cases the pattern itself is a stylized geometric design, not a "conventionalized" representational motif such as a flower. Thus the terms "Convention" and "Conventional" should not be applied to any one particular design but indicate an abstraction of a design.

160

Two other designs, quite unusual for Griffen, Smith and Hill or for American majolica in general, are a lion vase and a holy-water font. The lion vase is a small mottled amphora-shaped vessel with three Minton Renaissance lions' heads around the body, which rests on three lions' paws. It is pictured in the 1884 catalogue.

Not included in the 1884 catalogue is the Etruscan holy-water font for private use, first designed for Francis Malloy of Norristown, Pennsylvania, twenty miles from Phoenixville. The piece bears no Etruscan mark, but the patent number (288,085) and date (November 6, 1883) are incised on the gray background typical of Griffen, Smith and Hill majolica. The design includes the Virgin Mary, the Rose of Sharon, and the Tree of Life, in the traditional Etruscan colored glazes. Around the top are the familiar Griffen, Smith and Hill scallop shells.

A complete list of Etruscan majolica pieces would also include graduated pitchers in the Rustic pattern, strewn with maple leaves and branches on cream, green, or brown bodies; covered butter dishes with finials of butterflies or George Jones-inspired cows; a cobalt washstand set that has a Star of David finial on the soap dish; oval covered soap dishes and wall pockets (called "Hanging Soaps" in the 1884 catalogue) with twigs and oak leaves modeled on a wickerwork background; and a large planter with a fern design and a matching wickerwork under plate.

One hundred years after the Etruscan Shell and Seaweed pattern made its appearance, reproductions of cups and saucers and seven-inch plates in this pattern were made from Japanese molds. There is no mark on the white undersurface of the new pieces, but a paper label proclaims them "Made in Japan." (The nineteenth-century originals have gray undersurfaces, often with the factory mark.) The reproductions are lighter weight than the originals, and the colors do not vary from piece to piece as they do in the hand-painted originals. It is rewarding to know that a decade of Etruscan majolica designs continues to produce descendants a century later.

The earliest mark Griffen, Smith and Hill used on its majolica was its monogram "GSH," impressed, replaced in 1880 by the monogram "GSH" surrounded by two concentric circles, with the words "ETRUSCAN MAJOLICA" between them. There are rare examples of the early monogram placed above a curved "ETRUSCAN." Incised letters indicated specific shapes: butter pats were marked "A"; leaf dishes, "B"; trays, "C"; and so forth.

Incised numbers referred to patterns. Very small pieces, such as the salts and peppers, were identified by this number alone. White, or "albino," pieces in the Shell and Seaweed pattern were rarely marked. A third mark, another number, was sometimes used to indicate the decorator. Occasionally "ETRUSCAN" was impressed in a straight line. Some items may have had more than one mark. Pieces in the porcelain-like Pandora and Venicene patterns bear the impressed mark "ETRUSCAN IVORY" between two concentric circles, around the firm's monogram.

Tenuous Majolica

A recently resolved mystery is the identity of the potter or pottery that made the pieces of majolica curiously marked "TENUOUS MAJOLICA." The mark is impressed with the words either (1) between two concentric circles enclosing the initial "H" in a smaller circle, or (2) with "TENUOUS" in an arc above "MAJOLICA" written in a straight line, with the "H" (not in a small circle) either between the two words or below "MAJOLICA." The first mark is provocatively similar, at first glance, to Griffen, Smith and Hill's mark "ETRUSCAN MAJOLICA" with those two words between two concentric circles enclosing the firm's monogram. That mark, however, is more elegantly articulated than the Tenuous Majolica mark. The potter who made the pieces that bear the latter mark echoed some of the Etruscan patterns in his wares, but very much more crudely, and his pieces are heavier and more clumsily glazed.

The Tenuous pieces are primitive versions of the Etruscan Shell and Seaweed pattern (with only the scallop shell) or simplified leaf designs in the Etruscan style. A tiny creamer with a scallop-shell design—in cobalt, green, yellow, and pink glazes, with a majolica-pink interior—has a handle that suggests coral (a handle form used on some Etruscan teapots). White scallop shells encircle a blue-and-white cuspidor. A small mus-

tard pot in a greenish-blue leaf pattern on a sandy-yellow background has a snail-shell finial on the lid and snail shells on either side of the pot for handles, similar to finials and handles on Etruscan Shell and Seaweed tea services. A syrup jug in a leaf pattern in yellow-brown glazes, with a pewter top, has a twig handle reminiscent of some Etruscan syrup jugs. A shallow leaf-shaped dish is glazed in blue, yellow-brown, and pink. M. Charles Rebert, in *American Majolica 1850–1900* (p. 71), mentions a few other pieces with this mark: leaf-shaped butter pats and trays, the latter with twig handles.

The undersurfaces of the pieces with the circular Tenuous Majolica mark are a paler imitation of the gray-green undersurface glaze of many Etruscan pieces. The pieces with the second Tenuous Majolica mark have cobalt undersurfaces.

It has been tempting to trace the "H" of the two Tenuous majolica marks to William Hill, the potter who was briefly a partner of Henry and George Griffen and David Smith. Hill had left the firm soon after majolica production began. Tenuous majolica, however, was produced by Richard Harrison (hence the "H") at the Harrison Pottery Works in Peekskill, New York. Harrison, born in England in 1813, emigrated to the United States with his wife soon after the Civil War. His factory, established in 1867, produced utilitarian pottery until about 1896. Harrison joined other American potters in the production of majolica from about 1882 to 1887. Harrison's majolica was sometimes marked PEEKSKILL POTTERY CO. and HARRISON'S POTTERY WORKS/PEEKSKILL, N.Y., in addition to the TENUOUS MAJOLICA marks in the style of Etruscan majolica. What remains "tenuous" is the coincidence between the parallel shapes of the Tenuous marks and the Etruscan marks: perhaps Richard Harrison was involved with Griffen, Smith and Hill, or perhaps he appropriated their marks as well as their designs for his own interests.

Chapter 9
OTHER AMERICAN POTTERIES

James Carr

James Carr of the New York City Pottery was the major American exhibitor of majolica at the Philadelphia Centennial Exhibition of 1876. As Carr's majolica was not marked and no surviving pieces of majolica are attributable to him today, it is fortunate that a photograph taken of his Centennial exhibit exists. On view were garden seats, vases, pitchers, game dishes, sardine boxes, match strikers, compotes, and centerpieces. These pieces were "colored in the richest hues," according to an interview James Carr gave to the press at his home just before his wares were sent to Philadelphia for the Centennial display. It was also reported that the vases were in the shape of immense water lilies, and that the garden seats were ornamented on the sides with "boys bird-nesting in the regular school-boy style." (See J. G. Stradling, "American Ceramics at the Philadelphia Centennial," *The Magazine Antiques,* July 1976, p. 147.)

Carr, who was to become one of the most active forces in the development of American ceramics, was born in Hanley, Staffordshire, in 1820 and learned his trade by the age of ten. He was employed by John Ridgway in Hanley and by James Clews at Cobridge. On his arrival in America in 1844 Carr secured employment with the American Pottery Company of Jersey City, New Jersey, which operated between 1833 and 1854. In 1852, after having absorbed much about ceramic technique at that well-known "nursery" of the pottery industry, Carr moved to South Amboy, New Jersey. There, with Thomas Locker, Carr took over the Swan Hill Pottery. This association also included Enoch Moore and Daniel Greatbach as partners for a time. As with other potteries, the name of the firm changed with changes in the partnership: when Greatbach worked with Carr and Locker the enterprise was called the Congress Pottery. In

1853, after a fire at the Swan Hill Pottery, Carr moved to New York City and opened the New York City Pottery at 442 West 13th Street.

New York City, with its large and relatively prosperous population, welcomed the earthenwares of James Carr and his new partner, Alexander Morrison, a businessman from Columbus, Ohio. The firm of Morrison and Carr, from 1856 to 1871, when the partnership ended, made table services in white granite and opaque china. These details of the partnership were confirmed by Carr in his "Reminiscences of an Old Potter: A Series of Letters by James Carr," published in the *Crockery and Glass Journal* in the March 21 to April 25, 1901, issues. Barber apparently did not have this information when he wrote in 1893 and 1901 in *Pottery and Porcelain in the United States* (pp. 179–180) that Morrison and Carr made majolica from about 1853 to 1855. Carr did make the first American cauliflower-shaped teapot, a descendant of the Whieldon-Wedgwood piece, well glazed in the traditional green and off-white, but not as finely modeled. John Ramsay, in *American Potters and Pottery* (pp. 64, 198), states that Carr and Morrison produced majolica from 1858 to 1860, including the cauliflower teapot. In the catalogue of an auction of ceramics from the Philadelphia Museum of Art in 1954, however, in the section American Ceramics, the James Carr cauliflower teapot was listed with the date of production given as 1876 and the statement that it was displayed in the 1878 Paris exhibition.

It would seem more likely that the greater amount of Carr's majolica was made in the 1870s, soon after the departure of Morrison. Barber wrote, in *Marks of American Potters* (p. 79), that the great majority of Carr's majolica production was in preparation for the 1876 Philadelphia Centennial Exhibition. Majolica was be-

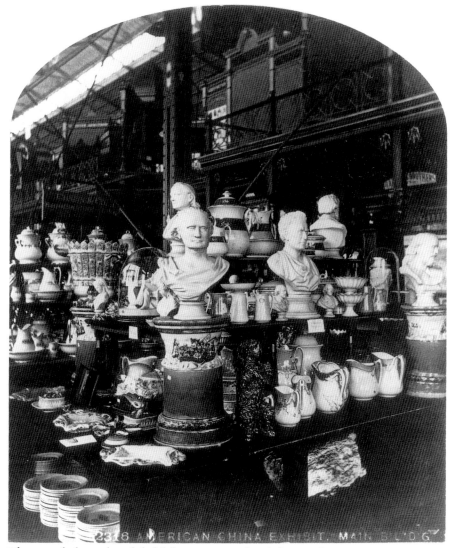

Photograph from the Philadelphia Centennial Exhibition of 1876. Courtesy
Library of Congress

coming more fashionable in America, and after experimenting with different fuels, clays, and glazes, Carr produced majolica that was more colorful than that of his predecessor Edwin Bennett and more English in design than that of most American majolica potters.

At the Philadelphia Centennial Exhibition Carr received recognition, but not without a struggle. No award was made to him until the Centennial commission was asked to reevaluate his innovative work. This action resulted in a gold medal for James Carr. Judge Arthur Beckwith pronounced: "The majolica is well fired, and coated with an excellent glaze of great hardness and transparency. The etchings under the glaze (designed by Mr. W. H. Edge) are commended for technical merit,

and as a progress in this department of American pottery" (Francis A. Walker, ed., *United States Centennial Commission, International Exhibition 1876* . . . , p. 284). This was high praise for a man who had arrived in the United States at the age of twenty-four with three shillings and who had once earned one dollar for a twelve-hour workday. Barber acquired for the Pennsylvania Museum Carr's Centennial display (the pieces were deaccessioned in the 1950s). Carr received further accolades in the next few years, with honors from the American Institute in New York for his technical and artistic endeavors. At the international exhibition in Paris in 1878, with much competition from English and Continental factories, Carr was honored for the excel-

163

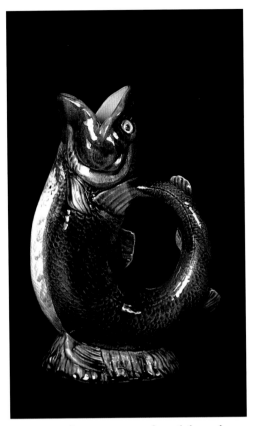

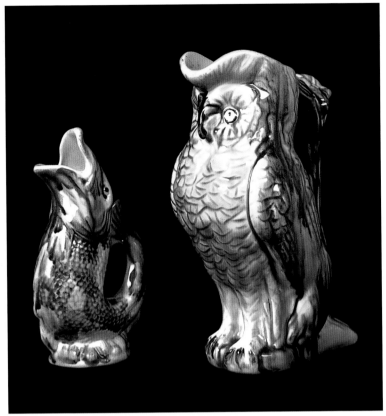

George Morley & Co. Gurgling-fish pitcher. c. 1880. Height 11"

George Morley & Co. Bouquet holder and owl pitcher. c. 1880. Height of owl pitcher 10"

lence of his work. His cauliflower teapot was exhibited there before it was displayed at the Pennsylvania Museum.

In 1878, although the New York City Pottery was still functioning, James Carr and Edward Clarke, an emigrant potter from Burslem, Staffordshire, formed a partnership in Trenton, New Jersey. As the Lincoln Pottery Company, Carr and Clarke produced cream-colored wares and white granite on the site where the old Taylor and Speeler works had been built in 1852—one of the first potteries in Trenton to produce Rockingham and yellow wares. After several months, Carr returned to New York, and Clarke's new partnership in Trenton in 1879 with William Burgess and John Campbell resulted in the formation of the International Pottery Company.

From 1879 to 1888 James Carr continued to produce at the New York City Pottery the majolica, Parian, white granite, jet, blue-glazed, and cream-colored wares, and *pâte-sur-pâte* that had made him known as one of the greatest potters of his time. His artistic legacy was left to the many artists he trained, including J. E. Jeffords of Philadelphia.

In 1888, because of the increasing competition from New Jersey, Pennsylvania, and Ohio potters, the New York City Pottery was closed. The buildings were razed, large stores were built on the site, and Carr reported that he received more revenue from rentals than from the pottery business. After sixteen years of retirement, James Carr died in January 1904, at the age of eighty-four. The Victorian era was over, an era in which Englishmen, Americans, and Anglo-Americans benefited from Carr's contributions to the ceramic industry.

No marked piece of Carr's majolica has come to light, although Barber mentions several marks used by Carr's firm on their other wares, including a JC monogram on hotel china. (In Chapter Six the erroneous attribution to Carr of some pieces of majolica in a shell and seaweed pattern is discussed.) One experimental piece with majolica glazes bearing Carr's mark is known. It is a vase in the Art Nouveau style decorated with daffodils and

glazed in browns, greens, cobalt, and yellow with the incised mark in an informal script "H. Lancaster/Sc/N3/ J Carr/City Pottery/NY" on the unglazed undersurface. H. Lancaster, a worker in Carr's pottery, sculpted the piece. Overfiring of the piece damaged the glaze, which bubbled and crazed, and because of the high kiln temperature the earthenware became nearly as dense as stoneware.

George Morley

After the departure of the Bennett brothers in 1844 from East Liverpool, the Ohio River region continued to welcome excellent potters to work the fine clays. During the next two decades westward migration across America provided a ready market for the potters' output. East Liverpool was said to resemble an English pottery town more than any other American community. Molders, kilnmen, and jiggermen earned from eight to twenty dollars a week, depending on their skill. Women and young girls painted biscuit pieces. Young men used their muscle as kiln loaders, mold runners, and sagger stackers. Potter's asthma and lead poisoning affected even those whose rural lives should have spared them.

After the disruption of the Civil War, the East Liverpool area enjoyed increased prosperity. By 1880 there were almost ninety potteries in East Liverpool and Wellsville, the "Crockery Cities." Ohio River steamboats carried Rockingham and yellow wares and majolica to the newly developed Middle West, and to New Orleans at the mouth of the mighty Mississippi.

Barber lists a dozen potters working in the East Liverpool area (*Pottery and Porcelain*, p. 201). Of these, George Morley made the greatest contribution to American majolica. He had been a skilled potter in Staffordshire who emigrated about 1852 to East Liverpool, where he worked for Woodward, Blakely and Company, producing yellow and Rockingham wares. From 1855 to 1878 he established a partnership with James Godwin and William Flentke, as the Salamander Pottery. In 1879 he moved to Wellsville, where, in partnership with Harmer Michaels and I. B. Clark, he organized his own firm, Morley and Company. Beginning in that year, almost concurrently with the establishment of Griffen, Smith and Hill in Pennsylvania (with whom he exchanged technical information), Morley produced majolica and ironstone china. From 1879 to 1884

he used the marks "MORLEY & CO./MAJOLICA or MAJOLLICA/ WELLSVILLE, O." In 1884 Morley returned to East Liverpool, using the mark "GEORGE MORLEY'S/ MAJOLICA/EAST LIVERPOOL, O." In 1884, with his two sons, Morley bought the Lincoln Pottery in East Liverpool from West, Hardwick and Company. The new firm, George Morley and Sons, made majolica and ironstone china, using the same molds for both wares. The body and glaze of Morley's majolica were judged to be more durable than Griffen, Smith and Hill's. Despite this apparent success, George Morley and Sons declared bankruptcy in October 1891.

The best known pieces of Morley majolica are the "gurgling fish" pitchers, also called "gurgling jugs," because of the sound emitted when liquid was poured. These fish pitchers were made in graduated sizes from five to eleven inches. The smaller ones were also referred to as bouquet holders by Morley. Some fish pitchers were better modeled than others, complete with freestanding fins, and they were glazed in a tortoiseshell pattern of green, blue, and russet-brown, or well delineated in more realistic charcoal colors. In rare instances examples were glazed in cobalt or pastel colors. Morley fish pitchers are difficult to recognize without marks, and few of his were marked. Fish pitchers were produced on both sides of the Atlantic, but Victorian examples with marks other than Morley's are not known. If the undersurface of a fish pitcher is glazed yellow, the pitcher is probably English; if white, probably American. Morley fish pitchers are less gracefully modeled than English examples.

Other Morley pitchers are decorated with flowers or birds. One graduated set—modeled with a rough-bark body and decorated with a branch of wild roses, buds, and leaves—is similar to English pitchers, and positive identification depends on the mark. If these pitchers are marked with brushstrokes on a white bottom, they are probably American, perhaps Morley. Although most of the pitchers have a brown body, some are glazed white, or occasionally pale blue. Morley figural owl and parrot pitchers were made in several sizes. Well modeled and with colorful glazes, these pitchers have tree-branch handles with a rose blossom on the thumbpiece of the handle. The English counterparts have sharper relief decoration, more highly colored glazes, and a bamboo handle with a rose-blossom thumbpiece. Unmarked pieces have been identified as Morley's by the staff of the

Museum of Ceramics at East Liverpool, which has a fine collection of Morley majolica.

A plate and a compote in a large leaf pattern, glazed mottled green and brown, and bearing the Morley majolica mark, were made from Griffen, Smith and Hill molds purchased by Morley. These pieces testify to the support that Griffen, Smith and Hill gave to Morley (in addition to exchanging information about glazes), much as Minton and Léon Arnoux helped their contemporaries.

Morley also used piscean motifs in the modeling of two handsome trout in high relief on a majolica wall plaque. Another marine motif, the large Morley conch shell, resting on small shell feet or presented as a compote on a five-inch pedestal, was probably inspired by a similar Holdcroft design. Quite as well modeled as its English counterpart, the Morley shell was glazed on the outside in mottled green and brown, with the traditional majolica-pink or blue interior.

Morley majolica napkin plates (c. 1880, marked MAJOLLICA/WELLSVILLE, O.) are excellent examples of Victorian style. A folded white napkin, decorated with a flower or with a fringed edging, was modeled on a plate of a contrasting color. Also produced in china or white granite by Morley and other potters, the napkin plate was frequently seen on Victorian luncheon or tea tables. Another example of Victoriana is a Morley spittoon with a textured background and decorated with a blackberry branch and fruit.

During his thirty-eight-year career George Morley created more majolica than any other potter west of Phoenixville, Pennsylvania.

Chesapeake Pottery

The Chesapeake Pottery, in Baltimore, Maryland, was established in 1880 by Henry and Isaac Brougham and John Turnstall. In 1882, because of business casualties, the owners sold the factory to David Francis Haynes, who remained the principal owner until his death in 1908. The name of the firm from 1882 to 1890 was D. F. Haynes and Company.

Haynes was a man who understood the pottery business from an entrepreneurial point of view, as well as in its artistic aspects. The descendant of a Puritan ancestor, Walter Haynes, who had arrived on the ship *Confidence* in 1638, David Francis Haynes was born in Brookfield, Massachusetts, in 1835. He was educated in the public schools until the age of sixteen, and then worked at a crockery store in Lowell, Massachusetts. In his twenty-first year he was sent to England in charge of important trusts. It was on these trips that he, having been raised on a farm, came to appreciate the arts in England and on the Continent. His natural artistic abilities were thereby enhanced and later contributed to his experimental and creative work in pottery.

In 1856 David Haynes moved to Baltimore to enter the employ of the Abbott Rolling Mills, manufacturers of plate iron. With the outbreak of the Civil War in 1861, when he was twenty-six, Haynes was placed in charge of the large mills that produced the armor plates for the ironclad ships. At the war's end he was sent to Virginia where he managed a large iron property and fortuitously became involved in the mining of iron ores and clays. It is not known how it came to pass that in 1871, armed with the knowledge of ores and clays, he was offered an interest in a crockery jobbing house in Baltimore. He was pleased to be back dealing with crockery, and a decade later he was in possession of his own pottery business. By this time he had a good knowledge of the business and marketing aspects of pottery, and he also had an understanding of the art forms that would please the American public.

Like David Smith at Griffen, Smith and Hill, Haynes was able to design and execute original examples of majolica. In 1882 he produced his first majolica pieces, a dinner service in a pattern named Clifton. The pattern, featuring blackberries, was modeled in high-relief and was perhaps inspired by the Wedgwood Blackberry Bramble design. The decoration was painted in naturalistic colors on an ivory body that simulated rough bark. Other Clifton patterns—with strawberries, grapes, geraniums, and ivy—were soon produced as well, all equally successfully received. A more elegant majolica design, Avalon Faience, was inspired by Haynes's appreciation of French faience and design. This new pattern of blackberry fruits and ivy was set on a smooth, off-white background. The design was well glazed in shades of red, green, and black. Haynes's use of antique gold to outline the painted fruits and leaves gave a new dimension to the majolica. Also new in American majolica were the off-white backgrounds used for these two patterns, echoing Wedgwood's Argenta wares.

Clifton and Avalon wares included dinner services, pitchers, compotes, punch bowls, mugs, butter dishes, and tea and coffee services. With continued success Haynes also made planters, clock cases, lamp bases, and toilet sets. A third faience design, Real Ivory, was added. All three patterns were made until 1890 and were well documented by their marks: "CLIFTON" and "DECOR'Ba." or "DECOR'B" on two intersecting crescents, enclosing the monogram "DFH"; "AVALON/FAIENCE/BALT." or "AVALON/FAIENCE/BALTO." forming a triangle around the monogram "DFHC"; and "REAL IVORY/BALT." or "REAL IVORY/BALTO" enclosing the monogram "DFHCO" in a shield, with an ampersand to the left of the monogram.

For nearly five years the Chesapeake Pottery competed favorably with imported English majolica, and indeed was praised by some who felt it was superior to the foreign product. The decision to expand the business, however, resulted in a financial crisis. This enabled the originator of American majolica, Edwin Bennett, to add to his pottery empire in Baltimore by purchasing the Chesapeake Pottery in 1890. Known then as Haynes, Bennett and Company, the firm was quite successful, winning honors at the Pan-American Exhibition in Buffalo in 1891, as well as at the 1893 Chicago World's Fair. Advertising appeared on Haynes, Bennett and Company pieces, extolling local items such as tobacco.

On Edwin Bennett's retirement in 1895 his son Edwin Houston Bennett bought into the enterprise. Born in Baltimore, Edwin Houston Bennett had spent his business life in the family potteries and his excellent knowledge of kilns operation made the Chesapeake Pottery one of the most progressive in the field. In 1900 Edwin Houston Bennett sold his share to David Haynes's son Frank R. Haynes. Father and son continued operations under the name D. F. Haynes and Son.

By the time of his death in 1908 at the age of seventy-three, David Haynes was highly respected in his field. He was a charter member of the American Ceramic Society, founded in 1899. He was an important member of the United States Potters' Association and the American Institute of Mining Engineers. In 1904, at the Louisiana Purchase Centennial Exhibition in St. Louis, Missouri, D. F. Haynes and Son had won great recognition for their wares.

After 1908 Frank R. Haynes tried to operate the pottery alone. Competition from Pennsylvania and Ohio potters, who were able to use low-cost gas for firing their kilns, made it difficult for the Baltimore potters, who could not convert the factory to the use of more efficient gas heat. As a result, in 1914, after more than three decades of prize-winning production, the Chesapeake Pottery was closed.

Many critics praise Clifton and Avalon wares for the superb hard glaze and for the well designed yet utilitarian features of the pieces pleasing to the Victorian housewife. There was humor too: a Baltimore beetle decorates an otherwise conventional fruit design in the Avalon pattern. Griffins and gargoyles are modeled on the lips and handles of some pitchers, recalling fifteenth- and sixteenth-century ceramics in the midst of nineteenth-century American fruits and flowers. Haynes anticipated the art pottery movement, as well as the simplicity of Art Deco tablewares of the 1930s. Haynes's pieces, with their delicate colors, were antidotes to the harsh glazes and poor modeling of latter-day majolica. Department stores such as John Wanamaker's, Marshall Fields, and Macy's sold D. F. Haynes and Son's majolica.

The Trenton potteries

The "Staffordshire of America," as Trenton, New Jersey, was called by the last quarter of the nineteenth century, was fortuitously situated in a manner similar to Stoke-on-Trent. It was close to clay deposits, with access by waterways to kaolin and feldspar in Delaware and Maryland. There were good shipping routes along the Delaware and Chesapeake canal systems, and docking facilities on the Delaware River. By 1875, when nineteen potteries in Trenton were producing about two million dollars' worth of various ceramics, the firm of Ott and Brewer began to experiment with the production of Parian ware. Their products offered creative ideas to later majolica designers.

The Glasgow Pottery was established in 1863 by John Moses, who had emigrated from Ireland in 1832, at the age of twenty. After an apprenticeship in the dry-goods business in Philadelphia, Moses moved to Trenton and in 1863 established a pottery for the production of yellow, Rockingham, and cream-colored wares, and white granite. Moses was one of the three American potters who displayed majolica, albeit unmarked, at the Philadelphia Centennial. Barber praised the ceramic production of

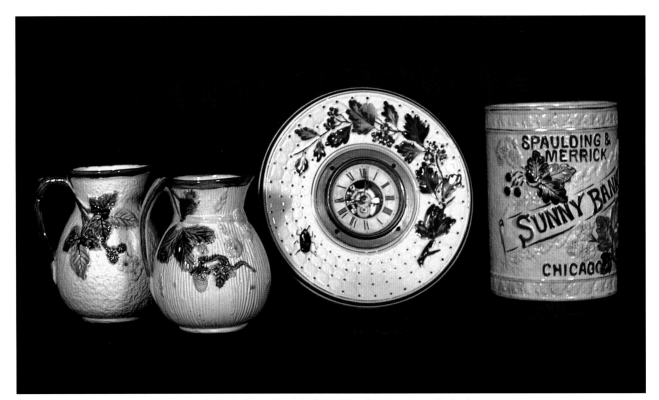

Chesapeake Pottery Co. Clifton pitchers with Avalon clock and bank. c. 1882. Clock diameter 8½"

the Glasgow Pottery, citing its "decorated wares of every description" (*Pottery and Porcelain,* p. 214), but he made no specific mention of majolica. The company ceased production around 1900.

The Trenton factory of Isaac Davis was listed in the Philadelphia Centennial catalogue for an exhibit of white granite and decorated crockery ware, but not for majolica. Davis was, however, listed as a manufacturer of majolica from 1872 to 1879 in an article in the *Sunday Times Advertiser* (July 15, 1928) entitled "Trenton in Bygone Days," by John J. Cleary. Davis had worked for John Moses as the manager of the Glasgow Pottery and headed his own pottery from 1875 to 1880. From 1880 to 1894 he was a partner of Dale and Davis, which produced decorated semiporcelain and graniteware.

Barber reported (*Pottery and Porcelain,* p. 241) that the Arsenal Pottery in Trenton manufactured majolica. City directories list the firm from 1877 to 1879 under the name Arsenal Pottery, with the name Joseph Mayer. The company continued until 1899 under several name changes, including Mayer Brothers, from 1880 to 1884,

reflecting Joseph's partnership with his brother James. The majolica produced by the Arsenal Pottery included well-modeled Toby pitchers and jugs, similar in form and color to English examples. The Arsenal Pottery exhibited majolica at the 1893 Chicago World's Fair. (Barber stated in 1893, in the first edition of *The Pottery and Porcelain of the United States,* that the Arsenal Pottery was probably the only American manufactory producing majolica at that time; p. 241.)

The company that made the most attractive majolica in Trenton was the Eureka Pottery established in 1883 by Leon Weil, who was succeeded by Noah and Charles Boch. The Eureka Pottery was the last of the commercial potteries constructed during the historic three decades during which potteries were established in Trenton. It was closed in 1887 as a result of fire, the constant enemy of potteries.

Two Eureka patterns are well marked and both are inspired by English interpretations of oriental designs. Bird and Fan, with colorful figures and prunus blossoms on a pebbly white or blue background, is a version of the

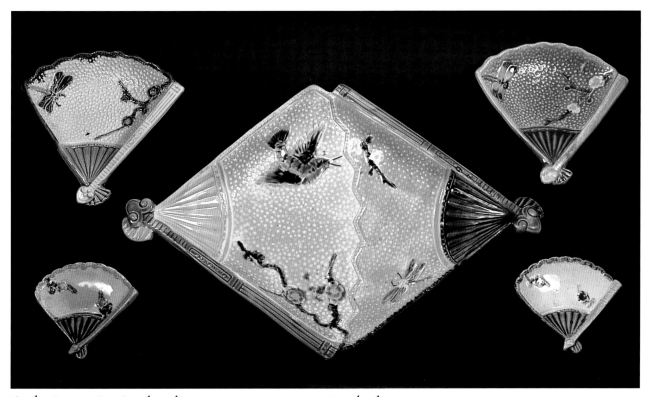

Eureka Pottery Co. Fan-shaped ice-cream service. c. 1885. Length of tray 16"

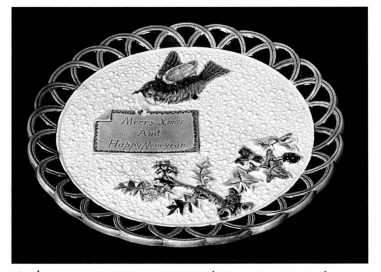

Eureka Pottery Co. "Merry Xmas and Happy New Year" plate. c. 1885. Diameter 9½"

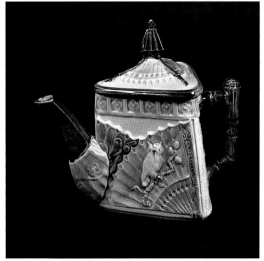

Eureka Pottery Co. Teapot. c. 1885. Height 7⅝"

Wedgwood pattern of that name. Dinner services, tea services, cake stands, and plates (some without the fan but bearing the yule message "Merry Xmas and Happy New Year"), graduated pitchers, wall pockets, match boxes, and tobacco humidors were made in the same pattern. Most pleasing are the Bird and Fan diamond-shaped ice-cream serving tray and matching fan-shaped dishes in three sizes.

Eureka's second oriental pattern, Owl and Fan, has pastel glazes similar to those of the Bird and Fan pieces, on a white, brown, or pebbly gray background. Undersurfaces are glazed white or gray. This pattern was used on tea services and on pitchers of graduated sizes. Pitchers, teapots, and accompanying small plates were frequently triangular.

The English influence at Eureka is also seen in the pottery's stork pitchers, with a large white bird surrounded by cattails and marshy plants, reminiscent of the Minton and George Jones storks. Backgrounds are white, yellow, cobalt, or brown. The pitcher was made in graduated sizes and the most impressive piece is eleven inches tall with a pewter lid. The handle of the pitcher is modeled as a snake or eel, with an eye glaring balefully at the holder. Undersurfaces of this Eureka pattern are frequently gray, but also occasionally mottled brown on cream backgrounds. Many pieces bear the impressed mark "EUREKA POTTERY" in an arc above the word "TRENTON."

The Crown Porcelain Works, started in Trenton in 1890 by Barlow and Marsh, produced in addition to porcelain "a fine line of decorated *faïence* specialties" (Barber, *Pottery and Porcelain*, p. 240), and majolica. There is no known mark.

One of the largest pottery firms in the United States, according to Barber (*Marks of American Potters*, p. 45) was the Willets Manufacturing Company of Trenton, which began operation in 1879. Although many marks are associated with the company's production of white granite, Belleek, and semi-porcelain no marked majolica by Willets has come to light.

Philadelphia City Pottery

J. E. Jeffords and Company was founded by a disciple of James Carr of New York City. Jeffords's majolica produced at the Philadelphia City Pottery was exhibited at the Philadelphia Centennial of 1876. The factory, also known as the Port Richmond Pottery, operated from 1868 to 1890. One of Jeffords's pieces was a huge teapot, capable of holding twenty gallons, supported by a majolica pedestal forty-eight inches high. Each side of the pedestal was decorated in relief with representations of large vases that had classical medallions and gilded lion's-head handles. Not the usual utilitarian piece of majolica, but quite impressive.

Mayer Pottery Company

This pottery, in Beaver Falls, Pennsylvania, made majolica starting in 1881. A small majolica tile depicting an owl in naturalistic colors bears the mark "MAYER."

Hampshire Pottery

A visit to the Colony House Museum in Keene, New Hampshire, will acquaint the majolica collector with the superb craftsmanship of the Hampshire Pottery. The museum is in an historic Federal-period house leased to the Foundation for the Preservation of Historic Keene, Inc. A collection of 750 pieces made at the Hampshire Pottery was generously donated to the Colony House Museum by A. Harold Kendall.

In 1870 Keene's population was 5,871, with 1,185 dwellings in need of utilitarian and decorative pottery. Keene's advantage over the short-lived potteries in Dublin, Jaffrey, Troy, Marlborough, and Westmoreland was due to its rich blue clay (ball clay) and white silica deposits. Feldspar and clay from nearby Troy, kaolin from New Jersey, and special European clays contributed to the success of the Keene potters.

In July 1871 James Scollay Taft, a twenty-seven-year-old native of Nelson, New Hampshire, joined forces with his uncle, James Burnap, of Marlow, New Hampshire, to create the Hampshire Pottery, on lower Main Street, where they began by producing flowerpots. Geological and economic factors favored the development of the pottery: raw materials were available and strong business interests developed in Keene. A wholesale and retail grocery became the largest establishment of its kind in New Hampshire, and the increased mercantile activity contributed to the success of the pottery.

Three months after Taft and Burnap started their venture, however, a fire consumed the entire factory. It was rebuilt two months later and a more ambitious line of earthenware was undertaken. New Hampshire recognized the value of Taft's stone jars and jugs, soup dishes, large pitchers, milk pans, and flowerpots. The firm's pottery was, like their earlier earthenware, glazed in Rockingham brown or gray. Though business difficulties, including other pottery fires, had to be surmounted, Taft and Burnap persisted and prospered.

Taft was able to buy at auction the pottery founded in Keene in February 1872 by John W. Starkey and Oscar J. Howard to manufacture stoneware and earthenware,

including Rockingham ware. They were not successful and declared bankruptcy in the summer of 1872. With the acquisition of their pottery Taft was able to manufacture stoneware and earthenware in larger quantities and to meet requests for individual designs.

Always an excellent and innovative merchant, Taft next turned to the production of majolica. The Philadelphia Centennial Exhibition of 1876 had stimulated great public interest in American majolica. In 1879 Taft, working with Thomas Stanley, initiated a line of majolica. Stanley, an English master potter and designer, was responsible for the introduction of majolica glazes. Early pieces were modeled in low relief with well-defined decorations, and glazed in green, yellow, blue, and brown. The majority of Hampshire Pottery majolica was heavier than that of other manufacturers. One of the most popular patterns was the corn pattern, used for pitchers, tea services, and salt and pepper shakers. Other pitchers were varied in shape, some with handles at right angles to the spouts, and some had handles in a different color from the bodies. Brown was the predominant color for pitchers and tea services. Vases were more decorative; one tall vase, glazed in green and white stripes, is now considered to be the transition piece from Hampshire majolica to their later decorated wares.

A special pattern for tea services named Nantucket, because it was inspired by a ceramic design Taft found on that Massachusetts island, had plates edged in blue, green, yellow, or red. Another pattern with a New England name, Monadnock (a mountain near Keene), was used for a fifteen-inch pitcher glazed in a brilliant dark green. Taft also produced pieces in a bamboo pattern, using a natural bamboo-colored background, decorated with green leaves. The bamboo shoots are wider and less sharply modeled than those in British pieces, but the Hampshire tea services and planters in this pattern have a rustic charm. Taft could also produce crisp modeling equal to the work of Griffen, Smith and Hill. Yellow wickerwork baskets with majolica-pink linings made by both factories can be distinguished only by the "GSH" monogram on the Etruscan model.

A piece never equaled by other American majolica factories is the Hampshire lidded marmalade pot in the shape of a large orange, with a rough-textured, pitted surface. It is the only known example of an orange glaze in the American majolica palette. The stem on the cover sprouts seven green leaves modeled in relief. The interior is glazed white and the name "HAMPSHIRE" is sometimes marked on the off-white glazed undersurface. It is similar to the orange marmalade pot made by George Jones, but the Taft example has no cut-out space at the edge of the lid for a serving spoon, and no accompanying under plate. Many late nineteenth-century orange-shaped marmalade pots resting on leaf serving plates are not from the Hampshire Pottery, but are more likely to be Continental. The Continental examples are frequently marked with three- or four-digit numbers, impressed. The Hampshire orange-shaped marmalade pots are heavier than Continental examples. Authorities on Hampshire pottery state that, contrary to popular belief, Taft did not produce any apple-shaped jam pots or any of the fruit-shaped pieces that conceal a toothpick holder on a leaf dish.

Another matter of controversy is the attribution to the Hampshire Pottery of an unmarked majolica design with asters. Although it has been so listed at auctions, and attributed to Taft in articles, authorities on Hampshire pottery say that it is not from that factory. With its floral sprays in pink, blue, yellow, and green on a pebbly white or pale blue background, the pattern is reminiscent of Wedgwood Argenta, but less formal and not as well modeled as the Wedgwood examples. The many pieces in this pattern—tea services, pitchers, trays, and serving pieces—have varied undersurfaces, some off-white, some mottled brown, and none marked. The Hampshire Pottery did not produce these delicate designs or colors, nor did they model such a variety of pieces. Just as an English shell and seaweed majolica pattern is often inaccurately attributed to James Carr of the New York City Pottery, majolica in the aster pattern also may be English, and not from the Hampshire Pottery.

Taft majolica was rarely marked, making identification difficult. Of the few marks that were used, an incised "James S. Taft & Co, Keene, N.H." was the most frequent. Other marks on majolica include "J.S.T. & CO./KEENE, N.H."; "HAMPSHIRE"; and "HAMPSHIRE POTTERY."

As public interest in majolica waned at the end of the century, the Hampshire Pottery turned to the production of art pottery and marks were used more frequently. By 1916 the loss of his leading designers caused Taft to sell the business to George Morton of the Grueby Faience

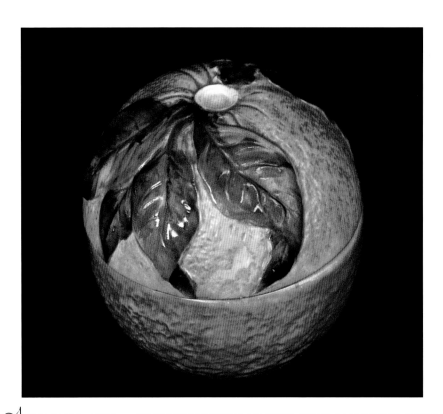

Hampshire Pottery. Lidded marmalade pot. c. 1880. Height 3⅞". Courtesy Colony House Museum, Keene, New Hampshire

Company of Boston. Although the company survived World War I, by 1923, with competition from New Jersey and Ohio potteries, and with the rising costs of importing fuel and clay, the Keene factory closed its doors.

James Scollay Taft's energies contributed in a major way to ceramic history for more than half a century. At his death in 1923 at the age of seventy-nine, Taft was one of the last potters to have produced Victorian majolica worthy of a place in museums.

New Milford Pottery Company and Wannopee Pottery Company

The New Milford Pottery Company of New Milford, Connecticut, was the last major American factory to produce majolica before "majolica mania" subsided. The seventeen-year history of the firm began in 1887, in that small town, which was then actively engaged in hat and button manufacture, tobacco farming, and general agriculture. Enterprising businessmen sought to establish a new industry that would take advantage of local resources and augment the town's productivity. It was thought that, with excellent clay and water supplies at hand, and with increasing need for household ceramics, a

pottery could be economically viable. Thirty-four enthusiastic townspeople raised $15,000 with dispatch. Led by Lewis F. Curtis, a local landowner, and by William Diamond Black, a New York businessman associated with the jewelers and silversmiths Black, Starr and Frost, the group established the pottery near both the railroad and the Housatonic River. Charles Beach Barlow, a past president of the New Milford Historical Society, reported in an unpublished interview that his great-grandfather, Merritt Beach, and his grandfather, Charles Merritt Beach, had sufficient faith in the company to join in the two subsequent reorganizations of the pottery.

Clay was obtained locally and also imported from England. The factory was supervised by Charles Reynolds, an experienced pottery designer and plant manager from Cleveland, Ohio. The company's production from 1887 to 1903 included whitewares, creamwares, semiopaque china, and, later, art pottery.

Majolica production began in 1888. The lead glazes used were cobalt blue, orange, green, mottled blue-black, and mottled yellow-brown. The simple lines were in keeping with the developing art pottery movement. Designs were created by mottling, streaking, or dripping

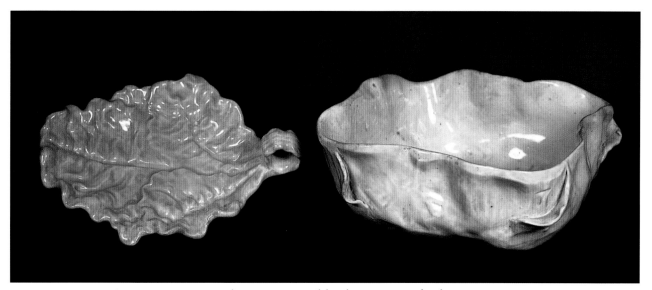

Wannopee Pottery Company. Lettuce Leaf pattern tray and bowl. 1893. Length of tray 8″

glazes over the body of the piece rather than by the bold modeling of early majolica.

In 1889, despite the business acumen of William Black and others, the pottery was in financial difficulty. It was soon reorganized and again flourished. Majolica production included large Victorian umbrella stands, wash bowl and pitcher sets, cachepots, cuspidors, small utilitarian dinner services, pitchers, jugs, and tea and coffee services. Two popular New Milford forms are a mottled blue flowerpot in the shape of a top hat, and a clock case in solid colors. The New Milford Pottery Company mark on majolica was "N.M.P.CO." in a diamond-shaped lozenge.

On William Black's death in 1892 the company was again liquidated, and then reorganized as the Wannopee Pottery Company. Lewis Curtis and Charles Merritt Beach were joined by a new director, William Black's widow, Sarah Northrop Sanford Black. Charles Beach Barlow reports that it was Mrs. Black who dictated artistic policy at Wannopee. "Wannopee" (the name of a now submerged island in the Housatonic River) was chosen by Mrs. Black to be the new company's name. Mrs. Black, the daughter of the New Milford judge David Curtis Sanford, was independently wealthy. She was also responsible for building a church and a school, now known as the Canterbury School—both institutions reflecting her own standards. Mrs. Black appreciated eighteenth-century French faience and therefore ap-

proved of Charles Reynolds's adaptation of Lettuce Leaf patterns for Wannopee.

The Lettuce Leaf majolica pattern of 1893 established the Wannopee factory as a leader in American majolica. Lettuce Leaf wares were shipped to New York, Baltimore, and Boston. Lighter in weight than majolica from other factories, Lettuce Leaf pieces were modeled with overlapping leaves and glazed light green, although some rare pieces are rose-pink, with leaf "veins" almost white. Delicate handles were modeled as twigs. Twenty-five shapes were made in the Lettuce Leaf pattern, including dinner services, with each dish a single leaf; celery dishes; olive dishes; asparagus plates; chop plates; and round, square, rectangular, and ovoid trays; as well as serving pieces. Also made were tobacco jars, butter pats, vases, compotes, candlesticks, and tea and coffee services with spooners. The Wannopee mark was "W" in a sunburst, incised on a white-glazed undersurface. Occasionally the words "NEW" and "MILFORD" were placed above and below the sunburst. The mark "WANNOPEE POTTERY CO." was also used.

By 1904 the Wannopee Pottery Company failed. After a local auction and public sale, at which pieces brought as little as three or five cents, the remainder was shipped to the firm's distributor, Osgood and Lang in Brooklyn, New York. Charles Reynolds took the Lettuce Leaf molds to the George Bowman Company in Trenton, New Jersey, and there Reynolds produced new pieces, identi-

cal in appearance to the Wannopee examples but heavier. The mark on the Trenton pieces, stamped in black, was composed of the words "LETTUCE LEAF" with the words "TRADE" and "MARK" above and below "LETTUCE LEAF."

The New Milford Historical Society presents a permanent display of colorful New Milford and Wannopee majolica in the setting of Connecticut antiques, paintings, and memorabilia.

New York

Although James Carr's work dominated New York majolica production, several other companies in the state produced interesting pieces. In 1878, at Tarrytown, New York, a pottery was started under the name of Odell and Booth Brothers. They produced majolica and faience, but little of it was marked. A mouth-pouring pitcher in the shape of a dog, glazed brown and white, is marked "O & BB" impressed. After about a dozen years the pottery closed and was reopened by the Owen Tile Company, manufacturers of decorative tiles.

The Faience Manufacturing Company (1880–1892), in Greenpoint, New York, marked its art pottery and majolica with the incised monogram "FMCO." Majolica, which was produced only in the company's early years, resembled French barbotine wares, with hand-modeled flowers applied to the surface. More simply shaped majolica was dipped in colored glazes, resulting in marbleized or tortoiseshell effects. Edward Lycett, born in Staffordshire and a ceramic artist of considerable skill, directed the pottery from 1884 to 1890. During his tenure he perfected better glazes and designed new shapes and floral patterns. Lycett and his son Joseph perfected a faience body with the superior glaze of hard porcelain. In 1890, when the company became the agent for a French manufacturer, the elder Lycett retired to Atlanta, Georgia.

Maine

In the 1850s the pottery of John T. Winslow in Portland, Maine, specialized in the production of decorative stoneware. In 1867 the enterprise was reorganized as the Portland Stone Ware Company. This pottery, not to be eclipsed by southern colleagues, imported a soft and fine clay from New Jersey for its version of majolica. In 1878, after years of experimenting with glazes, the Portland Stone Ware Company succeeded in developing a brilliant glaze resembling a majolica finish. The resulting product, known as Winslow ware, was used for vases, pitchers, match safes, tea services, and other household objects. An article on Winslow ware, titled "Majolica in Maine/A Visit to the Winslow Pottery," which appeared in the *Portland Daily Press* on November 5, 1878, described the majolica process in stages similar to those of other factories. Decorative details in low-relief medallions depicting cherubs' heads, Juno, Shakespeare, and Byron were mentioned; colors used were red, blue, and brown. The newspaper article reported that during the second firing, "the colors melt and fuse, forming an even, brilliant glaze . . . of fine color and surface, hardly to be distinguished from the genuine majolica" (quoted in Manlif Lelyn Branin, *The Early Potters and Potteries of Maine,* p. 15).

In 1882 the name of the company was changed to Winslow and Company, and in 1884 John T. Winslow's son Edward B. Winslow succeeded his father as superintendent of the firm. In a fire of November 1886 the main building was destroyed; when it was rebuilt the firm turned from producing artistic wares to commercial ceramic products. Under the Winslows the pottery existed from 1848 to 1969. No identifying marks were used on stoneware, terra-cotta, or majolica.

Indiana

The factory farthest west in the United States that produced majolica was a pottery built in Evansville, Indiana. Established in 1882 by an Englishman named A. M. Beck, it utilized three kilns and survived for two years. It was sold in 1884 on Beck's death. The successors, Bennighof, Uhl and Company, produced white graniteware. In 1891 the business was reorganized as the Crown Pottery Company.

Chapter 10
CONTINENTAL POTTERIES
By Sophie and Robert Lehr

FRANCE

French majolica of the second half of the nineteenth century is known as barbotine. Barbotine is the French word for slip, a mixture of water and clay, used for raised decorative details, usually floral. The basic manufacture of majolica was the same on both sides of the English Channel. The colored glazes—ranging from the cobalt blue of Palissy seascapes to the sandy beiges of Émile Gallé to the hot pinks and oranges of Delphin, Clément, and Jérôme Massier—alert the collector to palettes different from those of English and American majolica. Barbotine interiors are typically deep red, teal blue, or occasionally brown—colors not familiar to most majolica collectors. French majolica was glazed with enamels containing lead and fluxes colored by metallic oxides. The most frequently used oxides were cobalt blue, manganese violet, copper green, antimony yellow, gold chloride-based red and pink, or pure gold, which created purple. The opaque white background of barbotine, like that used for majolica during the Renaissance, was a product of stanniferous enamels or glazes. In some French majolica the designs were compartmentalized with thin strips of colored slip and the delineated areas were filled with colored enamels. The level of the enamel is slightly below the level of the partition. The modeling of many examples is quite dramatic, with very large three-dimensional barbotine flowers cascading from the sides of cachepots and vases. Almost all barbotine motifs are naturalistic, in both the Victorian and Art Nouveau styles.

The goal of nineteenth-century French ceramists was the re-creation of the glazes originated in the sixteenth century by Bernard Palissy. A ceramic artist in Tours, Charles-Jean Avisseau (1795–1861), resurrected Palissy's name and works. In 1843, after experimenting with clays and enamels for ten years, Avisseau was able to reproduce glazes and intricate floral and aquatic designs in the style of Palissy. Avisseau's work was extremely delicate and, although more densely decorated than the sixteenth-century prototype, had a finer finish. He developed a very plastic clay to eliminate *craquelure* (crazing) of the glaze due to differences in expansion and contraction of the body and the glaze in firing. Avisseau was a trail blazing master in the specialized discipline of slip-decorated and tin-enameled earthenwares. In his atelier he kept cages filled with various specimens of lizards, snakes, frogs, and insects, as well as bowls containing aquatic grasses, to use as models for his work. He inspired a score of *faïenciers* to produce extremely original pieces.

A ceramic school of Tours was established by Léon Brard, Charles-Jean Avisseau's children Édouard (1831–1911) and Caroline (b. 1820), and his grandson Édouard-Léon Deschamps Avisseau (1844–1910), Joseph Landais (1800–1883) and his son Alexandre (1868–1912), and Auguste Chauvigné (1829–1904), and his son, also Auguste (1855–1929). Another school of ceramists in Paris, who were also followers of Palissy, included Georges Pull (1810–1889), a German potter who settled in Paris in 1856, and Victor Barbizet, Alfred Renoleau, François Maurice, and Thomas Sergent. Early nineteenth-century French potters used not only the marine motifs of Palissy but also acanthus leaves, flower wreaths, Renaissance masks of grotesques, and human forms, all covered with brilliant lead glazes.

During this prebarbotine period there was also renewed interest in Henri Deux wares (Saint–Porchaire, also known as *faïence d'Oiron*). Joseph-Théodore Deck, whose career involved both the study of ceramic art of

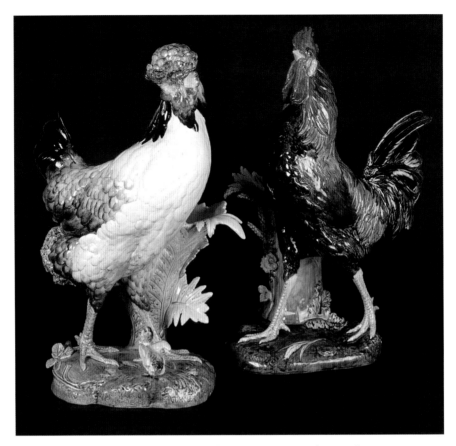

Choisy-le-Roi. Hen and Rooster. Height 26″. Artist: Paul Comolera. c. 1875

the past and extensive work with glazes and new ceramic designs in Paris and at Wedgwood, praised and imitated the techniques of Henri Deux wares.

At factories such as Choisy-le-Roi and Sarreguemines, faience production shifted in the nineteenth century from the craft stage to mass-production levels. With increasing expectations of success, many new pottery works were established. The great factories at Nevers, Rouen, Moustiers, and Strasbourg, however, did not take part in the exciting production of barbotine, which was inspired by English majolica shown at the international exhibitions in Paris in 1855 and London in 1862. While those factories had been important in the development of polychrome glazes, tradition triumphed and they continued to produce their own well-respected faience.

Although the sections of this book that deal with English majolica discuss some of them, no chapter including French majolica would be complete without mention of the French artists who made original and superb contributions to the production of English majolica. They are, of course, Léon Arnoux, Albert-Ernest Carrier-Belleuse, Paul Comolera, Pierre-Émile Jeannest, Émile Lessore, Hugues Protât, and Édouard Rischgitz. Despite their great contributions to English majolica, they do not seem to have taken part in the development of French barbotine. (Paul Comolera, a bronze sculptor, did, however, model majolica pieces for Minton and Hippolyte Boulanger at Choisy-le-Roi.) Even Carrier-Belleuse, who returned to France as art director at Sèvres, did not enable that manufactory to produce majolica of any note. This allowed the younger barbotine artists to develop their own majolica styles and color palettes, typically French but internationally admired.

There is, however, a link between early French faience and English pottery. Up to the end of the eighteenth century, England played a primary role in the industrial evolution of the earthenware arts. The production of earthenwares, including stoneware, in Staffordshire and

the technical and artistic wonders of the great Josiah Wedgwood encouraged French ceramists, sculptors, and painters to study in England. They returned to France with an improved knowledge and a growing awareness of the need to expand the production of ceramics.

This exchange greatly benefited the French potteries at Montereau, Creil, Choisy, Lille, Bordeaux, Marseilles, Toul, Lunéville, Niderviller, Sarreguemines, Onnaing, Gien, and others. The majority of these factories were modest: the main goal of these new faience works was to imitate the famous English earthenware. They duplicated all that Wedgwood had developed in the previous century: cream-colored earthenware (*faïence fine*), black stoneware in imitation of basalt, colored stoneware, vases copied from the models of antiquity—and, finally, majolica. Some forms were copied, but most often they were adapted to French (and also German) taste and needs. After the 1855 Paris exhibition, just as French artists crossed the Channel, a large number of English technicians emigrated to France. They taught the French ceramists their majolica expertise, at times bringing their English molds and secrets of majolica manufacturing.

By this time several ceramic factories were already well established in France and ready to produce the newly popular majolica. As with all pottery centers, they were located so as to be well supplied with suitable clay, abundant water, and, above all, sufficient wood. The latter was most important since, until coal-fired kilns were installed, it took ten kilograms of firewood to obtain 112 grams of finished products. The following faience centers were the most important in the production of majolica: Choisy-le-Roi, a few kilometers from Paris; Sarreguemines, Lunéville, and Saint Clément in Lorraine; Onnaing in the north; and Vallauris in the southeast, halfway between Cannes and Nice. Majolica from some of these factories was seen at the international exhibitions held in Paris in 1867, 1878, and 1889.

All French majolica manufacturers put their marks, either impressed or painted, on the majority, but not all, of their pieces. On rare occasions, as at Minton, the artist's signature was added. The word "majolica" was never used in marks on French majolica, except on Sarreguemines pieces. There "MAJOLICA" appears with the firm's name, but the artist's name is not indicated. There is no national pottery mark for France, unlike Great Britain with its diamond-shaped registry mark.

The word *déposée* (registered) on some French pieces, with the manufacturer's mark, indicates that the pattern is protected by registration with the Department of Patents and Trademarks in Paris.

Choisy-le-Roi

In 1804 a faience factory was established by Valentin Paillart in Choisy-le-Roi. From the outset the firm produced *faïence fine* inspired by the Chinese porcelain introduced by the East India companies. Jack Bagnall, an English pottery expert, helped the factory with technical procedures until French workers could be trained. Louis Boulanger became the manager of the business in 1836 and was succeeded in 1863 by his son Hippolyte Boulanger. The factory grew to employ three hundred workers. Choisy added majolica to its output in the early 1860s and continued to make it until 1910.

Historic events also promoted the growth of the Choisy factory. After the Franco-Prussian War of 1870, when Prussia annexed Alsace–Lorraine, Choisy-le-Roi's chief competitor in majolica, Sarreguemines, became German, and its wares were therefore not favored by French consumers. Choisy majolica was considered the best in France, and from 1867 to 1889 the company was awarded top medals for its various wares at national and international exhibitions.

Family ties contributed to Choisy's success as well. Hippolyte Boulanger, the director at Choisy-le-Roi, had married the daughter of the baron de Geyer, the head of the Sarreguemines faience works. Some of the French workers at the Sarreguemines pottery rejected German nationality and were able to move to Choisy-le-Roi, bringing with them the techniques and artistry of what had been one of France's most celebrated faience works before the Franco-Prussian War.

In the early 1860s artists such as Huber-Days and Carrier-Belleuse were influential in Renaissance and *trompe l'oeil* designs and these decorations were used on Choisy majolica. French artists discovered Japanese ceramics at the Paris exhibitions of 1867 and 1878. The French were enthusiastic about the spare and asymmetrical oriental designs. Collectors of Japanese prints were quick to recognize the merits of the ceramics designed with oriental motifs and turned to buying these exotic wares.

Choisy-le-Roi produced not only majolica but also

177

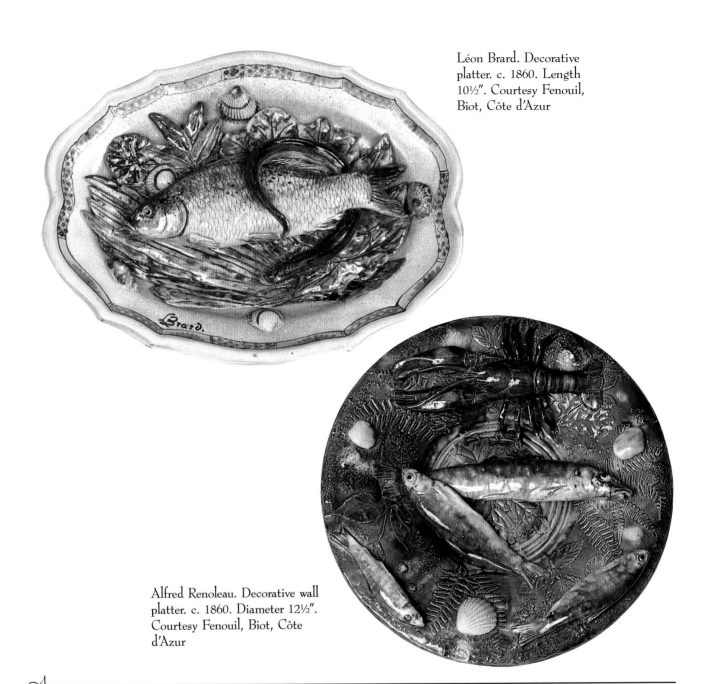

Léon Brard. Decorative platter. c. 1860. Length 10½". Courtesy Fenouil, Biot, Côte d'Azur

Alfred Renoleau. Decorative wall platter. c. 1860. Diameter 12½". Courtesy Fenouil, Biot, Côte d'Azur

Henri Deux and *pâte-sur-pâte,* as did Minton. Choisy majolica is remarkably delicate and compares favorably with that of Minton and Wedgwood. Dessert services are especially beautiful, with carefully modeled leaves and ferns adorned with eglantine (wild rose) blossoms. A Greek-key border, much like Wedgwood's, surrounds the central design. This service was produced with brown, blue, and cream-colored backgrounds or in monochrome green or brown, and it has frequently been copied by lesser factories. As with many manufacturers Choisy's asparagus service honors the tradition of realistic *trompe*

l'oeil asparagus and artichoke designs, and each plate has a well for the artichoke or the accompanying vinaigrette sauce. The plates are bordered in a columnar design and the handles of the serving platter are modeled as curved asparagus. A sauceboat is topped with a crisply modeled insect. Choisy also produced snail servers for that particularly French delicacy. Cachepots in the Renaissance style have Minton-like flower garlands, handles of female *mascarons* (grotesque masks), and a brilliant blue-glazed ground. Some authors have incorrectly illustrated as majolica a cream-colored plate and a compote, which are

Choisy-le-Roi. Sauceboat. c. 1900. Length of dish 8″. Courtesy Fenouil, Biot, Côte d'Azur

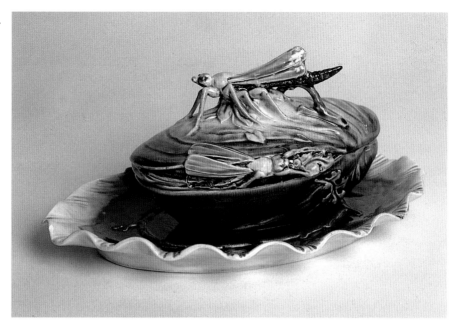

Saint Clément. (Émile Gallé). Asparagus service. c. 1880. Courtesy Fenouil, Biot, Côte d'Azur

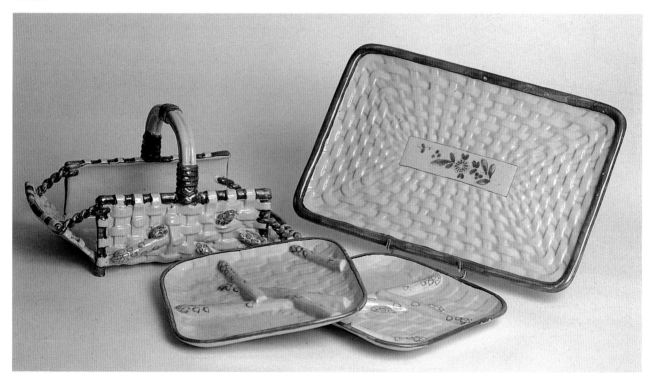

lighter in weight than majolica and are decorated with three large pansies in low relief around the edge. These are among the *faïence fine* wares made by Choisy.

Choisy-le-Roi majolica characteristically has careful glazing, naturalistic colors, classic lines and designs, and a lack of the flamboyance that is seen in majolica by other French potters in the last two decades of the nineteenth century. The firm's majolica is not always marked, but the mark is easily recognized: "Choisy-le-Roi" or "Choisy," sometimes with the letters "HB" (either as separate initials or in monogram) for Hippolyte Boulanger. A large rooster, one of a series ranging from fourteen to twenty-one inches high, made by Choisy bears the mark "LOUIS CARRIER-BELLEUSE." Louis-

179

Robert Carrier-Belleuse (1848–1913), son and pupil of Albert-Ernest Carrier-Belleuse, was the art director of the Hautin Boulanger and Company earthenware factory, in which Hippolyte Boulanger was a partner from 1863 to 1878. Louis-Robert Carrier-Belleuse also modeled portrait busts and mythological subjects in terracotta at Choisy-le-Roi. Choisy-le-Roi ceased the production of majolica at the time of World War I, but continued to produce industrial and utilitarian wares until the factory was closed in 1933.

Sarreguemines

The brothers Nicolas-Henri and Paul-Augustin Jacobi with Joseph Fabry established a small pottery works in Sarreguemines, Lorraine, about 1778. They were significantly assisted by François-Paul Utzschneider, who had worked for Wedgwood and brought extensive technical expertise with him. Utzschneider's descendants operated the factory until the end of the nineteenth century. For the first half of the century Sarreguemines had produced imitations of English earthenware and stoneware and built its success, as did Choisy-le-Roi, on transfer-printed *faïence fine*. Both Choisy and Sarreguemines were influenced by Minton's display of majolica at the 1855 Paris exhibition. In the early 1860s, like Choisy, Sarreguemines added majolica to its production. Sarreguemines (which became German after the Franco-Prussian War), in order to sell its wares in France, established a branch in Digoin, France, in 1876, and a warehouse in Vitry-le-François, in 1881. The mark on majolica was the word "MAJOLICA" stamped above "SARREGUEMINES" and, after 1881, "D.V." (for Digoin and Vitry).

Sarreguemines majolica was brilliantly glazed and spectacular: large pedestals, jardinieres, fountains, and cachepots, many of them decorated with Renaissance motifs similar to those of Minton majolica and all bearing witness to an extraordinary degree of ceramic dexterity. A magnificent peacock with colorful plumage in majolica glazes is enriched with cloisonné enamel decoration. It differs from the Minton peacock in that the Sarreguemines bird is perched on a pedestal ornamented with Renaissance motifs of masks, shields, and laurel-leaf swags. The Minton stork walking-stick stand was also re-created by Sarreguemines, but in the French version, which is forty inches tall, the bird has caught a frog rather than a snake in its beak, whereas in the English version the frog is trapped beneath the stork's foot. Delicate pink waterlilies decorate the base of the French example. Other pieces in the Renaissance style were great urns and vases glazed in deep *bleu de Sèvres*. There were also numerous pieces for the table—plates, compotiers, centerpieces, pitchers (especially some humorously designed as heads), tureens, and baskets—often decorated with naturalistic themes.

A significant part of the Sarreguemines production, as was the case with other French majolica manufactories in eastern France, consisted of *trompe l'oeil* asparagus plates and serving platters or cradles. The reason for this may be the German fondness for asparagus; Germans are the world's leading consumers of the delicacy. At the time of the annexation of Sarreguemines, Lorraine, by the German empire, the pottery, as did others in the same region, turned out an extravagant number of majolica asparagus plates, platters, and cradles in many different patterns.

The most dramatic and technically challenging pieces of Sarreguemines majolica were the large tile panels—veritable paintings of scenes, landscapes, perspectives of architecture, and floral compositions in the Art Nouveau style. Many such tile panels were manufactured, and were often signed. These panels ornamented boutiques and cafés as well as bakers' and butchers' shops. They compare favorably with the Minton majolica tile walls at the Victoria and Albert Museum, in the area known as the Old Refreshment Room.

Lunéville and Saint Clément

Lorraine, a province that has an important place in the history of French ceramics, contains both Lunéville and Saint Clément within the part of the province not ceded to Germany after the Franco-Prussian War. These two faience centers owed their success to their geographic position. The area was rich in clays needed for the production of ceramics. Also both were located in what was known as the Territory of the Three Bishoprics, a region around the three cities of Metz, Toul, and Verdun. Because in the eighteenth century the duchy of Lorraine was not an integral part of the kingdom of France, any business set up in that area benefited from a treaty allowing much lower customs duties on goods from France.

180

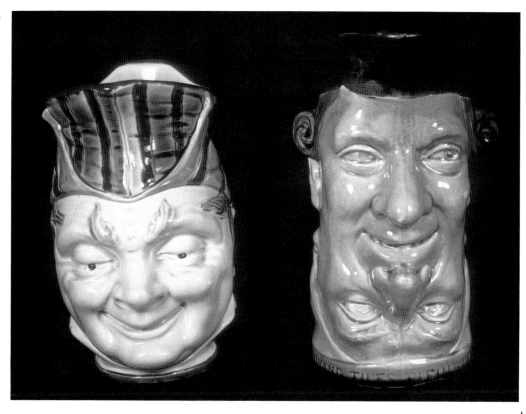

The pottery at Lunéville was established in 1731 by
Jacques Chambrette. The pottery at Saint Clément was
founded in 1758 as a branch of the Lunéville pottery, but
operated independently by Chambrette's son-in-law
Charles Loyal, in partnership with the architect Richard
Mique and with Paul-Louis Cyfflé, (1724–1806), the
master sculptor and porcelain modeler who came to
Lunéville in 1752. Large faience lions and dogs pro-
duced at Lunéville and Saint Clément were particularly
impressive. The tin-glazed tablewares of the two pot-
teries were less pure white than those of other major
French manufactories. After the death of Chambrette in
1758 the factories were managed by his son and son-in-
law and were not as successful as they had hoped, despite
the presence of Cyfflé, who left the firm in 1766. In 1788
the Lunéville pottery was sold to the family of Sebastian
Keller and their partner Guérin, whose descendants
operated the enterprise throughout the nineteenth
century.

During the second half of the nineteenth century, the
great glassmakers of Nancy—Émile Gallé and Auguste
and Antonin Daum—and René Lalique of Paris revolu-
tionized the art of glassmaking, both by innovative
techniques and by a rejuvenation of inspiration from
naturalistic themes. Floral themes, especially irises and
orchids, dominated their Art Nouveau designs. Saint
Clément artists, a few dozen kilometers away, used
similar motifs. It was a fortunate coincidence that Gallé,
before his success as a great glassmaker, had worked in
ceramics for many years. (Bernard Palissy had followed a
similar path in reverse in the sixteenth century.) It was
one of Saint Clément's glories that it was commissioned
to produce majolica based on drawings by Gallé, who,
residing near Saint Clément, was able to take up ceramics
again and worked at Saint Clément in 1864. One of the
results of this collaboration was a sandy-colored as-
paragus service of plates, cradle, and platter (c. 1878).

Majolica production at Saint Clément, which lasted
about forty years, was under the direction of the descen-
dants of Germain Thomas, who had acquired ownership
of the Saint Clément factory in 1824. Majolica pieces
included pitchers (some in the shapes of storks and
ducks), table and dessert services, ornamental vases, and
the familiar asparagus-artichoke service. Unusual for
Saint Clément were the jardinieres decorated in the style
of Palissy, attributed to a descendant of Germain

181

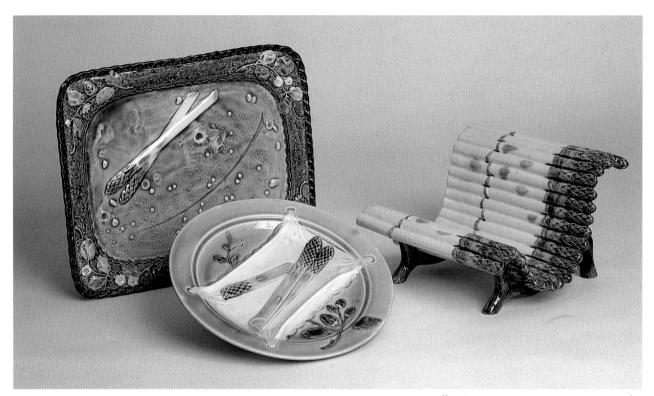

Lunéville. Asparagus service. c. 1890. Height of cradle 7″. Courtesy Fenouil, Biot, Côte d'Azur

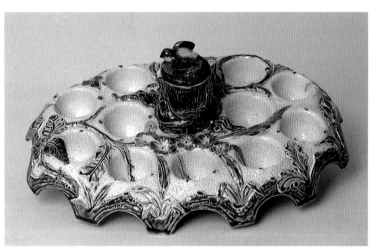

Lunéville. Egg holder. c. 1890. Diameter 15¾″. Courtesy Fenouil, Biot, Côte d'Azur

Thomas. For the most part, however, Saint Clément majolica is characterized by the delicacy of the reliefs and the subtle shadings of the colors. Clément marks included "SAINT CLEMENT" impressed, frequently with "K" and "G" for Keller and Guérin.

Lunéville majolica is more vibrant in color than that of Saint Clément, especially the blues and greens of the tea and coffee services and their special accessory pieces. A Lunéville asparagus service, complete with sauceboat and mustard pot, is quite handsome in naturalistic shades of green and mauve on a turquoise background. Other asparagus services were glazed yellow and brown with mauve and green accents. The mark on Lunéville asparagus services is "LUNEVILLE" impressed, sometimes with "K" and "G" and the word "DEPOSE." After almost two centuries of activity, the Lunéville pottery was closed in 1914. In 1922 the Fenal family, owners of the Badonviller pottery, acquired Saint Clément and Lunéville and operated all three together.

Lesser Lorraine faience works produced unmarked

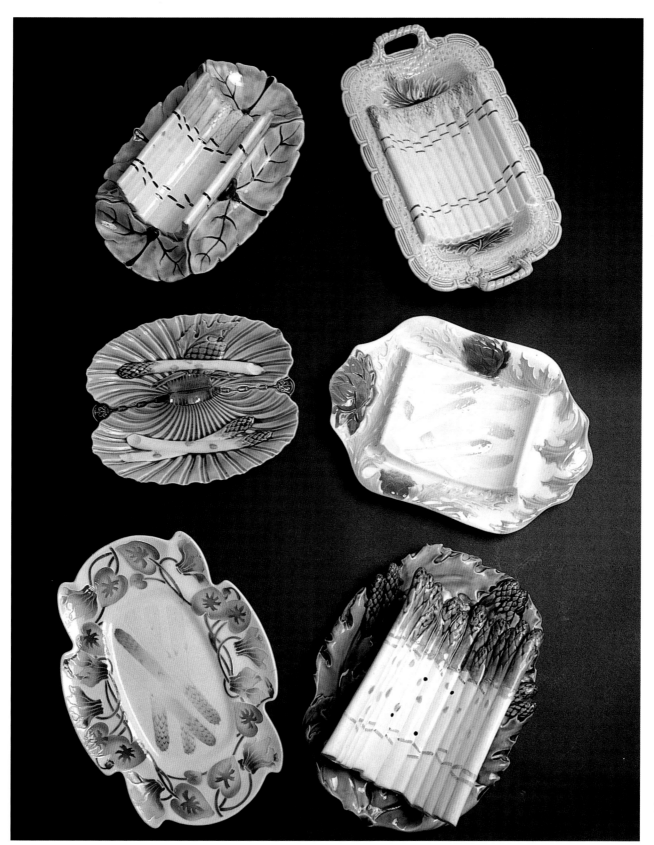

183

Various Continental factories. Asparagus cradles. Lengths 10″ to 14″. Courtesy Fenouil, Biot, Côte d'Azur

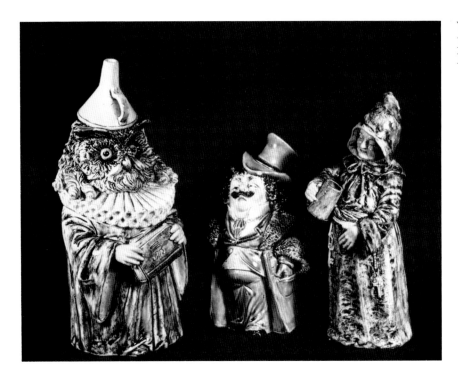

Various Continental factories.
Figural humidors. c. 1880–1900.
Heights from 5″ to 8½″

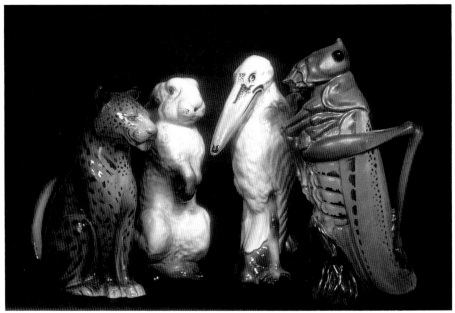

Various Continental factories.
Mouth-pouring pitchers.
c. 1875–1890. Heights from
8½″ to 10½″

pieces of majolica with cruder modeling and harsher colors.

Onnaing

La Faïencerie d'Onnaing, in northern France, produced rustic faience with naturalistic motifs from 1821 to 1838. Majolica was produced from 1870 to 1900. The pieces are somewhat lighter than those from many other pot-teries, reflecting a different clay formula. Clays were imported from England, Germany, and Belgium, but local clays were also included. Colored glazes were applied in a less than accurate fashion, the colors were somewhat muddy, and the inspiration for the pieces was fairly commercial and mundane. No great skill was used in rendering flowers, leaves, or geometric designs on plates and pitchers. Other similarly decorated majolica

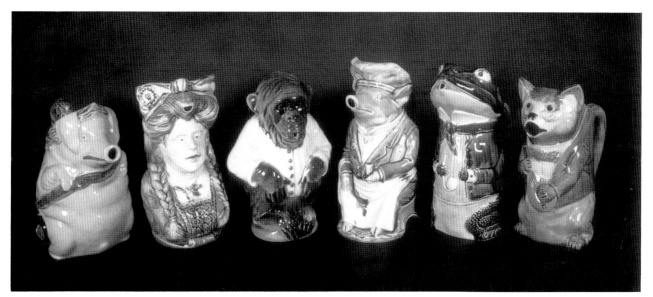

Various Continental factories. Mouth-pouring pitchers. c. 1875–1890. Heights from 8½″ to 10½″

pieces included flowerpots, vases, bowls, children's toys, umbrella holders, and small clocks.

Also made were match strikers and ashtrays in innumerable and disparate forms such as vultures, elves, American Indians, sultans, and monks. Tobacco jars masqueraded as frogs, bears, dragons, and devils. Candlesticks were held upright by elephants and figures in period dress. Calling-card boxes were shaped as pianos or decorated with artists and fair damsels. Piggy banks took traditional forms or were modeled as flowerpots. These items are much lighter in weight than traditional majolica, and the metallic-oxide glazes did not penetrate the clay in the way that gives traditional majolica its lustrous sheen. It is thus debatable as to whether they should be considered true majolica. They are, in fact, cheap majolica made for fairs from the end of the nineteenth century to 1914. Such pieces are known as *majolique de foire* or *barbotine de foire*. None is marked with the factory name, but they do bear a three- or four-digit number impressed on a white undersurface. Similar pieces were made in other French potteries and elsewhere in Europe, including Austria, where the mark "BB" signifies Brüder Bloch.

Onnaing also produced humorous pieces in traditional majolica clays and glazes. These included mouth-pouring pitchers in animal shapes, such as a whimsical assortment of frogs dressed as waiters and pigs as chefs, as well as dogs, ducks, goats, rabbits, donkeys, mice,

cows, horses, and the noisy chanticleer. Human figures included French politicians, protagonists of causes, and caricatures of foreigners, particularly the British. A pitcher in the shape of a young woman with long braids has the spout coming from the hair above her forehead. Another figural piece, in the form of a Toby jug, portrays a coal miner with his lamp. Nineteenth-century French pitchers depicting both men and women are called *Jacquelines*. This name is in contrast to the tradition of sixteenth-century French, Belgian, and Dutch pitchers representing male human figures that were called *Jacquelins.*

More than a million pieces of majolica were produced at Onnaing and for thirty years the pottery created five new models of pitchers annually. The Onnaing pitchers are reproduced today. The mark on Onnaing pottery includes a shield below a crown and a schematic radiant sun, with "Frie" to the left of the shield and a large "O" to the right—for "F[aïence]rie [d']O[nnaing]."

Moulin des Loups

In the late nineteenth century, three factories near Onnaing produced majolica. Orchies, Hamages, and St. Amand made utilitarian majolica with floral designs in naturalistic glazes. The name of each factory was impressed on the white undersurface of its products. In 1928 the three firms were united under the name Moulin des Loups.

St. Honoré les Bains

Also in northern France, St. Honoré les Bains produced majolica jugs and smoking services in the last quarter of the nineteenth century. No marked pieces from this pottery are known.

Gien

Previously under the name of Geoffroy et Compagnie, the business was reorganized as La Faïencerie de Gien in 1820 by a Mr. Hall. It was situated on the banks of the Loire in the buildings of a former convent. Gien produced tablewares as well as artistic, decorative pieces of faience. The company's designs included motifs from Italian pottery, Delft ware, and early French faience, as well as Persian and oriental works. In 1864 the firm began the production of majolica.

In 1866 the old buildings were razed and replaced with the most modern of ceramic factories. The pottery employed a thousand or more workmen and produced nearly 50,000 plates a day. Well-glazed majolica vases; large, square, and round plaques; and green-glazed dessert plates were exhibited at the Paris exhibition of 1878. The enterprise continues to produce majolica-glazed earthenware to the present day. One of the marks is a printed turreted castle, with "GIEN" above and "FRANCE" below; another is an oval with the words "La Faïencerie de Gien."

Salins

Majolica made at Salins, in Lorraine, may be recognized by the mark "SALINS" impressed, usually on a white undersurface. Most frequently seen are asparagus plates and cradles. Much rarer are simulated-wickerwork baskets. Pieces are well modeled and the delicate glazes are accurately applied. The factory was completely destroyed during the Franco-Prussian War.

Fontainebleau

This pottery, south of Paris, made majolica in a rustic style similar to Portuguese majolica. The mark is "FONTAINEBLEAU" impressed.

Longchamp

This establishment, near Dijon, produced majolica oyster plates and asparagus servers as well as wall plaques decorated with fruits such as apples, grapes, and lemons. The mark includes the words "LONGCHAMP" and "TERRE DE FER."

Creil et Montereau

Majolica produced by these two eighteenth century firms, which were united early in the nineteenth century, included dessert services decorated with strawberry blossoms and fruit and lilies of the valley. The mark, stamped in black, was "CREIL ET MONTEREAU." The factory was located near Paris.

Three factories near Lille

The factories Fives-Lille, Nimies-les-Mons, and Mouzin-les-Mines, about which little is known, produced naturalistically glazed majolica tablewares with floral motifs. The mark of the first was an impressed anchor with a "B" superimposed on the shaft. The marks of the other two factories consisted of the name forming a circle, both stamped.

Sèvres

The great manufactory of Sèvres, despite its worldwide reputation for porcelain, did not fare well with majolica. In the 1850s it attempted to duplicate Minton pieces, but with poor modeling and glaze. Rare examples may be viewed at the Victoria and Albert Museum, as well as at the Musée National de Céramique, Sèvres. In the last quarter of the century, despite the directorships of Albert-Ernest Carrier-Belleuse and Joseph-Théodore Deck, no majolica was produced.

Other French artists who produced barbotine

Ernest Chaplet (1835–1909) was a studio potter who had apprenticed at Sèvres and later worked at Haviland in Paris. He used polychrome techniques for barbotine wares with Hispano–Moresque and Renaissance motifs. Later he specialized in decorative naturalistic scenes, as well as still lifes of flowers and fruits. In 1887 he joined Choisy-le-Roi and designed elegant oriental patterns for *faïence fine* until his retirement in 1906. It is of great interest that he fired the brilliantly glazed stoneware made by his friend Paul Gauguin. Examples of Chaplet's barbotine were exhibited at the 1876 Philadelphia Centennial. His work influenced American ceramists, including the artisans at the Dedham Pottery, in

Longchamp. Asparagus basket with cover. c. 1890. Length of dish 14″. Courtesy Fenouil, Biot, Côte d'Azur

Georges Dreyfus. Oil and vinegar bottles. Height 6″. Courtesy Fenouil, Biot, Côte d'Azur

Massachusetts, and Maria Longworth Nichols, the founder of the Rookwood Pottery in Cincinnati.

Auguste Delaherche (1857–1940), who succeeded Chaplet at Haviland in 1887, worked in a naturalistic style, producing pottery both incised and modeled with floral and fruit designs. A four-hundred-piece collection of his work, including barbotine, stoneware, and por-

celain, may be seen in the Musée Départemental de l'Oise, in Beauvais, his birthplace. One of the most important French ceramic artists of his time, Delaherche won prizes at international exhibitions and his works are shown today in museums and private collections on both sides of the Atlantic. His barbotine wares were displayed at the 1893 Chicago World's Fair, and William H.

187

Grueby, of Chelsea, Massachusetts, was inspired by Delaherche's work. At the end of his career he turned from representational to abstract art, and influenced ceramic artists of the early twentieth century.

Albert-Louis Dammouse (1848–1926)—a sculptor, glassmaker, and potter—worked at both Sèvres and Haviland, at the latter factory with Chaplet. Beginning in 1874 he received prizes at exhibitions for imitations of Italian *maiolica*. He specialized in barbotine and developed his own style. In 1892 he returned to Sèvres and produced both faience and porcelain in Art Nouveau designs.

Jean Carriès (1855–1894), a sculptor and potter, established a studio in Montriveau, near Nevers. He was one of many who adapted Japanese styles to barbotine. In a different mode, his bizarre and grotesque masks and frogs with rabbit ears were well modeled and decorated with low-toned mottled or *flambé* glazes.

Georges Hoentschel (1855–1915) and Émile Grittel (1870–1953) continued in the style of Carriès. Hoentschel, an architect and potter who inherited Carriès's studio, also worked in the Art Nouveau style. Grittel was known for vases shaped as pears or gourds.

Joseph-Théodore Deck (1823–1891), an artist-potter born in Alsace, had worked as a designer and modeler at Wedgwood from the late 1860s into the 1870s. In France in the 1870s he experimented with various glaze techniques and produced tin-enameled faience. At the 1878 Paris exhibition he was one of three French exhibitors to win a gold medal for art pottery.

C. H. Menard was a mid-nineteenth century ceramist who worked in Paris. A majolica cheese bell with ferns on a mottled brown background and a water lily finial, very much in the English majolica style, is marked with Menard's impressed heart symbol. Another mark is that of the artist's name and address—72 rue de Popincourt, Paris—in oval formation (Cushion, *Marks,* p. 41).

Georges Pull (1810–1889), a German soldier, naturalist, and potter, settled in Paris in 1856, where he made much-admired imitations of Palissy's ceramics, which were considered to be the equal of the work of the sixteenth-century master. Pull marked his wares (PULL or Pull) but they have occasionally been mistaken for Palissy's. Both artists imitated the metal salvers of François Briot. Unlike the dense, heavy Palissy wares of England or Portugal, Pull's pieces were delicate and richly colored. One platter, glazed in rich cobalt, includes a sea monster and a triton. Another platter with a deep border depicts Pomona, the Roman goddess of orchards, supervising work in a Renaissance garden. Both pieces are bordered with white and green stylized marguerite daisy ornaments, perhaps a tribute to Marguerite of Navarre, Bernard Palissy's Protestant protectress. Pull's work was displayed at the 1878 Paris exhibition. A large tile panel entitled *La Céramique*—eight feet, nine inches by six feet—was so light the artist was able to carry it.

Thomas-Victor Sergent, a leading member of the Paris school of Palissy followers, specialized in representing lobsters, shrimp, and other sea creatures, often departing from naturalistic colors. Although the composition of his pieces closely resembled Palissy's, Sergent's glazes were thicker and glossier. He exhibited at the international exhibitions in Vienna (1873) and Paris (1878). The undersurfaces of Sergent's Palissy-like wares, in contrast to the white undersurfaces of pieces made by other French Palissy followers, were usually glazed cobalt blue or mottled blue and brown, like Palissy's own work. Sergent's marks were "T.S." impressed (which should not be confused with the same initials on the early, more rustic majolica of the English potter Thomas Shirley), "Thomas Sergent," "T. Sergent," or "Sergent."

Georges Dreyfus, who started his artistic career in advertising, became one of the most clever creators of French majolica. His shop in Paris was on the Massierrue de Paradis and his ceramic works were at Moret-sur-Loing, just south of Paris. His most original and humorous pieces were *trompe l'oeil* examples dealing with sardines or eggs. Sardine plates decorated with fish had a rectangular space to hold a tin of sardines. For the canned-food company Amieux he fashioned a sardine plate with a space defined by raised edges shaped especially to fit an Amieux sardine can. Dreyfus created majolica pieces to be given away by Amieux as premiums for purchases of large quantities of Amieux foods. Many of Dreyfus's monochrome pieces were glazed in the same acquamarine blue-green favored by the Massiers in Vallauris. An amusing Dreyfus egg-cup tray was modeled as a large swan, with the six egg holders shaped as chickens. Oil and vinegar bottles were whimsically modeled as a smiling and a crying baby. The heads were the bottle stoppers, and when removed and placed in holders they

served as rattle toys for the "infants." The figures were modeled wearing long dresses complete with bibs, and they were holding onto walkers. Other Dreyfus pieces are mouth-pouring pitchers, frequently in the shapes of cats and ducks, with elegant modeling and excellent glazes. Dreyfus's mark was "G.D." stamped on a simulated calling card with the right corner turned down in observance of calling-card amenities. On his more simply designed pieces of earthenware Dreyfus employed the mark "Gédé" as a pseudonym. Later in his career he created artistic containers for spices in a blue-and-white checked design, for the Lustucru pasta company; some of the designs are still in use today.

Rigal and Sanejouand, of the pottery founded in 1802 at Clairefontaine, exhibited green-glazed faience dessert services and multicolored utilitarian majolica pieces at the 1878 Paris exhibition.

The Massier family in Vallauris

The Massiers' work represents a link between traditional Victorian majolica and Art Nouveau pottery. There were three Massiers working in the second half of the nineteenth century, heirs of an ancient line of potters, who transformed traditional utilitarian ceramics into an art form. Their ancestors had worked for several centuries in Vallauris on the French Riviera, where, in the twentieth century, Pablo Picasso was the reigning ceramic artist. Delphin Massier, born in 1836, and Clément (1845–1917) were brothers. A cousin, Jérôme, born in 1850, worked with them, using the signature "Jérôme Massier fils." By 1899 the family firm was divided into branches headed by these three men.

In 1860 the Massiers began to produce their vibrantly colored majolica, perhaps inspired by the flowers of the Côte d'Azur. Clément was particularly interested in designs drawn from ancient Egypt, Greece, and Rome, as well as from Renaissance maiolica. Themes from these earlier cultures appeared in his highly decorative, large pieces, including vases, ewers, and free-standing decorative columns entwined with flowers. Delphin specialized in freestanding figures of birds, animals, and shellfish—including swans, storks, chickens, sparrows, goats, donkeys, frogs, and crabs—ranging from six to thirty-six inches high. Especially popular were his large roosters, representing the symbol of France. Cockerels and hens, thirty-six inches tall, similar to those of Minton, were

extremely well modeled. As with Minton majolica, tree trunks and branches were important in Massier designs. The firm also made majolica candlesticks, vases, and cachepots. An unusual pair of majolica tambourines, made by Delphin Massier about 1870, depicts an Arab and his veiled wife.

From 1860 to 1900 skilled painters and sculptors who worked with the Massiers included Jean Barerol, Jean Bagnis, Camos, the Scotsman Alexander Munrose, the Swiss sculptor James Reibert, and, greatest of all, Lucien Lévy. The latter was a passionate admirer of sinuous and sensuous floral arabesque patterns and his influence was felt in the Massiers' designs. Lévy worked with Clément Massier from 1887 to 1895 before devoting himself exclusively to painting. In Paris, under the name of Lévy-Dhurmer, he became one of the leaders of Art Nouveau.

The Massiers used in a particularly dramatic way the copper oxide flambé technique for glazing, a method that originated in China during the Sung dynasty (960–1280), in which the kiln is rich in carbon dioxide and low in oxygen (reduction atmosphere). The flambé technique as practiced by the Massiers also incorporated the lustre technique of the Hispano–Moresque ceramists. It entailed covering a previously glazed piece with a metallic silver or copper oxide and firing it again at a very low temperature (petit feu). The resulting new palette, intense rather than subtle, included colors hitherto unknown to majolica: powdered gold, speckled turquoise, willow-green, yellow orange, hot pink, purple-violet, and peacock blue, as well as flambé and solid reds.

Each Massier was competent in the production of majolica glazes: all three shared a preference for green, red, and blue, especially the peacock blue that had been created by Delphin and Clément's mother, Elisabeth. That inventive woman obtained the necessary copper oxide by scraping it from the sides of the stills used for the distillation of flowers by the manufacturers of perfumes in Grasse, a few kilometers from Vallauris. The Massiers were also indebted to a ceramist from Bologna, Gandolfo Gaetano, who had lived in Vallauris since the mid-century. Gaetano guided Clément Massier in the discovery of the splendors of the old ceramics, including the Hispano-Moresque techniques.

The French potter Jacques Sicard worked closely with Clément Massier and acquired a great knowledge of

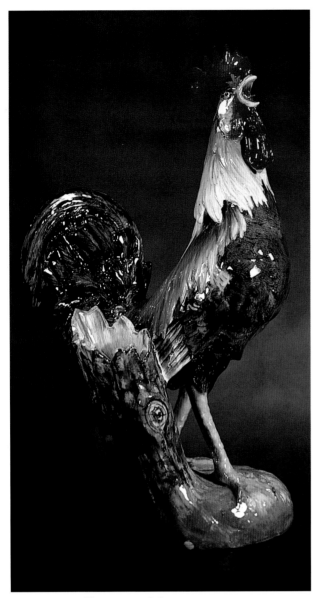

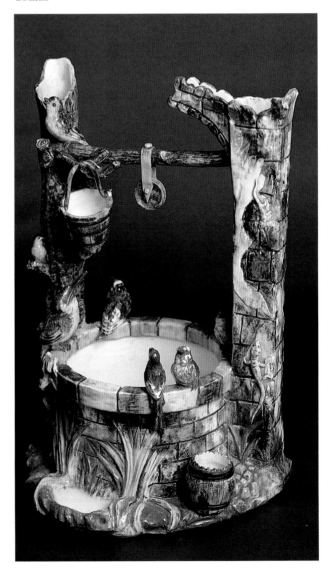

Massier at Golfe Juan. (Delphin Massier). Well with birds. c. 1890. Height 28″. Courtesy Fenouil, Biot, Côte d'Azur

Massier at Golfe Juan. (Delphin Massier). Rooster vase. c. 1890. Height 24¾″. Courtesy Fenouil, Biot, Côte d'Azur

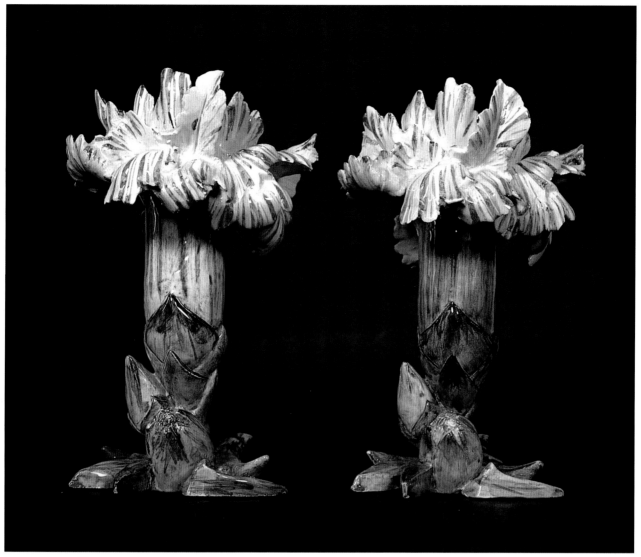

Massier at Golfe Juan. (Jérôme Massier). Vases. c. 1890. Heights 12″. Courtesy Barneys New York Chelsea Passage

iridescent glazes during that long association. In the early twentieth century he was employed at Samuel A. Weller's pottery in Ohio, where Sicard's technical skills enabled him to create a line of lustrous art pottery called Sicardo ware. He returned to France in 1907.

At the close of the nineteenth century the Massiers achieved a considerable reputation for their brilliantly glazed majolica and the factory enjoyed great success at national and international exhibitions. The arrival of the railroad in Vallauris increased their renown throughout France and the world of ceramics in general. A visit to the Massier atelier became mandatory for the cultured

visitor to the French Riviera. Queen Victoria, the king of Sweden, the Prince of Wales, Émile Zola, Victor Hugo, Camille Saint-Saëns, Charles Gounod, George Sand, Frédéric Mistral all visited and made purchases. They bought rectangular planters on which perched flocks of birds, plates and platters made of huge flower petals, wall plaques in the shape of butterflies, magnificent pitchers, and charming majolica-framed clocks.

Early Massier works rarely bore a signature. From 1862 to about 1902 (when the factory closed), with the firm's increasing success, the signatures of each of the Massiers appeared on their pieces. They are represented

191

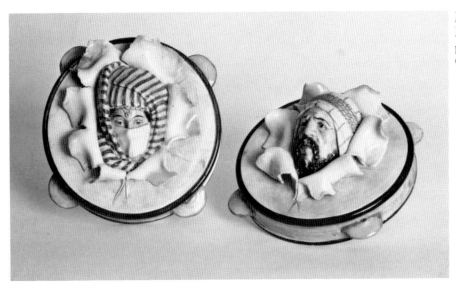

Massier at Golfe Juan. (Delphin Massier). Tambourine wall plaques. c . 1870. Diameter 7½". Courtesy Fenouil, Biot, Côte d'Azur

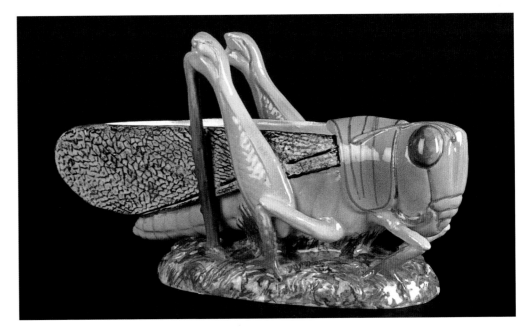

Jerome Massier, Vallauris, France. Grasshopper. c. 1890. Length 12"

in the Musée Municipal de Céramique et d'Art Moderne in Vallauris and two Paris museums: the Musée d'Art Moderne de la Ville de Paris on the quai de Tokyo and the Musée d'Orsay.

Unattributed French majolica

As with English and American majolica, it is not possible to determine the origin of all French barbotine. Many of the more rustic pieces are not marked, and although they have designs similar to those made by the famous potteries, the glazes are not applied with great accuracy and the colors are somewhat dull. Motifs on rustic pieces include birds, flowers, and animals. Some designs are so universal—especially those used on pitchers—that it is difficult to determine the country of origin of many pieces. A stork pitcher, for example, has been cited in various publications as English, American, or French, as has a drum-carrying bear pitcher (which was made by Joseph Holdcroft). A rule of thumb is: the darker the inside glaze, the more likely the piece is to be French.

Many unmarked plates depict historic events such as the siege of Orléans by Jeanne d'Arc, the Franco-Prussian War, or the building of the Eiffel Tower. Oyster plates are frequently unmarked, especially those with pleated

192

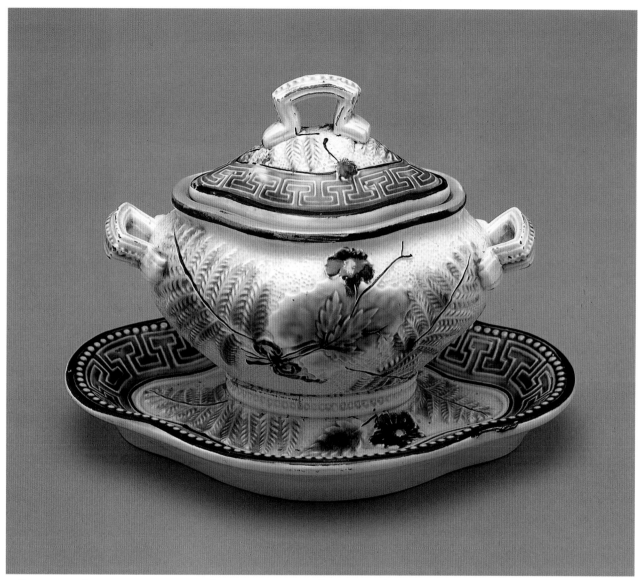

Villeroy & Boch. Tureen. c. 1885. Height 6½". Courtesy Villeroy & Boch

oyster "shells" glazed in dark blue, although some of these may be from Longchamp. A six-pointed majolica oyster plate with bizarre fish heads in each concavity resembles a Wedgwood design. The white undersurface is marked with the as yet unidentified initials "P.V." and the words "Made in France." The piece was therefore made after 1881, when the latter designation was first used. Unmarked sardine boxes and egg-cup trays decorated with appropriate naturalistic designs defy attribution, as do astonishingly realistic straight-sided, covered bowls representing a Charlotte Russe dessert or rectangular boxes with true-to-life glossy brown chestnuts

lavishly heaped on the lid. Large tureens, or soupières, made in the shape of cauliflower or of a group of ears of corn, were perhaps made by the Massier family of Vallauris. Unmarked barbotine hanging cachepots, with deeply modeled flowers and foliage, are also challenging to attribute to a specific factory.

Although the era of nineteenth-century French barbotine is past, many of the French factories continued to produce majolica well into the twentieth century, including Choisy-le-Roi, with its fruit-decorated plates; Sarreguemines and Onnaing, with their whimsical pitchers;

and various potteries that made Palissy platters. The modeling of the modern pieces is similar to that of early examples, but the newer barbotine is lighter and, saddest of all, the superb glazes and the meticulous craftsmanship of the nineteenth century no longer exist.

GERMANY

Villeroy and Boch

In the nineteenth century, Villeroy and Boch, one of the best known and diversified firms in the ceramic industry, began the production of German majolica. The history of Villeroy and Boch began in 1748 when a small faience factory was established by François Boch (d. 1754) at Audun-le-Tiche in Lorraine, near the Luxembourg border. The business was inherited by his three sons, who founded a second pottery at Septfontaines in Luxembourg in 1766. Pierre-Joseph Boch (1737–1818) took over the Septfontaines works in 1795, and in 1809 he founded a factory for the manufacture of the popular cream-colored earthenware at Mettlach in the Rhineland, not far from Septfontaines. Pierre-Joseph Boch's son Jean-François (1782–1858) was a pioneer in this domain. He had studied chemistry and mineralogy in Paris, and was an authority on the best raw materials and the new technology.

In 1785 Nicolas Villeroy (1759–1843), from Metz, established a pottery at Frauenburg, in East Prussia, and in 1790 built another at Vaudrevange (which was renamed Wallerfangen by the mid-nineteenth century). In 1836 the empires of Jean-François Boch in Mettlach and Septfontaines and Nicolas Villeroy nearby in Wallerfangen were united, and the firm has since been known as Villeroy and Boch. They acquired a glass manufactory at Wadgassen (1843), a porcelain factory at Tournai (1851), other ceramic works in Dresden (1856), Schramberg (1883), and Torgau (1926), and a tile company at Danischburg (1906). There were several dozen marks associated with these many enterprises. Although the business continues to flourish to this day, the factories located in East Germany were lost after World War II.

Many collectors associate the Villeroy and Boch mark with Mettlach steins. Mettlach, a shortened version of Mediolacum or "between the lakes," is in the Saar basin. During the French Revolution the Benedictine abbey of Mediolacum was plundered and the lands confiscated. In 1809 Jean-François Boch purchased the area from the government with the condition that Boch could use the area's great supply of hard coal to fire his newly built kilns. Mettlach became the first pottery in Europe to forsake wood for coal firing. Nicolas Villeroy's Wallerfangen factory adopted the new methods and, with their joint endeavors, Villeroy and Boch became a primary force in the production of earthenware. By 1851 the thousand-year-old abbey was completely restored and its tower became part of the Villeroy and Boch mark for Mettlach.

In 1843 Villeroy and Boch divided the production of the various types of ceramic ware among the three company factories in Mettlach, Wallerfangen, and Septfontaines, and the latter specialized in majolica. Many objects, such as table services, pitchers, paper weights, holy-water basins, and inkwells, were produced. A number of these pieces may be seen in the Musée de l'État in Luxembourg.

The pattern books at Septfontaines specify production of "colored goods made of enamel." These refer to the naturalistic majolica pieces of the second half of the nineteenth century—green, yellow, or purple-red enameled objects that were sometimes glazed with all three colors. A small tureen is decorated in a style similar to that of Choisy-le-Roi. The motifs modeled in low relief include vine leaves, fruits, and foliage.

From 1883 to 1912 some finer majolica was made at Mettlach, examples of which may be seen in the Keramic Museum Mettlach. At Mettlach the German craftsmen worked with immigrant English craftsmen who brought with them the refined techniques of Stoke-on-Trent. That knowledge, together with the excellent training of the Boch family at Saint Clément and Lunéville, resulted in some of the finest German majolica of the era. The plates are often made with pierced rims, similar to Wedgwood examples. The decoration is typically Art Nouveau, with such flowers as lily of the valley, violet, water lily, and sunflower.

Majolica was also made at Villeroy and Boch's factory in Schramberg, from 1895 to 1912. That factory's mark on its majolica is a shield with "SMF" in monogram, for Schramberger Majolika-Fabrik. The Schramberg pottery also produced stoneware and porcelain.

Unattributed German majolica in the nineteenth cen-

194

tury was less vividly colored and less handsomely modeled than English or American examples. Among the lower-toned German glazes, grays, quiet blues, greens, and browns predominated. Hunting scenes, floral or fruit patterns, and animals were frequently depicted. Plates, pitchers, and dessert services with compotes bordered with geometric patterns were the usual pieces. A new artistic language appeared in the late nineteenth century: plants and flowers were presented in a very supple, stylized fashion on majolica. The motifs included young women, dragonflies, and butterflies—all presaging the Jugendstil.

Other German factories that produced majolica
Cushion lists in his *Handbook of Pottery and Porcelain Marks* several other German potteries that produced majolica in the late nineteenth and early twentieth centuries. Although no pieces from these factories are known, it is hoped that further research will bring some to light. These firms include: J. Glatz of Villingen, Baden-Württemberg, which produced majolica beginning in 1870, with a mark of three stylized evergreens enclosed in a circle; the Grossherzogliche Majolika-Manufaktur (Grand Ducal Majolica Manufactory) of Karlsruhe, Baden-Württemberg, which was founded in 1901 and which made majolica from 1904 to 1927, with the mark "G.M.K." under a solid five-petaled flower; the Majolika-Werkstatt Cadinen, in Cadinen, West Prussia, which made majolica in the early twentieth century, with the mark "CADINEN" enclosed under a church dome in a circle; Münch, Wilhelm and Zapf, in Rudolstadt, Thuringia, which made majolica and hard-paste porcelain beginning in 1905, with the mark "W & M/Z" below two four-leaf clovers with crossed stems; and C. Gebrauer, in Bürgel, Thuringia, which made majolica starting in 1892, with the mark "CG" in monogram enclosed in a triangle pierced horizontally by an arrow.

CZECHOSLOVAKIA

Wilhelm Schiller and Sons
Established in Bodenbach, Bohemia, in 1829, the firm produced excellent porcelain and earthenware. Majolica pieces from this pottery are boldly modeled and well glazed. An outstanding example is a dramatically mod-

eled pitcher with marine motifs, in which the mouth of the pitcher is in the form of a small fish. A majolica compote in the Art Nouveau style is brilliantly colored and gracefully modeled (#1157). The factory closed in 1895. Its mark "W.S. & S." impressed may be confused with that of Wilhelm Sattler and Son, a firm that existed from 1829 to 1860 in Aschach, North Bavaria, and produced general pottery but not majolica.

PORTUGAL

Established in Caldas de Rainha (the queen's bath), long a center of Portuguese pottery about a hundred kilometers north of Lisbon, the firm known from 1853 to the present as (Manuel Cipriano Gomez) Mafra and Son specialized in the reproduction of the designs and glazing techniques of Bernard Palissy and Thomas Whieldon. The nineteenth-century versions of Palissy plates and large platters are not always easy to distinguish from the sixteenth-century prototypes. The imitations are, however, more cluttered with sea-life motifs than the originals. The Portuguese Palissy pieces produced by Eduardo Mafra, the son, also compare less favorably with the French Palissy adaptations made in the nineteenth century by Charles-Jean Avisseau. Portuguese copies of eighteenth-century tortoiseshell-glazed Whieldon pieces are not as finely made as the originals. The Portuguese wares may be recognized by the factory mark "M. MAFRA" in an arc above an anchor with the words "CALDAS" and "PORTUGAL" below.

A gracefully modeled nineteenth-century Mafra majolica tea and coffee service, with the pieces shaped as small lettuce or cabbage leaves, is similar to the American New Milford Lettuce Leaf pattern. The Portuguese leaves, however, are a richer emerald green, and the spouts and handles are not modeled as twigs, but are in the form of sinuous, delicately sculpted snakes. Candlesticks modeled with a mossy green surface are decorated with agile monkeys. The impressed mark is a crown above the words "MAFRA/CALDAS/PORTUGAL."

Twentieth-century Portuguese reproductions of Palissy ware are rougher, more grotesque, and not as well glazed as the earlier pieces. Among recent examples are oval plaques depicting seascapes, as well as bizarre flasks and round platters in several sizes. Many current pieces

are not marked and the undersurfaces are poorly mottled. A popular tureen, with matching plates, in a robust cabbage-leaf design is reminiscent of the nineteenth-century pattern, but these twentieth-century examples are easily recognized and bear the mark "PORTUGAL."

Mention should also be made of the remarkable work of Rafael Bordalo Pinheiro, a very gifted ceramist from Caldas da Rainha. He was born in 1846 and at the age of thirty-eight established a ceramics factory in Caldas. He was strongly influenced by Manuel Cipriano Gomez Mafra and by the work of Bernard Palissy, and produced many platters, pitchers, jars, bowls, and various other containers. Like Palissy and Mafra, he was inspired by local flora and fauna as well as reptiles, frogs, toads, and fish—and enameled his pieces in vibrant colors. His participation as a decorator at the Portuguese pavilion at the 1889 Paris exhibition considerably widened his vision, because of the displays of English and French majolica that he discovered and admired. That was also where he learned of the Minton kilns developed by Léon Arnoux with which he then equipped his factory. His work at the end of the century reflected Art Nouveau. His art exploded into twisting, sensual lines, and he made some extraordinary tiles and large pieces of majolica. In his last years, until his death in 1905, Pinheiro devoted himself to making large-scale groups of religious figures.

ITALY

Much of nineteenth-century Italian majolica pottery repeats the patterns and glazes of Renaissance *maiolica,* but the designs are not as bold and the colors are not as vibrant as those of the earlier ware. The Società Ceramica Richard in Milan, a descendant of the Doccia Porcelain Factory established near Florence in 1735 by the Marchese Carlo Ginori (1701–1757), produced majolica from 1842 to 1860. In 1896 the Ginori interests were united with the Società Ceramica Richard of Milan, and during the twentieth century the name Richard-Ginori has been associated with excellent porcelain. Although many marks were used by the company at different times, the mark associated with the manufacture of majolica is the name "GINORI" below a schematic crown.

Other Italian factories that produced majolica in the nineteenth century, as listed in Cushion's *Handbook of Pottery and Porcelain Marks,* include: Angelo Minghetti and Son in Bologna (founded in 1849), with the mark "AM" in monogram; A. Farini in Faenza (1850–1878), with the mark "FAENZA" above an anchor and "A. FARINI & CO" below; Ulisse Cantagalli in Florence (fl. 1878–1901), with a mark depicting a stylized rooster with or without the word "ITALIA"; Castelbarco Albani in Urbania (late nineteenth century), with the impressed mark (on an 1882 example) "CA/1882" under a crown in a vertical rectangle; and Carocci, Fabbri and Company in Gubbio, which exhibited wares at the 1862 London exhibition (the firm's marks were at least two semilegible versions of their monogram.)

SWEDEN

Majolica tablewares and ornamental pieces were made at the potteries of Rörstrand, near Stockholm, and Gustavsberg, on the island of Värmdö near Stockholm, beginning in the 1860s. Rörstrand, founded in 1725, made tin-glazed faience until about 1773, when the factory started to use lead glaze on its earthenwares, which were similar to English examples. A majolica jardiniere pedestal in the Renaissance style made at Rörstrand is reminiscent of a Minton design. In Sweden majolica was known as *flintporslin.* Gustavsberg, founded in 1827, at first made faience very much like that of the major Swedish manufactory Marieberg, but in 1860 began to produce glazed earthenware in the English style and was particularly noted for its Parian, majolica, and other pottery very like Wedgwood's.

RUSSIA

Tin-glazed earthenware decorated with polychrome glazes was known in Russia as early as the twelfth century. The production of majolica in the nineteenth century in many parts of Russia coincided with the years of Victorian majolica. Especially successful were the Ovodov brothers, potters in the town of Skopin in Ryazan Province, who established their factory in the 1860s. The production of tin-glazed wares included

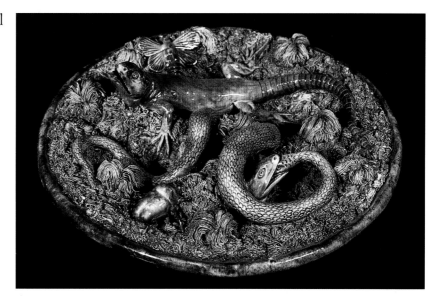

Unattributed Portuguese ceramist. Wall plaque. c. 1890. Diameter 12″. Courtesy Fenouil, Biot, Côte d'Azur

Mafra and Son. Chocolate pot, teapot, coffeepot. c. 1880. Height of chocolate pot 10″. Courtesy Garvin Mecking, New York

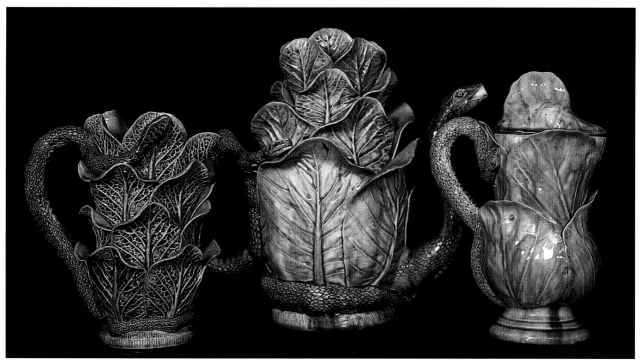

vessels modeled in the shapes of birds, lions and other animals, and centaurs. They are the equivalent of the mouth-pouring pitchers of western Europe. They were very popular and Russian examples may be seen at the Hermitage in Leningrad.

Just as important painters and sculptors in the Italian Renaissance and at Minton and Wedgwood in the nineteenth century lent their skills to the production of *maiolica* and Victorian majolica, so major Russian artists of the late nineteenth and early twentieth centuries designed for potters. These artists included Mikhail Alexandrovitch Vrubel, Serge Maliutin, and Alexander Terentyevitch Matveyev. Most active were the Abramtsevo Ceramic Factory, near Moscow; the Artistic Workshop at Talashkino, near Smolensk; and the Ceramic Works at Kikerino, near Saint Petersburg. Artisans at these factories revived designs of folk ceramics and historic Russian art in vividly colored majolica.

Chapter 11
CLAYS AND GLAZES

The word "ceramic" is derived from the Greek *keramos* (potter's earth). The production of pottery is a magnificent amalgam of chemistry, creativity, and commerce, but of most significance is the knowledge of clay. Each factory developed its own formula for a combination of several clays to provide the appropriate chemical components and physical properties required for a variety of wares. A clay mixture used for Victorian majolica, for example, would typically include Devon or Dorset clay (called "ball clay" because it is used in ball-shaped units of thirty pounds each), which withstands a high temperature and fires off-white; china clay, or kaolin, from Cornwall for increased whiteness; and flint. Flint, a substance consisting of small quartz crystals and water molecules, is calcined (reduced to powder) when heated to about 400°C. When added to clay, flint increases the whiteness of the clay, controls contractions, and enables the clay to maintain its shape during firing. In the late seventeenth and early eighteenth centuries potters in Staffordshire noticed that as the water evaporated from the clay mixture during the first firing, the clay body shrank some twelve to seventeen percent in volume. Since shrinkage may cause cracking or warping in the body or irregularities in the glaze during the second firing, it is very important to calculate the correct proportion of flint to clay. Flint also acts as a flux; that is, when added to clays or glazes, it enables the firing to the point of vitrification to take place at a lower temperature. Vitrification of the glaze on earthenware occurs from 700°C. to about 1200°C.; using a flux makes possible a lower firing temperature and thus saves both fuel and time. A nineteenth-century kiln took from twenty-four to seventy-two hours to heat and from ten to twenty-four hours to cool; therefore, the flux effect of flint was important.

In Victorian times, after the various clays were dug, before being mixed together, they were left to mature separately in large open pits for a number of years. When ready for use, each of the clays was made into slip and washed in a tank. The washed clays were then "blunged," or beaten in a huge vat with a wide paddle or by a machine with wide, rotating paddles, to eliminate lumps in the clay. The mixture of clay and water was sieved to remove impurities; iron oxides were removed by magnets. Washed clays and flint were mixed together to form a thick paste. Some of the water was evaporated by heating and the resulting doughy clay processed by a steam-driven filter press. The press consisted of a long central bar supporting some fifty iron plates lined with canvas bags. The press pumped the clay into the canvas bags, and by tightening a bolt on the press the canvas bags were squeezed together, forcing more of the water out of the clay.

The clay was then readied for shaping. A steam-driven pug mill mixed the plastic clay, homogenizing it by a kneading operation, freeing the clay of air pockets (a process called "pugging" or "wedging"). The clay was extruded from the pug mill and then flattened by a "spreader" into a uniform round sheet of clay, known as a "bat." This process prepared the clay for molding or throwing. Slip to be used for decoration was made from clay prepared by the pugging process and then weighed and mixed with a specific volume of water. The purity of this slip determined the smoothness of the surface of the finished product.

Plates and saucers were shaped on a "jigger," a machine with a rotating plaster mold. The flattened bat of clay was draped and pressed onto the jigger mold, which bore the imprint of the relief decoration for the top surface of the plate. The rim and the underside of the

plate (which was placed upside down on the mold) were formed with a "profile," a shaping tool or template, cut in the silhouette of the bottom of the plate, including the foot ring. The profile, when pressed onto the bat of clay on the rotating jigger, cut away the excess clay, thus forming the outside of the plate and the foot ring.

Hollow ware, such as cups and shallow bowls, were shaped in a "jolly," a machine also using a rotating plaster mold. The bat of clay was pressed into the mold, which carried the imprint of the relief decoration for the outside of the vessel. A profile pressed into the clay shaped the inner surface of the piece as the mold rotated on the jolly.

When the earthenware body was to be ornamented with separately molded parts, such as leaves or decorative figures, the attachment of these parts (a process known as "sprigging") was done with thin slip before the first, or biscuit, firing. Cutting and piercing, which were infrequently done in the manufacture of majolica, was also accomplished before the first firing. Before firing, the raw clay varied from soft, or "cheese-hard," to "leather-hard" states, according to the amount of moisture that had evaporated from or been pressed out of the clay.

Hollow ware, applied decorative details, and figures that could not be formed on a rotating mold were cast in plaster-of-paris molds (introduced into Staffordshire about 1745). A clay model was sculpted following the designer's drawing, with allowance for shrinkage during the drying and firing. That model was then covered with plaster of paris to make a block mold, which could be reused repeatedly for quantity production. More complicated pieces of majolica required plaster-of-paris molds that could be removed in segments. A very elaborate piece of Minton majolica, for example, needed a mold made up of as many as thirty segments.

The dried plaster-of-paris mold was used to cast vessels or other objects in slip. The mold was filled with slip, which left a layer of clay on the inner surface of the mold. When a shell of the desired thickness was built up inside the mold, excess slip was poured off. As water from the slip in the mold was absorbed into the plaster mold, the clay slip shrank as it hardened in the shape of the original model. When the slip reached the cheese-hard stage, the cast piece could easily be removed from the plaster-of-paris mold. Seam marks and other blemishes from the casting process were removed with a metal tool in a procedure called "fettling."

One more step was necessary before the initial firing. All "greenwares"—the raw, unfired, molded pieces— were dried further in "greenhouses" and then carefully arranged in fireclay boxes called "saggers" (a corruption of "safe guard"), which were sealed to protect the pieces from damage by smoke and dust in the kiln. The clay wares were supported in the saggers by "kiln furniture," also made of fireclay. Kiln furniture included "sagger pins" (which fit horizontally through triangular peg holes in the walls of the sagger), on which the pieces rested; "trivets" (triangular slabs of fireclay with three small feet), which were placed between flatware stacked in the saggers; and "cockspurs" or "stilts," tripod supports, which might cause sagger marks called "spur marks" or "stilt marks" on the undersurface inside the foot ring of plates. Other kiln furniture included "firing rings," which were similar to trivets; "girders" or "slugs," which were thin slabs used vertically to support flat pieces; and "rafters," which were slabs placed horizontally on girders to support other pieces. Some factories, such as Bullers in Milton, on the outskirts of Stoke-on-Trent, produced only kiln furniture, including the Bullers ring, a temperature-measuring device. Collectors prize such items because of their rarity.

Saggers filled with greenwares were placed into the kiln according to the amount of heat needed to fire the individual pieces. Heating requirements were gauged according to the size of the piece and the degree of residual moisture it contained. Saggers were stacked in tall columns. The fireman, whose all-important judgment determined the success of the operation, was in charge of the gradual buildup of heat. Controlling the oven by regulating the dampers, he raised the temperature to 1000°C. to 1150°C. for earthenware. For seventy-two hours he was guided by the color of the flames and by gauging the absorption of spittle on a cooled trial piece. A more sophisticated piece of kiln furniture was the "cone," in the shape of a pyramid. The cone top melted and bent over to the level of the base at a predetermined kiln temperature, thus assuring greater accuracy in the firing.

Victorian majolica was fired in seventy-foot-high bottle kilns built of brick. They take their name from their inverted-funnel shape. (Such a kiln was also called a

beehive kiln.) The great chemist and art director at Minton, Léon Arnoux, calculated that for the production of every ton of wares at least eight to ten tons of coal were necessary. Firing losses of twenty to thirty percent of the pieces were not uncommon until reliable temperature guides and modern tunnel kilns were developed. (The first tunnel kiln, gas fired, was introduced in Europe at Villeroy and Boch in Mettlach in 1902). In tunnel kilns, which were about 275 feet long and soon electrically heated, the raw earthenware was pulled through the kiln on low trucks into zones of gradually increasing and decreasing temperatures, and emerged fired. This continuous process eliminated saggers and the loss of time necessary for the stacking and cooling of the ovens.

At the end of the first firing, the pieces were cooled and removed from the oven. They were then in what is called the biscuit stage. "Brushers" and "chippers," usually women, especially in smaller potteries, cleaned the wares and smoothed off sagger marks and other irregularities. Pieces were then carefully stored to await glazing. The regulation of temperatures for biscuit firing was very important in majolica production, because at temperatures between 1200°C. and 1280°C. earthenware loses its porosity and becomes stoneware. For majolica, and majolica glazes, the earthenware must remain porous.

In the preparation for the second firing, or "glost" stage, the biscuit earthenware was covered with glaze to provide a protective surface impervious to liquids. The glaze was applied by painting or by dipping the piece into a bath of tin or lead glaze, or a combination of both. Design areas were then painted on the dry, unfired background glaze. Great care was necessary because no erasures could be made. The typical majolica glaze is recognized by rich jewel-like colors and an extremely smooth, lustrous sheen. This lustrous sheen on majolica results in part from the use of a lead flux in the glaze as well as from the interaction of the metallic-oxide glaze with the iron in the clay body. The use of lead as a flux in the background glaze allows the glaze to melt at a lower temperature, thus creating a special crystal configuration of the glaze that increases the surface gloss. In the glost firing of clay containing iron, some iron moves from the clay to the surface of the glaze; this also enhances the lustrous sheen. Since the majolica earthenware biscuit body is porous, the metallic-oxide glaze during the glost

firing melts into the body and is further influenced by the iron remaining in the body; this adds further to the lustrous quality of the glaze. Iron-free, nonporous porcelain bodies do not achieve the same lustrous effect when glazed and fired.

Glaze, briefly defined, is a glassy substance produced by the fusion of silica with alumina, catalyzed by a flux. Silica, the main constituent of glass and glaze, occurs naturally as quartz and flint in sand and pebbles. When finely ground to a powdered state and heated to 1700°C., silica melts and then cools to become glass. Since earthenware becomes stoneware when heated above 1200°C., however, a glaze for majolica must be prepared that will vitrify at a much lower temperature. To accomplish this, a flux is added to the silica to lower the temperature at which the silica can become vitreous, or glassy. Vitrification of glazes for majolica must occur from approximately 800°C. to 1050°C. Low-temperature fluxes (which lend their names to the resulting glazes) include oxides of lead, calcium, barium, sodium, potassium, magnesium, and zinc. Each flux has a different temperature-lowering strength and imparts a different quality to the glaze. Lead-oxide flux is most frequently used for majolica glazes. The flux itself is first combined with additional silica (known as "frit", or "fritt"). Heating the flux and the silica (called "fritting") will prevent flux solubility in water or acid and also flux instability. Alumina is added to increase the stability and adhesive quality of the glaze. It is found in several minerals such as the feldspars and the lithium compounds. The proportions in which silica, flux, and alumina are combined determine both the stability and the aesthetic appearance of a glaze. For example, too much alumina dulls the sheen of the glaze.

The color of a majolica glaze results from the addition of a specific metallic oxide suspended in an oil medium—and how that oxide reacts under different chemical conditions. The oxide is affected by (1) the acid-alkaline balance of the glaze, (2) the flux, which in majolica glazes is usually lead, and (3) the oxygen concentration in the kiln during firing. An oxidation kiln, or oxidation atmosphere, is one rich in oxygen and poor in carbon dioxide. A reduction (or deoxidation) kiln, or reduction atmosphere, is poor in oxygen and rich in carbon dioxide. In the oxygen-poor reduction kiln, the oxygen necessary for combustion for the firing to con-

Griffen, Smith and Hill. Mold for cake tray in geranium pattern. c. 1880. Courtesy Historical Society of the Phoenixville Area, Phoenixville, Pennsylvania

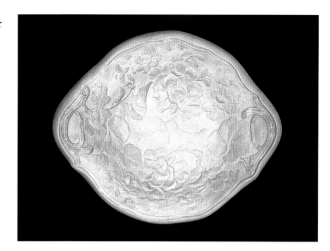

Griffen, Smith and Hill. Cake trays. c. 1880. Diameters 10″

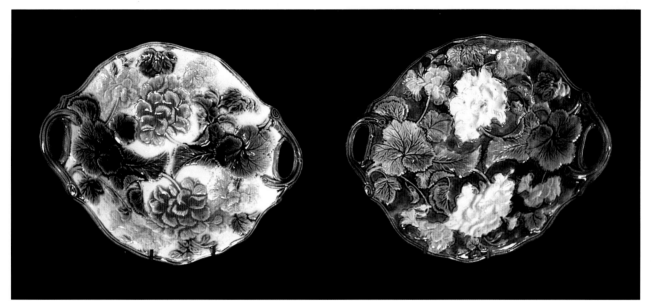

tinue must come from the residual moisture in the clay and glaze themselves. This loss of oxygen in the clay and glaze changes the color yielded by a given metallic oxide from the color that would develop in an oxidation kiln. For example, as the concentration of oxygen is decreased, copper oxide gives a range of color from blues to greens to oxblood red. Iron oxide yields a range of yellows and browns in an oxidation kiln, and in a reduction kiln results in blue-greens, olive-greens, reds, browns, and black. Manganese dioxide, depending on the decreasing oxygen in the kiln atmosphere, supplies the range of pink to purple to aubergine to rich brown. Chrome oxide gives a range from yellow to pinks and warm browns. Antimony furnishes a strong yellow. Cobalt oxide, which is stable in both oxidation and reduction kilns, produces

the most sought-after majolica palette of rich blues, depending on the cobalt oxide concentration.

Since metallic oxides also added to the effect of flux in a glaze, it was important to calculate correctly the individual amounts of both oxide and flux used in the glaze mixture. If there was an incorrect marriage between a clay body and the glaze (resulting from different rates of shrinkage in each of these two materials during the successive firings), crazing resulted and therefore the piece was then not waterproof. There also might have been delayed crazing, months or years after the piece was fired, caused by accumulated moisture due to a defect in the glazing. Crazing, however, can be a decorative feature, as in some Chinese ceramics—but it was not intended in majolica and is not desirable. Another

201

possible defect was "crawling," which occurred when the fired glaze did not adhere, but retracted and exposed the biscuit body. This was usually caused by grease or other impurities on the surface of the body when it was glazed.

In the second, or glost, firing, glazed pieces were carefully placed in saggers, separated and protected by kiln furniture. Saggers were stacked high, with wads of clay sealing the spaces around the lids of the saggers to prevent discoloration of the glaze by the sulphurous fumes at the start of the firing. Firing time was similar to that of the biscuit firing. The saggers and ovens used for the glost firing were not the same used for the biscuit firing because the glazes became volatile during the glost firing and adhered to the oven walls and to the saggers. The contaminated saggers and ovens would have discolored the biscuit wares. The glazes, almost colorless when applied to the wares, developed their colors during the glost firing. When the firing was completed the glost ware was carefully withdrawn from the kiln and saggers, to protect the brilliant glaze. Pieces were checked for imperfections.

Occasionally a third, or enamel, firing was required. Overglaze metallic-oxide enamels were fired at the lowest temperature (700°–900° C.), in a muffle kiln, or *petit feu.* The muffle kiln contained an inner chamber or box (muffle) made of fireclay, which protected objects during the heating process from flames or smoke which could discolor the glaze.

Not only was the firing process hazardous to the ceramic wares, unless protective measures were taken, but the workers themselves were in jeopardy from lead fumes penetrating their lungs, mouths, noses, and skin. Plumbism resulted in severe neurological and gastrointestinal damage, anemia, and sometimes death. Pottery painters, ingesting the lead glazes as they pointed their delicate brushes with their lips, also suffered the same fate. By the end of the nineteenth century, the lead content of the glazes was decreased, to protect the health of the pottery workers. Borax was a frequent substitute for lead as a flux.

Neither the chemical composition of all Victorian glazes nor the complexity of the glazing procedure can be fully determined today. It is fortunate, however, that the archives of the foremost American manufacturer of majolica—Griffen, Smith and Hill of Phoenixville, Pennsylvania—contain some of the rare formulas for majolica glazes that survive from the Victorian era. One of the most characteristic glazes of that period was "majolica pink," used for lining hollow ware. The formula for the Griffen, Smith and Hill version (included in Ruth Weidner's master's thesis) was:

Pink Fritt
32 lbs. Tin Ash
16 lbs. Paris White
2 lbs. Chromate Lead
Calcine in Biscuit Kiln
Pink Glaze for Lining
20 lbs. Oxide Tin
7 lbs. Spar
6 lbs. Borax
3 lbs. Flint
2 lbs. Common Salt
12 ozs. Chromate Lead
Calcine in top of Biscuit Kiln.
Mix for use: 1 pt. above Fritt,
15 pt. Glaze

Chapter 12

ON COLLECTING MAJOLICA

"The most creative and exciting thing a collector can do in the antiques market is to find a field about which little has been written and capture the subject for his own private amusement." Written by Jeremy Cooper (in *Dealing with Dealers: The Ins and Outs of the London Antiques Trade*, p. 76), a specialist in nineteenth-century decorative arts and the man responsible for an elegant exhibition of Minton majolica in London in 1982 (catalogued by Victoria Cecil), the statement could have been applied to majolica until about the mid-1970s. Although majolica had been quietly collected by farsighted cognoscenti since the 1940s, today's majolica collector is not enjoying quite such a private love affair. Majolica has been publicized in the international press, in magazines, and in museum exhibitions. A major Wedgwood exhibition held by Richard Dennis, also in 1982 in London, was documented by Maureen Batkin's *Wedgwood Ceramics 1846–1959,* which contains a chapter on majolica. In that same year in New York City the Cooper-Hewitt Museum held a "jeweler's exhibition" of English majolica in black-velvet-lined cases. In the exhibition *Design in the Service of Tea,* held at the same museum in 1984, majolica teapots were included because of their intriguing shapes and brilliant glazes. The exhibition *In Pursuit of Beauty: Americans and the Aesthetic Movement,* held in 1986 at the Metropolitan Museum of Art, included an example of the oriental-style majolica bamboo and butterfly plate made by the Eureka Pottery Company of Trenton, New Jersey, as well as a majolica sunflower saucer made by Griffen, Smith and Hill of Phoenixville, Pennsylvania. The magnificent exhibition catalogue, written by Doreen Bolger Burke et al., included large illustrations of the plate (in black and white) and of the saucer (in color). Nineteenth-

century floral displays at recent antiques shows have included majolica cachepots for their botanical style.

Collectors pursue majolica for many reasons—for the joy of being surrounded by favorite colors, for the delight of possessing intricately modeled and skillfully glazed ceramics, for the nostalgia evoked by reminders of romantic Victorian gardens and the bounteous Victorian dinner table, and for the amusement of discovering humor and whimsy in many of the pieces. Beautifully sculpted examples of Minton and George Jones flora and fauna bring an English landscape into a modern apartment; more rustic pieces enhance a country home. Almost all pieces of majolica were dedicated to food or flowers, both of which can evoke universal pleasure and passion.

An understanding of the fantasy of collecting reveals that, no matter what the quarry, all collectors enjoy the chase, the serendipitous path that leads to an unexpected treasure. With majolica in particular this is a great part of the allure, because no one has a precise idea of how much majolica was produced; and even the beginning collector may come upon a great new discovery. No one has a complete knowledge of all the different uses for which majolica pieces were made, or of which forms have been glazed in how many different colors. A rare find, and then another, gives the collector an illusory sense of completion. A sense of accomplishment against the odds—and in the competition with other collectors—is felt when another piece is put on the shelf. Until, of course, the obsessional quest begins again. If the object of the chase is fashionable, so much the better for the collector's sense of security and status. If the category is somewhat arcane, as majolica was prior to 1970, the collector feels quite independent and perceptive, feelings

203

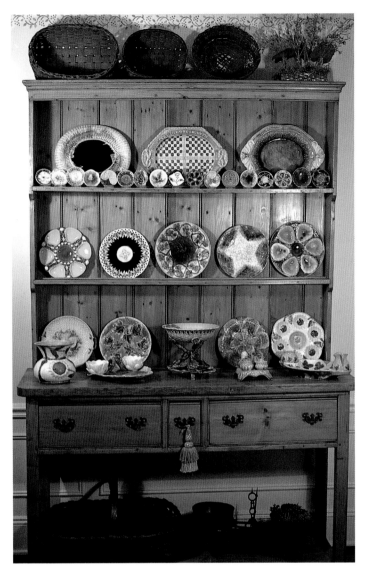

English and American
majolica featuring bread
trays and butter pats

204

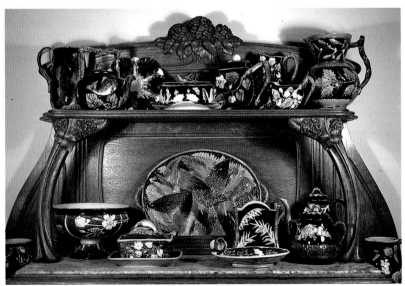

English majolica with cobalt
glaze displayed on a French
Art Nouveau sideboard

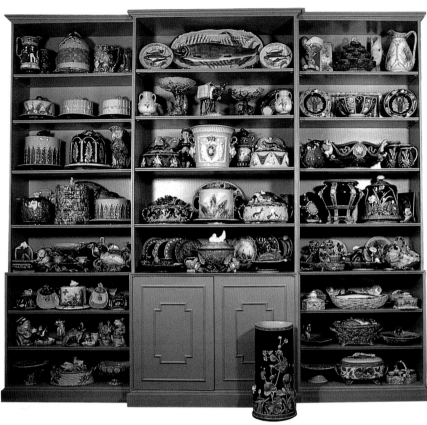

A collection of English, American, and Continental majolica in a majolica-pink setting.

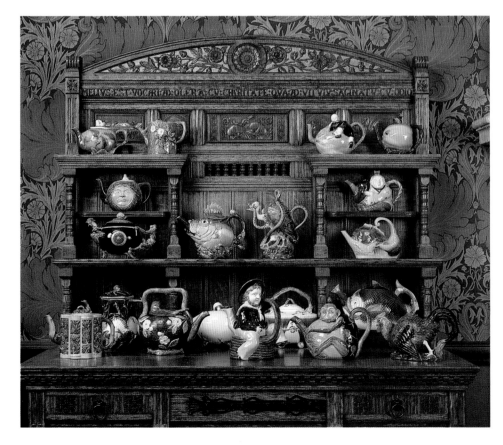

English majolica teapots on a Victorian pine dresser. Courtesy Richard Dennis, London

that are converted to prescience as the collection increases in recognition and value.

Pieces bought early may be relegated to back shelves (or to other collectors) when fortune smiles and more splendid pieces are purchased. Some collectors approach their collections as they do the stock market: buy when prices are low, sell when they are high. The ultimate allegiance of such collectors is not to the aesthetic appeal of the collection but to its market value.

Collections are not all symbols of competition. Many are mementos of travels, occasions, people, and places. Some afford the collector a sense of history or an understanding of the development of an art or of a process. A collector may enjoy owning or recognizing the "links" between centuries or countries. An eighteenth-century Meissen porcelain stork with a fish (1732) has its counterpart in a nineteenth-century Minton majolica stork (1875). National boundaries are crossed by a swan ewer (echoing its Sèvres porcelain prototypes) that was made by Royal Crown Derby in porcelain, in French and English majolica in graduated sizes, and ultimately in a more rustic American majolica version.

Perhaps because their subject seems less formidable than porcelain made by Meissen and Sèvres or less aristocratic than the fine arts, and because of its almost infinite variety, majolica collectors appear less competitive with each other. The belief that there are always two, and many times three, of almost any piece creates a rather benign mood at most auctions. This may change as more collectors enter the field. Collectors visit each other's homes and are pleased to recognize familiar pieces, to see rare prized possessions, and to learn of new examples. Of course, as with all collectors, there is the occasional majolica collector who feels that his sense of ownership is diminished if others view his collection. This, as with any other type of secrecy or censorship, decreases the chance for public knowledge and appreciation.

Dealing with the realities of collecting raises several questions: What specific categories shall be included? What is the most judicious way to go about collecting, and what are the caveats—universal and specific—for the collector? Many majolica collections are based on a comprehensive approach that includes all shapes, colors, makers, and countries. Some collections, on the other hand, are dedicated to one country, or one manufacturer,

or there may be a focus on European examples rather than American. A specialist might collect one form of majolica, such as pitchers, teapots, or cheese bells, or one color, such as turquoise or cobalt.

Some collectors include twentieth-century copies to compare with the Victorian models. The best twentieth-century pieces include imitations of the Minton wicker-work game-pie dish depicting the prey, a Minton compote supported by two rabbits, and the Etruscan Shell and Seaweed dessert plates and cups and saucers. The copies are lighter weight, less skillfully colored, and less well modeled, however, than the originals. The undersurfaces of the modern pieces are almost always white and marked with the name of the factory or the country of origin, and sometimes the date, printed or impressed. Occasionally the marks are on an easily removed paper label. Collectors should beware of fake impressed (and "antiqued") marks on some twentieth-century copies, such as a counterfeit diamond-shaped British registry mark or a spurious circular "ETRUSCAN" mark of Griffen, Smith and Hill. If nineteenth-century molds for Minton, Wedgwood, or Etruscan majolica—or those of any other firm—were to be used today, the pieces would be appropriately marked to indicate their recent manufacture. In order to be true majolica, however, the traditional majolica clay and glaze formulas would have to be used. Most current copies of majolica resemble colored creamware, or *faïence fine.*

Specifically, how does one go about collecting majolica? Frederick Litchfield, in *Pottery and Porcelain, A Guide to Collectors,* written in 1900, and as true today, suggested that the collector "ventilate the subject" with friends who also collect (p. 52). The best way to develop an eye and connoisseurship is to see and compare as many pieces as possible. It is important to visit museums and read the literature in the field. Visits to auction houses to study the pieces and to compare estimated prices in the catalogue with the actual sale prices can be most instructive.

Majolica dealers are very important to new, and to all, collectors. Today many dealers specializing in nineteenth-century decorative arts have become extremely interested in majolica. A knowledgeable dealer can point out factory marks and other, more subtle methods of identification such as undersurface or interior glazes, and can also discuss aspects of connoisseur-

ship. A reputable dealer will point out not only the obvious chips and defects but also the repairs. By tilting and rotating a piece of majolica under a good light, the buyer can learn to recognize discontinuity and discoloration in the glaze that would indicate repair, and to be aware of the pooling of glaze at the base of restored handles or finials. Also, inspection by ultraviolet light reveals areas of repair. Some experts may tap a piece of majolica, knowing that a dead sound can reveal a crack or repair, but one runs the risk of chipping the glaze by this maneuver. A prospective buyer should run a fingertip slowly around the periphery of pieces to feel for roughness or minuscule chips. It must be remembered, however, that some rough edges or surfaces originate during manufacture and are therefore acceptable to some buyers, if the piece is rare or much desired. Crazing of the glaze—either as a result of age or of a difference in the shrinkage rates of clay and glaze in the glost phase— might be similarly acceptable to some collectors. Hairline cracks—which travel from the rim toward the center—are caused by careless use or age. They may or may not penetrate through the body of the piece, but may be visible on only one surface. They can be repaired, unless the crack appears on a complex surface such as one with mottling, heavy modeling, a pebbly texture, or crazing, since the repair cannot easily be matched to the surrounding area.

Imperfections that can develop in the manufacturing process, rather than by later damage and repairs, include air bubbles in the clay. If air was not pressed out of the clay before the initial firing, there may be discontinuities in the body caused by heat expanding the air bubbles. Air trapped in the clay may also expand during the glost phase and bubble into the glaze. Other possible flaws such as pip marks or spur marks on the bottom of plates may result from the glost phase during which the glazed plate rests on the kiln furniture. When the plates are removed from the supports in the saggers, little imperfections may remain, but these do not alter the value of the piece.

Errors in glazing may occur during the preparation and application of the glaze, preventing it from fusing completely and adhering smoothly to the surface of the piece. Also, the glaze for one area may run into another part of the design before or during the glost phase. Crawling of the glaze may occur as well; that is, the fired glaze has retracted to expose the biscuit body. Glaze can flake; pale unstable glazes can become discolored during the glost phase; and if the glaze was chemically imperfect the color could fade from frequent use. Colored glaze could have been inaccurately applied to the different parts of the design by inexperienced artisans. All of these imperfections occurred in the lesser potteries where there was inadequate skill or supervision, but were rarely seen in the works of the major manufacturers. Nevertheless, there are collectors who would not part with some Holdcroft pieces, despite their less perfect color. Etruscan pieces, all hand painted, frequently show variation in the intensity and hue of the colors, especially in the majolica-pink linings, and all are in fact highly valued for this handcrafted variation.

The experienced collector will have handled enough pieces to distinguish true majolica from other wares by the weight of the piece in conjunction with other factors such as color and quality of glaze. Light pieces are apt to be an inferior type of earthenware, such as inexpensive carnival wares; heavier, denser pieces may be stoneware. At first glance, even the experienced collector may mistake other types of earthenware for majolica, especially if the motif and glaze resemble those of majolica. For example, a whimsical teapot in the shape of an owl, with the owl's head forming the lid, has been mistaken for majolica. The piece, though well glazed in majolica colors, is betrayed by its light weight as carnival ware. A Cadogan teapot (peach shaped, closed at the top, and filled through a conical opening underneath), also with good majolica glazes, was found to be stoneware when the unglazed undersurface was examined. A common error is the inclusion in majolica collections or majolica auctions of salt-glazed stoneware tea services and toilet sets with an orientalizing bamboo pattern in brown, tan, pink, and green on a beige background, made by the Brownhills Pottery Company of Tunstall, Staffordshire (discussed in Chapter Six).

It would be difficult to name many collectors who have not succumbed to the charms of some imperfect pieces of majolica. Each collector has to decide on the degree of perfection desired and to gather the beauty of the moment as mood and opportunity and purse dictate. Having introduced the matter of cost, the best that can be said on that painful subject is that the more perfect pieces command the higher prices. Most collectors know

English, American, and Continental majolica as a decorative focus

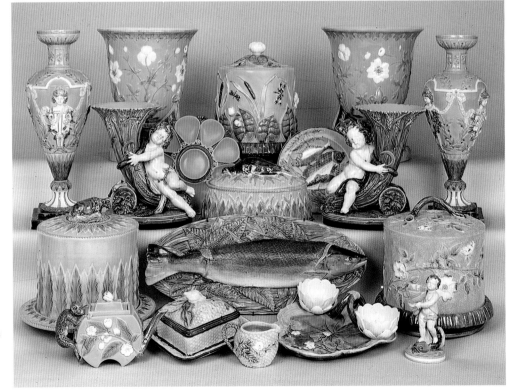

208

A group of majolica united by a turquoise background glaze. Manufacturers include Minton & Co., Josiah Wedgwood & Sons, and George Jones & Sons. Courtesy Britannia, London

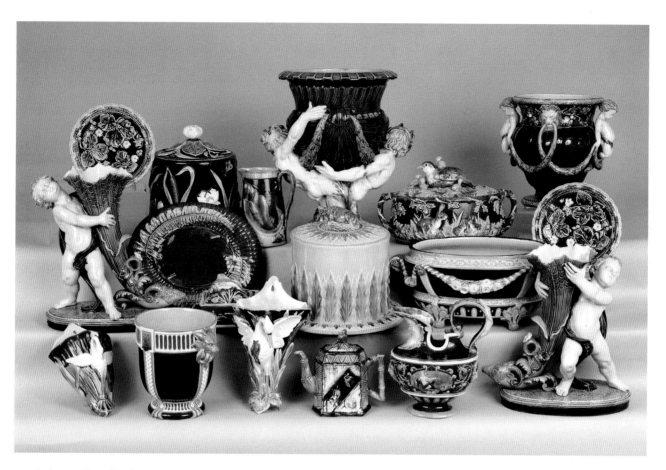

English majolica displaying animals, birds, fish, flowers, *putti*, and tritons. Courtesy Britannia, London

what they want, are guided by their own evaluation of a piece, and may choose to purchase a repaired piece, for example, rather than face the possibility of never finding a perfect, affordable, example.

Even if the piece of majolica seems perfect, it behooves the buyer to spend a few moments contemplating whether or not the piece at hand is a complete unit. There are so many shapes and designs of majolica that it is not easy to know all the variations. It is possible to see a beautiful example of majolica that seems to be complete, but is not. Sardine boxes should generally have an under plate, except for those modeled with a flaring or footed bottom. Cachepots with draining holes may be found without the necessary under plate. Game-pie dishes were made with plain white ceramic liners and, although the inner lining of the dish itself may be brilliantly glazed and therefore more attractive than the simple white liner, the game-pie dish without the liner is not complete. The sugar bowl in a Wedgwood straw-

berry service should include a lid, but in the almost identical Etruscan strawberry service the sugar bowl was not made with a cover. Strawberry services also may be missing leafy serving spoons as well as sugar and clotted-cream spoons, and the only way to know this is to have seen the complete service illustrated or displayed. The absence of the spoons should be reflected in a lower purchase price. How much lower? As in all cases, it depends on the original cost to the dealer, the dealer's awareness of the missing part, and perhaps the relationship between the dealer and the collector. The rare George Jones strawberry service decorated with two three-dimensional birds on a perch should include a removable sugar bowl and creamer, and three spoons. The spoons or the sugar bowl and creamer may be missing, and one or both of the birds may have been broken off and the piece skillfully repaired. Other incomplete pieces may be decorative but not able to fulfill their purpose: egg-cup trays without egg cups may be

The many faces of English and Continental mouth-pouring pitchers. Courtesy Hubert des Forges, New York

used as low flower holders; cheese bells without under plates can become shelf decorations. The collector is always optimistic that the missing pieces may be found. Because even good cups and saucers are becoming more scarce, most collectors will pick up one or the other, hoping that on the next foray its mate will appear. There is even a brisk trade in lids from tea and coffee services and in sardine-box covers. The experienced collector knows enough to collect single plates until the full dozen plus tazza are assembled. A very large plate may appear to be a charger, unless the buyer recognizes that the raised inner ring indicates that the "charger" once completed a cheese bell. There are few collections without "high shelf" pitchers, damaged on one side but presenting a beautiful facade to the visitor.

Collectors must decide for themselves the appropriate value of a perfect piece of majolica as against a damaged piece or an incomplete piece; a piece bought at a fashionable cosmopolitan auction versus a similar piece at a country auction or flea market; a piece bought from a knowledgeable as opposed to a casual dealer; or a piece acquired from another private collector. For the sake of comparison it may be instructive to cite the prices at which various examples of a very specific piece sold in recent years: the wonderful Griffen, Smith and Hill Shell and Seaweed humidor. These prices are noted over a five-

year period, and the tremendous range reflects how complicated it is to assign an absolute value. At an auction in 1985 in Phoenixville, Pennsylvania, the home of Griffen, Smith and Hill as well as of many enthusiastic collectors, the price of the humidor was $2300, plus the ten-percent buyer's premium. At various New York City auctions perfect pieces went for $2100, $1500, or $1900, all plus the ten-percent premium. A damaged piece, from which the well-modeled snail shell on the cover was missing, was $450 plus the ten-percent premium. At knowledgeable dealers' sales, prices ranged from $1500 to $1900; a dealer with no knowledge of majolica charged $750; a private citizen advertised a humidor for $275 and was inundated with calls for the next week. The lowest price for this form during the period under discussion was $200 for a humidor in a large cache of Shell and Seaweed pieces, and the snail shell was missing from the humidor lid.

The astute collector may acquire a piece of majolica at a great bargain in a flea market, a tag sale, or a country auction that does not specialize in majolica. With all the publicity in the media, however, there are few centers that are not aware of the great increase in the value of majolica. The highest prices have been in major cities and in auctions specializing in majolica here and abroad. The corollary is that the major centers offer the major

pieces. Before an auction the experienced auction-goer will have carefully examined the majolica during the presale exhibition period and then again just before the auction, to see if any new damage occurred during the exhibition period.

The malady known as "auction fever" should be anticipated and, if possible, avoided. The symptoms are unwise, impetuous, impulsive, and compromising bidding, and there are few collectors who have never succumbed during a competitive moment. (Perhaps the prize compensates for the fever.) Near the end of some auctions, if the bidders' interest is waning, the auctioneer may group the remaining lots to dispose of the less desirable pieces. The prices for such groups may be lower than for the pieces separately, but the bargains may be nullified by the damaged pieces that may be included in the group.

When all is said and done, why collect—and why collect majolica? What does a collector anticipate from the exhilarating and rewarding chase, which may last a year or a lifetime, and which may result in a collection of one hundred or one thousand pieces? Does the collector wish to display the elegant embellishments of a Victorian conservatory or garden: large, ornate jardinieres or jewel-colored pairs of garden seats? Would one fill exquisite George Jones vases and cachepots with fragrant flowers and luxuriant plants? Would one use fragile walking-stick stands with large stork and heron sculptures for their original purpose? Should a Sunday brunch be offered on a Wedgwood fish service? Should delicate Etruscan Shell and Seaweed plates grace an afternoon tea? Of course—because the happiest aspect of majolica is that it becomes a gracious part of one's life. Most collectors enjoy collecting majolica on several levels: the pursuit of knowledge in a fascinating part of ceramic history; the use of favorite pieces to enhance memorable hospitality; and, most of all, the delight of arranging majolica throughout the house, so that each view of beauty and whimsy will bring a new sense of excitement and pleasure.

English and French majolica guarded by T.C. Brown-Westhead, Moore's Tiger.

MAJOLICA IN THE MILLENNIUM

This book was published in November 1989, and its four subsequent printings, totaling more than 15,000 copies, attest to the increasing interest in the subject. Since the book's first publication, collectors and other interested persons have learned a great deal of new information about Victorian majolica and have participated in many events related to the subject. As the number of majolica collectors has risen, auction houses, dealers, book and magazine publishers, fabric houses and interior designers, commercial artists, and academics in the decorative arts have all become increasingly involved in the field, leading to important new data and perspectives.

In the same year that the book was published, a landmark in the growing attention being paid to majolica was the establishment of the Majolica International Society (MIS) by Michael Strawser in Fort Wayne, Indiana. Forty-six members appeared at the first meeting. Today, there are 450 members representing forty states in America, as well as Australia, Canada, France, Great Britain, and Romania. The society provides a forum for the interchange of ideas and information among collectors, dealers, and scholars of decorative arts and the Victorian period.

Major auction houses in the United States and Great Britain have greatly increased their involvement with Victorian majolica. Sotheby's conducted its first auction devoted exclusively to majolica in New York in March 1997. They also included greater numbers of majolica pieces in their ceramics auctions throughout England, Scotland, and the United States. Christie's followed a similar path and was the first to offer lectures on majolica to interested collectors. One of the most knowledgeable scholars in the field, Joan Jones, curator of the Minton Museum at Stoke-on-Trent, England since 1979, spoke at Christie's on the occasion of the fifth anniversary of the MIS.

The second year of the new millennium saw a great bur-geoning of interest in majolica. In January 2001, Sotheby's hosted a symposium on British pottery that included museum-quality majolica examples. The symposium accompanied the auction of part of a notable private ownership, the Harriman Judd collection, and the sale of other nineteenth- and twentieth-century British art pottery. The second part of the Harriman Judd auction, also accompanied by lectures, took place in October, and featured a rare Minton majolica mirror. Prominent speakers on that occasion included Peter Rose, retired professor of decorative arts at Brighton University, England, and Paul Atterbury, noted ceramics historian, author, and curator of the Victoria and Albert Museum's exhibition, "The Victorian Vision" (June 2001).

In March 2001, Jonathan Allen Preece, former exhibition curator of the Minton Museum, delivered Sotheby's lecture "The Minton Factory: An Overview of the Ornamental Tour de Force from 1851–1890." On that same day, Christie's displayed its ongoing interest in majolica with its auction of the nineteenth-century collection of Michael and Anne Ripley. The Ripley collection, entitled "The Aesthetic Interior," included forty-nine pieces of majolica from major English and American manufacturers.

In July 2001, Phillips, an international auction house that is part of Phillips de Pury & Luxembourg, was divided into two branches: with one in New York and the other in London, where Phillips UK merged with the English auction house, Bonham's. The new company is known as Bonham's and will conduct majolica auctions. In that same month, Phillips UK presented "Pieces from the Minton Museum, 1851-1951," which was originally scheduled to be held at Stoke-on-Trent but was moved to the Bond Street auction premises, where Dan Klein, John Sandon, and Mark Oliver were involved with the exhibition.

In other events of a busy year, Skinner's, the Boston auction house, featured majolica by Josiah Wedgwood & Sons as

Portuguese Palissy ware. Charger. Diameter 15″.
By Thomas-Victor Sergent

well as pieces by other manufacturers. And in August through November 2001, the Jones Museum of Glass and Ceramics in Sebago, Maine, exhibited more than one hundred examples of Victorian sanded majolica from the collection of over five hundred pieces donated to the Museum by Margaret E. C. Howland. Rare examples included signed pieces by Thomas Forester & Sons, Samuel Lear, Wardle & Company, and John and Thomas Bevington.

The increased activity of the auction houses has impressed collectors, auctioneers, and dealers and caused sharp increases in prices of majolica in recent years. Prices for the finest pieces of majolica multiplied tenfold or more. Even the middle-range unmarked examples commanded unexpectedly high prices. Continental majolica, valued Palissy wares, and unmarked but aesthetically pleasing majolica have brought higher sums. Majolica values have also been enhanced by the attention of television programs such as the *Antiques Roadshow*, the *Incurable Collector*, and antiques Web sites on the Internet, all of which have further raised the public's awareness of majolica.

Impressed by the greater demand, and sensing the growing sophistication of collectors, dealers at antiques shows carried more majolica, some even limiting their show inventories to this brilliantly glazed ceramic. In recent years, majolica dealers also took part in elegant antiques shows to which they had not previously had access. These included a Ceramics Fair and a Modernism antiques show in New York City, and the Palm Beach Town and Country Art and Antiques Show.

With increased sales, some dealers and collectors resorted to buying and selling desirable but damaged pieces. Talented ceramics restorers were called upon to repair pieces both simple and complex. Restoration, of course, raises many questions. Collectors have traditionally valued perfect pieces, but as prospective owners have increased in number and prized pieces became more costly, some people would buy a rare piece despite its restoration. As fewer perfectly preserved and intact pieces have become available, however, and as the quality of restorations has improved, the difference in cost between a "perfect" and "perfectly restored" piece has diminished. Responsible dealers will, of course, always inform a buyer whether a piece has undergone restoration, even if that alteration may be nearly invisible.

During the past decade, many lecturers and dealers encouraged new collectors to learn about majolica by reading about the subject, and a wealth of new writing appeared. Volumes on majolica by Victoria Bergesen and Nicholas M. Dawes soon followed publication of this book. Marshall Katz and Robert Lehr wrote books on the nineteenth-century French ceramics artists who had been inspired by the sixteenth-century artist Bernard Palissy and by nineteenth-century Portuguese majolica ceramists. These authors also published articles in American and French magazines. Jim and Vivian Karsnitz covered a specialized form of majolica in their book *Oyster Plates*, and majolica figural humidors were treated in the eponymously named book by Joseph Horowitz. Helen Cunningham also described majolica figu-

213

rals, and D. Michael Murray wrote about all manner of European majolica. Robert Cluett authored *George Jones Ceramics*. Magazines such as the British *Collect it!* added to English collectors' interest in the Victorian era. *Masterpiece*, a new British magazine first published in 2001, adorned one of its covers with a life-size Minton majolica "blackamoor." The cover banner proclaimed "Majolica: Second coming for the great success of the nineteenth century." David Battie, the magazine's editor, wrote a glowing and enthusiastic article further publicizing majolica with four lavish, densely packed, polychromatic full- and half-page advertisements. American magazines published articles on the history of majolica, stories of how majolica collections were built, how homes were decorated with these humorous and ornate pieces, and how the careful collector could distinguish reproductions from originals. *Art & Antiques* magazine included articles on the one hundred best-known treasures or collectors each year. The March 1998 issue praised a monumental Minton wine cooler dated 1873, and the June 2000 magazine cover listed the name of a collector of majolica illustrated in the "Passionate Collectors" section.

In addition to the ongoing publication of books and articles about majolica, exhibitions continue to teach people a good deal about the subject, and museums in the United States and abroad, as well as tours of stately English country homes, offer rare opportunities to study and enjoy the ceramics at first hand.

One of the most interesting and unusual settings that house majolica is the Royal Dairy at Frogmore, on the grounds of Windsor Castle. (The Royal Dairy is not open to the public, but the Keeper of the Privy Purse may arrange visits by application to Buckingham Palace, London SW1A 1AA.) Built between 1858 and 1861, during the reign of Queen Victoria, and designed by Minton sculptor and architect John Thomas (1813-1862), the Dairy is 37 feet, 7 inches long and 23 feet wide. In their *Dictionary of Minton*, Paul Atterbury and Maureen Batkin write that, among other things, it was the commission for the Frogmore dairy that underlined Minton's royal associations.

Victoria's consort, Prince Albert, was a meticulous collaborator in the decoration of the Royal Dairy. J. C. Morton, chronicler of Prince Albert's farms, stated that "the designs were repeatedly altered under the direction of His Royal Highness." The prince stipulated that although the queen "wished to have an ornamental dairy, no beauty of ornament would compensate for want of everyday usefulness." The

dairy provided an area in which to produce and protect milk, cheese, and cream for the royal table. Forty Wedgwood cream pans sat on marble shelves to cool the milk. Stained glass windows decreased incoming daylight. Pierced majolica tiles on the ceilings below the roof brought in cool air. Cooling water flowed from John Thomas's Minton-made majolica fountains. Seven percent of the milk and cream produced by Jersey and Ayrshire herds were served to Queen Victoria and the royal family; the rest of the milk was sold. The dairy continued in operation until the late twentieth century.

Although the Royal Dairy does not serve its original purpose any longer, it was restored in 1997. Visitors of all kinds and collectors of majolica in particular can now see the gloriously colored Minton majolica statues and tiles. Monumental Minton majolica heron fountains grace each end of the building, and the air is still made cool by the running water. Fourteen majolica bas-relief brackets representing the four seasons stand guard between the windows, and in the center of the room a long work table supports a battery of perfectly aligned cream-colored milk jugs and cream pans. Elsewhere in the building intricate designs on majolica tiles designed by unknown modelers include medallion portraits of Queen Victoria and Prince Albert, as well as portrait heads of other members of the royal family. Another outstanding tile features a large relief of seasonal pastimes.

Minton's richly colored fountains (page 216) were the dairy's most dramatic examples of majolica, standing four feet high. The fountain at one end of the creamery was composed of a heron supporting a statue of Aphrodite, or a sea nymph; a similar Triton fountain stood at the other end. Each figure supported smaller shells above its head. Majolica enthusiasts may recognize figures here from Minton's St. George and the Dragon fountain at the Great Exhibition of 1862, which is not surprising since John Thomas also modeled them. Other examples of his fountains for the Royal Dairy became an architectural part of the base of the St. George fountain.

As one might imagine, museums in Britain house the greatest exhibitions of majolica. Among them are the Victoria and Albert Museum in London, the Minton Museum in Stoke-on-Trent, and the Wedgwood Museum in Barlaston. In France, the Tours Museum owns a major body of nineteenth-century Palissy ware, which it has exhibited and permitted to travel elsewhere.

In the United States, various exhibitions of majolica

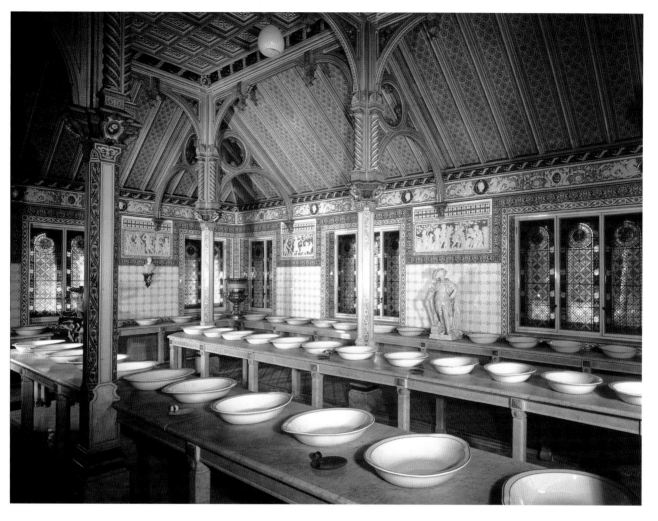

The Royal Dairy at Frogmore. Overall view. Minton & Co. Figurals and tiles. Photograph: The Royal Collection © Her Majesty Queen Elizabeth II. (Photo A.C. Cooper Ltd.)

The Royal Dairy at Frogmore. Minton & Co. Statuette in niche. Photograph: The Royal Collection © Her Majesty Queen Elizabeth II. (Photo A. C. Cooper Ltd.)

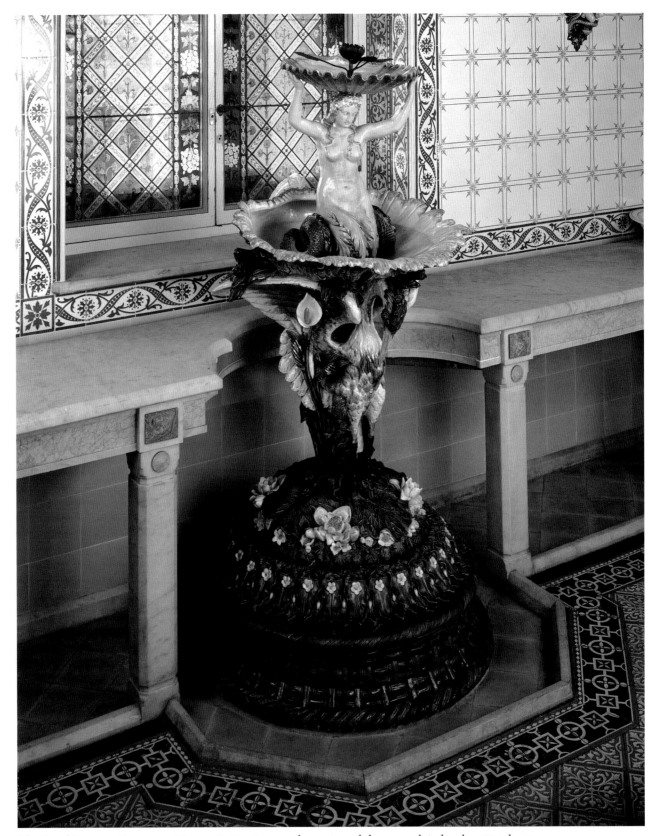

216

The Royal Dairy at Frogmore. Minton & Co. Ceramic fountain with heron and Aphrodite. Height 4'.
Photograph: The Royal Collection © Her Majesty Queen Elizabeth II. (Photo A. J. Cooper Ltd.)

have offered opportunities to museumgoers. The New Orleans Museum of Art shows the collection of English and Palissy majolica that it acquired from Brooke Hayward Duchin in 1997. The exhibition catalogue is appropriately titled "Grotesqueries: Form, Fantasy and Function in 19th Century European Ceramics." The Metropolitan Museum of Art in New York City displays sixteenth-century predecessors of majolica, such as Renaissance *maiolica*, sixteenth-century French pottery variously known as Saint-Porchaire, Henri Deux, or *faience d'Oiron*, along with Bernard Palissy pieces. The Metropolitan also shows a nineteenth-century Minton majolica centerpiece flanked by putti, and Minton tiles designed by Christopher Dresser and decorated with his familiar Japanese cranes. A pair of four-and-one-half-feet tall swan vases by Josiah Wedgwood & Sons highlights the display. The Lightner Museum in St. Augustine, Florida, has a special collection of majolica in the monumental French style. Smaller pieces are of Swedish and Continental derivation.

The world of majolica has continued to expand with the spread in use of the Internet. Members of the MIS, for example, have been invited to write articles about majolica for Internet antiques shows, and also to appear on the shows. Today, a collector can find extensive information on majolica at Web sites and in newsgroups, and can even acquire items by bidding at the eBay auction site. Independent dealers using the Internet list outstanding pieces of majolica under their own banners, encouraging purchases by showing beautiful digital photographs and full descriptions. Dealers also use the Web to notify collectors about future antiques shows, and Internet programs include appraisal advice. Collectors are encouraged to consult these programs about the value of pieces in their possession. Collector Café, a British Internet program, has published clear and informative descriptions of antiques and other collectibles. More than any other medium, the Internet has already proved to have the new capability to place a host of information at the collector's hand: locations and dates of antiques shows and the dealers who will exhibit; times and places of museum exhibitions, auction schedules, and various sources of useful information, including restoration. Virtually every search engine will reveal categories of majolica and related links. Clicking onto "Minton Majolica Cat," for example, can bring up reproductions of the Minton Cat-and-Mouse teapot and the upright figure of a Minton Gallé

cat, complete with prices. Search engines can also pull up catalogues of past auction sales and their prices.

Some questions are raised about material on majolica appearing on the Internet. For example, who owns the reproduction rights of objects that have appeared in auction catalogues: the auction house, the past or present owner of the piece of majolica, or the Internet site? It will be a matter of great interest to see how this issue plays out in the law. Will one be able, without infringing on someone's copyright, to reproduce an Internet-transmitted photograph of a piece of majolica for one's own use? It will be of particular interest to collectors whether the copyright law will distinguish between a photograph of a unique work of art, such as a painting, and copies of works such as a Minton garden seat, of which many identical (or near-identical) pieces exist. As a result of this current uncertainty in the law, auction houses have been reluctant to place their catalogue images on the Internet, a process that would then allow collectors and owners of the E-commerce programs to use images for other purposes. Further legal and judicial action may clarify some of these complex electronic reproduction rights issues.

The Majolica International Society (MIS), with its address as www.majolicasociety.com, has its own Web site. The MIS recommends reference books, publishes articles on majolica, and lists knowledgeable dealers known to the society. Informative articles from the quarterly MIS newsletter, "Majolica Matters," are repeated on the Web site, although some material is available only to members. The calendar of events keeps lengthening. The MIS Web site also lists museums with extensive majolica collections or exhibitions, auction houses that frequently sell majolica, and antiques newspapers that feature articles on the subject. There are also photographs of works for sale and owner-members sometimes list their need of a missing part, a lid for a teapot, for example. The Web site alerts the members and would-be members to the dates, location, and activities of the MIS annual three-day meeting. New members can download an application from the Web site, complete the information, send it (with a check) to the society's postal address, and thus be eligible to attend the meeting, where experienced dealers put on an exhibition and sale of thousands of pieces of Victorian majolica — the highlight of the meeting.

Given this increased interest in collecting majolica, the trends of the sales market seem steadily upward, despite the

abrupt declines in worldwide stock exchanges during the first half of 2001. In 1993, when a great upward curve in majolica prices, as well as in share values, became apparent, a monumental Minton cistern/wine cooler, estimated by Sotheby's (New York) at $12,000 to $18,000, was carried off by a bid of more than $50,000. During the following years, certain majolica shapes commanded noteworthy prices: oyster plates from Minton and George Jones increased from $400–500 to $1,500–$2,200, and even unmarked oyster plates could sell at $800. Garden seats made great increases: seats that were $1,500 could command ten times that price. In the first six months of 2001, even when worldwide stock prices were plummeting, auction houses witnessed record sales: at Sotheby's (London) the Minton majolica "Cat and Mouse" teapot sold for about £58,000 sterling ($100,000). A Minton beehive cheese bell, estimated at $15,000–$20,000, brought $46,200 at Michael Strawser's auction in Fort Wayne, Indiana.

Will the trend continue? It seems inevitable, almost certainly for the following reason. Harry Rinker, in the National Section of the June 18, 2001, issue of *AntiqueWeek*, considered that three factors determine the value of an antique — condition, scarcity, and desirability. According to his survey of buyers, the condition of a piece — assuming that it is not damaged in any way — figures less strongly in a collector's decision to purchase than the scarcity of the design. Desirability being a highly personal and subjective factor — difficult to measure — it thus appears that rarity is the single most influential consideration in collecting decisions. And with major pieces becoming more and more scarce, it seems that the upward trend of prices can be expected to continue.

In response to the greater interest in majolica, witnessed by the growing number of collectors and their increased desire to create more original collections, the second part of this chapter offers information about and photographs of majolica pieces that have rarely, if ever, been published. As you will see, the organization is by maker and, as always, the measurements given are of height followed by length or width.

ENGLISH MAJOLICA

Minton & Co.

In *Minton: The First Two Hundred Years of Design & Production* (Swan Hill Press, England, 1993), Joan Jones writes: "Majolica was a powerful ceramic. In some eyes it was grotesque, in others, beautiful. It has never failed to evoke a passionate reaction, whether enthusiasm or revulsion to its boldness."

In the rare example on page 219, left (Minton shape number 1025), the jardiniere with the Della Robbia-style wreath around its basin and three exquisite Renaissance maiden profiles, qualifies as a powerful piece. As with other Minton designs, there exists in the archives a sketch of a similar Renaissance jardiniere (shape no. 934), with the same triangular pedestal but with a basin surrounded by Renaissance heads and arches and a centerpiece of masks and swags.

The jardiniere on page 219, right (shape no. 1302), is more whimsical in its naturalistic design. A wreath of pond lilies encircles the rim of the bowl glazed in robin's-egg blue and emerald green. The bowl is raised above three egrets, which, in turn, are surrounded by cherubic "melusines" garlanded with pond lilies. A melusine, from the Greek word *melos*, or "limb," denotes the unusual double form of the more familiar single-tailed mermaid. The piece was made in 1871.

The two-tiered dolphin fountain on page 220 (shape no. 1207) stands 35 inches tall, with the dolphin itself surrounded by a daisy-and-trellis basin 23 inches wide. A similarly designed basin 13 inches wide balances at the end of the dolphin's tail. Minton created several pieces repeating the daisy-and-trellis design: a tall cupid (shape no. 860) supporting a similar pierced bowl (3 x 2 feet); another bowl (shape no. 971) supported by three garlanded cherubs (19 x 14 inches), and a reticulated bowl in the same pattern resting on a trio of gray fantailed pigeons (5 x 12 inches). A solid, imitation-wickerwork bowl edged in the same daisy-and-trellis pattern rests on oak branches (shape no. 1921).

On March 11, 1997, when Sotheby's New York conducted its first all-majolica auction, the cover of the auction catalogue was illustrated with a monumental Minton majolica cistern (shape no. 1261), dated 1873. The text describes a "lozenge-shaped tub molded on either side with a panel of mythological figures between panels of foliate scrolls glazed in turquoise-blue and shades of green, and applied at each end with a putto allegorical of either Summer or Autumn, both wearing wreaths and carrying bouquets of grapes or wheat and poppies, the bounty of their seasons." On each of the side panels are graceful female figures: young satyrs

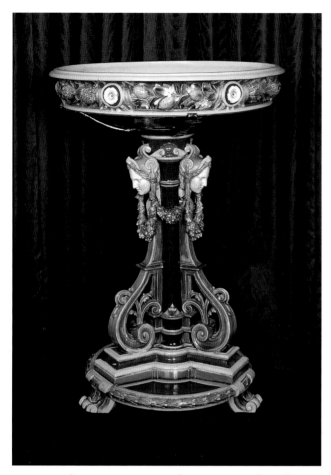

Minton and Co. Renaissance jardiniere. Triangular pillar with Della Robbia wreath. c. 1855. 41 x 28". (No. 1025)

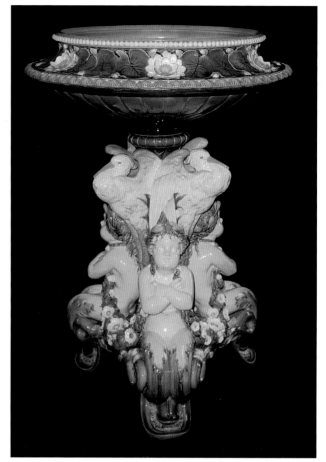

Minton & Co. Jardiniere with egrets and melusines. 1871. 34 x 24". (No. 1302)
(Photograph Charles Washburne)

besiege the one holding grapes; the other is comfortably ensconced with winged cherubs and dolphins.

Although the description of this piece is clear enough, its original use was not. In their *Dictionary*, Atterbury and Batkin make reference to the piece as a "large water container of flattish form," but similar large objects in the Minton shape book were usually referred to as wine coolers. Sotheby's catalogue also cites Joan Jones' comment (in her Minton book) on an article from the London *Art Journal* of 1871 that refers to the Sotheby piece as a wine cooler, despite its having a Minton number in the range of cistern shapes. Jones further cites the grapes pictured on the side panels as evidence relating the piece to the consumption of wine. It seems difficult to disagree.

There is also a source of disagreement as to the function of a Minton & Co. stand in a leaf-and-fern motif with woven vines in the Palissy style. Although this piece has been con-

sidered to be an oyster stand by many collectors, dealers, and ceramics historians, Joan Jones has it listed as an "Ice Stand, Two Tier in Leafy Form" among the Minton ornamental shapes in her Minton book. In support of her designation is the fact that both the traditional four-tiered and the five-tiered Minton oyster stands display clearly modeled oyster shells and crossed-fish finials. By contrast, the well-known Minton ice stand pictured on page 53 of this volume, and the Palissy-style ice stand show no oyster shells and have a shallow surface on the top of the piece, rather than the crossed-fish finial. Again Jones seems correct, but whatever one calls these pieces they are superbly made.

As is common in nineteenth-century decorative arts, mythological figures decorate many Minton objects. On a cobalt urn Diana, goddess of hunting, stands accompanied by her two hounds on one side of the urn with a bacchante flanked by two panthers on the reverse. Diana, the moon

219

Minton & Co. Fountain,
two-tier, daisy-and-trellis
embossed, dolphin support.
c. 1865. 35 x 23".
(No. 1207)

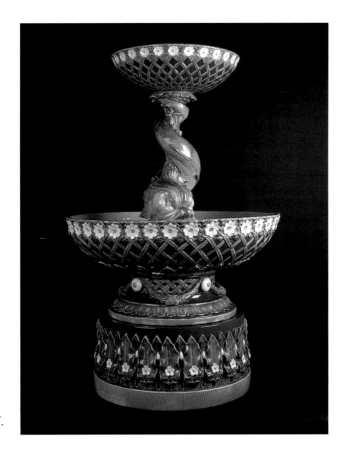

Minton & Co. Cistern or
wine cooler. c. 1873. 37½".
(No. 1261)

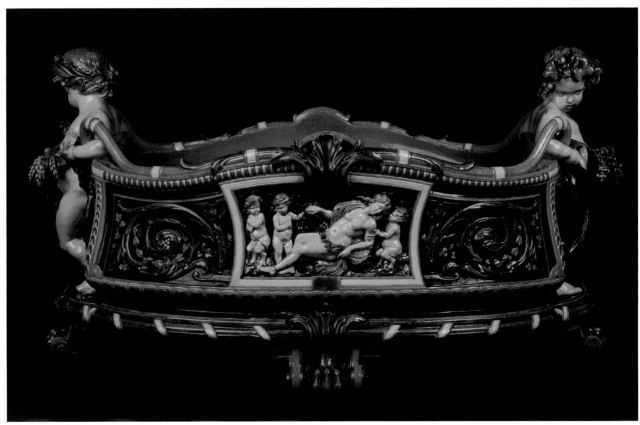

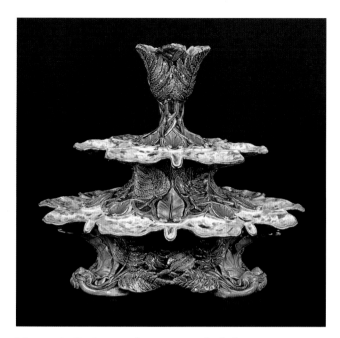

Minton & Co. Ice stand, two-tier, in leafy form. 1863.
Height 14″. (No. 684)

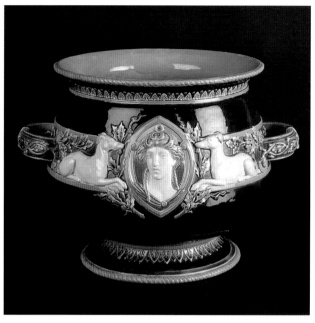

Minton & Co. Urn with mythological figures, hounds, and
panthers. c. 1865. 12 x 18″.

Minton & Co. Chrysanthemum téte-à-téte. c. 1867, 1868. Tray: diameter 15″. Teapot: height 5″.
Sugar bowl and creamer: height 4″. Cups: height 2¼″. Creamer in different pattern. (All marked No. 1349)

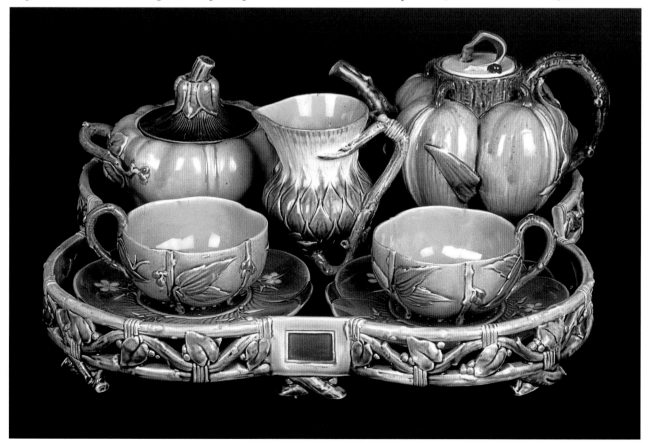

221

goddess and protector of women, seems here to form a contrast with the bacchantes, those women who shared the dissolute libations of Bacchus (also known as Libus). The artist of this piece and its intended use remain unknown.

More than a dozen teapots of humorous and whimsical design, a Minton specialty, appear in the company's repertoire. Very desirable today are the Cat and Mouse teapot, the Vulture and Snake teapot, the Fish teapot, and the most familiar Monkey teapot. All are highly valued by collectors. Among Minton's production, full-service tea sets were scarce, and tea services for two, called téte-à-tétes, were extremely rare. The Minton Chrysanthemum téte-à-tête reproduced here (page 221) is a beautiful example in the Oriental mode. The quatrefoil reticulated leafy tray is fifteen inches in diameter. Two sets of cups and saucers two and a quarter inches high are decorated with leaves resembling those on the tray gallery. The four-inch teapot and the similarly sized sugar bowl are modeled as lychee fruit in the Aesthetic style. The four-inch creamer is in a green, white, and gold pattern. All pieces are marked with the same shape number, 1349, which indicates that the creamer belongs to the set although it is of a different color and design. The date cipher on the tray indicates 1867; other pieces bear the cipher for 1868.

In 1993, Minton & Co. celebrated the firm's two-hundredth anniversary with some new releases of old patterns, choosing Minton majolica teapots as the commemorative design. Each year since then, Minton has reproduced one of its majolica teapots as a limited, numbered edition in fine bone china. Design examples include the Monkey, the Chinaman, the Fish, the Cat and Mouse, the Tortoise, and the Rooster. The Vulture and the Snake appeared in 2001, in an edition of approximately 2,500. The text on the undersurface of each piece includes the number of each reproduction within the edition. Another series of Minton majolica reproductions was scheduled for the one-hundred-fiftieth commemoration in 2001 of the Great Exhibition of 1851. These earthenware miniatures, ranging in size from four to six inches, represent the Minton Peacock, the Stork and the Heron, and the Monkey Garden Seat. Two other pieces were scheduled to appear in 2002: a miniature of the Minton Fawn and a copy of the Minton Cockerel in the same size as the cockerel created by John Henk.

Josiah Wedgwood & Sons

Among the largest pieces of majolica produced by Wedgwood are two swan vases (page 223) on exhibition at The Metropolitan Museum of Art in New York. Made in 1876 and 1883, the vases are also the largest examples of majolica at the museum. Both swans are fifty-four inches high, including a sixteen-inch plinth, and are shapes 93 in the Wedgwood pattern book. They had been displayed at Harrods department store in London in 1973, and in 1995 were given to the museum by collectors Gyora and Judith S. Novak, in honor of David T. Siegel.

A swan vase similar to these two, with a putto as the finial, was painted for Wedgwood by Emile Lessore and shown at the 1878 Paris exhibition. The Metropolitan Museum's *Bulletin* of winter 1998–99 notes that the "designer of these swan vases is not recorded, but the French sculptor Albert-Ernest Carrier-Belleuse has been proposed." Another monumental majolica swan vase (56 x 22 inches) produced by Wedgwood in 1875–76 is in the Art Gallery of South Australia, in Adelaide. A museum book, *Treasures from the Art Gallery of South Australia 1998*, notes that the vase, "hand painted and magnificently gilded . . . forms part of the initial purchases made by the gallery in 1904 to develop a decorative arts collection." The painted body of the vase shows scenes of the capture of Samson on blue monochrome. It is inscribed "Delilah enticed Samson and he was overcome," thus reminding some viewers of the Minton Prometheus Vase (*see* page 40) with its various battle scenes. Among other major Minton majolica pieces related to Australia were three Minton peacocks. The first was an 1878 example, famous for having survived a shipwreck by floating safely in its container to the Australian shore. After belonging to several private owners and appearing in a 1930s display at the National Museum of Victoria, the peacock was ultimately sold to the Flagstaff Hill Memorial Village at Warrnambool, Australia. The second peacock appeared at the 1880 Melbourne International Exhibition and remained in Melbourne until 1939, when it was sold for £2,500 and exported to Bombay, India. In 1954, it was transported back to Australia and offered for sale to the Minton Museum by a firm of Sydney solicitors who mistakenly believed that this peacock was the one that had been shipwrecked. The sale did not go through, but in 1983 the peacock found its present home with collectors in New York State. The third peacock was purchased at Sotheby's in London in 1984 by the Museum of Applied Arts and Sciences and given to the Power House Museum in Sydney.

Josiah Wedgwood & Sons. Swan Vase, 1883. Height 54″.
(No. 93) Courtesy The Metropolitan Museum of Art,
New York

Josiah Wedgwood & Sons. Swan Vase, painted
by Thomas Allen. 1875–1876. Height 56″.
Courtesy of the Art Gallery of South Australia, Adelaide

George Jones & Sons

In March 1873 the *Staffordshire Advertiser*, cited by Robert Cluett in *George Jones Ceramics: 1861-1951*, noted that "Mr. George Jones of Trent Potteries, Stoke-on-Trent, is preparing a considerable number of articles in majolica and earthenware. His efforts have in a great degree been devoted to the former." Jones was, indeed, one of the fountainheads of majolica design and one of his most elegant jardinieres (right) is now the icon of the Majolica International Society. Decorated with saffron-beaked birds flying over English snowdrops and yellow daffodils, the jardiniere's turquoise body rests on beautifully modeled padded feet of thick curled leaves. Registered in 1876, its pattern number is 3499. A smaller example also exists.

Other distinguished pieces produced by Jones include two moon flasks (page 225) each showing a beautiful young woman, one portraying love and the other, self-love. The flasks are not marked, but a moon flask of similar shape and imagery indicates that the pieces are by George Jones & Sons. Confirmation of this is an illustration in Llewellynn Jewitt's *Ceramic Art of Great Britain, 1883*, and included in the present volume on page 90. Produced in about 1873, the flasks are 15 x 10 inches in size. Their romantic designs, set into glazes of turquoise and yellow, may have been rendered by George Jones or by his oldest son, Frank Ralph Jones, both accomplished and recognized painters who exhibited at the Royal Birmingham Society of Artists. (For an example of the younger Jones's work see the majolica plaque initialed FRJ, on page 71 of Cluett's *George Jones Ceramics*.)

The two water coolers on page 225 were made by George Jones and Joseph Holdcroft, both of whom trained in majolica at Minton & Co. Water coolers were rarely produced in majolica. Neither of these is marked by date. Roses and foliage decorate the George Jones coolers. The Holdcroft cooler bears a simple decoration of leaves.

Joseph Holdcroft

It has been noted that Holdcroft produced majolica that resembled other artists' works. This was accomplished either by copying their designs or by glazing "blanks" obtained from other factories. Although other factories produced inkwells of various kinds, including those with birds, the Holdcroft inkwell on page 226, with bluebirds on either end of a pen tray of leaves, is one of the artist's most original pieces. Its distinction lies in glazing, color, and modeling.

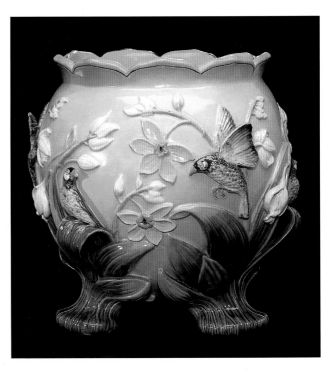

George Jones & Sons. Jardiniere. 1876. Height 13". (No. 3499) (Photograph Christie's, New York)

Here, the birds' heads protect the inkwells. The piece is marked J. Holdcroft and was produced in about 1875.

Thomas Forester & Sons

Sanded majolica, produced by the so-called barbotine method, has been an art form of Poland and England. (See page 109 of this volume.) Atterbury and Batkin explain that barbotine is the technique of painting on earthenware. Various artists, including Emile Lessore and Edward Rischgitz, brought the method to England during the late 1850s. There, Thomas Forester produced the best of "à la Barbotine," similar to nineteenth-century French majolica decorated with raised flowers made of clay or slip. In Forester's majolica centerpiece (page 226) raised flowers are carried forward by sanding floral ornaments on a rough-textured background. This example was made in about 1883.

S. Fielding & Co.

The pitcher by Fielding on page 226 was most likely designed as a birthday gift for a child, with a "Bo Peep" on one side and a milkmaid on the reverse. One can speculate that the artist may have first sketched the images for a young girl and later employed them on ceramics. The textured

George Jones & Sons. Moon flasks.
c. 1873. Height 15".

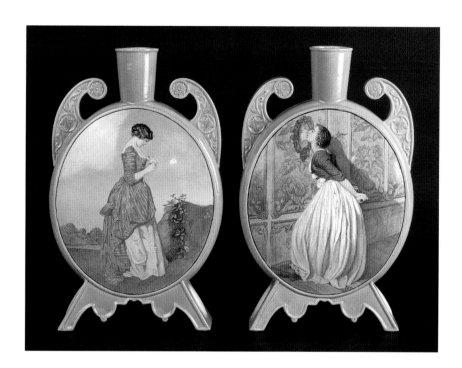

Below left: George Jones & Sons.
Water cooler. c.1875. Height 16".

Below right: Joseph Holdcroft.
Water cooler. c.1880. Height 23".

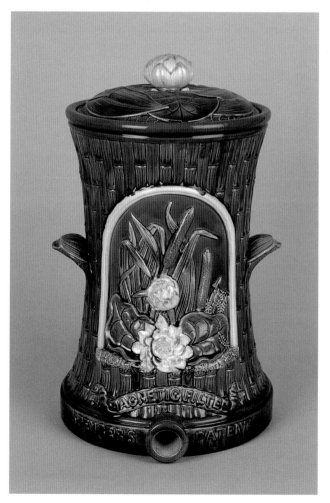

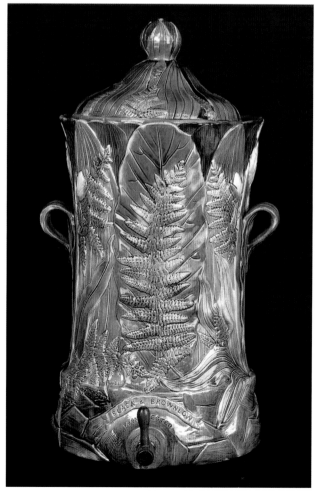

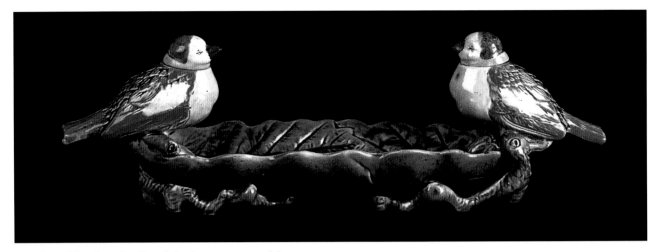

Joseph Holdcroft. Inkwell with birds. c. 1875. Width 13″

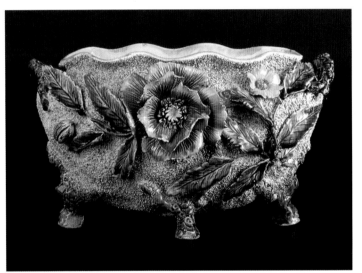

Thomas Forester & Sons. Sanded majolica centerpiece. c. 1883. Height 7″ and width 12″

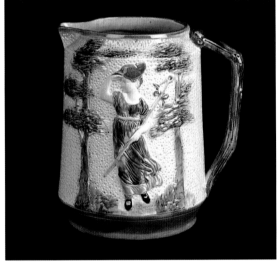

S. Fielding & Co. Pitcher. c. 1883. Height 8″

background design resembles the plaited backgrounds of some of Kate Greenaway's storybook illustrations as well as the Wedgwood Argenta pieces of the early 1880s, rather than the traditional images that appeared on majolica. The piece was designed in about 1883.

T.C. Brown-Westhead, Moore & Co.

The animal-design talents of Joseph Brown and the sculptural capabilities of a certain Mr. Marshall of the London Zoological Gardens (see page 124 of this volume) combined to provide T.C. Brown-Westhead, Moore & Co. with a series of almost life-size animals that were added to its more commercial products. On page 227, a naturalistic tiger twen-

ty-seven inches high and forty-three inches across rests on rocks and a tree trunk.

An animal also figures prominently in a dining table centerpiece composed of a neoclassical maiden embracing a young doe, resting on a base of lily pads and rocks. There is no mark or date on the undersurface. The piece is thought to be the representation of a poem written in 1807 by William Wordsworth, "The White Doe of Rylstone." The legend of the nearly two-thousand-line-long poem tells of a Catholic family living in North Yorkshire and loyal to Mary, Queen of Scots. The father and all his sons have been slain in the struggle against Queen Elizabeth. Only a daughter, Emily, survives. In the poem, Emily is represented as a Protestant who

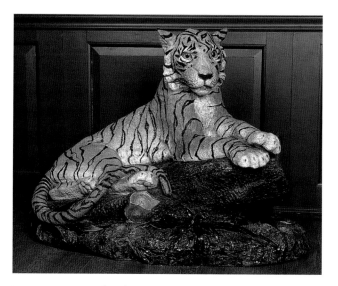

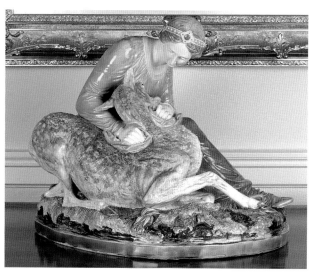

T. C. Brown-Westhead, Moore & Co. Tiger. c. 1875. Height 27″ and width 43″.

T. C. Brown-Westhead, Moore & Co. Neoclassical Maiden and Doe. c. 1875. Height 22″ and width 30″.

does not support either side. In her loneliness, Emily is comforted by memories of the past, and by the recurrent apparition of a white doe that she reared as a fawn. However, "Distress and desolation spread" and "At length, thus faintly, faintly tied/ To earth, she was set free and died."

CONTINENTAL MAJOLICA

When this book was first published, a great friend of the authors and their editorial advisor, the distinguished magazine editor Leo Lerman, celebrated its appearance in a droll article in *House and Garden* with a telegraphic caption that he wrote to accompany a photograph of the piece on page 228: "Victorians adored the anthropomorphic. A somewhat rowdy avian gentleman, seriously bespectacled, his frock coat fashioned of green feathers. A battered stovepipe hat stoppers this beak-spouted liqueur bottle, hatched on the Continent, c. 1880." The mark "2610" accompanies a foliate design impressed with M/K.

Bohemia

Marked "Royal Dux," the whimsical design of the umbrella stand on page 228 combines a sunflower and a well-stuffed proud turkey. It is a product of Duxer Porzellan-Manufaktur A.G. According to D. Michael Murray, in his book *European Majolica*, Eduard Eichler first opened in 1860 a porcelain

factory, casually known as Dux, in the city of Duchcov, in Bavaria. By 1898, Eichler expanded the production of the factory to include majolica. Pieces like the umbrella stand were produced there between 1898 and 1910, primarily in the Art Nouveau style. Collectors recognize Royal Dux by the originality of its modeling and glaze.

French and Portuguese Palissy Ware

During the nineteenth century, independent artists working in Paris and Tours became known for producing Palissy-style ceramics, but other manufacturers in France also produced similarly styled objects. The names most familiar to majolica collectors are: Choisy-le-Roi, Sarreguemines, Fives-Lille, Longchamp, Luneville, and St.-Clément. For some time now contemporary owners have responded to the fantastic pieces made by these artists, the gigantic sizes of some platters and chargers, and the rich glazes and textures. Anyone interested in Palissy can enjoy both the realistic designs and the bizarre whimsy of these pieces. Examples of French Palissy ware shown here on page 229 are: a candlestick, a mussel or oyster plate, and a creamer. All are unmarked.

In Portugal, during the early- to mid-nineteenth century years, ceramists produced wares that resembled the blue, green, and brown pieces of French Palissy and were based on those earlier French models. As the second half of the

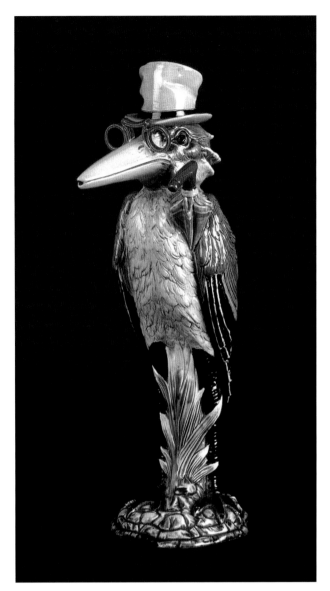

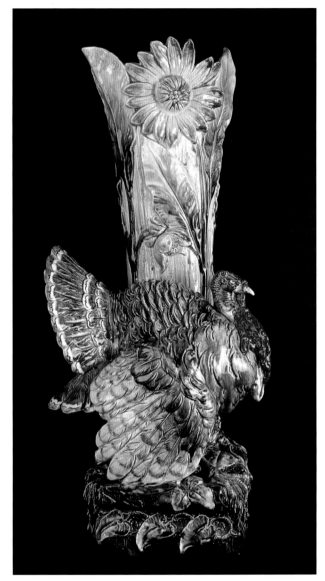

Continental majolica. Avian gentleman liqueur bottle.
c. 1880. Height 15″. Mark 2610 with shield design
impressed M/K

Bohemia. Duxer Porzellan-Manufaktur A. G.
(Royal Dux) Umbrella stand. c. 1900. Height 28 ¾″
Mark: ROYAL DUX

nineteenth century progressed, however, Portuguese ceramic artists added oranges, yellows, and whites to their palettes. The construction of these pieces was sharper and in high relief, with three-dimensional scenes of reptiles, fish, flora, and fauna increasing their dramatic effects. Portuguese examples shown here on pages 213 and 230 include a charger and an ink stand, both signed by Thomas-Victor Sergent. Other Portuguese pieces (page 230) include a plate with three fish and clams, signed by Manuel Mafra; a plate with three fish, impressed F. Gomes D'Avellar, Caldas Da

Rainha; and a plate with three frogs, impressed Mafra, Caldas, Portugal.

THE FUTURE OF MAJOLICA

Some seven years before the first edition of this book appeared in 1989, the Cooper-Hewitt Museum, under the direction of David McFadden, held the first exhibition of Victorian majolica in the United States. In the *New York*

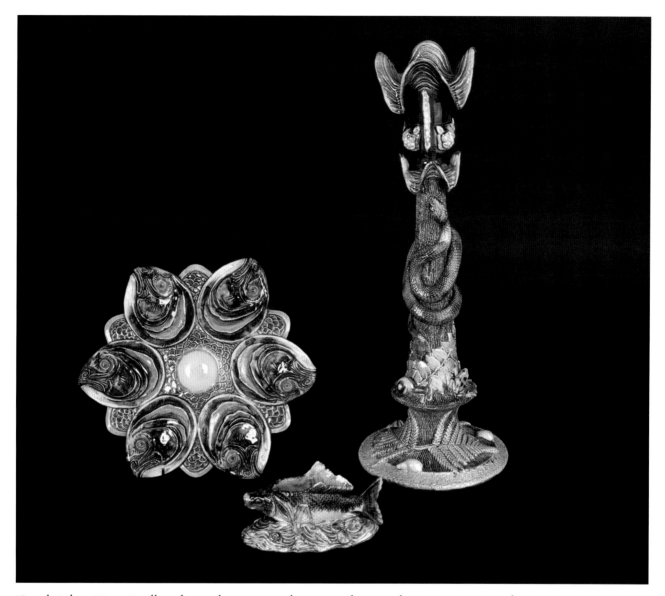

French Palissy Ware. Candlestick. Height 17″. Mussel or oyster plate. Height 10″. Creamer. Height 5″.

Times, Rita Reif exclaimed "Majolica Makes a Bold Comeback," and Lita Solis-Cohen announced in the *Maine Antiques Digest* that the "Majolica Market Heats Up." As we have seen, both writers were more than correct.

Among the pieces of majolica photographed for this new edition, most were unknown when the book was first published. There have been delightful new discoveries; for example, the Wedgwood swan vase at the Metropolitan Museum in New York City and another Wedgwood swan vase at the Art Gallery of South Australia in Adelaide.

Indicative of the new international interest in majolica and the new medium for the exchange of information, the Internet, is that word of the Australian swan came to light through the cooperation of a collector in New York, a dealer in Sydney, a curator in Victoria, and a museum officer in Adelaide. E-mail was the mechanism for this reconstruction of the history of a 125-year-old piece.

The geography of majolica is surely changing. Until recently, dealers from New England to Florida comprised the major part of the United States market. Now, the Great

229

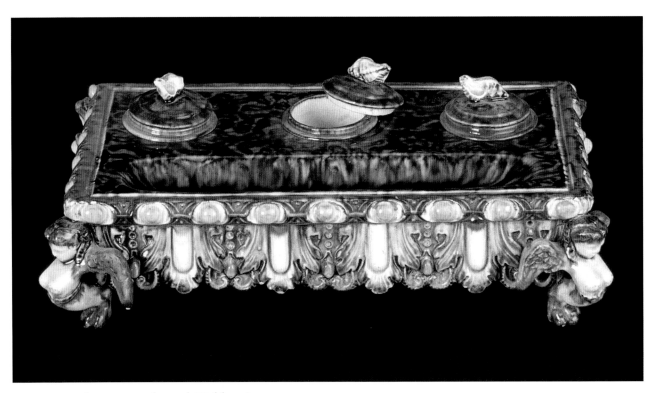

Portuguese Palissy Ware. Ink stand: Width 10″.
By Thomas-Victor Sergent.

Portuguese Palissy Ware.
Plate with three fish and clams.
Signed by Manuel Mafra. Diameter 8″.
Plate with three frogs. Impressed Mafra, Caldas,
Portugal. Diameter 7″.
Plate with three fish. Impressed F. Gomes D'Avellar,
Caldas Da Rainha. Diameter 8″

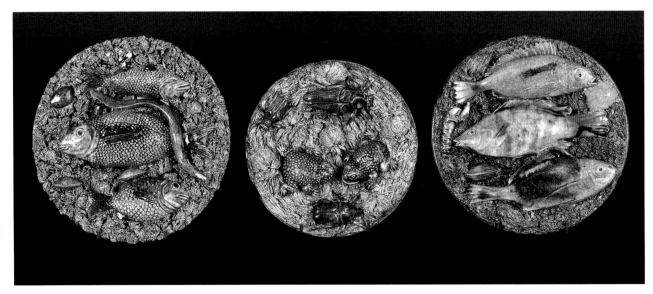

Lakes areas, Texas, and California are well represented. American dealers and collectors interact regularly at antiques shows across the U.S. and abroad with Australian, English, Canadian, and French dealers. A global pool of information has been formed. In 1999, the curator of decorative arts at the White House, in Washington, D.C., made a request for information from the Majolica International Society to identify what turned out to be English and French majolica in the White House collection.

In addition to large-scale national exhibitions, regional gatherings now attract much attention. The Majolica International Society has contributed to this trend by spreading out its annual meetings from New England and Pennsylvania to Delaware, Georgia, and Texas. Regional MIS meetings have been held in Oklahoma, New York, and California. Museums in New York, St. Augustine, and New Orleans have contributed knowledge to the majolica world. Ceramics historians and curators have conducted lectures and seminars on majolica at prominent auction houses. Recognizing the spread of interest in majolica, newspaper and magazine editors regularly keep collectors informed, and the Internet serves as a valuable medium of contact.

What else may happen during this millennium? Professor Peter Rose, the Victorian ceramics scholar, wrote the following observations to the authors: "Majolica's great strength is in its popularity. Collectors who are not afraid of being patronized by the ceramics traditionalists proclaim their enthusiasm. To recognize majolica fully, there is a need to bring in the social and historical context of nineteenth century majolica much more boldly, demonstrating just how strongly it lies within the mainstream of Victorian taste. Majolica collectors and writers must not concentrate exclusively on the technical and historical minutiae in their field. They must always look outward, making links with earlier as well as contemporary examples, crossing boundaries into other fields, applying concepts rather than technical rules in identification, and understanding the product being surveyed. Collectors must conquer the traditional bastions of conventional taste."

He ended his remarks with the admonition that we must "always continue to collect." To which we all agree. As for the cost of doing so in this millennium, only time will tell.

MARKS ON MAJOLICA

Although many pieces of majolica are not marked, many others are fully documented with names of manufacturers, British registry marks, date codes, and potters' marks. The following marks have been drawn from actual pieces of majolica and may also include symbols that are not as yet identified.

British Registry Mark

A diamond-shaped registration mark on a piece of ceramics indicates that it was registered at the British Patent Office between 1842 and 1883 and signals the year in which the shape or the decoration, or both, were registered. Patents of this kind were in force for only three years, and despite them pieces were imitated. Patent Office records for each mark include the date of registration, a description of the shape and design, and the maker's name and address. From 1842 through 1867 the letter signifying the year appears at the top of the diamond (under the circled Roman numeral IV for the class of the ware, ceramics); from 1868 through 1883 the year letter appears at the right side of the diamond. In the other three corners of the diamond were a capital letter for the month, an Arabic numeral for the day, and an Arabic numeral for the

"parcel" (which was keyed to the registration entry). The diagrams of sample registry marks given below indicate the relative positions of the code numbers and letters for each sequence: 1842–67 and 1868–83.

Index to letters for each year
from 1842 through 1867:

1842	X	1851	P	1860	Z
1843	H	1852	D	1861	R
1844	C	1853	Y	1862	O
1845	A	1854	J	1863	G
1846	I	1855	E	1864	N
1847	F	1856	L	1865	W
1848	U	1857	K	1866	Q
1849	S	1858	B	1867	T
1850	V	1859	M		

Index to letters for each year
from 1868 through 1883:

1868	X	1874	U	1880	J
1869	H	1875	S	1881	E
1870	C	1876	V	1882	L
1871	A	1877	P	1883	K
1872	I	1878	D		
1873	F	1879	Y		

Index to letters for the months
(1842 through 1883):

Jan.	C	May	E	Sept.	D
Feb.	G	June	M	Oct.	B
Mar.	W	July	I	Nov.	K
April	H	Aug.	R	Dec.	A

There were several errors in the dating code. In the first sequence the letter R, indicating August, was inadvertently used for September 1 to 19 in 1857. The letter K, indicating November, was used for December in 1860. An error between March 1 and March 6, 1878, resulted in the letter W being employed to indicate the year, instead of the letter D.

To determine whether or not the registry mark indicates the first or second sequence (1842–1867 or 1868–1883) the reader should consult the space below the Roman numeral at the top of the registry mark. If the space contains a letter, the registry mark is in the first sequence; if the space contains a number, the registry mark is in the second sequence.

Sample diagrams of the dating code for registry marks from 1842 through 1883:

April 7, 1859

Day — Class
Parcel No. — Year
— Month

June 17, 1883

From 1884 through 1909 a simpler system of dating registrations was instituted. Each design was given an individual registration number (preceded by "Rd. No."), which was impressed, painted, or molded on the undersurface. The table below indicates the registration number that had been reached by January of each year.

Rd. No.	1	1884
Rd. No.	19754	1885
Rd. No.	40480	1886
Rd. No.	64520	1887
Rd. No.	90483	1888
Rd. No.	116648	1889
Rd. No.	141275	1890
Rd. No.	163767	1891
Rd. No.	185713	1892
Rd. No.	205240	1893
Rd. No.	224720	1894
Rd. No.	246975	1895
Rd. No.	268392	1896
Rd. No.	291241	1897
Rd. No.	311658	1898
Rd. No.	331707	1899
Rd. No.	351202	1900
Rd. No.	368154	1901
Rd. No.	385500	1902
Rd. No.	402500	1903
Rd. No.	420000	1904
Rd. No.	447000	1905
Rd. No.	471000	1906
Rd. No.	494000	1907
Rd. No.	519500	1908
Rd. No.	550000	1909

Marks of factories that produced majolica in England and Scotland.

Minton & Co. Impressed mark indicates factory, date code symbol for 1867, ornamental shape number, and letters which may indicate artisan's marks.

Minton & Co. Monogram "H. P.", Hugues Protât, impressed.

H. PROTAT

Minton & Co. "H. Protât,", incised.

JHenk

Minton & Co. "J. Henk", John Henk, incised.

WEDGWOOD

Josiah Wedgwood & Sons. Impressed mark indicates factory; British registry mark for June 6, 1867 (first sequence); "OGY" impressed, for the production date of October, 1870; pattern number 674; and "B", the artisan's mark. "FBR", impressed monogram of artist Frederick Bret Russel.

George Jones & Sons. "GJ" in monogram, impressed, used from 1861–December 1873. Note Minton date code symbol for 1873; significance of its presence not clear. Pattern number 3371 in black paint in thumb mark.

George Jones & Sons. "GJ" impressed in monogram, placed between horns of crescent inscribed with impressed "And Sons", used from December 1873.

George Jones & Sons. Raised, irregular seal (or pad) with "GJ" in monogram, pattern number, and the words "STOKE ON TRENT".

George Jones & Sons. "STONE CHINA" and "STOKE ON TRENT" surrounding "GJ."

Joseph Holdcroft. "JH" in monogram, impressed and encircled.

233

J HOLDCROFT

Joseph Holdcroft. "J. HOLDCROFT" impressed.

Samuel Lear. "LEAR", impressed.

LEAR

Samuel Lear. "LEAR", incised.

FIELDING

S. Fielding & Co. "FIELDING", impressed or "S. FIELDING", impressed.

Worcester Royal Porcelain Co., Ltd. Impressed mark. From 1867 to 1889 the year of manufacture was indicated by a letter printed under the factory mark. (See table in Cushion, p. 117).

W. T. Copeland & Sons. "COPELAND" impressed; British registry mark; gill measurement.

234

W. T. Copeland & Sons. Mark designed for Tricorne vase of 1876.

Wm. Brownfield & Sons. "Double-globe" mark, raised, in use from 1871–1891. "ASTON" may refer to Jabez Aston, a ceramic artist who worked c. 1875.

Brownhills Pottery Co. "B.P.C." printed in black ink refers to the factory; "HERON" is the pattern name.

Prestonpans Pottery. The mark of the owner was impressed on a ribbon or encircled by an oval.

Victoria Pottery Co. The monogram of the firm is impressed and enclosed by a triangle of two swords and a straight line.

SANDFORD POTTERY

Sandford Pottery. The name of the firm is modeled on two raised pads.

J. Roth. The initials of the firm, above the letter "L", may signify the firm J. Roth of London, as included in the British registry lists from 1879 to 1882.

MANUFACTURED ON THE ESTATE OF THE EARL OF MARQ KELLIE
W. & J.A. BAILEY
ALLOA

Alloa. A firm in Alloa, Scotland owned by W. and J. A. Bailey whose mark here was made for a special design.

T.C. BROWN-WESTHEAD
MOORE & CO.

T. C. Brown-Westhead, Moore & Co. The name of the firm is impressed in two parallel lines.

Marks of factories that produced American majolica

Edwin Bennett Pottery. The firm's trademark, printed on black paint, includes the patent date.

N.1 ETRUSCAN

Griffen, Smith and Hill. The marks include the firm's monogram (GSH) impressed; replaced in 1880 by the words ETRUSCAN MAJOLICA encircling the monogram. "ETRUSCAN" was sometimes used in a straight line, impressed. Letter and numbers indicated shapes and patterns; other numbers indicated the decorator.

Tenuous Majolica. The name of the firm encircled or was placed above and below the letter "H," for Harrison's Pottery.

George Morley & Co. The firm's marks, in black paint, indicated the location of the factory (Wellsville 1879–1884 and East Liverpool 1884–1891).

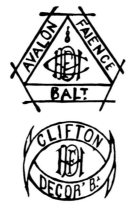

Chesapeake Pottery Co. The firm's monogram "DFH" is surrounded by intersecting crescents or straight lines. The marks include the pattern name and the firm's location.

TRADE
"LETTUCE LEAF"
MARK.

New Milford Pottery Company and Wannopee Pottery Company. The Wannopee Pottery Company "W" incised is surrounded by a stylized sunburst. A "Lettuce Leaf" successor, bears "Lettuce Leaf" as the trade mark for the George Bowman Company in Trenton, New Jersey.

Eureka Pottery Co. The name of the firm is impressed in an arc above its place of origin.

Marks of factories that produced Continental majolica

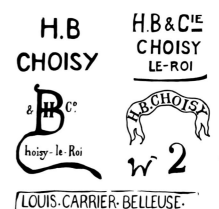

Choisy-le-Roi. Examples of the different marks of the firm printed in black ink. Designs incorporate the initials of the owner, Hippolyte Boulanger. The name of the modeler, Louis Carrier-Belleuse, is incised on the Choisy roosters, which he created.

SARREGUEMINES

Sarreguemines. The firm's name, impressed in block letters, is frequently accompanied by the word MAJOLICA.

DEPOSE
K ET G
LUNEVILLE

Lunéville. The firm's name and DEPOSE, the mark of patent registration, are impressed.

Saint Clément. There are many variations of the firm's mark, spelled out and frequently accompanied by K and G for Keller and Guerin. The example above is specifically for Emile Gallé's work (G), together with the firm's initials.

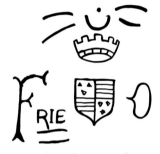

Onnaing. The schematic rebus indicates "F(aience)rie (d') O(nnaing)" raised or in black ink.

Wilhelm Schiller and Sons, represented by black letters of the monogram or by a raised plaque with the firm's letters.

Villeroy & Boch marks on majolica
a. Septfontaines
b. Mettlach
c. Schramberg

Mafra and Son. M. MAFRA appears above an anchor with CALDAS PORTUGAL below.

French artists
a. Signature of Charles-Jean Avisseau of the School of Tours.
b. Monogram of Joseph Landais.
c. Mark of Georges Pull.
d. C. H. Menard, represented by a heart-shaped design.

Delphin MASSIER. Vallauris. (A.M.)

Jérôme Massier
Vallauris

Clement-Massier

The Massier family signatures.
a. Jérôme
b. Delphin
c. Clément

GLOSSARY

AGATE WARE Pottery made to simulate the veining of agate stone by combining clays of different colors for the body (solid agate) or slips of different colors on the surface (surface agate).

AJOURÉ (Fr.) Pierced or perforated metalwork; also used to describe ceramic wares with openwork decoration, especially plate rims.

ALBARELLO (PL. *ALBARELLI*) (It.) Cylindrical dry-drug pot, with slightly concave sides, that originated in 12th-century Persia. Made in 15th-century Spain by Hispano–Moresque potters, in Renaissance Italy, and then throughout Europe into the 17th century. Revived as ornamental ware in the 19th century.

ALHAMBRA VASE Large Hispano–Moresque lustered earthenware vase tapered at the bottom, with wing-shaped vertical handles; decorated with Islamic calligraphy and foliage in cobalt blue and luster. The name derives from an example (c. 1400) at the Alhambra in Granada.

ARGENTA WARE A type of Wedgwood majolica produced after 1878. Designs, often naturalistic, were painted in colorful majolica glazes against distinctive white or other pale backgrounds. (Some of the same designs were also used on a cobalt or turquoise ground.)

AZULEJOS (Sp. and Port.) Tiles, frequently decorated in blue (*azul*). In English usage the term refers to large panels of tiles on exterior or interior walls.

BALL CLAY Potter's clay from Devon and Dorset, England; also found in the United States and on the Continent. So named because the clay was cut into 30-lb. balls. Before firing, usually gray, blue, or almost black, but nearly white after firing. Also called blue clay.

BARBOTINE (Fr.) Colored liquid slip applied by piping or trailing for raised decorations, first used on Rhenish pottery before A.D. 300. In France designates 19th-century French majolica with or without raised flowers made of slip. The term also refers to such flowers on English and American majolica.

BASALT (OR BLACK BASALT OR BASALTES) A hard, fine-grained, unglazed black stoneware perfected by Josiah Wedgwood c. 1768. (See Egyptian black.)

BAT A round sheet of clay made by flattening ball clay for molding or shaping flat and hollow wares. (See ball clay, jigger, jolly, spreader.)

BEEHIVE KILN (See bottle kiln.)

BELLEEK Delicate, translucent porcelain with a lustrous nacreous glaze. Chiefly made in Ireland, beginning in 1863; also produced in the United States in 1882 by Ott and Brewer of Trenton, N.J.

BERETTINO (It.) Lavender-blue (or dark blue) tin-glazed background on Italian Renaissance *maiolica*. Introduced c. 1520 in Faenza. (See *bianco sopra azzurro*; cf. *bianco sopra bianco*.)

BIANCO SOPRA AZZURRO (It.) Decoration in opaque white on a lavender-blue tin-glazed background on Italian Renaissance *maiolica*. (See *berettino*.)

BIANCO SOPRA BIANCO (It.) Decoration in opaque white on a faintly bluish or grayish tin-glazed ground. Used on Italian Renaissance *maiolica*.

BISCUIT Unglazed earthenware or porcelain that has been fired once and is ready for glazing. Some earthenware was left unglazed. (See Parian ware.)

BISCUIT FIRING First firing of raw, unglazed ceramic ware. For majolica, at 1000°C to 1150°C.

BLANC DE CHINE (Fr.) Highly translucent white Chinese porcelain, frequently decorated in relief; imitated in France and England.

BLOCK MOLD Plaster-of-paris mold for casting hollow ware. (See plaster of paris, slip casting.)

BLUE CLAY (See ball clay.)

BLUE-DASH Modern term for a decorative detail on 17th-century and 18th-century tin-enameled delftware; cobalt-blue slanting dashes around the rims of chargers painted in *maiolica* colors. (See delftware.)

BLUNGE To beat washed clay with a wide paddle (a blunger) or by a machine with wide, rotating paddles to remove lumps in the clay.

BONE CHINA A type of porcelain made in England by adding bone ash to clay and feldspathic rock so that the china is pure white; softer than hard-paste porcelain and more durable than soft-paste porcelain.

BOTTLE KILN Ceramic oven named for its bottle-shaped silhouette; also called beehive kiln. (See kiln, tunnel kiln.)

BRUBENSUL WARE Highly glazed majolica painted in light-brown and dark-brown shades, used for large jardinieres and pedestals; originated in 1894 at the Edwin Bennett Pottery Company, Baltimore, Md. A composite of the names of three men in the firm: William *Brunt*, Edwin *Bennett*, and Joseph L. *Sul*livan.

CALCAREOUS Relating to chalky clay containing calcium carbonate.

CALCINE To heat materials such as animal bones or flint so they may be crushed to a powder to be mixed with clay.

CHEESE HARD Consistency of clay after some of the water has been evaporated by heating and processing through a filter press, but retaining enough plasticity so that the clay is still soft enough to be worked. (See leather hard.)

CHINA CLAY English term for kaolin (Chinese, "high ridge"), the Chinese white clay derived from decomposed granite rocks, by water acting on the feldspar in the granite. Deposits found in Cornwall, England, on the Continent, and in the United States. (See china stone.)

CHINA STONE English term for petuntse (French corruption of Chinese *pai-tuntzû*, "little white bricks," the form in which the Chinese sent the pulverized stone to their porcelain makers). Feldspathic vitrifying ingredient that fuses at about 1450°C., essential for making hard-paste porcelain. Also called Cornish stone.

COCKSPUR Piece of kiln furniture made of fireclay in the shape of a tripod. (See sagger marks, spur mark, kiln furniture, stilt.)

CONE Piece of kiln furniture in the shape of a pyramid, used to measure temperature in the kiln. The top melted at a predetermined heat and bent over to the level of the base. Also known as pyrometric cone, Seger cone (Europe), and Orton cone (United States).

COPERTA (It.) Transparent lead glaze on 16th-century *maiolica* applied after the firing of the tin-enamel glaze to increase the brilliance of the colors and the sheen of the tin glaze.

CRACKLE Decorative cracks in the glaze accomplished deliberately by creating differences in the rates of expansion (during heating) and contraction (during cooling) of the body and the glaze during the firing process. (See *craquelure*; cf. crazing.)

CRAQUELURE (Fr.) (See crackle.)

CRAWLING Retraction of the fired glaze, which then exposes the body; usually caused by grease or other impurities on the surface of the body when the piece was glazed.

CRAZING Unintentional crackling of the glaze due to the differences in the rates of expansion and contraction during firing and cooling. Crazing may also occur any time after the pottery is made and will destroy the impermeability of the glaze. (See crackle.)

CREAMWARE Cream-colored earthenware, a type of hard pottery with a buff-colored body and a transparent lead glaze, perfected by Josiah Wedgwood c. 1760, and named Queens ware for Queen Charlotte.

CUERDA SECA (Sp., "dry cord") A technique that originated in the Near East and was frequently used in 16th-century Spain to decorate tiles, dishes, and vases. Pattern outlines were drawn in manganese-colored grease, which prevented merging of colored glazes. Grease disappeared during firing.

DELFT *DORÉE* Fine polychrome tin-glazed earthenware with gilded decoration, made in Delft, Netherlands.

DELFT *NOIRE* Tin-glazed earthenware with polychrome decoration on a black background, made in Delft in the late 17th century and imitating oriental lacquer work.

DELFT WARE Dutch tin-glazed earthenware inspired by Italian *maiolica* and made beginning in the early 16th century. After the mid-17th century, decoration imitated blue-and-white Chinese porcelain. Height of production 1640–1740.

DELFTWARE 16th-century English tin-glazed earthen-ware inspired by Dutch Delft examples first brought to London by potters from Antwerp in the mid-16th century. Sometimes called English delftware to distinguish it from Dutch Delft ware.

EARTHENWARE Pottery, not as hard as stoneware or porcelain, fired at relatively low temperatures from 700°C.–1200°C.; porous unless glazed.

EGYPTIAN BLACK A Staffordshire stoneware from which Josiah Wedgwood developed basalt c. 1768; also called black Egyptian. (See basalt.)

ENAMEL (ENAMEL COLORS) Vitreous opaque or transparent pigment colored with metallic oxides applied over glazes previously fired at high temperatures (800°C.–1050°C.), then fired with enamel decoration at low temperatures (700°C.–900°C.). (See enamel firing, tin glaze.)

ENAMEL FIRING Third, low-temperature firing in which the enamel decoration is fixed to the previously fired glaze; done in a muffle kiln at *petit feu* temperatures of 700°C.–900°C. (See enamel, muffle kiln.)

ENCAUSTIC TILE Square earthenware tile inlaid with patterns in different colored

clays fused to the tile by heat and pressure; frequently used in the Middle Ages; re-created by Herbert Minton c. 1844.

ENGOBE Slip, often used specifically for the slip applied to coarse ceramic bodies to improve the surface texture.

FAIENCE (Fr.) Tin-glazed earthenware; derived from the Italian town Faenza, from which emigrant Italian potters introduced *maiolica* to France.

FAÏENCE D'OIRON Term used from 1864 for 16th-century tin-glazed earthenware from Saint-Porchaire; correct origin of ware established in 1888. (See Henri Deux ware.)

FAÏENCE FINE (Fr.) Earthenware resembling creamware, with white or cream-colored lead glaze.

FETTLING Process of removing seam marks, casting marks, or other defects with a metal tool before the first firing of hollowware.

FIGULINES RUSTIQUES (Fr.) 16th-century term used by Bernard Palissy for rustic earthenwares; derived from Latin *figulus* for potter.

FIRECLAY Clay which, because of its high content of silica and low content of lime, iron, and alkali, is able to withstand high kiln temperatures without fusing and is therefore used for protective kiln furniture.

FIRING RING Piece of kiln furniture; usually triangular in section with a flat base, similar to cockspurs and trivets. (See kiln furniture.)

FLAMBÉ (FLAMBÉ GLAZES) (Fr.) Copper-oxide glazes fired in a reduction atmosphere to create a lustrous, irregularly streaked, rich crimson to purple to bluish-red glaze resembling coagulated oxblood (glaze called *sang de boeuf*). (See reduction kiln.)

FLUX Substance used to lower the fusion,

or vitrification, point of a ceramic body, glaze, or enamel. Glazes are usually named according to the flux used, e.g., lead glaze. (See kiln, enamel, glost firing.)

FRIT Silica which is crushed and powdered, then fused with a flux and added to low-temperature glazes or enamels to overcome problems of instability and solubility of glazes or enamels in water; or mixed with clay to make artificial porcelain such as bone china. (See flux, porcelain.)

FRITTING Fusing a flux with silica ground to a powder, to be added to a glaze, enamel, or clay. (See frit.)

GALLEYWARE (OR GALLYWARE) Term used in England in the 16th century for tin-enameled pottery; said to be derived from "gallipot." (See gallipot.)

GALLIPOT Term used in Holland in the 15th century for a small, tin-glazed earthenware pot shipped by galleys from Spanish and Italian Mediterranean ports to Holland. (See galleyware.)

GIRDER Piece of kiln furniture; thin slab of fireclay placed vertically in a kiln to support flatware during firing. Also called a slug, or slugg. (See kiln furniture; cf. rafter.)

GLAZE Impervious vitreous coating on pottery, made by the fusion of silica and alumina, to which a flux has been added to decrease the melting point of silica. Glazes are usually named according to the flux used, e.g., lead glaze. (See flux.)

GLOST FIRING (OR GLOST STAGE) Second firing of a ceramic piece which fuses the glaze applied after the first, or biscuit, firing. Majolica glazes on earthenware vitrify between 800°C.–1050°C., using a flux. (See flux, kiln.)

GRANITEWARE A type of stone china (a stoneware) sprayed with blue or gray lead glaze to create a speckled surface in imitation of granite. (See stone china.)

GREENHOUSE Place for drying ceramic ware before firing. (See greenware.)

GREENWARE Unfired pottery, also called raw ware. (See greenhouse.)

HENRI DEUX WARE 16th-century lead-glazed earthenware with patterns impressed into the clay by metal punches and then filled with black, brown, or reddish clay. Also known since 1888 as Saint-Porchaire ware, from its place of origin near Bordeaux, although from 1864 it was erroneously called *faïence d'Oiron*. Re-created in the mid-19th century at Minton and by Joseph-Théodore Deck in Paris.

IMPASTO Technique of applying heavy pigment so that the design on a surface is slightly raised. Impasto blue: blue pigment used on Renaissance Florentine *maiolica*. Impasto red: deep red pigment used on pottery made in the 16th century in Iznik, Turkey.

INTAGLIO Incised carving of a design sunk below the surface. Used in majolica in *Émail ombrant* invented c. 1842 by Baron Alexis du Tremblay at Rubelles, France, and then made by Wedgwood.

IRONSTONE CHINA Fine stone china, resembling porcelain, patented by Charles James Mason in Lane Delph (Staffordshire) in 1813; hardened by the addition of glassy ironstone slag. (See stone china.)

ISTORIATO (It.) Decoration with mythological, Biblical, or genre scenes occupying the center or the entire surface of a piece of *maiolica;* developed especially at Urbino in the 16th century.

JASPERWARE Fine-grained, unglazed stoneware introduced by Josiah Wedgwood c. 1774; the white body could be stained cobalt blue, lilac, sage-green, yellow, or black with metallic oxides; featured low-relief decoration with neoclassical themes.

JIGGER Machine with a revolving plaster mold used to shape the inside of plates and saucers in conjunction with a profile,

239

or template, which shapes the outside and foot ring. (See bat, jolly, profile.)

JOLLY Machine with a revolving plaster mold used to shape the outside of hollowware such as cups and shallow bowls in conjunction with a profile, or template, pressed into the bat of clay on the mold to form the inside of the vessel. (See bat, jigger, profile.)

KAOLIN (See china clay.)

KILN Oven used for firing ceramic wares. *Grand feu* kiln (1100°C.–1450°C.) used for porcelain and hard earthenwares; lower range (700°C.–1200°C.) used for first and second firings of majolica; *petit feu*, or muffle kiln (700°C.–900°C.), used for enamel overglaze colors. (See bottle kiln, tunnel kiln, kiln furniture.)

KILN FURNITURE Objects made of fireclay used in the kiln to support and protect ceramic pieces placed in saggers during the firing process. (See kiln, fireclay, sagger pin, trivet, cockspur, stilt, firing ring, girder, slug, rafter.)

LEAD GLAZE Transparent glaze of silica and alumina fused with lead oxide as the flux; used to enhance sheen. (See *coperta*, flux.)

LEATHER HARD Consistency of clay hardened by further evaporation of moisture after the cheese-hard state. (See cheese hard.)

LUSTER (OR LUSTRE) Metallic sheen, sometimes iridescent, achieved on ceramics by applying silver, copper, or gold metallic oxide to the already glazed ware, which is fired again in a reduction atmosphere at a low temperature of 700°C.–800°C. in a muffle kiln. (See kiln, muffle kiln, reduction kiln, metallic oxide.)

LUSTERWARE (OR LUSTREWARE) Pottery decorated with an iridescent sheen from metallic oxide applied to glazed ware then refired in a reduction kiln.

MAIOLICA (It.) Renaissance Italian earthenware covered with an opaque tin-oxide glaze and decorated with colorful metallic-oxide glazes; name derived from island of Majorca from which Hispano–Moresque precursors were shipped to Italy. (See tin glaze, metallic oxide.)

MAJOLICA 19th-century term for revival of Renaissance *maiolica;* low-fired porous earthenware, modeled in relief, covered with opaque tin-oxide and/or lead-oxide glaze, and decorated with colorful metallic-oxide glazes; originated by Herbert Minton, and first exhibited at the Crystal Palace Exhibition, London, 1851.

MAZARINE BLUE English equivalent of the Sèvres deep, rich blue underglaze ground color; perhaps named for Cardinal Jules Mazarin (1602–1661).

METALLIC OXIDE Oxide of a metal used as a pigment to decorate ceramics under or over the glaze; suspended in an oily medium and applied with a brush; development of color depends on concentration of oxygen in kiln. (See oxidation kiln, reduction kiln.)

MUFFLE KILN (OR *PETIT FEU*) Oven that functions in the range of 700°C.–900°C.; contains an inner chamber or box (muffle) to protect glazed ceramics painted in bright overglaze enamel colors from discoloration by flames or smoke. (See enamel, enamel firing.)

OXIDATION KILN Kiln rich in oxygen and poor in carbon dioxide. (See reduction kiln, metallic oxide.)

OXIDE (See metallic oxide.)

PALISSY WARE Tin-glazed and/or lead-glazed earthenware by or in the style of the French ceramist Bernard Palissy (c. 1510–1589); modeled with lifelike, high-relief representations of foliage, snakes, insects, and sea creatures. Produced anonymously in France in the 16th to 18th centuries; in France in the mid-19th century by Georges Pull, Charles-Jean Avisseau, and others; and in Portugal by Mafra in the 19th and 20th century. In the second half of the 19th century major and minor firms in England produced majolica in a brilliantly glazed Palissy style.

PARIAN WARE Unglazed biscuit porcelain that superficially resembles marble; name inspired by marble quarried on island of Paros. Used for busts and decorative pieces. First produced by Copeland in 1846, followed by Minton, Wedgwood, and Worcester. Usually white, but later pieces were tinted or painted with majolica glazes.

PÂTE COLORÉE (Fr.) A clay body colored with metallic oxides before firing.

PÂTE-SUR-PÂTE (Fr.) An intricate process of decorating ceramics with a relief design in which slip (*pâte d'application*) is applied to unfired porcelain in successive stages; the relief design is modeled with metal instruments; the piece is then glazed and fired. Used in China in the 18th century, further developed in the 19th century at Sèvres and Meissen, and brought c. 1870 to Minton from Sèvres by Marc-Louis-Émanuel Solon.

PEARL WARE An improved type of creamware, introduced by Wedgwood in 1779. To counteract the cream tone the body contained more flint and white clay; a trace of cobalt oxide in the glaze imparted a bluish-white cast.

PETIT FEU (Fr.) (See muffle kiln.)

PETUNTSE (See china stone.)

PIP (OR PIP MARK) Blemish on the undersurface of ceramic ware caused by contact with kiln furniture during firing. (See sagger marks, kiln furniture.)

PLASTER OF PARIS Calcined gypsum in white powdered form mixed with water to make a paste that soon sets and can be used for casts and molds.

PORCELAIN Hard, fine-grained, nonporous, vitreous, usually translucent and white ceramic ware; hard-paste porcelain contains petuntse and kaolin and is fired

at c. 1450°C., whereas soft-paste porcelain does not contain petuntse and is fired at c. 1200°C. (also called artificial porcelain, frit porcelain, or *pâte tendre*); name derived from *porcella*, a type of cowry shell. (See petuntse, kaolin, frit.)

PROFILE A shaping tool, or template, used in conjunction with a rotating mold on a jigger or jolly machine to form plates, saucers, cups, or shallow bowls. (See jigger, jolly.)

PUGGING Process of kneading clay in a pug mill, homogenizing it and freeing it of air pockets. (See wedging.)

PUG MILL (See pugging.)

QUEEN'S WARE (See creamware.)

RAFTER Piece of kiln furniture; slab of fireclay placed horizontally on girders, or slugs, to support wares during firing. (See kiln furniture; cf. girder, slug.)

REDUCTION KILN Oxygen-poor kiln, rich in carbon dioxide, in which incomplete combustion of fuel gases produces colors from metallic oxides unlike those produced in an oxidation kiln. (See oxidation kiln, metallic oxide, *flambé*.)

REGISTRY MARK Mark indicating registration by the British Patent Office, of a design on manufactured goods from 1842 through 1883. Diamond-shaped mark shows parcel number, year, month, and day the design was registered, but not necessarily the date of manufacture. (See appendix on marks.)

ROCKINGHAM WARE (OR ROCKINGHAM GLAZE) Earthenware made in late 18th and 19th centuries at a pottery on the estate of the marquis of Rockingham in Swinton, Yorkshire, then by other factories in England and America in the 19th century. A hard, white earthenware with a manganese-brown glaze.

ROSSO ANTICO (It.) Wedgwood's unglazed red stoneware which was an improvement on a similar ware introduced by the Elers in the late 17th century. Decorations were based on ancient Greek and Roman designs, called "antique," hence the name.

RUBY LUSTRE Iridescent glaze produced by the use of gold oxide; color varied from pale yellow to brilliant ruby red. Developed in the early 16th century by Maestro Giorgio Andreoli in Gubbio, Italy, and used on *maiolica* made and/or decorated there.

SAGGER Box made of fireclay that contains the raw or glazed ceramic wares during firing, used to support and protect the objects from damage by smoke or flames. (See kiln furniture, fireclay.)

SAGGER MARKS Marks left on ceramic wares by pointed supports used in saggers to protect pieces during firing. (See sagger, spur mark, stilt mark, pip, kiln furniture.)

SAGGER PIN Piece of kiln furniture; tapering triangular length of fireclay that fits through triangular peg holes in the walls of a sagger, on which ceramic bodies rest during firing. (See kiln furniture.)

SAINT-PORCHAIRE (See *faïence d'Oiron*, Henri Deux ware.)

SALT GLAZE Glaze with a slightly rough surface used on stoneware; achieved by vaporizing salt in the kiln at the maximum glazing temperature (c. 1000°C.). The sodium chloride salt decomposes under heat, chlorine escapes through the kiln chimney and sodium combines with the silicates in the body of the ware to form a thin, pitted glazed surface.

SANDED MAJOLICA A type of 19th-century majolica, usually unmarked and attributed to English, Continental, and American factories. The clay body is coated with a gritty, sandy glaze. Many pieces have deeply modeled and raised floral designs made of slip (see *barbotine*).

SGRAFFITO (It., "scratched") Decoration executed by scratching a design through slip or glaze to reveal a different-colored ground beneath. The decorated piece is then coated with transparent lead glaze and refired. (See slip.)

SILICEOUS GLAZE Glaze composed of silica (flint and quartz) heated with a flux that enables the silica to vitrify when fired below 1200°C. Alumina (found in feldspar) is added to stabilize the glaze. (See flux.)

SLIP Creamy suspension of fine clay in water used (1) to coat coarse clay vessels to make them less porous, (2) to attach parts of pottery, such as handles and spouts, to the body, (3) to create relief decoration, in lines, dots, script, or floral motifs, and (4) for slip casting in a plaster-of-paris mold. Slip is often colored by the addition of metallic oxides. (See slip casting, slipware, sprigging, *barbotine*.)

SLIP CASTING Process of casting hollow-ware by pouring slip into a plaster-of-paris block mold; excess slip is poured off and the mold is removed when the remaining slip has become cheese hard. (See slip, block mold, plaster of paris, cheese hard.)

SLIPWARE Lead-glazed earthenware decorated with slip in low-relief patterns such as dots, dashes, wavy lines, messages of a pious nature, or the names of the potters.

SLUG (OR SLUGG) Piece of kiln furniture. (See girder, kiln furniture.)

SPREADER Tool, now electrically operated, for flattening a bat of clay to be put on the rotating mold of a jigger or jolly machine. (See ball clay, bat, jigger, jolly, profile.)

SPRIGGED WARE Ceramic ware decorated with separately molded or stamped parts or ornamental elements that are attached to the body with slip. (See sprigging, slip.)

SPRIGGING Process of attaching separately molded or stamped parts or ornamental elements to the body of a ceramic

241

piece with slip before the first firing. Parts include spouts and handles; ornamental elements include leaves, decorative figures. (See sprigged ware, slip.)

SPUR Piece of kiln furniture. (See cockspur.)

SPUR MARK
(See cockspur, sagger marks.)

STANNIFEROUS Containing tin, such as tin oxide in a tin glaze for earthenware.

STANNOUS Relating to, or containing, tin.

STILT Piece of kiln furniture; same as cockspur. (See stilt mark, kiln furniture.)

STILT MARK (See stilt, sagger marks, spur mark.)

STONE CHINA A type of hard, fine, white porcellaneous stoneware developed by John Turner in Staffordshire c. 1800; patent said to have been sold to Josiah Spode in 1805, who named the ware stone china or new china. Led to development of Mason's Ironstone China in 1813. (See graniteware, ironstone china.)

STONEWARE Pottery made of clay and a fusible stone; fired between 1200°C and 1400°C, halfway between earthenware and porcelain; opaque, very hard and nonporous; additional glaze is unnecessary except for decoration.

TEMPLATE (See profile.)

TIN ENAMEL (See enamel, tin glaze.)

TIN GLAZE Glaze made white and opaque by adding tin oxide; applied to biscuit earthenware as a background for polychrome decoration with metallic-oxide glazes and can itself be colored by adding metallic oxides. (See enamel, *bianco sopra azzurro, bianco sopra bianco*, biscuit, metallic oxide, glaze.)

TONDO (It.) Large circular medallion made in Renaissance *maiolica*, with high-relief decoration in the style of Luca Della Robbia (c. 1400–1482).

TRANSFER PRINTING Process for decorating ceramics in which an engraved copperplate is covered with an ink prepared with metallic oxides. The engraved design is then transferred to paper, which while wet with pigment is pressed on the surface of the object. The design is then fixed by firing.

TREK Dutch term for a drawn outline, in blue, black, or manganese-purple, to create designs on Delft ware.

TRIVET Piece of kiln furniture; triangular slab of fireclay with concave sides and three small feet placed between flatware stacked in saggers. (See kiln furniture.)

TUNNEL KILN Modern kiln (first used in 1902 at Villeroy and Boch at Mettlach,

Germany, heated with gas, now electrically) about 275-feet long through which ceramic wares to be fired are conveyed on trucks as the heat gradually increases to a maximum temperature and diminishes toward the exit.

VIGORNIAN WARE Term used at Wedgwood in the 1870s for a majolica contemporary with etched or engraved naturalistic patterns of flora, fauna, and insects over Rockingham and mazarine-blue glazes. This allowed the underlying body color to show through, similar to *sgraffito*. (See Rockingham ware, mazarine blue, *sgraffito*.)

WASTERS Discarded inferior ceramic pieces (usually deformed by excessive heat in the kiln) which, when excavated, can be used (with circumspection) for the identification of manufacturer, date of production, and pottery location.

WEDGING (1) Same as pugging. (2) The process of combining slabs of clays of different colors to make solid agate ware. (See pugging, agate ware.)

WHITE GRANITE (See graniteware.)

WINSLOW WARE A form of majolica produced from 1878 to c. 1886 by the Portland Stone Ware Company, Portland, Maine (owned by John T. Winslow), which changed its name to Winslow and Company in 1882.

MAJOLICA IN MUSEUMS

When planning visits to the museums listed below,
it would be wise to write or call them first, to see if pieces
of majolica are on display or if they are in storage.

UNITED STATES

California

LOS ANGELES Los Angeles County Museum of Art
SAN FRANCISCO Fine Arts Museums of San Francisco

Connecticut

NEW HAVEN Yale University Art Gallery
NEW MILFORD New Milford Historical Society

District of Columbia

Daughters of the American Revolution Museum
• National Museum of American History, Smithsonian
Institution

Florida

ST. AUGUSTINE Lightner Museum

Illinois

CHICAGO Art Institute of Chicago

Indiana

INDIANAPOLIS Indianapolis Museum of Art

Louisiana

NEW ORLEANS Louisiana State Museum
• New Orleans Museum of Art

Maine

AUGUSTA Maine State Museum
EAST SEBAGO Jones Museum of Glass and Ceramics
PORTLAND Portland Museum of Art

Maryland

BALTIMORE Museum and Library of Maryland
History, Maryland Historical Society • Walters
Art Gallery

Massachusetts

BOSTON Gibson House Museum, Gibson Society
• Museum of Fine Arts, Boston • Society for the
Preservation of New England Antiquities
SALEM Peabody Museum of Salem

Michigan

DEARBORN Henry Ford Museum and Greenfield Village

Minnesota

MINNEAPOLIS Minneapolis Institute of Arts

Missouri

ST. LOUIS St. Louis Art Museum

New Hampshire

KEENE Colony House Museum, Historical Society of
Cheshire County

New Jersey

NEWARK Newark Museum
TRENTON New Jersey State Museum

New York

NEW YORK CITY Brooklyn Museum • Cooper-Hewitt
Museum • Metropolitan Museum of Art • Museum
of the City of New York
ROCHESTER Strong Museum
SYRACUSE Everson Museum of Art of Syracuse
and Onondaga County

Nevada

Liberace Museum, Las Vegas

North Carolina

ASHEVILLE Biltmore Estate

Ohio

CINCINNATI Cincinnati Art Museum

CLEVELAND Cleveland Museum of Art • Western Reserve Historical Society

EAST LIVERPOOL Museum of Ceramics at East Liverpool, Ohio Historical Society

OBERLIN Allen Memorial Art Museum

Pennsylvania

MERION Buten Museum of Wedgwood

PHILADELPHIA Philadelphia Museum of Art

PHOENIXVILLE Historical Society of Phoenixville

WEST CHESTER Chester County Historical Society

Rhode Island

NEWPORT Chateau sur Mer • The Elms

South Carolina

CHARLESTON Charleston Museum

Vermont

BENNINGTON Bennington Museum

Virginia

NORFOLK Chrysler Museum

RICHMOND Virginia Museum of Fine Arts

AUSTRALIA

New South Wales

ULTIMO Power House Museum

South Australia

ADELAIDE Art Gallery of South Australia

Victoria

WARRNAMBOOL Flagstaff Hill Museum

CANADA

TORONTO Royal Ontario Museum

FRANCE

BEAUVAIS Musée Départemental de l'Oise

GIEN Musée de Gien

ILE-LES-BAINS Musée de St. Honoré-les-Bains

LIMOGES Musée Principal de Limoges • Musée Nationale Adrien Dubouche

LYON Musée des Beaux-Arts de Lyon

PARIS Musée d'Art Moderne de la Ville de Paris • Musée des Arts Décoratifs • Musée d'Orsay • Musée du Louvre • Musée Carnavalet

SARREGUEMINES Musée Régional de Sarreguemines • Musée de la Faience

SÈVRES Musée National de Céramique

TOURS Musée des Beaux-Arts

VALLAURIS Musée Municipal de Céramique et d'Art Moderne • Massier Museum

GREAT BRITAIN

England

BRIGHTON Brighton Museum and Art Gallery

LIVERPOOL Merseyside County Museum

LONDON British Museum • Victoria and Albert Museum

STOKE-ON-TRENT City Museum and Art Gallery, Hanley • Gladstone Pottery Museum, Longton • Minton Museum • Copeland-Spode Museum • Wedgwood Museum, Barlaston

Scotland

GLASGOW Art Gallery and Museum, Kelvingrove

LUXEMBOURG

Musée de l'État

PORTUGAL

CALDAS da RAINHA Faiancas Artisticas Bordalo Pinheiro • Museu de Ceramica • Museu José Halboa

LISBON Museu de Artes Decorativas Portuguesas • Museu Rafael Bordalo Pinheiro

SWEDEN

MALMÖ Malmö Museum

WEST GERMANY

METTLACH Keramic Museum Mettlach

U.S.S.R

ST. PETERSBURG Hermitage

BIBLIOGRAPHY

Books, magazine and newspaper articles are included.

Aberbach, William. "Wedgwood Majolica." *The Wedgwoodian* (March 1982): 103–105.

Albertson, Karla Klein. "Mostly Majolica." *Antique Review* (November 1986): 30-33.

All about Wedgwood. Hammond Museum [North Salem, N.Y.] in collaboration with the Wedgwood Society of New York. Mimeographed exhibition catalogue. North Salem, New York: 1984.

Allwood, Rosamund. "Luxury Furniture Makers of the Victorian Period." *Antique Collecting* (June 1988): 4–8.

Arnoux, Léon. "Ceramic Manufactures, Porcelain and Pottery." In De la Beche, Henry, and Trenham Reeks, *Catalogue of Specimens Illustrative of the Composition and Manufacture of British Pottery and Porcelain, from the Occupation of Britain by the Romans to the Present Time,* 1–40. London: Eyre and Spottiswoode, 1855.

The Art-Journal Illustrated Catalogue of the London International Exhibition of 1871. London and New York: Virtue and Company, Ltd., 1872.

The Art-Journal Illustrated Catalogue of the Paris International Exhibition of 1878. London: Virtue and Company, Ltd., 1878.

The Art-Journal Illustrated Catalogue of the Paris Universal Exhibition of 1867. Porcelain and pottery section by James Dafforne, 279–308; majolica, 283, 297–299. London and New York: Virtue and Company, Ltd., 1868.

Aslin, Elizabeth, and Paul Atterbury. *Minton 1798–1910.* London: Victoria and Albert Museum, 1976.

Atterbury, Paul and Maureen Batkin. *The Dictionary of Minton.* Woodbridge, Suffolk, England: Antique Collectors' Club, 1990.

Atterbury, Paul. "Minton Maiolica." *Connoisseur* (August 1976): 304–308.

————, ed. *English Pottery and Porcelain, An Historical Survey.* New York: Universe Books, 1978.

Aubrier, Nadia. "Les Barbotines." *Trouvailles* (August–September 1985): 58-63.

Ball, Bernice. "Ceramic Heritage in Chester County, Pa." *Hobbies* (September 1953): 80-81.

————. "Etruscan Majolica." *Antiques Journal* (September 1964): 24–25.

Barber, Edwin AtLee. *Marks of American Potters.* Philadelphia, Patterson and White, 1904. Reprint. Ann Arbor, Michigan: Ars Ceramica, Ltd., 1976.

————. *Pottery and Porcelain of the United States.* New York: G. P. Putnam's Sons 1893, 1901. Reprint: Watkins Glen, New York: Century House Americana, 1971.

Barber, Edwin AtLee, Luke Vincent Lockwood, and Hollis French. *The Ceramic, Furniture and Silver Collectors' Glossary.* New York: Da Capo Press, Inc., 1976. Reprint of works originally published as *The Ceramic Collectors' Glossary, The Furniture Collectors' Glossary, A Silver Collectors' Glossary,* and *A List of Early American Silversmiths and Their Marks.* New York: Walpole Society, 1913, 1914, and 1917.

Barker, Dennis. *Parian Ware.* Aylesbury, Bucks, England: Shire Publications, Ltd., 1985.

Batkin, Maureen. *Wedgwood Ceramics 1846–1959.* London: Richard Dennis, 1982.

Battie, David. "The Brightest Heaven of Invention," *Masterpiece,* Spring 2001.

Battie, David, and Michael Turner. *The Price Guide to 19th and 20th Century British Pottery, Including Staffordshire Figures and Commemorative Wares.* Woodbridge, Suffolk, England: Antique Collectors' Club, Ltd., 1979; 2nd ed., 1987.

Beckwith, Arthur. "Observations on the Material and Manufacture of Terra-cotta, Stone-ware, Fire-brick, Porcelain, Earthen-Ware, Brick, Majolica, and Encaustic Tiles, with Remarks on the Products Exhibited." *International Exhibition, London, 1871. Pottery.* New York: D. Van Nostand, 1872.

Bellew, Diana. "English Majolica Wares." *Antique Collecting* (July–August 1986): 40–41.

Bergesen, Victoria. *Majolica: British, Continental and American Wares, 1851–1915.* London: Barrie & Jenkins, 1989.

Bishop, Robert, and Patricia Coblentz. *The World of Antiques, Art, and Architecture in Victorian America.* New York: E. P. Dutton, 1979.

Blacker, J. F. *The A.B.C. of Collecting Old Continental Pottery.* London: Stanley Paul and Co., 1913.

Boger, Louise Ade. *The Dictionary of World Pottery and Porcelain.* New York: Charles Scribner's Sons, 1971.

Branin, Manlif Lelyn. *The Early Potters and Potteries of Maine.* Augusta, Maine: Maine State Museum, 1978.

Briggs, Asa. *Victorian People, A Reassessment of Persons and Themes, 1851–67.* London: Odhams Press, 1954. Rev. ed. Middlesex, England: Pelican Books, 1965.

———, ed. *The Nineteenth Century, The Contradictions of Progress.* New York: Bonanza Books, 1985.

British Museum. *A Guide to the English Pottery and Porcelain in the Department of Ceramics and Ethnography.* 1904. 3rd ed. Oxford: Oxford University Press, 1923.

Brossard, Yvonne, and Alain Jacob. *Sarreguemines: faïences et porcelaines de l'est.* Paris: G. J. Malgras, 1975.

Brown, Christie. "What a difference a 'j' makes," *Forbes,* October 25, 1993.

Bulfinch, Thomas. *Bulfinch's Mythology.* 1855. Reprint. New York: Avenel Books, 1979.

Burke, Doreen Bolger, et al. *In Pursuit of Beauty: Americans and the Aesthetic Movement.* New York: Metropolitan Museum of Art and Rizzoli International Publications, Inc., 1986.

Cameron, Elisabeth. *Encyclopedia of Pottery and Porcelain, The Nineteenth and Twentieth Centuries.* London and Boston: Faber and Faber, 1986.

Campbell, Bill. "Mold Making for the Jigger." *Ceramics Monthly* (June–July–August 1987): 42-44.

[Carr, James]. "Reminiscences of an Old Potter." *Crockery and Glass Journal,* (April 20, 1876): 14; (October 5, 1876): 14.

———. "Reminiscences of an Old Potter: A Series of Letters by James Carr." *Crockery and Glass Journal,* (March 21–April 25, 1901).

Casson, Michael. *The Craft of the Potter: A Practical Guide to Making Pottery.* Edited by Anna Jackson. Woodbury, New York: Barron's Educational Series, 1979.

Cecil, Victoria. *Minton Majolica: An Historical Survey and Exhibition Catalogue.* London: Trefoil Books, Ltd., 1982.

The Centennial Exhibition of 1876. What We Saw, and How We Saw It. Part I. Art Glances, A Companion to the Art Gallery. Philadelphia: S. T. Souder and Company, 1876.

Chaffers, William. *Marks and Monograms on European and Oriental Pottery and Porcelain.* Edited by Frederick Litchfield. 14th rev. ed. Los Angeles: Borden Publishing Company, 1946.

Clark, Sally. "Defining Style," *Traditional Home,* June–July 2000.

Cleary, John J. "Trenton in Bygone Days." Trenton, New Jersey, *Sunday Times Advertiser,* July 15, 1928.

Cluett, Robert. *George Jones: Ceramics 1861–1951.* Atglen, Pennsylvania: Schiffer Publishing Ltd., 1998.

———. "The Majolica of George Jones," *The Antique Dealer and Collector's Guide,* January–February 2001.

Clopton, Linda E. "A Love of Majolica: Flora and Fauna," *Veranda,* Winter 1999.

Cole, Ann Kilborn. "Phoenixville Majolica." *The Philadelphia Inquirer Magazine* (June 11, 1961).

Cooper, Jeremy. *Dealing with Dealers: The Ins and Outs of the London Antiques Trade.* London: Thames and Hudson, 1985.

———. *Victorian and Edwardian Furniture and Interiors.* London: Thames and Hudson, 1987.

Cox, Warren E. *The Book of Pottery and Porcelain.* New York: Crown Publishers, 1944.

Crockery and Glass Journal (New York), Vols. 9–12, 1879–1880.

The Crystal Palace Exhibition, Illustrated Catalogue, London 1851. London: *The Art-Journal,* 1851. Reprint. New York: Dover Publications, 1970.

Cunningham, Helen. *Majolica Figures.* Atglen, Pennsylvania: Schiffer Publishing Ltd., 1997.

Curtis, Tony, ed. *The Lyle Official Antiques Review 1988, Price Guide to Antiques.* Glenmayne, Galashiels, Scotland: Lyle Publications, 1987.

Cushion, John Patrick. *Pocket Book of British Ceramic Marks.* London and Boston: Faber and Faber, 1959.

———. *Pottery and Porcelain Tablewares.* New York: William Morrow and Company, 1976.

Cushion, John Patrick, with William B. Honey. *Handbook of Pottery and Porcelain Marks.* London: Faber and Faber, 4th ed. (Revised and expanded), 1980.

Dawes, Nicholas M. *Majolica.* New York: Crown Publishers, Inc., 1990.

De Jonge, C. H. *Delft Ceramics.* New York and London: Praeger Publishers, 1970.

De Luynes, Victor. "Rapport sur la céramique dans Classe 20." In *Paris. Exposition Universelle, 1878. Rapport administratif sur l'Exposition universelle de 1878 à Paris.* Paris: Imprimerie Nationale, 1881.

DeWulf, Karol K. "Collectible Color." *Country Home* (February 1987): 74–84.

DiMartino, Christina and Kathy Bryant. "Passionate Collectors," *Art and Antiques,* June 2000.

"Dining in Victorian America." *Antiques and the Arts Weekly* (March 20, 1987): 38–39.

Early Arts of New Jersey: The Potters Art, c. 1680–c. 1900. Trenton, New Jersey: New Jersey State Museum, 1956.

Elliott, C. W. *Pottery and Porcelain from Early Times down to the Philadelphia Exhibition of 1876.* New York: D. Appleton and Company, 1878.

Elliott, Raymond A. "Chester County, Pennsylvania." *The American Antique Journal* (August 1947): 4–5.

Emmerling, Mary Ellisor. "Bed, Breakfast and History." *House Beautiful* (January 1983): 66–69.

———. "How to Have a Great Collection." *House Beautiful* (February 1979): 72–73.

Englefield, Carolyn. "The Art of Mixing Styles." *House Beautiful* (February 1987): 84–87.

Evans, Paul. *Art Pottery of the United States.* New York: Charles Scribner's Sons, 1974.

Exposition Universelle de 1867 à Paris. Catalogue Général publié par la Commission Impériale. Vols. 1–2. Paris: E. Dentu, 1867(?).

Fairholme, Georgina. "Fresh Style for an 1800s House." *House Beautiful* (February 1987): 76–83.

———. "Personal Style." *House Beautiful* (September 1983): 62.

———. "Sleight of Hand." Edited by Jason Kontos. *House Beautiful* (June 1985): 94–99.

———. "Viva Victorian." *House Beautiful* (January 1988): 48–53.

Favelac, P. M. "Les Barbotines." *Art et Décoration* (August 1981): 70–75.

Faÿ-Hallé, Antoinette, Francine Heisbourg-Sulbout, and Thérèse Thomas, eds., *Villeroy and Boch, 1748–1985, Art et industrie céramique.* Paris: Ministère de la Culture, Éditions de la Réunion des Musées Nationaux, 1985.

Feild, Rachael. *MacDonald Guide to Buying Antique Pottery and Porcelain.* London and Sydney: MacDonald and Company Publishers, Ltd., 1987.

Fitzpatrick, Nancy. "The Chesapeake Pottery Company." *Spinning Wheel* (September 1957): 14.

Fitzpatrick, Paul. "Chesapeake Pottery." *Antiques Journal* (December 1978): 16–19.

Fleming, John, and Hugh Honour. *The Penguin Dictionary of Decorative Arts.* New York: Penguin Books, 1979.

Foshee, Rufus. "Majolica." *Country Living* (June 1984): 36, 15

Frantz, Henri. *French Pottery and Porcelain.* New York: Charles Scribner's Sons, 1906.

Freeman, Larry. *China Classics, I. Majolica.* Watkins Glen, New York: Century House, 1949.

Gallo, Jonna M. "Mad About Majolica," *Family Circle Easy Gardening,* Spring 2000.

Gasnault, Paul, and Édouard Garnier. *French Pottery.* London: Chapman and Hall, Ltd., 1884.

Gates, William C., Jr., and Dana E. Ormerod. *The East Liverpool, Ohio, Pottery District: Identification of Manufacturers and Marks.* Glassboro, New Jersey: Society for Historic Archaeology, 1982.

George Jones Pattern Books. Unpublished manuscript now at the Wedgwood Museum, Barlaston, Stoke-on-Trent, Staffordshire, England. n.d.

Giacomotti, Jeanne. *Catalogue des majoliques des musées nationaux.* Paris: Éditions des Musées Nationaux, 1974.

Gibbs-Smith, C. H. *The Great Exhibition of 1851.* London: For Her Majesty's Stationery Office by Raithby, Laurence and Co., Ltd., 1950. Reprinted 1981.

Godden, Geoffrey A. *British Pottery, An Illustrated Guide.* New York: Clarkson N. Potter, Inc., 1975.

———. *Encyclopaedia of British Pottery and Porcelain Marks.* Exton, Pennsylvania: Schiffer Publishing, Ltd., 1964.

———. *An Illustrated Encyclopaedia of British Pottery at Porcelain.* London: Herbert Jenkins Ltd., 1966.

———. *Victorian Porcelain.* London: Herbert Jenkins, Ltd., 1961.

———. ed. *Jewitts Ceramic Art of Great Britain 1800–1900.* London: Barrie and Jenkins, 1972.

Goggin, John Mann. *Spanish Majolica in the New World; types of the sixteenth to eighteenth centuries.* New Haven, Connecticut: Yale University, Department of Anthropology, 1968.

Greene, Elaine. "A Vivid House for a Lively Collector." *House and Garden* (September 1983): 98–105.

Griffen, Smith and Co., *Catalogue of Majolica.* Phoenixville Pennsylvania, 1884. Reprinted in facsimile, Phoenixville, Pennsylvania: Brooke Weidner, 1960.

Guide to the Gladstone Pottery Museum. Longton, Staffordshire, England: Gladstone Pottery Museum, 1984.

Haggar, Reginald G. *The Concise Encyclopedia of Continental Pottery and Porcelain.* London: André Deutsch, Ltd., 1960.

Haggar, Reginald G., A. R. Mountford, and J. Thomas. *Staffordshire Pottery Industry.* London: University of London, 1967. Reprint. Stafford, England: Staffordshire County Council, 1981.

Hamer, Frank and Janet Hamer. *The Pottery Dictionary of Materials and Techniques.* London: Adam and Charles Black, 1975. 2nd ed. 1986.

Handley-Read, Charles. "Prince Albert's Model Dairy." *Country Life,* June 29, 1961.

Hardy, C. D. *The World's Industrial and Cotton Centennial Exposition* [1884–1885]. New Orleans: Historic New Orleans, 1978.

Harney, W. J. "Trenton's First Potteries." Trenton, New Jersey, *Sunday Times Advertiser,* July 14, and July 21, 1929.

Haslam, Malcolm. "Bernard Palissy." *Connoisseur* (September 1975): 12–17.

Hayden, Arthur. *Chats on English Earthenware.* 1909. 3rd ed. London: T. Fisher Unwin, Ltd., 1919.

Hayward, Helena. *World Furniture.* New York and Toronto: McGraw-Hill Book Company, 1965.

Hayward, Karen. "English Majolica at the Cooper-Hewitt Museum." *Antiques and the Arts Weekly* (May 21, 1982): 1, 94.

Henrywood, R. K. *Relief-Moulded Jugs 1820–1900.* Antique Collectors' Club, Woodbridge, Suffolk. 1984.

Hobhouse, Hermione. *Prince Albert: His Life and Work.* Royal College of Art Exhibition Catalogue. London: Hamish Hamilton, Ltd., 1983.

Honey, William B. *English Pottery and Porcelain.* 1st ed. London: Adam and Charles Black, 1933; 6th ed. rev. by R. J. Charleston. London: Adam and Charles Black, 1969.

———. *European Ceramic Art from the End of the Middle Ages to about 1815.* London: Faber and Faber, Ltd., 1952.

Horowitz, Joe. *Figural Tobacco Jars.* Baltimore: FTJ Publications, 1994.

Hughes, G. Bernard. *English and Scottish Earthenware, 1660–1860.* London: Abbey Fine Arts, n.d. [after 1959].

Hughes, Kathy. *A Collector's Guide to 19th Century Jugs.* R.K. Paul, London and Boston, 1985.

247

Huntbach, Alfred. *Hanley, Stoke-on-Trent, 13th to 20th Century*. Stafford, England: J. and C. Mort, Ltd., 1910.

Jacquemart, Albert. *History of the Ceramic Art*. New York: Scribner, Armstrong and Company, 1877.

James, Arthur E. *The Potters and Potteries of Chester County, Pennsylvania*. 1945. Reprint. Exton, Pennsylvania: Schiffer Publishing, Ltd., 1978.

Jervis, W. Percival. *A Book of Pottery Marks*. Philadelphia: Hager Brothers, 1897.

———. *The Pottery Primer*. New York: O'Gorman Publishing Company, 1911.

———. "Wannopee Pottery." *Pottery, Glass and Brass Salesman* (September 26, 1918): 11.

Jewitt, Llewellynn. *The Ceramic Art of Great Britain*. London: J. S. Virtue and Company, Ltd., 1878, rev. 1883. Reprint. Poole, Dorset: New Orchard Editions, Ltd., 1985.

Jones, Joan. *Minton: The First Two Hundred Years of Design and Production*. Shrewsbury, England: Swan Hill Press, 1993.

———. "Minton and Queen Victoria." *Antique Collector* (December 1987): 80–86.

Jones, Vere. "Minton Majolica." *Antique Trader Weekly* (August 6, 1986): 62–63.

Karmason, Marilyn G. "Victorian Majolica," *The Magazine ANTIQUES*, February 1990.

———. "Majolica Mania," *Today's Collector*, March 1997.

Karsnitz, Jim and Vivian. *Oyster Plates*. Atglen, Pennsylvania: Schiffer Publishing Ltd., 1993.

Kassebaum, John Philip. "Italian Majolica." *The Magazine Antiques* (February 1967): 202–206.

Katz, Marshall P. *Portuguese Palissy Ware*. New York: Hudson Hills Press, 1999.

Katz, Marshall P., and Robert Lehr. *Palissy Ware: Nineteenth-Century French Ceramists from Avisseau to Renoleau*. London and Atlantic Highlands, New Jersey: The Athlone Press, 1996.

Katz-Marks, Mariann. *Majolica Pottery, An Identification and Value Guide. Second Series*. Paducah, Kentucky: Collector Books, a division of Schroeder Publishing Company, Inc., 1986.

Ketchum, W. C. *Early Potters and Potteries of New York State*. New York: Funk and Wagnalls, 1970.

Kevill-Davies, Sally. "A Sardine Box." *Antique Collecting* (December 1985): 58–59.

King, Jean Callan. "A Pottery for Everyone." *House Beautiful* (February 1985): 62–65, 118.

Kingery, W. David, and Pamela B. Vandiver. *Ceramic Masterpieces: Art, Structure*, and *Technology*. New York: The Free Press, a Division of Macmillan, Inc., 1986.

Klein, Elinor. "A Case for Clutter." *House Beautiful* (May 1979): 173–174.

Klemperer, Louise. "Wayne Higby." *American Ceramics*, vol. 3, no. 4 (1985): 32–41.

Kovel, Ralph, and Terry Kovel. *Kovels' New Dictionary of Marks*. New York: Crown Publishers, Inc., 1986.

LaGrange, Marie J. "More about Makers of Majolica." *Hobbies* (June 1939): 54.

Lehner, Lois. *American Kitchen and Dinner Wares*. Des Moines, Iowa: Wallace-Homestead Book Company, 1980.

———. *Lehner's Encyclopedia of U.S. Marks on Pottery, Porcelain and Clay*. Paducah, Kentucky: Collector Books, a division of Schroeder Publishing Company, Inc., 1988.

Lehr, Robert. "L'Asperge et l'art." *Trouvailles* (June–July 1987): 20–23.

———. "Barbotines des Massier à Vallauris." *Antiquitiés, beaux-arts, curiosités* (April–May 1987): 47–52.

———. "La grande illusione." *Tutto Cucina* (May 1987): 51–54.

Lerman, Leo. "A Grand Surprise," *HG House & Garden*, November 1989.

Lerrick, Joan. "Majolica Mania." *House and Garden* (September 1982): 82–85, 136–137.

Lewis, Griselda. *A Collector's History of English Pottery*. Woodbridge, Suffolk, England: Antique Collectors' Club, Ltd., 1969. 3rd ed. 1985.

———. *An Introduction to English Pottery*. London: Art and Technics, 1950.

Litchfield, Frederick. *Pottery and Porcelain, A Guide to Collectors*. London and New York: Truslove, Hanson and Comba, Ltd., 1900.

McClinton, Katharine Morrison. *Collecting American Victorian Antiques*. New York: Charles Scribner's Sons, 1966.

Mackay, James. *Turn-of-the-Century Antiques, An Encyclopedia*. New York: E. P. Dutton, 1974.

MacKenzie, John M., ed. *The Victorian Vision: Inventing New Britain*. London: V&A Publications, 2001. Distributed by Harry N. Abrams, Inc., Publishers.

Mankowitz, Wolf, and Reginald G. Haggar. *The Concise Encyclopedia of English Pottery and Porcelain*. London: André Deutsch, 1957.

Maples, Lois. "Majolica Madness Maintains Its Charm." *The Sunday Star-Ledger*, Newark, New Jersey. (November 13, 1988): 9.

Marks, Mariann K. *Majolica Pottery, An Identification and Value Guide*. Paducah, Kentucky: Collector Books, a Division of Schroeder Publishing Company, Inc., 1983.

Micucci, Dana and Kenneth L. Ames, Karin Drew, Dick Kagan, David Masello, George Melrod, and Stephen Wallis. "Top 100 Treasures," *Art & Antiques*, March 1998.

Miller, Judith. "Earthly Delights," *Homes and Antiques*, May 1998.

Minton Shape Books (1826–present). Unpublished manuscript at the Minton Museum, Stoke-on-Trent, Staffordshire, England.

[Minton's] *Catalogue of the Principal Works Exhibited at the International Exhibition [London, 1862] in Class 35, No. 6878* by Minton and Company, 1862.

"Mintons Patent Glost Ovens. Remarks in reference to the working of these ovens and the regulation of their draughts." Undated 19th-century manuscript No. 986–989 in the Minton Museum archives, Stoke-on-Trent, Staffordshire, England.

[Minton's] *Priced Catalogue of Pottery Exhibited by Mintons, Limited, at the Imperial Institute* [London]: n.d. [1894].

Morley-Fletcher, Hugo, and Roger McIlroy. *Christie's Pictorial History of European Pottery.* Englewood Cliffs, New Jersey: Prentice-Hall, 1984.

Morley Hewitt, A. T. "Early Whieldon and the Fenton Low Works." *English Ceramic Circle Transactions,* vol. 3, pt. 3 (1954): 142–154.

Mountford, Arnold. "Thomas Whieldon's Manufactory at Fenton Vivian." *English Ceramic Circle Transactions,* vol. 8, Pt. 2 (1972): 164–182.

Murray, D. Michael. *European Majolica.* Atglen, Pennsylvania: Schiffer Publishing Ltd., 1997.

Myers, Susan H. "Ceramics." *1876: A Centennial Exhibition,* edited by Robert C. Post, 109–113. Washington, D.C.: Smithsonian Institution, 1976.

Nelson, Glenn C. *Ceramics, A Potter's Handbook.* New York: Holt, Rinehart and Winston, 1971.

Nilson, Lisbet. "Down from the Attic." *Connoisseur* (February 1984): 68–73.

Norton, F. H. "A Checklist of Early New England Potteries." *American Ceramic Society Bulletin* (May 1939): 181–185.

Osborne, Harold, ed. *The Oxford Companion to the Decorative Arts.* Oxford and New York: Oxford University Press, 1975. Reprint, 1985.

Pappas, Joan, and A. Harold Kendall. *Hampshire Pottery Manufactured by J. S. Taft and Company, Keene, New Hampshire.* Manchester, Vermont: Forward's Color Productions, Inc., 1971.

Paris Exposition Universelle, 1867. Complete official catalogue including the British and all other sections. English version translated from the French catalogue published by the Imperial Commission. London: J. M. Johnson and Sons, 1867.

Paris Exposition Universelle, 1878. Catalogue Officiel publié par le Commissariat Général. Paris: Imprimerie Nationale, 1878.

Paris Exposition Universelle, 1889. Catalogue Général Officiel. vols. 1–8. Lille: L. Danel, 1889.

Paris Universal Exposition [of] *1878. Official catalogue of the United States Exhibitors.* Compiled by Thomas R. Pickering. London: Chiswick Press, 1878.

Parshall, Margaret. "Majolica, Useful and Decorative." *Antiques Journal* (May 1950): 17.

——. "Majolica Wares." *Antiques Journal* (May 1972): 19–20.

Penkala, Marie. *European Pottery.* Hengelo, Holland: H. L. Smit and Zoon, 1951.

Pennypacker, Frances W. "Majolica and Its Makers." Chester County Historical Society, West Chester, Pennsylvania. Typescript of lecture given November 17, 1942.

Percival, Allison, ed. "New Majolica." *House Beautiful* (January 1988): 14–15.

Phillips, Annie. "Majolica," *Collect it!,* January 2001.

Pietra, Gianfilippo. "Sinfonia per Asparagi." *Nuova Cucina* (April 1987): 42–50.

Poese, Bill. "Majolica Wares." *Antiques Journal* (May 1972): 19–20.

Pottery Gazette (London) 1877–present (1877–1880 as *Pottery and Glass Trades Review;* 1881–1971 as *Pottery Gazette;* 1971 succeeded by *Tableware International).*

Prime, William C. *Pottery and Porcelain of All Times and Nations.* New York: Harper and Brothers, 1878.

Ramsay, John. "American Majolica." *Hobbies* (May 1945): 45, 48.

——. *American Potters and Pottery.* Clinton, Mass.: Hale, Cushman and Flint, 1939. Reprint. Ann Arbor, Michigan: Ars Ceramica, Ltd., 1976.

Ramsey, L.G.G., ed. *The Complete Encyclopedia of Antiques.* London: The Connoisseur, 1962. Reprint. New York: Hawthorn Books, Inc., 1967.

Rawson, Philip. *Ceramics.* 1971. Philadelphia: University of Pennsylvania Press, 1984.

Ray, Marcia. *Collectible Ceramics.* New York: Crown Publishers, Inc., 1974.

Rayner, Philip M. *Thomas Goode of London 1827–1977.* London: Thomas Goode of London, 1977.

Rebert, M. Charles. *American Majolica 1850–1900.* Des Moines, Iowa: Wallace-Homestead Book Company, 1981.

Reif, Rita. "Majolica Makes a Bold Comeback." *New York Times* (April 4, 1982): 36.

——. "New Categories: '85 Auction Stars." *New York Times* (January 23, 1986): C8.

——. "Pottery Inspired by the Renaissance." *New York Times* (April 20, 1986): 33.

Reilly, Robin. *Wedgwood, Volume II.* London, and Basingstoke: Macmillan London Limited, 1989; New York: Stockton Press, 1989.

Reports of the United States Commissioners to the Paris Universal Exposition, 1878. Vol. 3. Iron and Steel, Ceramics and Glass, Forestry, Cotton. Washington: Government Printing Office, 1880.

Rhead, Frederick H. "The Italian Majolica Process and Painting over Tin Enamels." *American Ceramic Society Bulletin,* vol. 1 (1922): 177–180.

Rhodes, Daniel. *Clay and Glazes for the Potter.* Radnor, Pennsylvania: Chilton Book Company, 1957, 2nd ed., 1974.

Rickerson, Wildey C. *Majolica, Collect it for fun and profit.* Chester, Connecticut: The Pequot Press, 1972.

Rinker, Harry. "Web changes the emphasis of the Big Three, " *AntiqueWeek,* June 18, 2001.

Roberts, Jane. *Royal Landscape: The Gardens and Parks of Windsor.* New Haven and London: Yale University Press, 1997.

"Romance of a Family Firm." *Pottery and Glass* (August 1956): 252–55.

Russian Majolica in the Collection of the State Hermitage. Leningrad, 1982.

Salkaln, Elaine. "Majolica." New York *Daily News, Sunday News Magazine* (October 24, 1982): 18–19.

249

"Samuel. H. Gilbert Reveals Struggle to Keep Phoenix Pottery in Operation." Phoenixville *Daily Republican* (July 11, 1933): 5.

Satō, Masahiko. *Chinese Ceramics, A Short History.* New York and Tokyo: Weatherhill/Heibonsha, 1981.

Savage, George. *Dictionary of 19th Century Antiques and Later Objets d'Art.* New York: G. P. Putnam's Sons, 1979.

——. *English Ceramics.* New York: The Alpine Fine Arts Collection, Ltd., 1981.

Schwartz, Marvin D. "Fine American Ceramics of the Victorian Period." *The Magazine Antiques* (April 1960): 386–389.

——. "Majolica Is Rediscovered." *Antique Monthly* (June 1982): 1, 6.

Schwartz, Randi. "Majolica," *Country Kitchen of Better Homes and Gardens,* Fall/Winter 1996.

Sekers, David. *The Potteries.* 1981. Reprint. Aylesbury, Bucks., England: Shire Album 62, Shire Publications, Ltd., 1983.

Shaw, Simeon. *History of the Staffordshire Potteries.* Hanley, Staffordshire: privately printed, 1829.

Sineau, Alain. "Les Successeurs de Bernard Palissy." Auction catalogue. Auxerre, France. December 6, 1981.

Skurka, Norma. "Style Makers Today." *House Beautiful* (November 1986): 77.

Smith, Clarissa. "Etruscan Majolica." *Antiques Journal* (June 1957): 80.

Smith, Walter. *Examples of Household Taste.* New York: R. Worthington, n.d. (c. 1880).

Snyder, Jeffrey B. "European Majolica: many blooms, many roots," *AntiqueWeek,* August 2000.

——. *Marvelous Majolica..* Atglen, Pennsylvania: Schiffer Publishing, 2001.

Solis-Cohen, Lita. "Majolica Market Heats Up." *Maine Antique Digest* (November 1985): 16B–20B.

Staab, Nancy. "Majolica Primer," *Southern Living,* August 2001.

Stern, Anna M. P. "Majolica, Flamboyant Victorian Ware." In *The Encyclopedia of Collectibles.* Alexandria, Virginia: Time-Life Books, 1979, 104–121.

——. "Phoenixville Majolica." *The American Antique Journal* (August 1974): 10–12.

Strachey, Lytton. *Queen Victoria.* New York: Harcourt, Brace and Company, 1921.

Stradling, J. Garrison. "American Ceramics at the Philadelphia Centennial." *The Magazine Antiques* (July 1976): 146–158.

——. "East Liverpool, Ohio." *The Magazine Antiques* (June 1982): 1366–1373.

Strong, Susan R. *History of American Ceramics: An Annotated Bibliography.* Metuchen, New Jersey: Scarecrow Press, 1983.

Taylor, Robert B. "The Magic of 19th-Century Majolica." *The Antique Trader, Price Guide to Antiques and Collectors' Items* (summer 1980): 31–34.

Tellerman, Ann. "Seven Designers Restore a Splendid Old Kitchen's Former Grandeur." *House Beautiful* (October 1981): 96–97.

Tenent, Rose. "Potteries Took Flight with Bird Figures." *Antique Week* (November 14, 1988); 1,40.

——. "Minton's Majolica," *The Lady,* 25 to 31 May, 1993.

Thompson, Christopher. "Minton Peacock in Australia," *The Australian Antique Collector,* July–December, 1985.

Turner, Michael. "Occidental or Oriental: 19th-Century Majolica Wares in Eastern Taste" *Antique Collecting (*May 1978): 9–11.

United States Centennial Commission. *Official Catalogue of the International Exhibition of 1876.* Philadelphia: Centennial Catalogue Company/John R. Nagel and Company, 1876.

Van Lemmen, Hans. *Victorian Tiles.* Aylesbury, Bucks., England: Shire Publications, Ltd., 1981.

"Victoriana and Majolica Stir Enthusiasm at Phillips." *Antiques and the Arts Weekly* (August 7, 1987): 35.

Wakefield, Hugh. *Victorian Pottery.* New York: Thomas Nelson and Sons, 1962.

Walker, Francis A., ed. *United States Centennial Commission International Exhibition 1876, Reports and Awards, Group II* ("Pottery, Glass, Artificial Stone, etc."). Philadelphia, 1877.

Ware, Dora, and Maureen Stafford. *An Illustrated Dictionary of Ornament.* New York: St. Martin's Press, 1974.

Watkins, Lura Woodside. "A Check List of New England Potters." In *The Art of the Potter,* edited by Dianna and J. Garrison Stradling. New York: Main Street/Universe Books, 1977.

——. *Early New England Potters and Their Wares.* Cambridge, Massachusetts: Harvard University Press, 1950.

Watson, Wendy M. *Italian Renaissance Maiolica from the William A. Clark Collection.* London: Scala Books, Ltd., 1986.

Wedgwood, Barbara, and Hensleigh Wedgwood. *The Wedgwood Circle, 1730–1897.* Westfield, New Jersey: Eastview Editions, Inc., 1980.

The Wedgwood Illustrated Catalogue of Ornamental Shapes 1878. Reprint. London: Wedgwood Society, 1984.

Wedgwood Pattern Books (1869–1896). Unpublished manuscript at the Wedgwood Museum, Barlaston, Stoke-on Trent, Staffordshire, England.

Weidner, Ruth Irwin. *American Ceramics before 1930: A Bibliography.* Westport, Connecticut: Greenwood Press, 1982.

——. *The Majolica Wares of Griffen, Smith and Company.* Master's thesis, University of Delaware, May 1980.

Wintermute, H. Ogden. "More About Majolica." *American Antiques Journal* (October 1946): 9–11.

Wolfman, Peri, and Charles Gold. *The Perfect Setting.* New York: Harry N. Abrams, Inc., 1985.

Wymans, Donald. *Wymans's Gardening Encyclopedia.* New York: Macmillan, 1986.

Young, Jennie J. *The Ceramic Art: The History and Manufacture of Pottery and Porcelain.* New York: Harper and Brothers, 1878.

Zeder, Audrey B. "Majolica: The Wonderful World of Fantasy Pottery." *Hobbies* (June 1985): 26–30.

WEB SITE ARTICLES

Collectorcafe.com (Kate Davidson)
———"Mad About Majolica," by Jonna M. Gallo, January 2001
———"Majolica—On both sides of the Atlantic," Part 1, by Marilyn G. Karmason, June 2000.
———"Majolica—On both sides of the Atlantic," Part 2, by Marilyn G. Karmason, November 2000.
Collectoronline.com (Tom Jiamachello)
———"Victorian Majolica," by Marilyn G. Karmason; Images courtesy of Charles Washburne, June 2000.
Eppraisals.com (Lois Goldberg)
———"Victorian Majolica: In Vogue After 70 Years," by Marilyn G. Karmason, December 2000

Krause.com (Rena Stierman)
———"Collector Magazine & Price Guide," by Marilyn G. Karmason, June 2000
Majolicasociety.com (Duane Matthes)
———"Phoenixville Majolica," by Anna M. P. Stern, with contributions by Linda LaPointe, October 2000
———"Majolica On Both Sides of the Atlantic," Part 1, by Marilyn G. Karmason, June 2000
———"Majolica On Both Sides of the Atlantic," Part 2, by Marilyn G. Karmason, November 2000
———"Collecting Majolica," by Marilyn G. Karmason, December 2000

259

PHOTOGRAPH CREDITS